THE
ARTIST'S
COMPLETE
HEALTH
AND
SAFETY
GUIDE

BY
MONONA ROSSOL

ALLWORTH PRESS
NEW YORK

GRAPHIC ARTISTS GUILD

© 2001 Monona Rossol

05 04 03 02 01 5 4 3 2 1

Copublished with the Graphic Artists Guild

Published by Allworth Press
An imprint of Allworth Communications
10 East 23rd Street, New York, NY 10010

Copublished with the Graphic Artists Guild

Cover and Interior Design by Jelly Associates, NYC

Page composition/typography by SR Desktop Services, Ridge, NY

Library of Congress Cataloging-in-Publication Data

Rossol, Monona.

The artist's complete health and safety guide / by Monona Rossol.—3rd ed.

p. cm.

Includes bibliographical references and index.

ISBN 1-58115-204-3

1. Artists—Health and hygiene—Handbooks, manuals, etc. 2. Artists' materials—

Safety measures—Handbooks, manuals, etc. 3. Artists' materials—

Toxicology—Handbooks, manuals, etc. I. Title.

RC963.6.A78 R67 2001

Printed in Canada

DEDICATION

To John S. Fairlie and the vast Fairlie clan to which I belong.

ACKNOWLEDGMENTS

There are so many professional friends and colleagues I would like to thank, but the list is far too long. Instead, I will mention only a crucial few. First, always is Jack Holzhueter, who labored long to teach me to write. Next, my thanks to Ted Rickard at the Ontario College of the Arts for his help on the Canadian regulations, and to Tad Crawford, who knows how to spur a writer along without puncturing the ego.

My thanks goes also to the Board of ACTS (Arts, Crafts and Theater Safety), Susan Shaw, Eric Gertner, Nina Yahr, Elizabeth Northrop, Tobi Zausner, and Diana Bryan for sharing their expertise and encouragement. And my deepest gratitude goes to Tom Armino, who gave me the idea of starting ACTS, set up our accounting system, and served on our board until his death in 1988.

TABLE OF CONTENTS

PART III: PRECAUTIONS FOR INDIVIDUAL MEDIA

PART IV: THE NEXT GENERATION

APPENDIX A: SOURCES AND ANNOTATED REFERENCE LIST

APPENDIX B: GLOSSARY 391

LIST OF TABLES AND FIGURES

FIGURES

PREFACE

The idea for this book can be traced back to the University of Wisconsin, where I earned a B.S. in chemistry. I was working and teaching in the chemistry department when I decided to enter the graduate art program. As I went back and forth between the chemistry and art schools, it occurred to me that many of the same acids and other chemicals were used in both places.

As a research chemist, I defended myself against chemicals with goggles, gloves, fume hoods, and other safety equipment. My art colleagues and I, on the other hand, saw these same chemicals as art materials that were to be used lovingly and intimately. As I look back at our work practices now, I think we must have confused "exposure to art" with "exposure to art materials."

My first writings on art hazards were graduate school seminar and term papers in the early 1960s. They were not well received. My classmates and teachers told me bluntly that this kind of information interfered with their creativity. Unfortunately, illness and death also interfere with creativity, so I persisted.

I continued to include health hazard information in my teaching. However, it was only a love labor until 1974, when I received a grand sum of $300 for writing a ceramic studio evaluation and consultation report on toxic ceramic kiln gases.

I have since done many more important things in the art hazards field, but that first consultation had the greatest effect on me. It led me to believe that I could do something for art besides trying to be a good potter and teacher. And because the consultation was for a cerebral palsy center, it greatly affected my thinking about the disabled artist's special health and safety problems.

The book's subject is necessarily technical, and you may find you have questions or need additional information. There are data in this book for which I expected some people would want proof. In these cases, I have cited references. These footnotes do not always appear in a consistent footnote format, but each should provide precisely the correct information to assist the reader in accessing the source of that data. In addition, I have made arrangements for readers to be able to reach me personally at:

Arts, Crafts, and Theater Safety (ACTS)
181 Thompson Street, #23
New York, New York 10012
Telephone: (212) 777-0062
E-mail: *ACTSNY@cs.com*

ACTS is a not-for-profit corporation dedicated to providing a variety of health and safety services for artists. I already answer thousands of requests for information at ACTS every year and would be proud to hear from you. In fact, the comments and questions from artists served as a guide for the material covered in this book. My thanks to you all.

—Monona Rossol, M.S., M.F.A., Industrial Hygienist

PART I
THE REGULATED ART WORLD

Safety laws and common sense both dictate that we understand the hazards of the materials we use and the precautions we must take to work safely. Subjects in which we must be versed include:

Health and Safety Laws
Health Hazards and the Body
Chemical Hazards
Physical Hazards
How to Identify Hazardous Materials
General Precautions
Ventilation
Respiratory Protection

CHAPTER 1

HEALTH AND SAFETY LAWS

As artists and teachers, most of us believe our creative work must be free, uninhibited, and independent. Actually, it is encumbered by a host of laws and regulations.

For example, fire, health, and safety laws affect how we must design our studios and what we can teach in our classrooms. And environmental protection laws limit the kinds of art materials available to us, as well as how we must store, use, and dispose of them. These laws apply to us, because many materials used in art contain substances that now are known to be both toxic and hazardous to the environment. By using these materials improperly, we risk our health and pollute our world just as industry does. While we each may use much smaller amounts of chemicals than industry, there are so many of us.

Today, these laws are becoming more restrictive. They not only apply to professional and industrial materials, but to many common household and hobby products. Art materials packaged for consumer use, in particular, now are regulated under a special amendment to the Hazardous Substances Act (see chapter 5 page 40).

Either we can see these new laws as impositions and resist them at every turn, or we can accept change and do our share in protecting ourselves and the environment. But whether we resist or not, progressively stricter regulation and enforcement is inevitable.

Schools and universities should be at the forefront of this movement. They could encourage teachers and students to explore safer media, find substitutes for toxic materials, and research and develop alternatives to hazardous processes.

Schools that teach art also must develop curricula that include formal health and safety training. This kind of training is already mandated by law for

all employed teachers using toxic art materials (see table 32, page 359), and it should be made available to students and self-employed artists as well.

Health and safety training for artists, teachers, students, and all users of art materials should consist of basic industrial hygiene, which has been adapted for the arts.

INDUSTRIAL HYGIENE FOR THE ARTS

Industrial hygiene is the science of protecting workers' health through control of the work environment. As an artist–turned–industrial hygienist, I have spent more than a dozen years specializing in protecting artists from their environments—and themselves.

To be honest, I would not describe this work as a "glamorous career in the arts." However, my work enables me to visit each year between fifty and a hundred schools, universities, museums, commercial studios, theaters, and other sites in the United States, Canada, Australia, and England. I have also been involved in planning new art buildings, in developing state and federal art materials regulations, testifying as an expert witness in art-related lawsuits, and counseling literally thousands of artists, teachers, administrators, and the like.

This book is an attempt to share the perspective I have developed through these experiences and to provide a training reference to help us comply with applicable health and safety laws and regulations.

THE CARROTS (INDUCEMENT)

One of the most humbling aspects of my first few years in industrial hygiene was observing how steadfastly both artists and administrators ignored my advice. I talked enthusiastically about health and safety programs, ventilation, respiratory protection, and so on. While I was talking, there would be interest, motivation, and good intentions. But before my vocal cords cooled, people would be back to business-as-usual.

It wasn't that people didn't want to be safer and healthier—they did. It wasn't that they didn't understand the technical information—they did. It wasn't even that the precautions would cost too much—they often didn't. The failure to institute proper health and safety procedures usually boiled down, in the main, to inertia and old habits.

These are formidable foes. We are all infected terminally with the desire to do the familiar—even if we know it is not in our best interest. There is an exquisite pain associated with the effort of hauling habits out of our spinal cord reflexes

and putting them back into our brains to be thought through again. Confronting this resistance taught me that there is no industrial hygienist clever enough, no lecturer interesting enough, no argument convincing enough to make us change the way we make art. The lectures and training only make us feel a little more guilty as we routinely bet little bits of our life on risky familiar activities.

THE STICKS (ENFORCEMENT)

If lectures and training will not change our habits, force, in the form of our own governmental agencies and the courts, will. Enforcement is necessary and beneficial, despite the bitter complaints we hear about excessive jury awards and restrictive Occupational Safety and Health Administration (OSHA) rules.

And certainly, enforcement works. One lawsuit improves safety practices in an entire school district overnight. One hefty OSHA fine causes shop managers for a hundred miles around to put the guards back on the saws.

Personally, I have found that juries and judges usually are fair. And complaints about the cost of complying with regulations merely reflect our difficulty in facing the fact that, for far too many years, we have spent far too little on health and safety.

In this case, the law and the lawsuit are not our enemies. They reflect our own collective (not always perfect) wisdom in the form of our governmental servants and a jury of our peers. If you doubt this, try this exercise: Imagine yourself defending your work practices, reporting your accident, or describing conditions in your studio or classroom to OSHA or a jury.

LAWS PROTECTING ART WORKERS

Both the United States and Canada have very complex regulations governing the relationship between employer and employee. However, whether the regulations are called the Occupational Safety and Health Act (OSHAct in the United States) or Occupational Health and Safety Act (OHSAct in Canada), their main purpose is very simple—to protect workers.

The OSHAct general duty clause reads in part that the "employer shall furnish . . . employment and a place of employment which are free from recognized hazards." The Canadian OHSAct requires employers and supervisors to "take every precaution reasonable in the circumstances for the protection of a worker."

These brief general statements serve as the foundation for complex regulatory structures. The Acts include rules about chemical exposures, noise, ladder

safety, machinery guarding, and a host of subjects. And many of these rules apply to schools, art-related businesses, etc.

All of us should be aware of these rules. In my opinion, even high schools should not graduate students who are unacquainted with their rights in the workplace. If you also are not versed in these regulations, first call your nearest department of labor and obtain a copy. Although the Acts are not reader-friendly, it is worth the extra effort for you to become as familiar with them as possible.

THE RIGHT TO KNOW. Certain OSHA regulations instituted in the late 1980s are proving particularly useful in pressing us to upgrade our health and safety practices. These are the so-called right-to-know laws.

United States right-to-know laws were first passed by a number of states. Then, a similar federal regulation called the OSHA Hazard Communication Standard (HAZCOM) was instituted. The result is that all employees in the United States are now covered by one or the other (sometimes both) of these laws. Even federal workers, so long exempt from OSHA regulations, come under this rule. There is a similar history in Canada, with the resulting passage of the federal Workplace Hazardous Materials Information System (WHMIS).

For the most part, both these laws require employers to provide written hazard communication programs, give workers access to complete inventories and data sheets for all potentially hazardous chemicals in the workplace, and require formal training of all employees who potentially are exposed to toxic chemicals.

Even an ordinary office worker comes under the rule if he or she works long hours with an ozone-producing copy machine. That worker must be told of the effects of ozone, shown what kind of ventilation is necessary to reduce it to acceptable limits, given access to a data sheet describing details of the toner's hazardous ingredients, instructed formally about what to do if the toner spills, and so on.

How much more, then, should the law be applied to art teachers, craftspeople, or artists who use hazardous paints, dyes, solvents, metals, and so on!

Yet many schools and art-related businesses still do not comply with the new laws. This is partly due to a peculiar common belief that the laws do not apply to art—that art is somehow "special." Actually, producing art should more correctly be considered a "light industry" that uses toxic substances to create a product. This also is how government inspectors see artmaking.

Today, OSHA gives more citations for hazard communication violations than for any other rule infraction. Many art schools, businesses, and institutions have been cited. I am personally aware of a number of these citations. For example, one major university was cited for failure to formally train their art faculty in hazard

communication. I was hired to conduct four four-hour training sessions over a two-day period on an emergency basis to get the school into compliance.

WHO'S COVERED? Essentially, all employees[1] in the United States are covered by state or federal Hazard Communication laws. All employees in Canada are covered by the Workplace Hazardous Materials Information System (WHMIS). All employers in workplaces where hazardous materials are present, therefore, are required to develop programs and train their employees. (The employer is the person or entity that takes deductions for taxes out of the paycheck.)

Self-employed artists/teachers are not covered, but they may be affected indirectly by the laws. For example, if you work as an independent contractor working or teaching at a site where there are employees, all the products and materials you bring onto the premises must conform to the employer's Hazard Communication or Workplace Hazardous Materials Information System program labeling requirements. Your use of these products also must conform.

Teachers in the United States have a unique hazard communication obligation arising from the fact that they can be held liable for any harm classroom activities cause their students. To protect their liability, teachers should formally transmit to students hazard communication training about the dangers of classroom materials and processes. They also must enforce the safety rules and act as good examples of proper precautions.

Precautionary training is not necessary at the elementary school level unless ceramic materials are used in the program. However, elementary teachers should train students to handle the materials as if they were toxic in order to help young students develop the habits they will need when they are older. For example, students should be taught to keep art materials off the skin, to wash carefully before handling food, and to never use the art room as a lunch room.

COMPLYING WITH THE HAZARD COMMUNICATION STANDARD AND WORKPLACE HAZARDOUS MATERIALS INFORMATION SYSTEM

1. To comply, first find out which law applies to you. Call your local department of labor, and ask them to tell you whether you must comply with a state/provincial or federal right-to-know.

[1] A few state and municipal employees in states that do not have an accepted state OSHA plan are still exempt.

2. Ask for a copy of the law that applies to you. Also, ask for explanatory materials. Some of the government agencies have prepared well written guidelines to take you through compliance step-by-step.

GENERAL REQUIREMENTS—HAZARD COMMUNICATION STANDARD/WORKPLACE HAZARDOUS MATERIALS INFORMATION SYSTEM

There are small differences between the United States and Canadian laws. For example, the definition of "hazardous" varies, and the Canadian law requires information in French. However, the two laws require employers to take similar steps toward compliance:

1. Inventory all workplace chemicals. Remember, even products such as bleach and cleaning materials may qualify as hazardous products. List everything. (This is an excellent time to cut down paperwork by trimming your inventory. Dispose of old, unneeded, or seldom-used products.)
2. Identify hazardous products in your inventory by applying the definition of "hazardous" in the right-to-know law that applies to you.
3. Assemble Material Safety Data Sheets (MSDSs) on all hazardous products. Write to manufacturers, distributors, and importers of all products on hand for MSDSs. Require MSDSs as a condition of purchase for all new materials.
4. Check all product labels to be sure they comply with the law's labeling requirements. Products that do not comply must be eliminated or relabeled.
5. Prepare and apply proper labels to all containers into which chemicals have been transferred. (Chemicals in unlabeled containers that are used up within one shift need not be labeled.)
6. Consult Material Safety Data Sheets to identify all operations that use or generate hazardous materials. Be aware that nonhazardous materials, when chemically reacted, heated, or burned, may produce toxic emissions.
7. Make all lists of hazardous materials, Material Safety Data Sheets, and other required written materials available to employees. (The OSHA Hazard Communication Standard also requires a written hazard communication program that details all procedures.)
8. Implement a training program. (See Training, below.)

9. Check to see if you are responsible for additional state and provincial requirements. For example, regulations in New Jersey and Massachusetts require state certification of trainers for public employees, including teachers.

TRAINING

All employees in both the United States and Canada should already have received right-to-know training, since most of the laws have been in effect since the late 1980s. Additional training should take place whenever new employees are hired or new materials or processes introduced. Some state laws require yearly training as well.

The amount of time the training should take is usually not specified. This is because the law intends the training requirements to be performance-oriented—that is, the employees must be given whatever information they need to understand the hazards of their specific jobs and how to work safely. Often, short quizzes are used to verify that employees have understood the presentation.

Initial training for artists and art teachers can usually be accomplished in a full day. Annual retraining can take less time. The information that must be communicated includes:

1. The details of the hazard communication program that the employer is conducting, including an explanation of the labeling system, the Material Safety Data Sheets, and how employees can obtain and use hazard information.
2. The physical and health hazards of the chemicals in the work area. This should include an explanation of physical hazards, such as fire and explosions, and health hazards, such as how the chemical enters the body and the effects of exposure.
3. How employees can protect themselves. This should include information on safe work practices, emergency procedures, use of the personal protective equipment provided by the employer, and an explanation of the ventilation system and other engineering controls that reduce exposure.
4. How the employer and employees can detect the presence of hazardous chemicals in the work area. This should include training about environmental and medical monitoring conducted by the employer, use of monitoring devices, the visual appearance and odor of chemicals, and any other detection or warning methods.

This book can be used by employers or administrators to address points 2 to 4 above. An outline of the material that should be covered in an artist's right-to-know training is found in chapter 30. The lists of precautions at the ends of chapters on specific media can be used as shop safety inspection checklists.

OTHER REGULATIONS

All the material above applies to the Hazard Communication Standard, which is only one of OSHA's rules. There are dozens of others that apply directly to art. And like the Hazard Communication Standard, there are different state and federal provisions for each law. Canada also has many laws that are very similar to these. Since it is not possible to refer to all these laws, this book will reference the U.S. federal regulations. They will be in the standard Code of Federal Regulations (CFR) format, which is:

1. 29 CFR 1910 for general industry regulations
2. 29 CFR 1926 for construction standards

Construction standards are applicable to art only when large projects are being built or installed.

Some of the applicable laws and their code numbers are listed in table 1. Anyone familiar with standard practices in art businesses, colleges, universities, and studios will see from table 1 that most art facilities are in serious violation of OSHA laws.

TABLE 1	APPLICABLE OSHA REGULATIONS

HAZARD COMMUNICATION (29 CFR 1910.1200). This rule requires a written program, MSDS compilation, and formal training for employees (including teachers) who use toxic substances.

PERSONAL PROTECTIVE EQUIPMENT (29 CFR 1910.132–133). OSHA requires formal, documented training for all protective equipment, including gloves and eyewear.

RESPIRATORY PROTECTION (29 CFR 1910.134). To wear a respirator or mask, employees must be medically certified, professionally fit-tested, and formally trained in respirator use and limitations.

BLOOD-BORNE PATHOGENS STANDARD (29 CFR 1910.1030). Workers must be trained in the proper precautions to be taken when exposure to blood and other body fluids may occur. This rule is applicable to employees on any job in which cuts and small accidents are a likely or common occurrence.

SANITATION (29 CFR 1910.141). Included in this regulation is a rule prohibiting workers from eating wherever toxic substances are used or stored.

EMERGENCY PLANS AND FIRE PREVENTION (29 CFR 1910.38). All employees must be trained to do what is expected of them in an emergency.

FIRE EXTINGUISHER USE AND TRAINING (29 CFR 1910.157). If employees are expected to use fire extinguishers, they must be trained annually in their use.

MEDICAL SERVICES AND FIRST AID (29 CFR 1910.151). This rule includes requirements for the availability of medical aid, eyewash stations, etc.

ELECTRICAL SAFETY (29 CFR 1910.301-304). Workers using, repairing, or working around electrical equipment must follow the many provisions of this regulation.

FLAMMABLE AND COMBUSTIBLE LIQUIDS (29 CFR 1910.106). This regulation mandates the proper handling and storage of solvents and other flammables.

LEAD STANDARD (29 CFR 1910.1025). This standard requires expensive monitoring, record-keeping, blood tests, and other precautions if airborne lead is generated during activities such as spraying, soldering, kiln firing, etc.

CADMIUM STANDARD (29 CFR 1910.1027). This rule is applicable if airborne cadmium is generated (e.g., from spray painting, sanding paint, silver soldering, ceramic glazing).

WELDING, CUTTING, AND BRAZING (29 CFR 1910.251–255). Employers are required to provide proper training and safety equipment for this work.

OCCUPATIONAL NOISE EXPOSURE (29 CFR 1910.95). If it is suspected that machinery used on the job exceeds noise standards, the sound must be measured and appropriate precautions instituted. This may include audiograms for workers and many written program requirements.

ERGONOMIC PROGRAM STANDARD (29 CFR 1910.900). This rule, ten years in the making, became effective in the final days of the Clinton administration. President Bush used the Congressional Review Act to enable Congress to overturn federal regulations within sixty days of their being issued. The rule was repealed. Until a new ergonomic standard is developed, I suggest using the old one as a guideline for protecting workers who do tasks that employ repetitive, forceful, or awkward motions. (See chapter 4.)

CHAPTER 2
HEALTH HAZARDS AND THE BODY

Art and craft workers need to understand how chemicals in their materials affect them in order to protect their health and to meet the requirements of new occupational and environmental laws.

Studying the hazards of art and craft materials is difficult, because these materials contain so many different toxic chemicals. For example, many toxic metals, including highly toxic ones such as lead and cadmium, are still found in traditional paint and ink pigments, ceramic glazes, metal enamels, and in alloys used in sculpture, stained glass, jewelry, and other crafts. In addition, new synthetic dyes and pigments, plastics, organic chemical solvents, and a host of other toxic materials are often used.

Each of these chemicals affects the body in its own unique way. The study of these effects is called toxicology.

BASIC CONCEPTS

Dose. Chemical toxicity is dependent on the dose—that is, the amount of the chemical that enters the body. Each chemical produces harm at a different dose. Highly toxic chemicals cause serious damage in very small amounts. Moderately and slightly toxic substances are toxic at relatively higher doses. Even substances considered nontoxic can be harmful if the exposure is great enough.

Time. Chemical toxicity is also dependent on the length of time over which exposures occur. The effects of short and long periods of exposure differ.

Short-Term or Acute Effects. Acute illnesses are caused by large doses of toxic substances delivered in a short period of time. The symptoms usually occur

13

during or shortly after exposure and last a short time. Depending on the dose, the outcome can vary from complete recovery, through recovery with some level of disability, to—at worst—death. Acute illnesses are the easiest to diagnose, because their cause and effect are easily linked. For example, exposure to turpentine while painting can cause effects from lightheadedness to more severe effects, such as headache, nausea, and loss of coordination. At even higher doses, unconsciousness and death could result.

Long-Term or Chronic Effects. These effects are caused by repeated, low-dose exposures over many months or years. They are the most difficult to diagnose. Usually, the symptoms are hardly noticeable until severe, permanent damage has occurred. Symptoms appear very slowly, may vary from person to person, and may mimic other illnesses. For instance, chronic exposure to turpentine during a lifetime of painting may produce dermatitis in some individuals, chronic liver or kidney effects in others, and nervous system damage in still others.

Effects between Acute and Chronic. There are also other effects between acute and chronic, such as "subacute" effects produced over weeks or months at doses below those that produce acute effects. Such in-between effects are also difficult to diagnose.

Cumulative/Noncumulative Toxins. Every chemical is eliminated from the body at a different rate. Cumulative toxins, such as lead, are substances that are eliminated slowly. Repeated exposure will cause them to accumulate in the body.

Noncumulative toxins, like alcohol and other solvents, leave the body very quickly. Medical tests can detect their presence only for a short time after exposure. Although they leave the body, the damage they cause may be permanent and accumulate over time.

Total Body Burden. This is the total amount of a chemical present in the body from all sources. For example, we all have body burdens of lead from air, water, and food contamination. Working with lead-containing art materials can add to this body burden.

Multiple Exposures. We are carrying body burdens of many chemicals and are often exposed to more than one chemical at a time. Sometimes, these chemicals interact in the body.

Additive Exposures. Exposure to two chemicals is considered additive when one chemical contributes to or adds to the toxic effects of the other. This can occur when both chemicals affect the body in similar ways. Working with paint thinner and drinking alcohol is an example.

Synergistic Exposures. These effects occur when two chemicals produce an effect greater than the total effects of each alone. Alcohol and barbiturates or smoking and asbestos are common examples.

Cancer. Occupational cancers are a special type of chronic illness. Chemicals that cause cancer are called carcinogens. Examples include asbestos and benzidine dyes and pigments. Unlike ordinary toxic substances, the effects of carcinogens are not strictly dependent on dose. No level of exposure is considered safe. However, the lower the dose, the lower the risk of developing cancer. For this reason, exposure to carcinogens should be avoided altogether or kept as low as possible.

Occupational cancers typically occur ten to forty years after exposure. This period of time, during which there are no symptoms, is referred to as a latency period. Latency usually makes diagnosis of occupational cancers very difficult.

Mutagenicity. Mutations (and cancer) can be caused by chemicals that alter the genetic blueprint (DNA) of cells. Once altered, such cells usually die. Those few that survive will replicate themselves in a new form.

Any body cell (muscle, skin, etc.) can mutate. However, when the affected cell is the human egg or sperm cell, mutagenicity can affect future generations. Most pregnancies resulting from mutated sperm and eggs will result in spontaneous termination of the pregnancy (reabsorption, miscarriage, etc.). In other cases, inherited abnormalities may result in the offspring.

Only a handful of chemicals, pesticides, and drugs have been studied sufficiently to prove they are human mutagens. Such proof requires that thousands of exposed individuals be studied for many decades. Since this is not practical, chemicals are considered "suspect human mutagens" if they cause mutation in bacteria or animals. Some chemicals found in arts and crafts have been shown to be suspect mutagens, including a number of pigments, synthetic dyes, and solvents. (See tables 9 and 10, "Common Solvents and Their Hazards" and "Hazards of Pigments," pages 95 and 114.) Both men and women should avoid exposure to suspect mutagens, since both may be affected.

Teratogenicity. Chemicals that affect fetal organ development—that is, cause birth defects—are called teratogens. They are hazardous primarily during the first trimester. Two proven human teratogens include the drug thalidomide and grain alcohol. Chemicals that are known to cause birth defects in animals are considered "suspect teratogens." Among these are many solvents, lead, and other metals.

Fetal toxicity. Toxic chemicals can affect the growth and development of the fetus at any stage of development.

Allergenicity. Allergies are adverse reactions of the body's immune system. Common symptoms may include allergic dermatitis, hay fever effects, and asthma. Most allergies are triggered by plant and animal proteins found in natural substances, such as pollen, rubber, and wood dusts. Chemicals that can cause respiratory and/or skin allergies include epoxy adhesives, chrome compounds, batik dyes, and isocyanates (in urethane resins).

Once developed, allergies tend to last a lifetime, and symptoms may increase in severity with continued exposure. A few people even become highly allergic—that is, they develop life-threatening reactions to exceedingly small doses. This effect is caused by bee venom in some people, but industrial chemicals have produced similar effects—including death.

Hypersensitivity. Chemicals inhaled into the lungs, however, are more likely to cause hypersensitivity reactions than allergic reactions. When irritating or damaging chemicals are repeatedly inhaled over time, the mucous membranes in the lungs may become damaged and inflamed. Such damage results in increased sensitivity to airborne chemicals, in much the same way as a tight shoe causes the foot to be sensitive to chafing. This is called hypersensitivity. It is not an allergy, but it can be just as serious.

Sensitizers. Chemicals that can produce allergic or hypersensitivity reactions in significant numbers of people are called sensitizers. The longer people work with sensitizers, the greater the probability they will begin to react to them.

HOW CHEMICALS ENTER THE BODY (ROUTES OF ENTRY)

In order to cause damage, toxic materials must enter the body. Entry can occur in the following ways:

Skin Contact. The skin's barrier of waxes, oils, and dead cells can be destroyed by chemicals such as acids, caustics, solvents, and the like. Once the skin's defenses are breached, some of these chemicals can damage the skin itself, the tissues beneath the skin, or even enter the blood, where they can be transported throughout the body, causing damage to other organs.

Cuts, abrasions, burns, rashes, and other violations of the skin's barrier can allow chemicals to penetrate into the blood and be transported throughout the body. There are also many chemicals that can, without your knowing it, enter the blood through undamaged skin. Among these are toluene and wood alcohol.

Inhalation. Inhaled substances are capable of damaging the respiratory system acutely or chronically at any location—from the nose and sinuses to the

lungs. Examples of substances that can cause chronic and acute respiratory damage include acid vapors and fumes from heating or burning plastics.

Some toxic substances are absorbed by the lungs and are transported via the blood to other organs. For example, lead in solder fumes may be carried via the blood to damage the brain and kidneys.

Ingestion. You can accidentally ingest toxic materials by eating, smoking, or drinking while working, pointing brushes with your lips, touching soiled hands to your mouth, biting your nails, and similar habits. The lung's mucous also traps dusts and removes them by transporting them to your esophagus, where they are swallowed.

Accidental ingestions occur when people pour chemicals into paper cups or glasses and later mistake them for beverages. Some of these accidents have even killed children who were allowed in the studio.

WHO IS AT RISK?

Anyone who handles chemicals frequently is more susceptible to occupational illnesses. How they are affected will depend on the nature of the chemical, its route of entry, the degree of exposure, and, in some cases, the susceptibility of the exposed person. For example, most people's lungs will be affected equally by exposure to similar concentrations of strong acid vapors. However, someone who already has bronchitis or emphysema may be even more seriously harmed.

High-Risk Individuals. Certain segments of the population—particularly disabled persons, the chronically ill (especially those with preexisting damage of organs such as the liver or lungs), pregnant women and the fetus, children, and the elderly—are at especially high risk from certain art activities. For example, the hearing-impaired may risk further damage to their already-defective hearing if they engage in woodworking activities that employ noisy machinery. People with mental disabilities should not be exposed to chemicals that are known to adversely affect mental acuity and behavior, such as lead and chemical solvents.

People taking certain medications are sometimes at higher risk. For example, medications—and recreational drugs—that are narcotic may potentiate the effects of solvents and metals that are also narcotic (numbing to the brain).

OCCUPATIONAL ILLNESSES

Any organ in the body can be affected by an occupational illness. Some occupational illnesses include the following:

Skin Diseases. Two types of dermatitis are among the most common occupational skin diseases:

1. *Primary irritant contact dermatitis* is a nonallergic skin reaction from exposure to irritating or corrosive substances and accounts for 80 percent of the cases of occupational contact dermatitis. There are two major types of substances that can cause the disease:
 a. Mild irritants that require repeated and/or prolonged exposure. Included in this category are soaps, detergents, and many solvents.
 b. Corrosives, which require only short exposures to cause damage. Substances included in this category are strong acids, alkalis, and peroxides.
2. *Allergic contact dermatitis* (sometimes called hypersensitivity dermatitis) is a delayed allergic skin reaction occurring when sensitized individuals are exposed to allergens. Common allergens include epoxy adhesives, turpentine, chrome and nickel compounds, and wood dust.

Other occupational skin diseases include infections and skin cancer. Working with cuts, abrasions, or other kinds of skin damage may lead to infections. Lampblack pigments and ultraviolet radiation are associated with skin cancer.

Eye Diseases. Irritating, caustic, and acid chemicals can damage the eye severely. Infrared (e.g., from glowing hot kilns) or ultraviolet light (e.g., from welding) can cause eye damage. A few chemicals, such as methanol and hexane, can also damage eyesight when inhaled or ingested.

Respiratory System Diseases. Any irritating or corrosive airborne chemical can be potentially hazardous to the respiratory system. Damage can range from minor irritation to life-threatening chemical pneumonia, depending on the substance and how much is inhaled. Exposures to smaller amounts of irritants over years can cause chronic respiratory damage, such as chronic bronchitis or emphysema.

Often, the first symptom of respiratory irritation is an increased susceptibility to colds and respiratory infections. This is commonly seen among artists exposed to the small amounts of ammonia and formaldehyde released by acrylic paints.

Another factor affecting respiratory damage is the chemical's solubility in liquid and mucous. Highly soluble corrosives, such as hydrochloric acid gas, produce immediate symptoms in the upper respiratory tract. These warning

symptoms usually cause people to take action to avoid further exposure. Poorly soluble chemicals, such as ozone or nitric acid (from acid etching), cause delayed damage to the lower respiratory tract. In cases of heavy exposure, pulmonary edema may occur as much as twelve hours after exposure.

Some types of soluble chemicals, including lead and solvents, are absorbed by the lungs, pass into the bloodstream, and are transported to other organs in the body. Insoluble particles, on the other hand, may remain in the lungs for life if they are deposited deeply in the air sacs (alveoli). Some of these insoluble particles, such as asbestos and silica, can cause lung-scarring diseases (fibroses), such as asbestosis and silicosis, and lung cancer.

Allergic and hypersensitivity diseases such as asthma, alveolitis, and hypersensitivity pneumonia may result from exposure to sensitizing chemicals.

Smokers are at greater risk from lung cancer and almost all other diseases of the lungs. Smoking inhibits the lungs' natural clearing mechanisms, leaving toxic particles in them longer and allowing them to do more damage.

Heart and Blood Diseases. Many solvents at high doses can alter the heart's rhythm (arrhythmia) and even cause a heart attack. Deaths related to this phenomenon have been noted among both industrial workers and glue sniffers whose level of exposure to solvents was very high.

Benzene, still found as a contaminant in some solvents and gasoline, can cause aplastic anemia (decreased bone marrow production of all blood cells) and leukemia.

Nervous System Diseases. Metals like lead and mercury are known to cause nervous system damage. The early symptoms of exposure are often psychological disturbances and depression.

Almost all solvents can affect the nervous system. Symptoms can vary from mild narcosis (lightheadedness, headache, dizziness) to coma and death at high doses. People exposed to small amounts of solvent daily for years often exhibit the symptoms of chronic nervous system damage, such as short-term memory loss, mental confusion, sleep disturbances, hand-eye coordination difficulties, and depression.

Some chemicals, such as n-hexane (found in rubber cements, some aerosol sprays, etc.), are particularly damaging to the nervous system, and chronic exposure can result in a disease similar to multiple sclerosis.

Liver Diseases. Hepatitis can be caused by chemicals as well as by disease organisms. Some toxic metals and nearly all solvents, including grain alcohol, can damage the liver if the dose is high enough. Liver cancer is caused by chemicals such as carbon tetrachloride.

Kidney Diseases. Kidney damage is also caused by many metals and solvents. Lead and chlorinated hydrocarbon solvents, such as trichloroethylene, are particularly damaging. Heat stress and accidents (damaged blood and muscle cell debris block kidney tubules) are also causes of kidney damage.

Bladder Diseases. While bladder cancer may be caused by various carcinogens, the toxic substances most strongly associated with the disease are the benzidine-derived pigments and dyes.

Reproductive Effects. Chemicals can affect any stage of reproduction: sexual performance, the menstrual cycle, sperm generation, all stages in organ formation and fetal growth, the health of the woman during pregnancy, and the newborn infant through chemicals secreted in breast milk. More is being learned each day regarding such effects. Prudence dictates that both men and women planning families exercise care when working with art and craft materials containing toxic chemicals. (See also the sections above on mutagenicity and teratogenicity and chapter 31.)

CHAPTER 3

CHEMICAL HEALTH HAZARDS AND THEIR CONTROL

Health-damaging chemicals can enter our body by skin contact, ingestion, and inhalation. Exposure by skin contact can usually be prevented by wearing gloves, using tools to handle materials, and so on. Ingestion can be prevented by good work habits and by not eating, smoking, or drinking in the workplace. Precautions against inhalation are more complex.

INHALATION HAZARDS
To prevent inhalation of airborne chemicals, it is first necessary to understand the nature of airborne contaminants, such as gases, vapors, mists, fumes, and dust.

Gases. Scientists define gas as a formless fluid that can expand to fill the space that contains it. We can picture this fluid as many molecules moving rapidly and randomly in space.

Air, for example, is a mixture of different gases—that is, different kinds of molecules. Even though each different gas has a different molecular weight, the heavier gases will never settle out, because the rapid molecular movement will cause them to remain mixed. In other words, once gases are mixed, they tend to stay mixed.

In almost all cases, gases created during artmaking are mixed with air as they are released. This means that they also will not settle, but instead will expand into the space that contains them. In most cases, the gas will diffuse evenly throughout the space—the room—in time.

When the gas escapes from the room or is exhausted from the room by ventilation, expansion of the gas continues theoretically forever. It is this expansion that causes, for example, spray-can propellants to reach the stratospheric ozone layer.

Under certain conditions, gases will not freely mix with air. For example, carbon dioxide gas from dry ice will form a foggy layer at ground level, because the cold gas is denser and heavier than air (the molecules are closer together). In another instance, certain gases may layer out or take a long time to mix with air in locations where there is little air movement, such as in storage areas.

Gases vary greatly in toxicity. They can be irritating, acidic, corrosive, poisonous, and so on. Some gases also have dangerous physical properties, such as flammability or reactivity. Toxic gases that may be encountered in artmaking include: hydrochloric acid gas from etching and pickling solutions, ozone and nitrogen oxides from welding, and sulfur dioxide and acetic acid gases from photographic developing baths.

Some gases are not toxic. An inert gas such as argon, which is used in inert gas welding, is an example. Such gases are dangerous only when present in such large quantities that they reduce the amount of oxygen in the air to levels insufficient to support life. These gases are called *asphyxiants*.

Vapors. Vapors are the gaseous form of liquids. For example, water vapor is created when water evaporates—that is, when it releases vapor molecules into the air. Once released into the air, vapors behave like gases and expand into space. However, at high concentrations, they will recondense into liquids. This is what happens when it rains.

There is a common misconception that substances do not vaporize until they reach their "vaporization point"—that is, their boiling point. Although greater amounts of vapor are produced at higher temperatures, most materials begin to vaporize as soon as they are liquid.

Even some solids convert to a vapor form at room temperature. Solids that do this are said to *sublime*. Mothballs are an example of a chemical solid that sublimes.

Vapors, like gases, may vary greatly in toxicity, flammability, and reactivity. Among the most common toxic vapors created in artwork are organic chemical vapors from solvents such as turpentine, mineral spirits, and lacquer thinners.

Mists. Mists are tiny liquid droplets in the air. Any liquid, water, oil, or solvent can be misted or aerosolized. The finer the size of the droplet, the more deeply the mist can be inhaled. Some mists, such as paint spray mists, also contain solid material. Paint mist can float on air currents for a time. Then, the liq-

uid portion of the droplet will vaporize—convert to a vapor—and the solid part of the paint will settle as a dust.

A mist of a substance is more toxic than the vapor of the same substance at the same concentration. This results from the fact that when inhaled, the droplets deliver the mist in little concentrated spots to the respiratory system's tissues. Vapors, on the other hand, are more evenly distributed in the respiratory tract.

Fumes. Laymen commonly use this term to mean any kind of emission from chemical processes. In this book, however, only the scientific definition will be used.

Technically, fumes are very tiny particles usually created in high-heat operations such as welding, soldering, or foundry work. They are formed when hot vapors cool rapidly and condense into fine particles. For example, lead fumes are created during soldering. When solder melts, some lead vaporizes. The vapor immediately reacts with oxygen in the air and condenses into tiny lead oxide fume particles.

Fume particles are so small (0.01 to 0.5 microns in diameter)[1] that they tend to remain airborne for long periods of time. Eventually, however, they will settle to contaminate dust in the workplace, in the ventilation ducts, in your hair or clothing, or wherever air currents carry them. Although fume particles are too small to be seen by the naked eye, they sometimes can be perceived as a bluish haze rising like cigarette smoke from soldering or welding operations.

Fuming tends to increase the toxicity of a substance, because the small particle size enables it to be inhaled deeply into the lungs and because it presents more surface area to lung fluids (is more soluble). The more surface area a substance has, the more area the lung fluids have to attack in their attempt to dissolve it, allowing it to pass all the more quickly through the lung's alveoli and to be transported by the blood throughout the body.

In addition to many metals, some organic chemicals, plastics, and silica will fume. Smoke from burning organic materials may also contain fumes.

Dusts. Dusts are formed when solid materials are broken down into small particles by natural or mechanical forces. Natural wind and weathering produces dusts from rocks. Sanding and sawing are examples of mechanical forces that produce dusts.

[1] A micron is a metric system unit of measurement equaling one millionth of a meter. There are about 25,640 microns in an inch. Respirable fume and dust particles are in the range of 0.01 to 10 microns in diameter. Such particles are too small to be seen by the naked eye.

The finer the dust, the deeper it can be inhaled into the lung and the more toxic it will be. "Respirable" dusts—those which can be inhaled deeply into the lungs—are too small to be seen with the naked eye (0.5 to 10 microns in diameter).

The larger dusts deposit in the upper respiratory system, where they are raised by lung- clearing mechanisms and ingested. These larger dust particles are referred to as "inhalable," "total dusts," or "nonrespirable" by various agencies.

Smoke. Smoke is formed from burning organic matter. Burning wood and cutting plastic with a hot wire are two smoke-producing activities. Smoke is usually a mixture of many gases, vapors, and fumes. For example, cigarette smoke contains over four thousand chemicals, including carbon monoxide gas, benzene vapor, and fume-sized particles of tar.

EXPOSURE STANDARDS

Exposure to airborne chemicals in the workplace is regulated in the United States and Canada. The United States limits are called OSHA Permissible Exposure Limits (PELs). The Canadian limits are called Occupational Exposure Limits (OELs).

Although the levels at which various chemicals are regulated may differ occasionally, both countries' regulations are based on a concept called the Threshold Limit Values (TLVs). The Permissible Exposure Limit and Occupational Exposure Limit for many substances are identical to the Threshold Limit Value, and in those cases in which they vary, it is wise to use the lower, more protective limit.

TLVs are airborne substance standards set by the American Conference of Governmental Industrial Hygienists (ACGIH). Copies of the TLVs can be obtained from the ACGIH (see address in footnote under table 2, page 26). TLVs are designed to protect the majority of healthy adult workers from adverse effects. There are three major types:

1. Threshold Limit Value–Time-Weighted Averages (TLV-TWAs) are air-borne concentrations of substances averaged over eight hours. They are meant to protect from adverse effects those workers who are exposed to substances at this concentration over the normal eight-hour day and a forty-hour work week.

2. Threshold Limit Value–Short-Term Exposure Limits (TLV-STELs) are fifteen-minute average concentrations that should not be exceeded at any time during a workday.

3. Threshold Limit Value–Ceiling limits (TLV-C) are concentrations that should not be exceeded during any part of the workday exposure.

TLVs should not be considered absolute guarantees of protection. TLVs previously thought adequate have repeatedly been revised as medical tests have become more sophisticated and as long-term exposure studies have revealed chronic diseases previously undetected.

At best, TLVs are meant to protect most, but not all, healthy adult workers. They do not apply to children, people with chronic illnesses, and other high-risk individuals.

TLV-TWAs also do not apply to people who work longer than eight hours a day. This is especially true of people who live and work in the same environment, such as artists whose studios are at home. Living and working in the same location can result in very high exposures, since the artist is likely to be exposed to contaminants twenty-four hours a day. With no respite during which the body can detoxify, even low concentrations of contaminants become significant.

Expensive and complicated air sampling and analysis are usually required to prove that TLVs have been exceeded. For this reason, TLVs are primarily useful to artists as proof that a substance is considered toxic and that measures should be taken to limit exposure to substances with TLVs.

Many substances known to be very toxic have no TLVs because the ACGIH has not assessed the chemical or they think there is insufficient data to quantify the risk from exposure. In such cases, it is wise to see if there are other air-quality standards that apply. Other agencies, such as the National Institute for Occupational Safety and Health (NIOSH) and the American Industrial Hygiene Association (AIHA), have standards that apply to chemicals for which there are no TLVs. Standards in other countries should also be considered. The German federal workplace standards, called MAKs (Maximum Concentration Values) are especially useful and are usually accepted by other European countries as well.

USING EXPOSURE STANDARDS

When additional factors, such as evaporation rate, are considered, artists can also use TLVs to compare the toxicity of various chemicals. Table 2 lists the TLV-TWAs of some common air contaminants. This table illustrates that while the TLV concept may seem complicated, using them is relatively simple. In general, the smaller the TLV, the more toxic the substance is to inhale.

Guidelines artists can use include considering gases and vapors with TLV-TWAs of 100 parts per million (ppm) or lower to be highly toxic. Dusts whose

TLV-TWAs are set at 10 milligrams per cubic meter (mg/m³) are considered only nuisance dusts. Particulates with TLV-TWAs smaller than 10 mg/m³ are more toxic.

TABLE 2	TLV-TWAs (THRESHOLD LIMIT VALUE–TIME-WEIGHTED AVERAGES)* OF COMMON SUBSTANCES

GAS OR VAPOR	PARTS PER MILLION (PPM)
ethanol (grain alcohol)	1,000
acetone	500
VM&P† naphtha (paint thinner)	300
turpentine, mineral spirits, and xylene	100
n-hexane and toluene	50
ammonia	25
fluorine	1
acrolein (created when wax is burned/overheated)	0.1
TDI and MDI‡ (from urethane casting/foaming)	0.005

FUME OR DUST	MILLIGRAMS PER CUBIC METER (MG/M³)
calcium carbonate (marble dust, whiting)	10
aluminum:	
aluminum oxide (abrasives)	10
metal dust	10
fume	5
soluble salts	2
kaolin (clay), talc, graphite	2
silica:	
amorphous (unfired diatomaceous earth, silica gel)	10
crystalline (quartz, sand, flint, etc.)	0.1
calcined/fired (cristobalite, tridymite)	0.05
manganese (metal and fume)	0.2
lead (all forms)	0.05
beryllium (metal and compounds)	0.002

* TLV-TWAs taken from 2001 ACGIH list. Available from American Conference of Governmental Industrial Hygienists, 1330 Kemper Meadow Drive, Cincinnati, Ohio 45240.
† Varnish Makers and Painters (VM&P) Naphtha.
‡ Toluene diisocyanate (TDI) and methylene bisphenyl isocyanate (MDI).

ODOR THRESHOLD

Many chemicals have odors that can be detected by most people within range of concentrations in the air. For people with a keen sense of smell, odor thresholds can be useful for determining when overexposure is likely to occur. For example, if a chemical has an odor threshold of 10 ppm and a TLV of 500 ppm, then it is likely the chemical could be detected by odor well before the TLV was exceeded. Conversely, chemicals whose odor thresholds are larger than the TLV are detected by odor only after the TLV has been exceeded.

Artists must understand, however, that odor only indicates that something is present in the air—not how toxic it is. Toxicity cannot be determined merely by smelling the chemical, despite some people's claims. Some substances that smell awful are not hazardous. Some substances that smell good or that have no odor are dangerous. For example, unscrupulous manufacturers of ozone generators sold as "air purifiers" rely on consumers being unaware that ozone, which smells like good, fresh air, is actually highly toxic.

Artists should also be aware that many manufacturers use chemicals that have very low odor thresholds, so that users will not be aware that solvents or other volatile hazardous chemicals are present. Never assume that failure to detect an odor in a product means that nothing volatile is present.

CHAPTER 4
PHYSICAL HAZARDS AND THEIR CONTROL

Physical phenomena, such as noise, vibration, various kinds of light, and heat, can also be damaging to the body. There are Threshold Limit Values (TLVs) for these phenomena similar to those for chemical exposure. And there are OSHA regulations that apply to them as well.

NOISE

Artists perform many noise-producing tasks. Working with electrical tools, hammering on hard surfaces, or even playing loud music can produce ear-damaging sound.

Whether caused by music or machinery, noise-induced hearing loss is permanent and untreatable. Signs of overexposure may include a temporary ringing in the ears or difficulty in hearing for a while after work. Except for these minor symptoms, there are no obvious signs or pain to warn artists that their hearing is being damaged. Noise may also cause increased blood pressure and stress-related illnesses.

Threshold Limit Values for noise vary with the length of time of exposure and with the intensity of the noise (sound pressure) measured in decibels (dB). (See table 4, page 31, and figure 1, page 31.) Decibels are nonlinear, logarithmic functions, so a doubling of noise increases the sound level by only 3 dB. For example, if one table saw produces 105 dB, turning on another equally noisy saw adds only 3 dB to the sound level, for a total of 108 dB.

Conversely, an increase of 3 dB corresponds to a doubling of the sound intensity. So, 108 dB is not "just a little over 105 dB"—it is twice as intense and does twice as much damage. To illustrate this point, see table 3, below.

TABLE 3	RELATIONSHIP BETWEEN NOISE INTENSITY AND DECIBEL LEVEL	
INTENSITY OF NOISE		**dB**
10,000,000,000,000		130
1,000,000,000,000		120
100,000,000,000		110
10,000,000,000		100
1,000,000,000		90
100,000,000		80
10,000,000		70
1,000,000		60
100,000		50
10,000		40
1,000		30
100		20
10		10
0		0

Artists should evaluate the noise levels produced by their work. As a rule of thumb, if you must raise your voice to be heard by someone only two feet away, you probably need hearing protection. If you are not sure about the amount of noise in your workplace, you may want to have an industrial hygienist measure it.

To protect yourself from noise, use ear plugs. Earplugs, particularly the foam type, provide the best and cheapest protection. Package labels on earplugs list their attenuation, or noise reduction ratings (NRR). For example, those with a 25 dB NRR would reduce the noise level at most frequencies by about 25 dB. Earmuffs are more expensive and not always more effective. However, muffs can be designed to attenuate only certain frequencies.

Engineering methods for reducing noise include installing muffling and damping devices on machinery or mounting machines on vibration-absorbing rubber pads. When selecting new equipment, try to choose those products

whose manufacturers provide decibel ratings. Select machines with low dB ratings if they are available, or at least listen to equipment before purchasing.

Artists working in noisy environments should also get baseline hearing tests and yearly reexaminations to monitor any change in hearing.

TABLE 4	THRESHOLD LIMIT VALUES FOR NOISE
DURATION PER DAY (HOURS)	**SOUND LEVEL (dBA)**
16	80
8	85
4	90
2	95
1	100
1/2	105
1/4	110
1/8	115*

Sound levels in decibels are measured on a sound-level meter, conforming as a minimum to the requirements of the American National Standard Specification for Sound Level Meters, SI.4 (1971) Type S2A, and set to use the A-weight network with slow meter response. This means that the meter automatically calculates an eight hour time-weighted average exposure to noise analogous to the TLV-TWA calculated for airborne toxic substances. The decibel or dB reading would be analogous to a TLV-Ceiling limit.
*No exposure should be allowed to continuous (dBA) or intermittent (dB) sound in excess of 115 decibels.

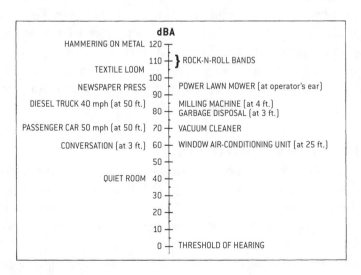

FIG. 1. Typical A-Weighted Noise Levels in Decibels (dBA)

VIBRATION

Handheld tools also transfer harmful vibration to the user. It may be noticed as a tingling of the hands and arms that usually disappears within an hour. Some people, however, risk a more permanent condition known as "white hand," "dead fingers," or Raynaud's syndrome. This disease, more correctly called Vibration Syndrome, may progress in stages from intermittent tingling, numbness, and white fingertips to pain, ulcerations, and gangrene.

Recommendations to avoid this condition include using tools with low amplitudes of vibration, keeping tools in good condition, taking ten-minute work breaks for every hour of continuous exposure, maintaining normal workplace temperatures (cold weather aggravates the condition), and not grasping tools harder than needed for safe use. (See also Ergonomic Injuries, below.)

IONIZING RADIATION

Radiation is either ionizing or nonionizing. Ionizing radiation can cause harmful biological effects. Examples of ionizing radiation are x-rays and emissions from radioactive metals, such as uranium. Artists rarely encounter these forms of radiation unless they work with uranium-containing glass, glaze chemicals, or metal enamels (e.g., Thompson's Burnt Orange #153 and Forsythia #108) or work with radioactive minerals of various types. Products containing uranium should be replaced with safer materials.

Ceramic collectors and curators may be at risk of overexposure to radiation from a number of types of antique ceramic and glassware. The most well-known is Fiestaware, but there are many others. (See referenced articles by Ralph W. Sheets in section II of the annotated reference list, page 390.)

Conservators of art use ionizing radiation when they x-ray paintings or artifacts. They should follow all guidelines that apply to medical and dental x-ray use.

NONIONIZING RADIATION

Light. Natural light contains a wide spectrum of visible, ultraviolet, and infrared rays. Artificial light contains a more limited array of light waves. It is well known that ultraviolet rays can damage the skin and eyes and even cause skin cancer. Both sunlight and unshielded fluorescent lights have been implicated in causing cancer.

Inadequate lighting, glare, and shadow-producing direct lighting can cause eyestrain and accidents. Use accepted lighting guidelines to plan lighting, espe-

cially for close work. Good diffuse overhead lighting combined with direct light on the task is a good solution for many situations.

Ultraviolet (UV) and Infrared (IR) Radiation. Ultraviolet sources include sunlight, welding, and carbon arc lamps. Infrared is produced whenever metals or ceramic materials are heated until they glow. Ultraviolet is well known for causing eye damage and even skin cancer in welders and others exposed to it. Infrared radiation can also damage the eye and has produced infrared cataracts in potters and enamelists who spend years looking into their kilns. Protective goggles should be worn whenever these types of radiation are present. Standards for appropriately shaded protective goggles can be obtained from the American National Standards Institute. (See figures 3 and 4, pages 61 and 63, in chapter 6.)

There are many sellers of eyewear who make false claims about their products' ability to block optical radiation. This is especially true for infrared-blocking eyewear. Demand that sellers provide printouts of the transmission spectrums of the lenses. Good companies will have this data readily at hand.

The lenses you buy should block a very large percentage of the range of radiation specifically caused by your work (see figure 4, page 63). Glassblowers and people firing kilns have a special problem, because they need protection from all infrared, but especially in the high ranges (3,000 nanometers and above). Unfortunately, most transmission spectrums do not extend beyond 3,000 nanometers at present.

TABLE 5	REGIONS OF THE OPTICAL RADIATION SPECTRUM

REGION	WAVELENGTH RANGE IN NANOMETERS (NM)
Ultraviolet (UV)	**100 to 380–400**
UV-C	100 to 280
UV-B	280 to 315–320
UV-A	315–320 to 380–400
Visible (light)	**380–400 to 760–780**
blue light	400–500
yellow (sodium flare)	588–590
Infrared (IR)	**760–780 to 1,000,000**
IR-A	760–780 to 1,400
IR-B	1,400 to 3,000
IR-C	3,000 to 1,000,000

Lasers. Various grades of lasers are used in special welding processes and in the new laser cleaning methods employed by art conservators. Precise precautions for the various types of lasers used in art are beyond the scope of this book. In general, lasers can be damaging to the eyes, even causing blindness in some cases.

Lasers should not be used unless the operator is thoroughly trained in their use and wears the kind of protective eyewear needed for the specific application. Art conservators should not only protect themselves from the laser's hazard, but from the potentially toxic material that gets volatilized or made airborne from the surfaces they are cleaning.

Video Display Terminals (VDTs). Video display terminals emit a number of kinds of radiation, including low-level, pulsed, electromagnetic radiation. This kind of radiation is emitted from all electrical appliances and was thought to be harmless for many years. Now, clusters of abnormal pregnancies in some workers using video display terminals and increased cancer rates in children living near power lines have cast suspicion on it. However, at this time, there is no conclusive evidence that these effects are due to radiation.

To be on the safe side, pregnant Canadian government workers have been given the right to transfer from video display terminal jobs without loss of pay. Similar rights are being legislated for pregnant workers in other provinces and states.

Some video display terminal manufacturers claim models are being designed to shield users from all types of radiation suspected to be hazardous. When these are perfected, they may be recommended for use by pregnant women.

In addition to radiation, video display terminals are associated with eyestrain, ergonomic injuries (see below), and stress. Artists using video display terminals should plan lighting and desk and chair arrangement carefully. Be sure your vision is checked frequently, and get regular physical examinations. Take frequent work breaks.

Radiation Threshold Limit Values. There are Threshold Limit Values for the forms of ionizing and nonionizing radiation discussed above. In addition, there are Threshold Limit Values for heat stress, laser radiation, microwaves, and more. All these phenomena can be harmful. Artists exposed to such radiation should obtain appropriate guidelines, codes of practice, and other information about these hazards.

PHYSIOLOGICAL HAZARDS AND THEIR CONTROL

Artists' specialized activities often cause unusual bodily stresses and strains. Potters, glassblowers, and weavers, for example, engage in repetitive actions, which cause wear and tear on their muscles and tendons. "Potter's thumb," for instance,

is the term some potters have used to describe symptoms that are now associated with the early stages of carpal tunnel syndrome, a debilitating nerve problem.

In response to such injuries, a new field called "arts medicine" has been created to address the special needs of artists. Doctors and clinics specializing in arts medicine can be located by consulting your doctor or arts organizations such as ACTS (see appendix A, part 1).

There are now also many tools, machines, and furniture for the office and shop that have been redesigned to enable workers to avoid the awkward positions that cause such injuries. And recently, OSHA published a regulation designed to prevent and respond to such injuries.

Ergonomic Injuries. Workers doing tasks that employ repetitive, forceful, or awkward motions are injured at rates far higher than workers doing less physical work. These are called "ergonomic" injuries. Ergonomics is the science of preventing injuries to the muscles, ligaments, and/or bones called *musculoskeletal disorders*.

To reduce the large number of musculoskeletal disorders seen in workers, OSHA published a new rule on November 14, 2000, called the "Ergonomics Standard Program" (29 CFR 1910.900). Ten years in the making, the rule was rescinded by President George W. Bush almost as soon as he took office. I suggest that the rule be used as a guideline for those who wish to protect their workers from ergonomic injuries.

The OSHA rule would have required employers to inform and train workers about common musculoskeletal disorders, their signs and symptoms, and the importance of early reporting. When a worker develops a musculoskeletal disorder, the job should be evaluated to determine if there are the following risk factors:

1. *Repetition.* Two categories are listed: 1) repeating a motion or cycle of motions more than twice per minute for more than two consecutive hours, and 2) using a keyboard and/or mouse for more than four hours steadily.
2. *Force.* Four categories of force are defined: lifting, pushing/pulling, pinching, and gripping.
3. *Awkward Postures.* These can include working with the hands above the head or the elbows above the shoulders for more than two hours per day, kneeling or squatting for more than two hours total per day, or working with the back, neck, or wrist bent or twisted for more than two hours total per day.
4. *Contact Stress.* Using the hand or knee as a hammer more than ten times per hour for more than two hours total per day.

5. *Vibration.* Two types are listed: 1) from using high-vibration tools, such as chainsaws and jackhammers, and 2) from using tools with moderate vibration levels, such as grinders and sanders.

Lifting. One of the tasks OSHA lists under "force" that puts workers at especially great risk is lifting. OSHA describes lifting hazards as:

> **Lifting more than 75 pounds at any one time, more than 55 pounds more than 10 times per day; or more than 25 pounds below the knees, above the shoulders, or at arms' length more than 25 times per day.**[1]

Clearly, all art schools, businesses, and studios whose activities involve heavy lifting should evaluate these jobs. Included are potters who mix their own clay from fifty- to one-hundred-pound sacks, lithographers whose stones can weigh a hundred pounds or more, sculptors who manipulate metal ingots or pour molten metal from crucibles, and so on.

Prevention. To prevent these injuries, artists must pay careful attention to their bodies for signs of fatigue, pain, changes in endurance, weakness, and the like. In other words, listen to your body while it is still whispering rather than waiting until pain shouts for attention.

In addition, certain good work habits can help to resolve early symptoms, including:

1. Keeping good posture
2. Taking frequent rest breaks
3. Alternating tasks or varying the types of work done frequently
4. Warming up muscles before work, moving and stretching muscles during breaks
5. Easing back into heavy work schedules rather than expecting to work at full capacity immediately after holidays or periods away from work
6. Modifying technique and/or equipment to avoid uncomfortable positions or movements

If your symptoms do not respond quickly to better work habits, seek medical attention. Early medical intervention will cause the majority of ergonomic injuries to resolve without expensive treatment or surgery. Delaying treatment can leave you disabled for long periods of time or even for life.

[1] Table W-1, Subpart W, 29 CFR 1910.900 (now repealed).

CHAPTER 5

IDENTIFYING HAZARDOUS MATERIALS

There are two major sources of information available to artists on their materials: labels and Material Safety Data Sheets.

LABELS: READING BETWEEN THE LIES

To identify hazardous materials, begin by reading product labels. However, do not assume that the label will warn of all the product's potential hazards. The truth is that the hazards of many of the ingredients in consumer products have never been fully studied, especially for chronic hazards.

Evaluating label information is further complicated by the fact that many common art products are imported. By law, these products' labels are supposed to conform to standards in the United States and Canada. However, many improperly labeled products escape scrutiny and turn up in art stores.

Even if the labeling meets standards, the label terminology may be difficult to interpret. The following United States and Canadian label terms illustrate the point:

Use with Adequate Ventilation. Many people think "ventilation" means a window or door should be kept open while using the product. Actually, this label only indicates that the product contains something toxic that becomes airborne during the product's use. The ventilation required must be sufficient to keep the airborne substance below levels considered acceptable for industrial air

quality. Sufficient ventilation could vary from a simple exhaust fan to a specially designed local exhaust system, depending on the amount of the material and how it is used.

In order to plan such ventilation, you must know exactly what substance the product gives off and at what rate. Ironically, this is often precisely the information the manufacturer excludes from the label. In order to plan ventilation, first get the Material Safety Data Sheet from the manufacturer. If you use a lot of the material or if you use it in your business, get advice from an industrial hygienist or ventilation engineer.

••••

Adequate Ventilation Really Means: Something toxic gets airborne during use. You need to know what it is, how toxic it is, and how much ventilation you will need for the amount of the substance you use. You should refer to a Material Safety Data Sheet, and you may need professional advice.

••••

Biodegradable. Disposal of products bearing the "biodegradable" label is easy. Liquids may go down the drain. Solids may go out with the trash. However, do not assume that what is safer for the environment is necessarily safer for you. For example, the new refrigerants and spray-can propellants are safer for the ozone layer, but most are more toxic to people.

And remember the old phosphate detergents? They were not very toxic, and they were readily taken up by plants as fertilizer. It was because we poured too much detergent "fertilizer" into lakes and streams that they were banned.

We replaced the phosphates with the new biodegradable detergents and enzyme cleaners. Some of the enzymes cause serious allergies and health effects in some people. And while the detergents do not break down into simple substances that are used as fertilizer by plants, they do break down into something! Currently, scientists are investigating the possibility that degradation products from certain detergents are causing deformity in the sex organs of fish and aquatic life in wetlands.

As if this were not enough, the environmental fate of many of the chemicals we use is utterly unknown. This includes a majority of the hundreds of non–metal-containing organic pigments and dyes used in our materials. Since no one knows what happens to them in the waste stream, they cannot be regulated and may be labeled "biodegradable." The Environmental Protection Agency (EPA) and the National Toxicology Program suspect that many dyes and

pigments have long-term, adverse effects on people and perhaps on the environment. Studies are underway.

••••

Biodegradable Really Means: You won't get into trouble if you flush or trash the product, but there are no guarantees related to your health while you use it. And it may not be safe for the environment in the long run either.

••••

Water-Based. When water-based products were first introduced in the 1980s, many people assumed this meant that the products were safe. But the Material Safety Data Sheets from the manufacturers revealed that many water-based products contained both water and solvents. For example, some water-based silkscreen inks contained up to 20 percent glycol ether solvents.

Glycol ethers are highly toxic solvents that are absorbed through your skin and can penetrate several types of heavy chemical gloves without changing the glove's appearance. Some glycol ethers cause reproductive problems in humans and birth defects and atrophy of the testicles in experimental animals. These and many other toxic solvents still can be found in many water-based latex wall paints, paint strippers, felt-tip markers, and spray cleaners.

The amount of water in "water-based" products also varies greatly. Some "water-based" products contain more solvents than water, and others contain almost no water at all. These are called "water-based" only because water can be used to clean them up.

••••

Water-Based Really Means: Water is probably an ingredient, but the product also may contain solvents and other toxic ingredients. You need the Material Safety Data Sheet for further information.

••••

Natural. There is nothing inherently safe in substances derived from nature. This is obvious if we just think for a moment about turpentine, wood dust, molds, poison ivy, cocaine, jimsonweed, curare, hemlock, tobacco, and so on. In fact, natural toxins like ricin (a protein from castor oil beans) or botulism toxin are thousands of times more toxic than man-made chemicals like sodium cyanide or the methyl isocyanate that killed over two thousand people in Bhopal, India! Judge natural products just as you would synthetic ones. For example, take a cold, hard look at just one commonly used natural product from citrus fruit.

CITRUS OIL—A CASE IN POINT. Citrus oil and its major component, d-limonene, are derived from the rinds of citrus fruit. Products containing d-limonene are touted as "natural" and "biodegradable." Examples of products containing citrus ingredients include CitraSolve™, Lithotine™, Citrus Clean™, Grumtine™, Fast Orange Hand Cleaner™, and many other solvents, paint strippers, and cleaning agents.

Advertisements for these products often emphasize that the FDA allows small amounts in food as an additive. The advertisements fail to mention that d-limonene is one of Mother Nature's own pesticides. She put it in citrus rinds to protect her fruit from insects. It kills flies efficiently enough to be registered with the EPA as an "active ingredient" in commercial pesticides. D-limonene and citrus oil usually are contaminated with other pesticides from the spraying of the fruit in the orchards, including pyriproxyfen, imazalil, fenabutin oxide, and cyfluthrin.

The American Industrial Hygiene Association set a workplace air-quality standard for d-limonene that is more restrictive than those for turpentine, toluene, and most other common solvents. (See chapter 9.)

••••

Natural Really Means: The manufacturer wants you to prejudge the product's toxicity on the basis of its origins. Instead, ask questions, and look up the hazards. Highly toxic products are manufactured by both God and Goodyear.

••••

Nontoxic Consumer Products. Under the United States Federal Hazardous Substances Act and the Canadian Federal Hazardous Products Act, toxic warnings are required on products capable of causing acute (sudden onset) hazards. Products requiring warning labels are identified by tests that expose animals to a single dose or period of exposure by skin or eye contact, inhalation, and ingestion. These tests are incapable of identifying products that cause long-term hazards such as cancer, birth defects, allergies, and chronic illnesses. To illustrate the inadequacy of this labeling, powdered asbestos could be labeled "nontoxic" on the basis of these tests. All the animals will appear perfectly healthy in the two-week-long tests, because cancer and asbestosis take years to develop.

••••

Nontoxic Consumer Products Really Mean: The products don't kill half or more of the animals in short-term toxicity tests, but there are no long-term guarantees.

••••

Nontoxic Art Materials. In the past, art materials were labeled only under the consumer laws, and even asbestos-containing products, such as instant papier-mâchés, and clays were routinely labeled "nontoxic." This should not happen today, because a new law, the Labeling of Hazardous Art Materials Act (LHAMA), requires warning labels on products containing known, chronically hazardous substances.

The law requires that all art materials sold in the United States be evaluated by a toxicologist, who will determine what the label should say in order to provide adequate warnings. Some art materials manufacturers have their products evaluated by toxicologists who work for trade groups. The best known of these is the Arts and Creative Materials Institute (ACMI), whose product seals are seen on a large number of art materials. Most artists are familiar with the AP (approved product), CP (certified product), and HL (health label) seals of the ACMI.

Only products that conform to LHAMA can be sold legally in the United States. Such products can be identified, because they reference an American Society for Testing and Materials labeling standard, ASTM D 4236, on each label. The law also requires the label to provide a telephone number at which further information about chronic hazards can be obtained.

However, the art materials labeling law has serious deficiencies. Some of these include:

1. Substances requiring labeling must be *known* to possess chronic hazards. Yet, most substances used in art materials, especially organic colorants, have never been tested for chronic hazards. They can be labeled "nontoxic" by default! Many "nontoxic" pigments and dyes are members of classes of chemicals that the National Toxicology Program is trying to list as carcinogens.
2. Some tests used to determine toxicity are faulty. For example, a test in which materials are placed in acid is sometimes used to determine whether the toxic substances in the product will be released in the digestive tract. This test does not consider that, in addition to acid and water, digestive tracts use bases, enzymes, cellular activities, heat, and movement to dissolve materials. Only after there were poisonings from "nontoxic" lead glazes were these tests abandoned by glaze manufacturers. Acid tests are still used to evaluate some other art products.

3. Faulty methods are used to determine when the amounts of toxic substances in art materials will result in significant exposure. Toxicologists who estimate exposures during artmaking usually have never created or taught art themselves. They often do not take into account the artist's penchant for experimenting, intimate contact with materials, crowded classrooms or tiny home studios, poor ventilation, lack of sinks, long hours of work, and other conditions common to studios and schools.

4. The hazards of materials used in ways other than the label directs are not considered. Artists and teachers traditionally use materials "creatively." For example, melting crayons for candle-making, batik resist, or for other processes causes these "nontoxic" products to release highly toxic gases and fumes from decomposition of the wax and from some of the pigments.

5. Methods for determining how exposures occur are often faulty. For example, many ceramic glaze labels in the past did not warn about dust exposure, even though anyone who has ever used glazes knows that dust gets everywhere and is the major source of exposure.

As a result of these flaws, I recommend treating all art materials as potentially toxic and handling them with commonsense precautions.

• • • •

Nontoxic Labels on Art Materials Really Mean: A toxicologist who probably never taught or practiced art says that users will not be exposed to significant amounts of any *known* chronically toxic ingredients. Untested ingredients may be labeled "nontoxic" even though they are expected to be toxic or cancer-causing on the basis of their chemical structure. Use other than directed at your own risk.

• • • •

CALIFORNIA'S PROPOSITION 65

The federal Labeling of Hazardous Art Materials Act does not incorporate provisions of some state laws. One of these laws is California's Proposition 65. This law requires warning labels on products containing even very small amounts of chemicals on California's list of cancer-causing, reproductively toxic, and other chronically hazardous chemicals. California requires this label even if a toxicologist certifying a product under LHAMA says that people using the product as

directed will not be exposed to significant amounts of the toxin. For this reason, many art material manufacturers refuse to include Proposition 65 warnings on their labels. But I agree with California that it is better to tell people that the toxic chemical is there.

In addition, California can list chemicals as cancer-causing or chronically toxic based on a shorter review of the data than that required by other agencies. I think the State of California is justifiably frustrated by the method of listing carcinogens used by the National Toxicology Program, OSHA, and other agencies. Listing takes years—even decades. And industry usually sues the agency to further delay the official listing. Again, I agree with the State of California. Consumers should be warned when a product contains a chemical for which significant data exists indicating it *may* cause cancer or other chronic hazards, even if absolute proof and consensus with the chemical industry is not yet established.

I congratulate manufacturers, such as Golden Artists Colors, who have added Proposition 65 warnings to their labels. This is clearly the right tactic. But many other art and paint manufacturers and their trade organizations are wasting time and money lobbying for an exemption from listing various toxic ingredients by trying to prove that consumers are not exposed to significant amounts when their products are used "as directed." I hope they will not be successful, because withholding ingredient information will, in the long run, only be interpreted by consumers as deceptive. This is especially true for art consumers who commonly do not use products "as directed" and indeed may be overexposed.

Instead, manufacturers should list the ingredient and the required warnings and provide data showing consumers that they need not fear exposure when the product is used correctly. This gives manufacturers an opportunity to win the confidence of the consumer and to provide useful safety information.

INDUSTRIAL OR PROFESSIONAL USE ONLY

Products carrying this label are not supposed to be readily available to general consumers and should never be used by children or untrained adults.

This label warns workers that they should be skilled in the use of the product and should have a Material Safety Data Sheet (see next section) as a guide to safe use of the product. Rules for the types of information and warning symbols that conform to your right-to-know law can be obtained from your local department of labor.

MATERIAL SAFETY DATA SHEETS

WHAT ARE THEY? Material Safety Data Sheets (MSDSs) are forms that provide information on a product's hazards, as well as the precautions required for its safe use in the working environment. MSDSs are usually filled out by the product's maker, and the quality of the information varies depending on the diligence and cooperativeness of the individual manufacturer. However, manufacturers are responsible to their respective government agencies for the accuracy of information they provide.

MSDSs are essential starting points for the development of a database on your materials for health and safety programs. They should not be considered complete sources of information on their own.

WHO NEEDS THEM? The OSHA Hazard Communication Standard, WHMIS, and right-to-know laws require that MSDSs be made available to all those who use or could be exposed to potentially hazardous products in the workplace. This would include not only the products' users, but those working near the materials, those storing or distributing the materials (in case of breakage), anyone exposed to airborne emissions from the products' use, and so on.

All employers and administrators are required by the new laws to obtain MSDSs and make them available to all employees. Art teachers, who are employees, must have access to MSDSs and should, in turn, make them available to all students old enough to understand them. Self-employed artists should obtain MSDSs for their protection as well.

In addition, all employers and administrators are responsible for training employees to interpret and use MSDS information.

HOW ARE THEY OBTAINED? MSDSs can be obtained by writing to manufacturers, distributors, or importers of the product. Schools, businesses, and institutions can require MSDSs as a condition of purchase. If makers or suppliers do not respond to requests for MSDSs, send copies of your requests and other pertinent information to the agency responsible for enforcing your federal or local right-to-know law. These agencies usually get very good results.

Artists should be very wary about getting MSDSs from large databases, such as those provided by some universities. These databases often contain old or outdated MSDSs.

Products for which there are no MSDSs or whose MSDSs are incomplete must be removed from the workplace and replaced with products for which better information is available.

WHERE SHOULD THEY BE KEPT? MSDSs should be filed or displayed where the products are used and stored. For schools, experience has shown that the best procedure is to have a central file for all MSDSs and also to have in each classroom, shop, or work area a set of smaller files that contain copies of the MSDSs for products used at that location.

WHAT DO THEY LOOK LIKE? To begin with, the words "Material Safety Data Sheet" must be at the top. Some manufacturers resist sending real MSDSs, sending instead sheets labeled "Product Data Sheet," "Hazard Data Sheet," or other improper titles. These information sheets do not satisfy the laws' requirements.

Although MSDSs must contain the same basic information, the actual sheets may look very different. For example, some are computer-generated and some are government forms. Figure 2 is a copy of the most recent U.S. MSDS form (the OSHA 174 form). The Canadian forms require similar information (see figure 2A, page 51), one important difference being that they require the chemicals' odor threshold (OT) when known. This is a practical piece of information. For example, if the Odor Threshold is higher than the Threshold Limit Value, workers know they are overexposed if they can smell the substance.

INFORMATION REQUIRED ON MSDSs. All of the information on the form in figures 2 and 2A should be on an MSDS. In general, MSDSs should identify the product chemically (with the exception of trade secret products); identify any toxic ingredients; list its physical properties, its fire and explosion data, its acute and chronic health hazards, and its reactivity (conditions which could cause the product to react or decompose dangerously); tell how to clean up large spills and dispose of the material; identify the types of first aid and protective equipment needed to use it safely; and discuss any special hazards the product might have.

HOW TO READ MSDSs

It would take a small book to explain how to interpret Material Safety Data Sheets. Fortunately, there already are many small books and pamphlets on this subject. Some good ones are listed in appendix A, Annotated Reference List,

beginning on page 380. For definitions of common terms used on Material Safety Data Sheets, see the glossary, beginning on page 391. All of these materials can be used for your right-to-know program or as training aids.

Artists should also be aware of certain common errors on Material Safety Data Sheets. For example, some manufacturers send out data sheets with blank spaces. This is not allowed. If no data exists or it is not applicable, the form must state this. Other problems are addressed below by section. (Remember that some MSDSs are not divided into the sections below, but all the information should be present somewhere in the MSDS.)

SECTION I—IDENTIFICATION. The Material Safety Data Sheet must have the art material manufacturer's name, address, and emergency telephone number at the top. It is the company whose name is on the MSDS that is responsible to you for information and help.

Some art materials makers violate the law by sending out Material Safety Data Sheets from other companies—often the companies that sell them the raw materials. The reason is that art materials companies do not manufacture pigments, solvents, glaze chemicals, and so on. They may mix these ingredients into new products or simply relabel them. In these cases, they must put their own name at the top of the MSDSs and rework the information to reflect the consumer's use of the products. For example, an MSDS for a paint is improper if it discusses the hazards of only the liquid if the paint also is to be sprayed or sanded.

Some suppliers send old, outdated Material Safety Data Sheets. Look for the date of preparation either in this section or at the end of the form. If there is no date or if the MSDS is several years old, demand a proper one. In Canada, three-year-old MSDSs are automatically invalid.

SECTION II—HAZARDOUS INGREDIENTS. The definition of a "hazardous ingredient" varies in different state, provincial, and federal laws. But the OSHA Hazard Communication Standard defines as hazardous any chemical that is a physical hazard (flammable, unstable, etc.) or a health hazard. "Health hazard" is further defined to mean any "chemical for which there is statistically significant evidence based on at least one study. . . ."

This means that a chemical should be listed if there is even one proper animal study indicating a potential problem. On the other hand, manufacturers may decline to list chemicals that have never been studied or that are not listed by OSHA as regulated chemicals. This means there may be toxic chemicals in the product that are not listed.

Some art materials manufacturers decline to list any of their ingredients, because they claim their products are proprietary or trade secrets. Artists should be aware that there are legal criteria for claiming trade secret status, and in many states, they must have a registration number. If you receive a Material Safety Data Sheet for a trade secret product, contact your department of labor to find out if these criteria were met.

Ingredient identification should include chemical name, chemical family, synonyms, and common name(s). Good MSDSs also include the CAS number. "CAS" stands for the Chemical Abstracts Service, an organization that indexes information about chemicals. The CAS number enables users to look up information about the chemical in many sources.

Exposure limits should also be listed if they exist. Any existing standards or exposure limits for each ingredient should be listed in this section. For example, U.S. MSDSs must list the ACGIH Threshold Limit Values and OSHA Permissible Exposure Limits in this section. Canadian MSDSs must list their Occupational Exposure Limits (see page 52). Sometimes manufacturers will provide their own recommended limits if no others exist for the material. Chemicals for which there are no exposure limits should never be assumed to be safe.

This section may also list the percentage of each ingredient in products that are mixtures. This information is optional, but responsible manufacturers supply it.

SECTION III—PHYSICAL/CHEMICAL CHARACTERISTICS. Boiling point, evaporation rate, and other properties of the material are listed here. The description of appearance and odor can be compared to the look and smell of your product to verify that you have the right Material Safety Data Sheet.

SECTION IV—FIRE AND EXPLOSION HAZARD DATA. Flash point and other data are listed here, along with information about the proper fire extinguisher to use and any special fire hazard properties of the material. This section should be consulted when planning emergency procedures.

SECTION V—REACTIVITY DATA. Artists who experiment with their media should pay special attention to the section on reactivity. This section describes how stable the material is, under what conditions it can react dangerously, and materials with which it is incompatible. If you don't understand this section, do not experiment.

SECTION VI—HEALTH HAZARD DATA. Toxicological information is briefly summarized here, and many manufacturers still do not include chronic hazards. You will need to investigate possible hazards further and may want to use one of the resources mentioned above or the glossary in this book to understand some of the terminology.

Cancer information that should be included on United States MSDSs includes whether the material is considered a cancer agent by either the National Toxicology Program (NTP), the International Agency for Research on Cancer (IARC), or OSHA. (See "cancer" in the glossary, page 393, for their criteria.)

SECTION VII—PRECAUTIONS FOR SAFE HANDLING AND USE.
Use the information in this section to plan storing and handling of the material. Waste disposal information cannot be detailed, because so many different local, state, provincial, and federal regulations exist. Check regulations that apply to your location.

SECTION VIII—CONTROL MEASURES. Proper respiratory protection, ventilation, and other precautions should be described here. Consult the ventilation and respiratory protection chapters of this book for more detailed information.

Material Safety Data Sheet
May be used to comply with
OSHA's Hazard Communication Standard,
29 CFR 1910.1200. Standard must be
consulted for specific requirements.

U.S. Department of Labor
Occupational Safety and Health Administration
(Non-Mandatory Form)
Form Approved
OMB No. 1218-0072

IDENTITY *(As Used on Label and List)*

Note: Blank spaces are not permitted. If any item is not applicable, or no information is available, the space must be marked to indicate that.

Section I

Manufacturer's Name	Emergency Telephone Number
Address *(Number, Street, City, State, and ZIP Code)*	Telephone Number for Information
	Date Prepared
	Signature of Preparer *(optional)*

Section II — Hazardous Ingredients/Identity Information

Hazardous Components (Specific Chemical Identity; Common Name(s))	OSHA FEL	ACGIH TLV	Other Limits Recommended	% *(optional)*

Section III — Physical/Chemical Characteristics

Boiling Point		Specific Gravity (H_2O = 1)	
Vapor Pressure (mm Hg.)		Melting Point	
Vapor Density (AIR = 1)		Evaporation Rate (Butyl Acetate = 1)	
Solubility in Water			
Appearance and Odor			

Section IV — Fire and Explosion Hazard Data

Flash Point (Method Used)	Flammable Limits	LEL	UEL
Extinguishing Media			
Special Fire Fighting Procedures			
Unusual Fire and Explosion Hazards			

(Reproduce locally)

OSHA 174, Sept. 1985

FIG. 2. Material Safety Data Sheet (U.S.)

Section V — Reactivity Data

Stability	Unstable	.	Conditions to Avoid	
	Stable			

Incompatibility (*Materials to Avoid*)

Hazardous Decomposition or Byproducts

Hazardous Polymerization	May Occur		Conditions to Avoid	
	Will Not Occur			

Section VI — Health Hazard Data

Route(s) of Entry:	Inhalation?	Skin?	Ingestion?

Health Hazards (*Acute and Chronic*)

Carcinogenicity:	NTP?	IARC Monographs?	OSHA Regulated?

Signs and Symptoms of Exposure

Medical Conditions
Generally Aggravated by Exposure

Emergency and First Aid Procedures

Section VII — Precautions for Safe Handling and Use

Steps to Be Taken in Case Material Is Released or Spilled

Waste Disposal Method

Precautions to Be Taken in Handling and Storing

Other Precautions

Section VIII — Control Measures

Respiratory Protection (*Specify Type*)

Ventilation	Local Exhaust		Special	
	Mechanical (*General*)		Other	
Protective Gloves			Eye Protection	

Other Protective Clothing or Equipment

Work/Hygienic Practices

FIG. 2. Material Safety Data Sheet (U.S.) (continued)

Minimum Information Required on Canadian MSDSs for Controlled Products

Hazardous Ingredient Information

1. Chemical identity and concentration
 - of the product (if the product is a pure substance)
 - of each controlled ingredient (if the product is a mixture)
 - of any ingredient that the supplier/employer has reason to believe may be harmful
 - of any ingredient whose toxic properties are unknown
2. The product's CAS, UN, and/or NA registration numbers
 - CAS = Chemical Abstracts Service Registration Number
 - UN = number assigned to hazardous materials in transit by the United Nations
 - NA = number assigned by Transport Canada and the United States Department of Transportation and for which a UN number has not been assigned
3. The LD50 and LC50 of the ingredient(s)
 - LD50 = the dose (usually by ingestion) that kills half of the test animals in standard acute toxicity tests
 - LC50 = the airborne concentration that, when inhaled, kills half of the test animals in standard acute toxicity tests

Preparation Information

- The name and telephone number of the group, department, or person responsible for preparing the MSDS
- The date the MSDS was prepared

Product Information

- The name, address, and emergency telephone number of the product's manufacturer and, if different, the supplier
- The product identifier (brand name, code or trade name, etc.)
- The use of the product

Physical Data

- Physical state (gas, liquid, solid)
- Odor and appearance
- Odor threshold (level in parts per million at which the odor becomes noticeable)
- Specific gravity
- Vapor pressure
- Vapor density
- Evaporation rate
- Boiling point
- Freezing point
- pH (degree of acidity or alkalinity)
- Coefficient of water/oil distribution

FIG. 2A.

Fire and Explosion Hazards
- Conditions under which the substance becomes a flammable hazard
- Means of extinguishing a fire caused by the substance
- Flash point
- Upper flammable limit
- Lower flammable limit
- Auto-ignition temperature
- Hazardous combustion products
- Explosion data, including sensitivity to mechanical impact and to static discharge

Reactivity Data
- Conditions under which the product is chemically unstable
- Name(s) of any substance with which the product is chemically unstable (will react hazardously)
- Conditions of reactivity
- Hazardous decomposition products

Toxicological Data
- Route of entry (skin contact, inhalation, ingestion, eye contact)
- Acute effects
- Chronic effects
- Exposure limits (Threshold Limit Values, Occupational Exposure Limits, etc.)
- Irritancy
- Sensitization potential (ability to cause allergies)
- Carcinogenicity
- Reproductive toxicity
- Teratogenicity (ability to cause birth defects)
- Mutagenicity (ability to cause mutation)
- Synergistic effects (names of substances that may enhance toxic effects)

Preventative Measures
- Personal protective equipment needed
- Specific engineering controls required (e.g., ventilation)
- Spill or leak procedures
- Waste disposal methods
- Handling procedures and equipment
- Storage requirements
- Special shipping information

First Aid Measures
- Specific first aid measures in event of skin/eye contact, inhalation, or ingestion

FIG. 2A. (continued)

CHAPTER 6
GENERAL PRECAUTIONS

In addition to specific precautions such as ventilation and respiratory protection, there are general precautions that should be used in all situations.

HOUSEKEEPING

The most important safety rule is housekeeping: keeping art studios and classrooms clean and neat. This is not only wise, it's the law. Occupational Safety and Health Administration (OSHA) rule 1910.22(a)(1) reads: *All places of employment, passageways, storerooms, and service rooms shall be kept clean and orderly and in a sanitary condition.* In addition, 1910.141(a)(3)(i) says: *All places of employment shall be kept clean to the extent that the nature of the work allows.*

There is nothing inherent in artwork that prevents artists from being clean and neat. But instead, I often see classrooms and studios in which clay dust or paint residues are on the floors, clutter is everywhere, the sinks are dirty, and there are more materials stored in the room than it can safely hold—including items teetering on tops of cabinets or on high shelving. OSHA requires proper access to all storage, such as a ladder of the appropriate height, to be available right in the room where such storage exists.

Last year, I inspected a school that was riddled with clutter and high storage. The teachers and administrators on the inspection tour refused even to consider taking this storage down or buying ladders for each room. One of the teachers left the inspection party briefly to retrieve a paint about which she had a question. We heard a crash and found she had fallen from the stool she had used to reach the paint—she had broken her arm. She served as an illustration of a common workplace accident, as she sat with her arm in a cast in the front row of the OSHA training session we held the next day.

Another common housekeeping problem is water or other spills on the floors, making them slippery. This occurs especially at cleanup sinks, around potters' wheels, or during special projects such as papermaking. But wet, slippery floors simply are not acceptable. Spills must either be cleaned up immediately or special mats or flooring need to be installed so that people cannot slip. (See 29 CFR 1910.22(a)(2) for the law that applies.)

It really is very simple. Artworking areas must be clean, organized, free from slip and trip hazards, and unencumbered by too much storage or storage that is not easily accessible. The organization of the room itself can teach students their first lesson in safety. And the reverse is also true: If you put students or artists in a pigsty, do not be surprised if they act like pigs.

KNOW YOUR INVENTORY

Make a complete list of all the products you use. The list should also include all ordinary consumer products—even if your workplace regulations do not require it. This is necessary, because artists often use consumer products in greater amounts or in ways that are not typical.

Reduce your inventory by discarding old materials for which ingredient information is no longer available. Throwing things away is often psychologically difficult for artists and teachers who have spent years existing on tight budgets. However, it is a violation of the OSHA regulations to have unlabeled or improperly labeled products or products whose hazards and ingredients are unknown in the workplace.

RULES FOR PURCHASING ART MATERIALS

1. Ask lots of questions when you buy art materials and industrial products. Good salespeople selling good products have good answers. They will also have documentation to back their claims and are proud of it. Ask for this information.

2. If you need additional information, call the manufacturer. The art materials labeling law requires manufacturers to put on their labels a telephone number at which information about chronic hazards can be obtained. If the number is not there, be suspicious. If the number provides only a recorded message rather than someone who is familiar with the product and how artists use it, be concerned. For example, some companies refer callers to their own doctors or to poison control centers that are not familiar with artists' practices and that focus primarily on acute hazards.

3. Investigate water-based, natural, nontoxic, and biodegradable products with the same vigor that you would any other product. Get MSDSs on them all. Do not purchase materials from companies that will not provide MSDSs.

4. Buy your materials from companies that put ethics first and whose labels exceed the minimum requirements of the law. Two good examples:

 a. Golden Artists Colors is a company that no longer uses the word "nontoxic" on their products. Their labels also inform users that most chemicals have never been studied for chronic hazards.

 b. R and F Encaustics also does not use the word "nontoxic." In addition, they put cancer warnings on their cadmium colors, even though the labeling standard would not require it because the cadmium is embedded in wax. R and F knows that artists heat their painting surfaces and also may work with encaustics in other ways that expose users to cadmium.

5. Get professional product advice from people who have no financial interest in your purchases. Your local health department, *Consumer Reports* magazine, and the U.S. Consumer Product Safety Commission are examples of such agencies. The nonprofit corporation Arts, Crafts, and Theater Safety (ACTS) can also help you evaluate MSDSs, label terminology, and ventilation needs. ACTS provides free advice and information by mail, e-mail, and telephone.

SUBSTITUTION

The most effective precaution, of course, is substituting safe materials for more hazardous ones. Material Safety Data Sheets (MSDSs) and labels can be used to compare products for toxicity and to identify the safest one. General rules for substitution include the following:

1. Choose water-based or latex paints, inks, and other products over solvent-containing ones whenever possible. Solvents are among the most hazardous chemicals used by artists. For this reason, acrylics and watercolors are much safer to use than oils and enamels, which are thinned with turpentine or paint thinner.

2. If solvents must be used, Threshold Limit Values, evaporation rates, and other data on MSDSs can be used to choose the least toxic ones. (See chapter 9 for additional guidelines.)

3. Choose products that do not create dusts and mists. Avoid materials in powdered form or aerosol products whenever possible to avoid inhalation hazards.

4. Avoid products containing known cancer-causing chemicals whenever possible, since there is no safe level of exposure.

PERSONAL HYGIENE

One of the simplest and most neglected methods of avoiding exposure to toxic substances is to practice good hygiene in the workplace. Industrial experience has taught that tiny amounts of toxic substances left on the skin, or brought home on clothing, can affect even the workers' families. Some basic hygiene rules include the following:

1. Do not eat, smoke, or drink in studios, shops, or other environments where there are toxic materials. Dust, after all, settles in coffee cups, vapors can be absorbed by sandwiches, and hands can transfer substances to food and cigarettes. Smoking is especially hazardous, because some substances inhaled through a cigarette can be converted by the heat to more hazardous forms.

2. Wear special work clothes, and remove them after work. If possible, leave them in the workshop, and wash them frequently and separately from other clothing. If the workplace is dusty, wear some form of hair covering (hair is a good dust collector). And for safety as well as hygiene, do not wear loose clothing, scarves or ties, or jewelry. Tie back long hair.

3. Wash hands carefully after work, before eating, after using the bathroom, and when applying makeup.

STORAGE OF MATERIALS

Many accidents, spills, and fires can be avoided by following rules for safe storage and handling of materials.

1. Clearly mark every bottle, box, or gas cylinder as to its contents, its hazards, and the date received and opened. Even containers into which materials are transferred for storage should be so labeled.

2. Use unbreakable containers whenever possible.

3. Apply good bookkeeping rules to chemical storage. Keep a current inventory and location information on all the materials on hand. Post locations of flammable or highly toxic materials.

4. Maintain records of dates of purchase of materials in order to dispose of chemicals with limited shelf lives properly. Some chemicals even become explosive with age.

5. Apply good housekeeping rules to chemical storage. Have cleaning supplies and facilities for handling of spills at hand. Never store any material that you are not prepared to control or clean up if it spills. If respiratory protection, gloves, or other personal protective equipment will be needed for cleaning up spills, have these in the studio at all times.

6. Organize storage wisely. For example, do not store large containers on high shelves where they are difficult to retrieve. If storage is above arms' reach, a step stool or ladder of the correct height must be available in the room. Never store hazardous chemicals directly on the floor or above shoulder height.

7. Store reactive chemicals separately. Check each product's MSDS and other technical sources for advice about storage.

8. Keep all containers closed except when using them, in order to prevent escape of dust or vapors.

9. Ventilate the storage room. Keep it cool, and keep chemicals out of direct sunlight. OSHA requires a minimum ventilation rate of six room exchanges per hour for chemical storage rooms.

10. Do not allow dispensing or mixing of chemicals in or near the storage area.

11. If chemical corrosives or irritants are stored, install an eyewash station and emergency shower.

12. Storage of flammable chemicals should conform to all state/provincial fire regulations. Contact your local authorities for advice. Store large amounts of flammable solvents in metal flammable-storage cabinets or specially designed storage rooms.

13. Install fire suppression systems or extinguishers that are approved for fires caused by the types of chemicals stored. Train personnel about the fire suppression system and/or how to use the type of extinguisher available.

HANDLING AND DISPOSING OF MATERIALS

1. Check labels and MSDSs of your materials, and have available the types of face shields, eye protection, gloves, washup facilities, and first aid equipment that are recommended.

2. When accidents occur, wash skin with lots of water, and remove contaminated clothing. If eyes are affected, rinse them for at least fifteen minutes in an eyewash fountain, and get medical advice. (Note: There are a few chemicals for which water washing is hazardous or for which other procedures should be used. See MSDSs for advice.)

3. Do not use any cleaning methods that raise dusts. Wet-mop floors, or sponge surfaces.

4. Dispose of waste or unwanted materials properly. Check federal and local environmental protection laws. Often, you must have containment barriers and no floor drains in rooms where polluting chemicals are stored, used, or held prior to being picked up for disposal. Certain sinks must also drain into containment rather than to sewers. Never pour solvents, acids, metal-containing liquids, or other polluting chemicals down drains. Pour nonpolluting water solutions down the sink, one at a time, with lots of water. Hire a waste disposal service to pick up toxic waste.

5. Clean up spills immediately. If you use flammable or toxic liquids in the shop, stock chemical absorbents or other materials to collect spills, self-closing waste cans, and respiratory protection, if needed. Empty waste cans daily.

6. When practical, dispense solvents from self-closing safety cans to reduce evaporation.

7. Do not store flammable or combustible materials near exits or entrances. Keep sources of sparks, flames, UV light, and heat, as well as cigarettes, away from flammable or combustible materials. (See chapter 9 for additional rules about flammable liquids.)

8. Have appropriate fire suppression or extinguishers for areas where materials are used or in toxic waste holding areas. Train workers about the suppression system and/or the extinguishers.

CHOOSING PROTECTIVE EQUIPMENT

Many types of protective equipment are on the market. Some general rules for selecting appropriate equipment include:

1. Get expert advice when planning for safety and health. For example, consult an industrial hygienist (either private or governmental) to survey your facilities for hazards and recommend equipment. Some state/provincial government industrial hygiene services are free.

2. If you are in a school or a business with employees, remember that OSHA and OHSA require written programs and documented training if gloves, goggles, or any other personal protective equipment is used.

3. Do not use respirators unless you can afford to provide medical certification for each worker, a written program, professional fit testing, training, and other requirements of the OSHA regulations.

4. Get advice from more than one source when purchasing protective equipment, machinery, etc. Never rely solely on equipment manufacturers or distributors for information.

5. Survey personnel and students' special needs and problems regarding protective equipment. For example, people with dermatitis may need special hand protection. Do the required training for personal protective equipment with each individual's needs in mind.

6. Enforce proper use of protective equipment. Respirators are useless if they are not worn, hearing is not protected by unused earmuffs, etc.

7. Include regular repair, replacement, and maintenance of protective equipment in your program.

WHERE TO BUY SAFETY SUPPLIES

Appendix A, part 4 at the end of this book lists two catalog suppliers. However, there are many other good sources. It is wise for artists to purchase supplies from large catalog distributors that also provide free technical advice to help them select the right products. Another resource is the yellow pages: Consult the entries under "Safety."

EYE AND FACE PROTECTION

Suitable eye and face protection in the form of goggles or shields will guard against a variety of hazards, including impact (from chipping, grinding, etc.), radiation (welding, carbon arcs, lasers, etc.), and chemical splash (solvents, acids, etc.).

Only use protective equipment that conforms to American National Standards Institute (ANSI) standards. (See figures 3 and 4, page 61 and 63.) These standards are recognized in both the United States and Canada. Approved

items will be labeled with the numbers of the standards with which they comply. Be certain to choose equipment appropriate to the hazard. A common mistake is to see chemical splash goggles used for protection against grind-wheel particles.

There are many sellers of eyewear making false claims about their products' ability to block optical radiation. Demand that sellers provide printouts of the transmission spectrums of the lenses to prove their claims. The lenses you buy should block a very large percentage of the range of radiation specifically caused by your work. (See table 5 on page 33.)

Ordinary glasses are not proper eye protection. Contact lenses can be worn under proper eye protection if the following guidelines from the Contact Lens Ophthalmologists Association are followed.

1. Wear contact lenses in industrial environments in combination with appropriate industrial safety eyewear, except where there is likelihood of injury from intense heat, massive chemical splash, highly particulate atmosphere, or where regulations prohibit use.
2. Employees wearing contact lenses should tell their immediate supervisors and safety medical personnel that they use contacts.
3. First-aid personnel must be trained to remove contacts properly.
4. Employees whose central and peripheral vision is increased by contact lenses as contrasted to spectacles (e.g., those with cataracts removed or corneal scars) should be encouraged to wear contact lenses.
5. Employees should keep a spare pair of contacts or prescription spectacles or both handy in case they damage or lose a contact lens while working.
6. Safety and medical personnel must not discriminate against employees who can achieve visual rehabilitation by contact lenses, either in job placement or on return to a job.

EYEWASH FOUNTAINS AND DELUGE SHOWERS

If you use any materials that can damage the eyes, an eyewash fountain should be a fixture in your shop. The fountain should be able to deliver at least fifteen minutes of water flow. Small eyewash bottles are not satisfactory for this purpose and also may become contaminated with bacteria.

AMERICAN NATIONAL STANDARD Z87.1-1989
SELECTION CHART — PROTECTORS

Category	Activity	ASSESSMENT SEE NOTE (1)	PROTECTOR TYPE	PROTECTORS	LIMITATIONS	NOT RECOMMENDED
IMPACT	Chipping, grinding, machining, masonry work, riveting, and sanding.	Flying fragments, objects, large chips, particles, sand, dirt, etc.	B,C,D, E,F,G, H,I,J, K,L,N	Spectacles, goggles faceshields. SEE NOTES (1) (3) (5) (6) (10). For severe exposure add N	Protective devices do not provide unlimited protection. SEE NOTE (7)	Protectors that do not provide protection from side exposure. SEE NOTE (10). Filter or tinted lenses that restrict light transmittance, unless it is determined that a glare hazard exists. Refer to OPTICAL RADIATION.
HEAT	Furnace operations, pouring, casting, hot dipping, gas cutting, and welding.	Hot sparks	B,C,D, E,F,G, H,I,J, K,L,N	Faceshields, goggles, spectacles. *For severe exposure add N. SEE NOTE (2) (3)	Spectacles, cup and cover type goggles do not provide unlimited facial protection. SEE NOTE (2)	Protectors that do not provide protection from side exposure.
		Splash from molten metals	*N	*Faceshields worn over goggles H,K		
		High temperature exposure	N	Screen faceshields. Reflective faceshields. SEE NOTE (2) (3)	SEE NOTE (3)	
CHEMICAL	Acid and chemicals handling, degreasing, plating.	Splash	G,H,K	Goggles, eyecup and cover types. *For severe exposure, add N	Ventilation should be adequate but well protected from splash entry	Spectacles, welding helmets, handshields
			*N			
		Irritating mists	G	Special purpose goggles	SEE NOTE (3)	

FIG. 3. ANSI Protection Standards

This material is reproduced with permission from the American National Standards Institute. "Practice for Occupation and Educational Eye and Face Protection," Z87.1–1989, ©1989 by the American National Standards Institute. Copies of this standard may be purchased from the American National Standards Institute at 25 West 43rd Street, Fourth Floor, New York, New York, 10036.

	Operation	Hazard	Protectors	Typical Filter Lens Shade / Protectors	Notes
DUST	Woodworking, buffing, general dusty conditions.	Nuisance dust	G,H,K	Goggles, eyecup and cover types	Atmospheric conditions and the restricted ventilation of the protector can cause lenses to fog. Frequent cleaning may be required. — Protectors that do not provide protection from optical radiation. SEE NOTE (4)
OPTICAL RADIATION				**TYPICAL FILTER LENS SHADE** / **PROTECTORS** SEE NOTE (9)	
	WELDING: Electric Arc		O,P,Q	10-14 — Welding Helmets or Welding Shields	Protection from optical radiation is directly related to filter lens density. SEE NOTE (4). Select the darkest shade that allows adequate task performance.
	WELDING: Gas		J,K,L, M,N,O, P,Q	4-8 — Welding Goggles or Welding Faceshield	SEE NOTE (9)
	CUTTING			3-6	
	TORCH BRAZING			3-4	
	TORCH SOLDERING		B,C,D, E,F,N	1.5-3 — Spectacles or Welding Faceshield	SEE NOTE (3)
	GLARE		A,B	Spectacle SEE NOTE (9) (10)	Shaded or Special Purpose lenses, as suitable. SEE NOTE (8)

16

FIG. 3. ANSI Protection Standards (continued)

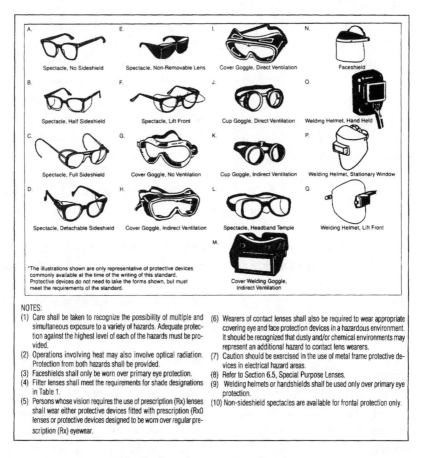

A. Spectacle, No Sideshield
B. Spectacle, Half Sideshield
C. Spectacle, Full Sideshield
D. Spectacle, Detachable Sideshield
E. Spectacle, Non-Removable Lens
F. Spectacle, Lift Front
G. Cover Goggle, No Ventilation
H. Cover Goggle, Indirect Ventilation
I. Cover Goggle, Direct Ventilation
J. Cup Goggle, Direct Ventilation
K. Cup Goggle, Indirect Ventilation
L. Spectacle, Headband Temple
M. Cover Welding Goggle, Indirect Ventilation
N. Faceshield
O. Welding Helmet, Hand Held
P. Welding Helmet, Stationary Window
Q. Welding Helmet, Lift Front

*The illustrations shown are only representative of protective devices commonly available at the time of the writing of this standard. Protective devices do not need to take the forms shown, but must meet the requirements of the standard.

NOTES:
(1) Care shall be taken to recognize the possibility of multiple and simultaneous exposure to a variety of hazards. Adequate protection against the highest level of each of the hazards must be provided.
(2) Operations involving heat may also involve optical radiation. Protection from both hazards shall be provided.
(3) Faceshields shall only be worn over primary eye protection.
(4) Filter lenses shall meet the requirements for shade designations in Table 1.
(5) Persons whose vision requires the use of prescription (Rx) lenses shall wear either protective devices fitted with prescription (RxO lenses or protective devices designed to be worn over regular prescription (Rx) eyewear.
(6) Wearers of contact lenses shall also be required to wear appropriate covering eye and face protection devices in a hazardous environment. It should be recognized that dusty and/or chemical environments may represent an additional hazard to contact lens wearers.
(7) Caution should be exercised in the use of metal frame protective devices in electrical hazard areas.
(8) Refer to Section 6.5, Special Purpose Lenses.
(9) Welding helmets or handshields shall be used only over primary eye protection.
(10) Non-sideshield spectacles are available for frontal protection only.

FIG. 4. Eye Protection Products

Fountains should be activated by a foot pedal, lever, or other mechanism that requires only a single movement taking a single second to turn on the water and keep it running. Fountains should be flushed by running the water for three minutes, once a week, to keep fresh, clean water in the line. A tag should be kept by each fountain, recording each week the time, date, and initials of the person flushing the eyewash. Emergency or deluge showers should also be flushed at least each week. The manufacturers will provide information on proper installation, testing, and maintenance of deluge showers.

Fountains and showers must be placed near the chemicals that are in use and not where the worker would have to open a door or go up or down stairs to reach them.

SKIN PROTECTION

Satisfactory chemical-resistant gloves have been developed for almost any use imaginable. They can be purchased in any length up to shoulder length, in any thickness from paper-thin to very thick, and in many types of plastic and rubber to resist almost every kind of material. Surgical or ordinary household gloves should not be expected to stand up to solvents, acids, and other strong chemicals.

Find a glove supplier who provides information (usually in the form of a chart) that indicates how long each type of glove material can be in contact with a chemical before it is 1) degraded and 2) permeated. Degradation occurs when the glove deteriorates from the chemical's attack. Permeation occurs when molecules of the chemical squirm through the glove material. Permeated gloves often appear unchanged, and the wearer may be unaware that they are being exposed to the chemical.

Many artists are unaware that even common solvents like acetone, glycol ether, and xylene can penetrate certain chemical gloves in minutes and begin damaging and/or penetrating the skin.

Manufacturers' catalogs often provide access to proper gloves for other purposes, such as protection from heat, radiation, and abrasion. Asbestos gloves should not be used—substitutes for them are available.

For protection from occasional splashes or from very light exposure to chemicals, you may use special creams called "barrier creams." Some of these creams protect skin from solvents and oils, others from acids, and so on. Choose the right cream, and use it exactly as directed. Never wear barrier creams under gloves, as they compromise the efficacy of the gloves.

Do not use harsh hand soap. Waterless skin cleaners are useful if their ingredients do not include solvents or other harsh chemicals. Never wash your hands with solvents. Rubbing baby oil (mineral oil) on the skin and then washing with soap and water will remove many paints and inks. Using a barrier cream prior to working should enable you to wash off paints with soap and water. After cleaning your skin, apply a good hand lotion to replace any lost skin oils.

Hands are not the only part of the body for which skin protection has been developed. Aprons, leggings, leather or plastic clothing, shoes, and a myriad of other special protective products are available. Remember, your skin's protective barrier is your first defense against many hazardous agents.

RUBBER GLOVES: A SPECIAL PROBLEM. Allergies to natural rubber are serious. Symptoms include skin rash and inflammation, hives, respiratory irritation, asthma, and systemic anaphylactic shock. Between 1988 and 1992,

the FDA (Food and Drug Administration) received reports of a thousand systemic shock reactions to latex. As of June 1996, twenty-eight latex-related deaths had been reported to the FDA.

While these serious reactions are seen primarily among medical professionals and patients, anyone working with natural rubber latex products regularly is at risk.

Natural rubber is derived from sap drawn from Hevea trees. It contains a chemical called isoprene, which can be treated chemically to form a polymer, or plastic-like material, called *poly*isoprene—the fancy name for natural rubber.

Natural rubber latex sap also contains many impurities, including about two hundred different proteins. Fifty of these proteins can cause allergies. The proteins cannot be completely removed from finished natural rubber products. Gloves labeled "reduced proteins" are less sensitizing, but all natural rubber products can cause allergy. For this reason, the FDA now prohibits the word "hypoallergenic" on latex-glove labels.

PRECAUTIONS FOR NATURAL RUBBER GLOVES

1. Try to switch to plastic gloves. If rubber latex gloves must be used, use reduced-protein gloves and powder-free gloves. The powder used as a lubricant can increase exposure though skin contact and inhalation.

2. Reduce exposure to rubber. Use nonlatex gloves for food preparation, housekeeping, and all other tasks that do not involve contact with infectious agents, such as blood.

3. Be alert for reactions, such as itching or rashes, so that you can take action promptly, before the allergy gets out of hand.

4. Wash your hands with a mild soap immediately after removing latex gloves or working with rubber-containing products.

5. Never use hand lotion or barrier creams under gloves, because they can leach the proteins out of the rubber and make the situation worse. Lotions and creams can also make rubber and plastic gloves more easily penetrable by germs and chemicals.

6. See your doctor if allergy symptoms start. There is no remedy for latex allergy, but some medications can reduce symptoms. If you are diagnosed with rubber latex allergy, plan to avoid all products containing natural rubber.

7. Learn about your latex allergies. For instance, you should know that allergies to certain foods like avocados, potatoes, bananas, tomatoes, chestnuts, kiwi fruit, and papaya are also associated with latex allergy.

MEDICAL SURVEILLANCE

Artists should keep in mind that there are no tests for some types of chemical exposure, and there are no treatments for many kinds of bodily damage from certain chemical and physical agents. Medical monitoring is never a replacement for preventing exposure to toxic substances.

Medical monitoring, however, can be a valuable tool in early recognition and prevention of occupational illnesses. Such tests can serve three purposes:

1. To identify preexisting disorders, so artists can avoid media that would put them at great risk
2. To detect early changes in performance before serious damage occurs
3. To detect damage that has already occurred and that may be permanent

Two examples of useful medical tests are regular (in some cases yearly) lung-function tests for artists exposed to respiratory hazards and blood tests for lead for those artists using lead-containing materials. There are special blood or urine tests for several other toxic metals and many organic chemical exposures as well.

Choosing the right tests and interpreting the results can be done best by doctors who are board certified in Occupational Medicine or Toxicology or who have experience with occupational health problems. Such doctors may be found by contacting your state or provincial health departments or artists' advocacy organizations such as ACTS (see appendix A, part 1, beginning on page 380).

Consult only physicians who explain the results of medical tests in meaningful terms, so that you can be an active participant in your own health care.

CHAPTER 7
VENTILATION

Providing proper ventilation is the single most important method of protecting artists from hazardous airborne substances. There are two basic kinds of ventilation: 1) comfort ventilation to keep people healthy in offices and classrooms in which toxic substances are not used, and 2) industrial ventilation for the industrial processes used in art, such as solvent oil painting, welding, ceramics, and printmaking. These two types of ventilation systems must be designed to the specifications of the two major standard-setting organizations: ASHRAE and ACGIH.

COMFORT STANDARDS

The American Society of Heating, Refrigerating, and Air-Conditioning Engineers (ASHRAE) sets standards for indoor air quality and ventilation. In order to avoid buildup of humidity, heat, and air pollution in buildings—which can cause adverse health effects—ASHRAE sets ventilation standards for natural and recirculating systems.

Natural ventilation systems take advantage of rising warm air and prevailing winds to cause the air in buildings to circulate and exchange with outside air in sufficient amounts to provide comfort to those inside the building. Often, chimney-like flues are constructed behind walls to draw out warm air. Such systems are found mostly in older buildings, where high ceilings and open spaces enhance the system.

Some buildings employ "univents" installed in rooms on outside walls. These units draw in some outside air through louvers in the wall, mix it with room air, and then heat and expel the mixture. During the energy crisis in the 1970s, many of these units' access to outside air was cut off to save fuel. In this case, the units provide no ventilation—only heat.

Recirculating ventilation is the most common method of providing comfort ventilation. The design standards for these systems are set out in ASHRAE's most recent standard (ASHRAE 62-1999). In most instances, ASHRAE requires that fifteen or twenty cubic feet of outside fresh air (not recirculated) per minute, per person, be delivered to the level at which people are breathing (not supplying and exhausting air at the ceiling, as most recirculating systems do).

Fans or blowers are used to circulate air from room to room throughout the building. On each recirculating cycle, some fresh air from outside is added and some recirculated air is exhausted. The amount of fresh air added usually varies from 5 to 30 percent, depending on how tightly insulated the building is and the vagaries of the particular ventilation system or its operator. Building engineers who operate ventilation systems often are encouraged to add as little fresh air as possible to reduce heating and cooling costs.

"Sick building syndrome" occurs when insufficient amounts of fresh air are added to comfort ventilation systems. People in these buildings may complain of eye irritation, headaches, nausea, and other symptoms. The symptoms are apparently caused by the accumulation of body heat, humidity, cigarette smoke, dust, formaldehyde, and other pollutants in the air.

But no matter how much outside air is supplied, recirculating systems may be used only in locations where airborne chemicals are not generated. *ASHRAE standards never apply to shops that use toxic substances.* For these situations, ASHRAE refers to ACGIH standards.

INDUSTRIAL STANDARDS

The American Conference of Governmental Industrial Hygienists (ACGIH) sets internationally accepted standards for workplace air quality and for industrial ventilation in their publication *Industrial Ventilation: A Manual of Recommended Practice* (see appendix A, part 3). The ACGIH sets standards for both basic types of industrial ventilation: (1) dilution ventilation; and (2) local exhaust ventilation.

Dilution ventilation does exactly what its name implies. It dilutes or mixes contaminated workplace air with large volumes of clean air to reduce the amounts of contaminants to acceptable levels. Then, the diluted mixture is exhausted (drawn by fans or other devices) from the workplace. It is cheap to install, but very expensive to run, because it exhausts large volumes of conditioned air, which must be replaced by conditioning more air.

Dilution ventilation also is limited to control of vapors or gases of low toxicity or very small amounts of moderately toxic vapors or gases. It should not be used to control dusts.

In special cases, the exhaust fan can be positioned very close to the work station (see figure 5). In this way, it is effective as a local exhaust. Do not use this system with aerosol cans, spray painting, airbrush operations, or with flammable materials unless the fan is explosion-proof.

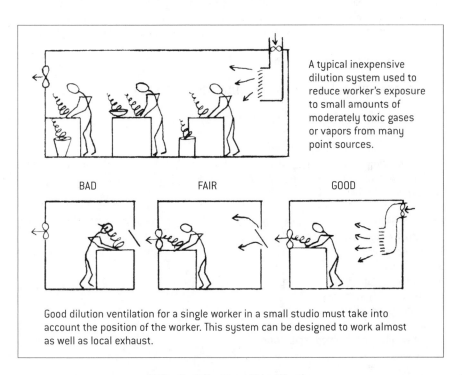

A typical inexpensive dilution system used to reduce worker's exposure to small amounts of moderately toxic gases or vapors from many point sources.

BAD FAIR GOOD

Good dilution ventilation for a single worker in a small studio must take into account the position of the worker. This system can be designed to work almost as well as local exhaust.

FIG. 5. Dilution Ventilation

Local exhaust ventilation is the best means by which large amounts of airborne substances, or substances of moderate to high toxicity, are removed from the workplace. Table 6 lists processes that require local exhaust ventilation.

Local exhaust systems consist of:

1. A hood enclosing or positioned very close to the source of contamination to draw in the air
2. Ductwork to carry away the contaminated air
3. If needed, an air cleaner to filter or purify the air before it is released outside
4. A fan to pull air through the system (see figure 6)

TABLE 6	INDUSTRIAL VENTILATION

PROCESSES REQUIRING DILUTION VENTILATION
1. Painting with oil paints or solvent-containing paints (only if solvents have TLVs of 200 ppm or greater)
2. Use of small amounts of solvent-containing adhesives, inks, shellacs, and similar products
3. Black-and-white photo developing

PROCESSES AND EQUIPMENT REQUIRING LOCAL EXHAUST VENTILATION
Dusts from:
1. Abrasive blasting
2. Dry hand sanding
3. Power sanding, grinding, and polishing
4. Wet grinding, abrading, and polishing
5. Dry mixing of clays, glazes, dyes, photochemicals, etc.
6. Powered carving and chipping of stone

Heat, Fumes, and Other Emissions from:
1. Batik wax baths and ironing-out stations
2. Burn-out kilns
3. Ceramic firing
4. Enameling, slumping, fusing, glass paint kilns
5. Glassblowing furnaces
6. Foundry furnaces
7. Hot dye baths
8. Metal soldering, melting, and casting
9. Welding

Mists from:
1. Aerosol spraying
2. Airbrushing
3. Wet grinding, abrading, and polishing
4. Power spraying (all types)

Vapors and/or Gases from:
1. Acid etching (all types, including hydrofluoric)
2. Acid pickling baths
3. Electroplating
4. Photochemical processes* (color processing, toning, photoetching, photolithography)
5. Plastic resin casting
6. Screen printing (all phases: printing, print drying, screen cleaning)

* For nonchemical processes such as film changing, ASHRAE standards for darkrooms can be used.

Local exhaust ventilation is the best means by which materials of moderate to high toxicity—gases, vapors, dusts, fumes, etc.—are removed from the workplace. Because local exhaust ventilation captures the contaminants at their source rather than after they have escaped into the room air, exhaust ventilation systems remove smaller amounts of air than dilution systems. Table 6 lists processes that require local exhaust ventilation.

TYPES OF HOODS. A hood is the structure through which the contaminated air first enters the system. Hoods can vary from small dust-collecting types built around grind wheels to walk-in-sized spray booths. Some hoods that artists may find useful include the following:[1]

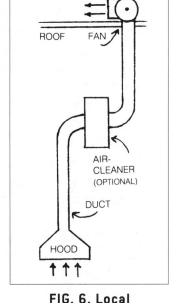

FIG. 6. Local Exhaust Ventilation

1. *Dust-collecting systems (fig. 7).* Most grind wheels, table saws, and other dust-producing machines sold today have dust-collecting hoods built into them. Some machines need only to be connected to portable dust collectors, which can be purchased off-the-shelf. In other cases, stationary ductwork can be used to connect machines to dust collectors. These collectors include cyclones (which settle out particles) and bag houses (which capture particles on fabric filters). Artists should not work with dust-producing machines unless they are connected to dust collectors.
2. *Spray booths (fig. 8).* Spray booths, from small table models to walk-in-sized or larger,

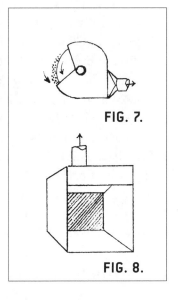

FIG. 7.

FIG. 8.

[1] See also figures 7 to 11, Types of Local Exhaust Systems, pages 71–72.

can be purchased or designed to fit the requirements of a particular shop. Some common uses for spray booths include spraying of paints, lacquers, adhesives, and other materials; plastic resin casting; paint stripping; and solvent cleaning of silkscreens. Since spray paints and other sprays are likely to contain flammable solvents, the spray booth, its ducts and fans, and the area surrounding the booth must be made safe from explosion and fire hazards.

3. *Movable exhaust systems (fig. 9).* Also called "elephant trunk" systems, these flexible duct-and-hood arrangements are designed to remove fumes, gases, and vapors from processes such as welding, soldering, or any small tabletop processes that use solvents or solvent-containing products. Movable exhausts can also be equipped with pulley systems or mechanical arms designed to move hoods to almost any position.

4. *Canopy hood systems (fig. 10).* These hoods take advantage of the fact that hot gases rise. They are used over processes such as hot dye baths, wax and glue pots, stove ranges, and the like. Unfortunately, they are often installed above worktables, where they are not only ineffective because the hood is too far above the table, but even dangerous because they draw contaminated air past the worker's face.

5. *Slot hood systems (fig. 11).* These systems draw gases and vapors across a work surface, away from the worker. Slot hood systems are good for any kind of bench work, including silkscreen printing, color photo developing, airbrushing, and soldering. They are rather expensive to design and build, but they provide a shop with surfaces on which many processes can be safely carried out.

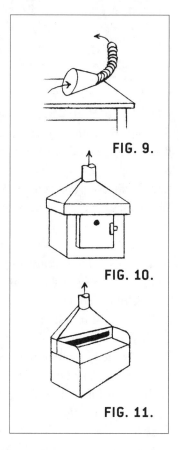

FIG. 9.

FIG. 10.

FIG. 11.

RULES FOR DESIGNING SYSTEMS

1. Enclose the process as much as possible by placing the hood close to the source or surrounding the process as completely as possible with the hood. The more the process is enclosed, the better the system will work.

2. Place the hood in a location that ensures that contaminated air flows away from the operator's face, not past it.

3. Make sure the airflow into the hood is great enough to capture the contaminant. Keep in mind that dusts are heavy particles and require higher-velocity airflow for capture than lighter vapors and gases.

4. Place the exhaust opening or stack in a location that ensures that exhausted air cannot reenter the room through makeup air inlets, doors, windows, or other openings.

5. Make sure enough makeup air is provided to keep the system operating efficiently.

PLANNING VENTILATION FOR ART BUILDINGS

Planning ventilation systems for schools, studios, and shops usually requires experts for each phase of work. You should carefully apprise these experts of your special needs before they begin their work.

SELECTING THE ARCHITECT. Schools and universities usually seek a famous and innovative architect who will create an exciting and novel building plan. The school needs this exciting plan to impress alumni, trustees, and other potential funders. The more stunning the architectural model, the easier it is to sell to funders. Conversely, the more beautiful the building, the harder it usually is to put safe art studios in that building!

The reason is that art is an industrial process that requires exhaust ventilation systems whose components cannot be hidden from view. For example, if the architectural model does not show exhaust stacks sticking up into the airspace above the roof, then you cannot have environmentally compliant gas kilns, spray booths, or other types of local exhaust systems for removing significant amounts of regulated airborne substances.

SELECTING THE TEAM. Architects must choose a design team that includes engineers and industrial hygienists who will be able to integrate all the electrical, plumbing, ventilation, fire suppression, and other services needed by the building. In terms of ventilation, teams for large facilities must employ an industrial hygienist and two types of engineers:

1. The industrial hygienist is needed to interview and observe system users to determine precisely which chemicals and processes will be used in order to select the systems and airflow rates needed to capture the contaminants.

2. An experienced industrial ventilation engineer is needed to design the local and dilution ventilation systems specified.

3. A heating/air-conditioning mechanical engineer is needed to design systems for classrooms, auditorium, offices, and other public spaces.

These professionals must work together to plan all types of ventilation systems. Industrial ventilation systems are usually designed to control air contaminants at levels that meet ACGIH workplace air-quality standards. These standards will protect nearly all healthy adult workers. However, if the facility is a school, the TLVs cannot be used, because students are not "workers" and may not be "healthy," or even "adult." Instead, students require air that meets ASHRAE indoor air-quality standards.

The ASHRAE 62-1999 standard recommends designing ventilation systems that will reduce air pollution to levels that are one-tenth the ACGIH TLV, unless the air contaminant is one of those few for which other ASHRAE standards exist (e.g., carbon monoxide, ozone, or nitrogen oxides). In some cases, contaminant levels may need to be even lower than one-tenth of the TLV. The Americans with Disabilities Act requires acceptance of students who may be seriously sensitive to airborne chemicals or who have breathing problems.

LIABILITY ISSUES. Architects and engineers must design ventilation systems that meet ACGIH and ASHRAE professional standards of practice. If these standards are not incorporated, it can be interpreted to mean that *in the expressed and expert opinion of ACGIH and ASHRAE, the building cannot be used safely for the purpose for which it was intended.*

I have personally participated in a legal action that was settled by payment of large sums by architects and engineers who designed an art building that did not meet ACGIH industrial ventilation standards.

Planning ventilation for small shops and individual studios is less complicated. A good reference called *Ventilation: A Practical Guide,* by Nancy Clark, et al. (available on Amazon.com), provides basic ventilation principles and calculations. Mechanically inclined artists should be able to use this manual to design and install simple systems.

Artists should be leery of salesmen who tout products that appear to solve ventilation problems cheaply by purifying contaminated air and returning it to the workplace. Some of these devices, such as ozone gener-

ators and negative ion generators,[2] not only are useless in most studios, but they can actually be harmful, since they also generate toxic ozone gas. Others, such as electrostatic precipitators, are very limited in their uses and, at best, can be used only as adjuncts to traditional ventilation. For example, they can successfully remove cigarette smoke fume particles, but not the gases and vapors produced by cigarettes.

CHECKING THE SYSTEM. After a ventilation system has been installed, it should be checked to see that it is operating properly. If an engineer, industrial hygienist, or contractor worked on the job, he or she should make the initial check and recommend any changes necessary to meet design specifications. If experts were not consulted, you may decide to consult one at this stage.

To check the systems, experts use devices that measure airflow. I recommend that users also purchase such devices to check their systems. The one I found most useful for unsophisticated users is the Alnor Velometer Jr. It costs around $600 and can be ordered from IVL Technical Sales (1-800-355-1855 or *www.ivltech.com*). This is a small price to pay for artists and teachers to be able to know how well their systems work rather than depending on the experts.

But even without airflow measuring, some commonsense observations can be made:

1. Can you see the system pulling dusts and mists into it? If not, you might use incense smoke or soap bubbles to check the system visually. When released in the area where the hood should be collecting, the smoke or bubbles should be drawn quickly and completely into the system.
2. Can you smell any gases or vapors? Sometimes, placing inexpensive perfume near a hood can demonstrate a system's ability to collect vapors, or it can show that exhausted air is returning to the workplace (or some other place where it should not be).
3. Do people working with the system complain of eye, nose, or throat irritation or have other symptoms?

[2] These systems cannot collect gases or vapors. They only remove positive electric charges on some kinds of particles, such as pollens and house dust, causing them to settle temporarily on surfaces and walls. While this might be helpful to some individuals sensitive to pollens and certain dusts, it is essentially useless against toxic gases, vapors, fumes, and dusts.

4. Is the fan so noisy and irritating that people would rather endure the pollution than turn it on? Fans should not be loud, and experts should be expected to work on the system until it is satisfactory.

5. Check the maintenance schedules for changing filters, cleaning ducts, changing fan belts, and the like to see that these are being followed faithfully.

CHAPTER 8
RESPIRATORY PROTECTION

Adequate ventilation, not respirators, should be the primary means of controlling airborne toxic substances. United States Occupational Safety and Health Administration (OSHA) regulations restrict use of respiratory protection except: 1) when a hazardous process is used only very occasionally (less than thirty times a year); 2) while ventilation is being installed, maintained, or repaired; 3) where engineering controls result in only a negligible reduction in exposure; 4) during emergencies; or 5) for entry into atmospheres of unknown composition.

Most Canadian provincial regulations allow more liberal use of respiratory protection.

NIOSH APPROVAL
The National Institute for Occupational Safety and Health (NIOSH) sets standards for respirators, filters, and all respirator parts and components. Both the United States and Canada accept these standards. All approved respirators and components will carry the initials "NIOSH" and an approval number. Only NIOSH-approved products should be used.

TYPES OF RESPIRATORS
It is important to choose precisely the right type of protection for a particular task. Wearing the wrong type of respirator, a surgical mask (which is designed as protection against biological hazards, not chemical ones), or a damp handkerchief may actually make the situation worse.

There are three basic respirator types: air-supplying, air-purifying, and powered air-purifying.

Air-supplying respirators bring fresh air to the wearer, usually by means of pressurized gas cylinders or air compressors. They are the only respirators that can be used in oxygen-deprived atmospheres. They also are complex and expensive systems requiring special training for those using them.

Air-purifying respirators use the wearer's breath to draw air through filters or chemical cartridges in order to purify it before it is inhaled. Most air-purifying respirators are priced in a range that artists will find practical. These respirators will be covered in detail below.

Powered air-purifying respirators provide wearers with air that has been pumped (usually by a small unit attached to the wearer's belt) through filters or cartridges. This filtered air is supplied under slight pressure to a mask or shield over the wearer's face. These are usually priced somewhere between the two other types of respirators.

TYPES OF AIR-PURIFYING RESPIRATORS

Artists are most likely to find the following types of air-purifying respirators useful:

1. *Disposable or single-use types,* which often look like paper dust masks and are thrown away after use
2. *Half-face types,* which cover the mouth, nose, and chin and have replaceable filters and cartridges
3. *Full-face types,* which look like old-fashioned gas masks and have a replaceable canister

RESPIRATOR PROGRAMS

Learning to select and use respirators properly is not as easy as it looks. For this reason, United States employers are required by OSHA to institute written programs for all workplaces where respirators are used. At present, Canadian regulations are not as strict, but many regulations for specific chemicals require written respirator programs. Among these substances are several used by artists and conservators, including silica, lead, and ethylene oxide.

Respirator programs should be instituted in schools, universities, businesses, museums, and all institutions whose personnel use respirators. If students are allowed to use respirators, the program should be extended to include them. Although students are not covered under occupational laws, the school's liability will be jeopardized if students do not receive equal or better protection than staff.

PROGRAM ELEMENTS. Schools or businesses where respirators are used must institute programs that have the following elements:

1. *A written program* explaining how the employer will meet all the requirements below.
2. *A written hazard evaluation* to determine hazards on each type of job and the employer's rationale for selecting particular respirators.
3. *A Medical Evaluation* to determine each worker's ability to wear the selected respirator. The evaluation may be done by either a physician or a "licensed medical professional."
4. *Formal fit testing* at least annually by a qualified person using one of the approved methods.
5. *Documented training* annually to ensure that each worker is familiar with the use and limitations of the equipment; procedures for regular cleaning, disinfecting, and maintaining all respirators; how to don, doff, and do a "seal check" before each use; and other technical matters.
6. *Periodic program evaluation* to ensure that respirator use continues to be effective.
7. *Medical certification.* This is the most expensive of the OSHA requirements. Usually, very detailed medical questionnaires are given to workers. If the answers on this questionnaire indicate the worker may have a physical problem that makes respirator use hazardous, a personal interview and/or medical examination is required. For example, heart or lung problems may be identified by the questionnaire—these problems could be worsened by the additional breathing stress created by a respirator. Some psychological problems such as claustrophobia also preclude respirator use. Temporary conditions that curtail respirator use include head colds, skin infections, and, in some cases, pregnancy.

The medical questionnaire and follow-up must be paid for by the employer. And in all cases, the medical information is confidential between the worker and the medical provider.

FITTING RESPIRATORS. Artists cannot know whether or not their respirators are protecting them unless they have been fit-tested by a "qualified person." This qualified person must be provided by their employer. Self-employed artists will have a difficult time finding someone to fit-test them. The companies that

sell respirators rarely provide fit testing. You can hire an industrial hygienist or consultant, but this is expensive. Some workers mistakenly think they can test themselves by doing a "fit check."

FIT CHECK/USER SEAL CHECK. Confusion between the terms "fit test" and "fit check" caused OSHA to change the term "fit check" to "user seal check."

A user seal check for a mask is done by putting the mask on and seeing if it will briefly maintain negative pressure when the wearer inhales or will maintain positive pressure when the wearer exhales. The respirator doesn't fit if the wearer feels air escaping near the nose, under the chin, or from some other place where the seal is broken.

To perform a user seal check for a cartridge respirator, the wearer closes the exhalation valve with his or her hand and exhales into the facepiece. Next, the wearer can block air coming into the cartridges with his or her hands and inhale. The facepiece should not let air leak in or out on either procedure.

Employers are required to provide trainers who will give workers hands-on instruction on seal checks. Workers are expected to do this check every time they put on a respirator or mask.

THE REAL FIT TEST. For workers under OSHA, the employer must provide fit testing of all respirators (including masks). Your employer may hire a consultant or have an employee specially trained to do the job. The OSHA regulations describe the various approved methods for doing the two basic types of fit testing.

1. *Qualitative fit testing* depends on the wearer's ability to sense an odor, taste, or irritation from one of four approved chemicals delivered in a controlled way to an enclosure around the user's head. Chemicals approved for this use include banana oil (isoamyl alcohol), saccharin mist, an irritant smoke (stannic chloride), and a bitrex (denatonium benzoate). These tests are not allowed for full-face negative-pressure and supplied-air-pressure-demand respirators.

2. *Quantitative fit testing* is done by measuring and comparing the pressure or contaminants inside and outside the mask or respirator. The equipment required is expensive, but the tests are applicable to all types of respirators, are more accurate, and create a document that makes it easy for employers to keep on file the required written records.

BEARDS. Many men mistakenly think that they can successfully wear their respirator over a beard. They can't. And the new OSHA rules contain very explicit wording about facial hair. Under 29 CFR 1910.134(g) *Use of respirators,* it says:

> (1) FACEPIECE SEAL PROTECTION. **(i) The employer shall not permit respirators with tight-fitting facepieces to be worn by employees who have:**
> **(A) Facial hair that comes between the sealing surface of the facepiece and the face or that interferes with valve function,**
> **or**
> **(B) Any condition that interferes with the face-to-facepiece seal or valve function.**

In addition, in OSHA's mandatory fit-testing procedures listed in appendix A, part 2, it says:

> 9. **The [fit] test shall not be conducted if there is any hair growth between the skin and the facepiece sealing surface, such as stubble beard growth, beard, mustache, or sideburns which cross the respirator sealing surface. . . .**

Employers who let their bearded workers wear respirators risk OSHA citations. In fact, employers can require their OSHA-covered workers to shave.

A hooded supplied-air or air-powered system will work for most workers who are determined to keep their beards. These systems are more expensive and require special training and maintenance. The air-supplied systems require the purchase of a special compressor or a special air filtering system that can produce air that is safe to breathe. Air from ordinary shop compressors must not be used for this purpose.

NEW STANDARDS FOR FILTERS

In 1998, OSHA rewrote the respiratory protection standard. Of all the changes, the most important to us was the adoption of new NIOSH standards for some of the filters that are in masks or in respirator cartridges.

Chemical filter standards have not changed. These filters capture substances such as ammonia, formaldehyde, acids, and organic solvents. It is crucial to know exactly what kind of chemical is in the air, because the wrong cartridge

will render the respirator useless. In addition, there are many chemicals for which there are no cartridges. Included are ozone, nitric acid, methyl alcohol, carbon monoxide, and many more.

Particulate filters are those that capture airborne solid particles and liquid mists. These are the ones we can use to protect ourselves against dusts, spray-can mists, and airbrush mists. Picking the right mask used to be easy; the filters came in only three types: dust, mist, and fume. Now, there are nine different types. And we should know them.

Particulate filters now come in three different series, designated as N, R, and P. All of these filters are tested against "fume-sized" particles (0.3 microns). The filters in each series have three minimum efficiency levels—95 percent, 99 percent, and 99.97 percent. That is:

1. N95, R95, and P95 filters are certified as having a minimum efficiency of 95 percent.
2. N99, R99, and P99 filters are certified as having a minimum efficiency of 99 percent.
3. N100, R100, and P100 filters are certified as having a minimum efficiency of 99.97 percent. Filters that are this efficient are also called "HEPA," high efficiency particulate air filters.

N-series filters can be used only in atmospheres containing non-oil-based particulates. For example, artists should not use the N filters if people nearby are machining metal with cutting oils or are spraying oil-based paints.

N filters also have a "time-use restriction." This means you should only use them for eight hours. The eight hours can be either continuous or intermittent. Intermittent use means that you are using the filter for short periods of time, sealing it in plastic Ziploc® bags between wearings, and discarding the mask when the amount of time it was used adds up to eight hours.

R-series filters can be used whether or not there is oil present. R filters also have a time-use restriction of eight hours of continuous or intermittent use.

P-series filters may be used in either non-oil- or oil-containing atmospheres. They do not have any time-use restrictions, which means they can be used until they are soiled or damaged, are causing an increase in breathing stress, or bear some other sign that they are worn out or faulty. The P100 is the top of the line and the only filter assigned a distinctive magenta color.

CHOOSING THE RIGHT RESPIRATOR

Since it is rare that oil mists are present in the studio or shop, we may be able to use any of the particulate filters. To choose the right one, you need to consider two primary factors:

1. The toxicity of the contaminant
2. The particle size distribution of the contaminant

TOXICITY. The choice is simple when artists work with highly toxic substances, such as powdered pigments containing lead, cadmium, or any other substance with a threshold limit value of 0.05 mg/m³ or less. In these cases, a filter with a 100-percent rating should always be used. A 100-percent HEPA filter is required by OSHA whenever lead is airborne, regardless of particle size.

PARTICLE SIZE. Silica flour, metal fumes, pigment powders, and other substances known to contain significant amounts of particles in the range of 0.3 microns in diameter require a respirator with a filter efficiency of 99.97 percent. Unfortunately, some pigment and dye products are smaller in size than 0.3 microns, so some material may get through even the very best of filters.

Coarse grinds or granular materials of moderate or low toxicity may be combated with one of the less efficient filters. It would be easier to choose a respirator if suppliers of powdered materials would provide the particle size distribution data on their products. This data is readily available from most of the primary manufacturers, but secondary product manufacturers usually will not pass it along to customers.

Until you know the particle size of the materials you use, it is wise to use the highest-efficiency filters for operations involving moderate to highly toxic materials. Choosing among N100, R100, and P100 filters will depend on how the artist works. If, at the end of the day, an artist's mask usually looks dirty and bent out of shape, it would be wise to buy the least expensive N-series mask and replace it frequently. If the artist's mask usually looks as good as new at the end of the day, you will save money buying the more expensive P100s and taking good care of them.

WHEN FILTERS SHOULD NOT BE USED

Air-purifying respirators should never be used in oxygen-deficient atmospheres, such as when gas is released in a confined space or in fire fighting.

In addition, NIOSH does not approve air-purifying respirators for use against chemicals that are of an extremely hazardous nature or that lack sufficient warning properties (smell or taste), are highly irritating, or are not effectively captured by filter or cartridge materials. Included among these are hot or burning wax vapors (acrolein and other hazardous decomposition products), carbon monoxide, methyl (wood) alcohol, isocyanates (from foaming or casting polyurethane), nitric acid, ozone, methyl ethyl ketone peroxide (used to harden polyester resins), and phosgene gas (created when chlorinated hydrocarbon solvents come into contact with heat or flame).

RESPIRATOR CARE

At the end of a work period, clean the respirator and store it out of sunlight in a sealable plastic bag. Respirators should never be hung on hooks in the open or left on counters in the shop. Cartridges left out will continue to capture contaminants from the air; they should also be stored in sealable plastic bags.

If a respirator is shared, it should be cleaned and disinfected between users. Most respirator manufacturers provide educational materials that describe proper breakdown and cleaning procedures. Inspect respirators carefully and periodically for wear and damage.

WHERE TO BUY RESPIRATORS

Schools and businesses can easily contact their safety equipment suppliers for advice about good local sources. However, individual artists may find it more difficult.

Begin by talking to some of the safety equipment suppliers in the yellow pages of your telephone book. If this route proves unproductive, consult the technical support people of large safety supply companies (see appendix A, part 4). Ask if they have a distributor near you.

Be sure to explain that you need a company that provides fit-testing, expert advice on matching the respirator to the hazard, and other technical services. These services are more important and more costly than the respirator.

VOLUNTARY USE EXEMPTIONS

Section 1910.134(c)(2) of OSHA's regulations provides an exemption from some of the OSHA requirements if respiratory protection is not really needed, but employers want to give workers the option of wearing them. However, to qualify for this exemption, the employer must prove that the contaminants are

TABLE 7	RESPIRATOR CARTRIDGES AND FILTERS	
CARTRIDGE	**COLOR**	**USE***
Organic vapor	black	organic vapors (e.g., solvents)
Organic vapor/acid gas	yellow	organic vapors, chlorine, hydrogen chloride, sulfur dioxide
Acid gases	white	chlorine, hydrogen chloride, sulfur dioxide
Ammonia/methylamine	green	ammonia and some organic amines (e.g., epoxy curing agents)
Formaldehyde	khaki	formaldehyde
Mercury/chlorine	red	mercury or chlorine
P100 particulate	purple	99.97% efficient against particulates
Other particulates	no color	see text for explanation of P, N, and R category particulate filters
Paint spray	black + filter	an organic vapor cartridge plus a spray pre-filter

* All substances must not exceed the maximum-use concentrations established by OSHA and NIOSH for the cartridge. For substances other than those listed, manufacturers must be contacted to see if they are effectively captured. There are no approved cartridges for many airborne substances.

well below any action limit or permissable exposure limit (PEL) for the contaminant. This is usually done by performing personal monitoring of workers doing typical work. Unfortunately, there is very little "typical" artwork, and most work is nonroutine and hard to assess. For this reason, I rarely recommend that employers and school administrators use this exemption.

Assuming, however, that the employer has proven that the worker would be safe without a respirator, 1910.134(c)(2)(i) of the OSHA regulations says:

(i) An employer may provide respirators at the request of employees or permit employees to use their own respirators, *if the employer determines that such respirator use will not in itself create a hazard.* If the employer determines that any voluntary respirator use is permissible, *the employer shall provide the respirator users with the information contained in Appendix D to this section ("Information for Employees Using Respirators When Not Required Under the Standard").* . . . [Italics mine]

I have emphasized two important provisions in this rule. A common example of a violation of this rule occurs when voluntary users leave masks and respirators lying about. Leaving masks out where they will be worn after they get dusty and dirty or possibly be shared is a potential hazard. In fact, Appendix D—a copy of which employers are required to give to their voluntary users—addresses shared use specifically:

4. **Keep track of your respirator so that you do not mistakenly use someone else's respirator.**

Another common way in which voluntary use may put the wearer in jeopardy is when individuals with asthma or other serious respiratory problems attempt to protect themselves without knowing if breathing stress will exacerbate their condition.

In summary, employers can't even let workers wear respirators voluntarily on their premises unless they:

1. Have documented that exposure will be below action levels or PELs
2. Have a program to assure that neither use nor misuse of respirators will put workers at risk
3. Have provided training in the form of the information in Appendix D of 29 CFR 1910.134 of the OSHA regulations

COST OF COMPLIANCE

The complexity of the rules and the cost of compliance for either voluntary or required use are one of the strongest arguments for installing local exhaust ventilation instead. Often, in the long run, the ventilation is cheaper.

PART II
ARTISTS'
RAW MATERIALS

Most of the hazardous chemicals in art materials can be organized in five groups of related materials. These are:

Solvents
Pigments and Dyes
Metals and Their Compounds
Minerals, Frits, and Glass
Plastics

CHAPTER 9
SOLVENTS

Solvents are used in almost every kind of art material. They are found in many paints, varnishes, and inks, as well as in these media's thinners. Solvents are components in most aerosol-spray products, in some leather and textile dyes, in ceramic lustre glazes, in felt-tip pens, in glues and adhesives, in some photographic chemicals, and much more.

WHAT ARE SOLVENTS?

The term "solvents" refers to liquid organic chemicals used to dissolve solid materials. Solvents can be made from natural sources, such as turpentine and the citrus solvents, but most are derived from petroleum or other synthetic sources. Solvents are used widely, because they dissolve materials like resins and plastics and because they evaporate quickly and cleanly.

SAFE OR NATURAL SOLVENTS

There are no "safe" solvents. All solvents, natural or synthetic, are toxic. For example, turpentine is very toxic, and it is derived from pine-tree pitch (resins).

Today, many products are being marketed to artists as safe and natural. Of these, the most common are citrus oil and d-limonene. Advertisements promoting citrus products emphasize the solvents' natural origins and fail to mention that d-limonene and citrus are registered as both "active" and "inert" ingredients in commercial pesticides. (See chapter 5 for more details.)

A two-year animal study of d-limonene for cancer effects found only equivocal (unclear) data, but the study clearly showed that d-limonene is very toxic.[1]

[1] "Toxicology and Carcinogenesis Studies of d-Limonene in F344/N Rats and B6C3F1 Mice (Gavage Studies)" (TR 347), NTP Public Information Office, MD B2-04, P.O. Box 12233, Research Triangle Park, North Carolina 27709.

The test animals sustained liver damage, and many died after inhaling vapors of d-limonene at rather moderate doses. Based on this and other data, the American Industrial Hygiene Association (AIHA) set a Workplace Environmental Exposure Level (WEEL) guide for d-limonene at 30 parts per million (ppm).[2] WEELs are similar to TLVs (see chapter 1). The AIHA's standard for d-limonene is even more restrictive than the standards for turpentine and other very toxic solvents.

TABLE 8	AIR-QUALITY LIMITS FOR VARIOUS SOLVENTS	
SUBSTANCES	**AIR-QUALITY LIMIT**	**AGENCY**
Ethyl alcohol (grain alcohol)	1,000 ppm	ACGIH TLV-TWA
Odorless paint thinner, VM&P naphtha	300 ppm	ACGIH TLV-TWA
Turpentine, xylene, coal tar naphtha	100 ppm	ACGIH TLV-TWA
N-hexane, methyl chloride, toluene	50 ppm	ACGIH TLV-TWA
D-limonene	30 ppm	AIHA WEEL-TWA

A more complete discussion of the hazards of d-limonene are found in the data sheet "D-Limonene: The Citrus Solvent" (see data sheet listing in appendix A, part 1).

SOLVENT TOXICITY

In general, solvents can irritate and damage the skin, eyes, and respiratory tract, cause a narcotic effect on the nervous system, and damage internal organs, such as the liver and kidneys. These kinds of damage can be acute (from single heavy exposures) or chronic (from repeated low-dose exposures over months or years). In addition, some solvents are especially hazardous to specific organs or can cause specific diseases, such as cancer.

SKIN CONTACT. All solvents can dissolve the skin's protective barrier of oils, drying and chapping the skin and causing a kind of dermatitis. In addition,

[2] "D-Limonene," Workplace Environmental Exposure Level Guide, 1993, American Industrial Hygiene Association, 2700 Prosperity Avenue, Suite 250, Fairfax Virginia 22031.

some solvents can cause severe burns and irritation of the skin. Natural solvents such as turpentine and d-limonene are known to cause skin allergies. Other solvents may cause no symptoms, but may penetrate the skin, enter the bloodstream, travel through the body, and damage other organs.

THE EYES AND RESPIRATORY TRACT. All solvent vapors can irritate and damage the sensitive membranes of the eyes, nose, and throat. Inhaled deeply, solvent vapors can also damage lungs. The airborne concentration at which irritation occurs varies from solvent to solvent. Often, workers are unaware of solvents' effects at low concentrations. Their only symptoms may be increased frequency of colds and respiratory infections. Years of such exposure could lead to chronic lung diseases, such as chronic bronchitis.

At higher concentrations, symptoms are more severe and may include nosebleeds, running eyes, and sore throat. Inhaling very high concentrations or aspirating liquid solvents may lead to severe disorders, including chemical pneumonia and death. Liquid solvents splashed in the eyes can cause eye damage.

THE NERVOUS SYSTEM. All solvents can affect the brain or central nervous system (CNS), causing narcosis. Immediate symptoms of this effect on the CNS may include dizziness, irritability, headaches, fatigue, and nausea. At progressively higher doses, the symptoms may proceed from drunkenness to unconsciousness and death. Years of chronic exposure to solvents can cause permanent CNS damage, resulting in memory loss, apathy, depression, insomnia, and other psychological problems that are hard to distinguish from problems caused by everyday living.

Some solvents also can damage the peripheral nervous system (PNS), which is the system of nerves leading from the spinal cord to the arms and legs. The symptoms caused by this PNS damage are numbness and tingling in the extremities, weakness, and paralysis. One solvent, n-hexane (found in some rubber cements and many spray products), is known to cause a combination of CNS and PNS effects, resulting in a disease with symptoms similar to multiple sclerosis.

DAMAGE TO INTERNAL ORGANS. There is considerable variation in the kinds and degrees of damage different solvents can do to internal organs. Many solvents can damage the liver and kidney as these organs attempt to detoxify and eliminate the solvents from the body. One solvent, carbon tetrachloride, has such a devastating effect on the liver, especially in combination with alcohol ingestion, that many deaths have resulted from its use. Many solvents can also

alter heart rhythm, even causing heart attacks or sudden cardiac arrest at high doses. This may be the mechanism that has killed many "glue sniffers."

Some solvents are also known to cause cancer in humans or animals. Benzene can cause leukemia. Carbon tetrachloride can cause liver cancer. Many experts suspect that all chlorinated solvents (those with "chloro" or "chloride" in their names) may be carcinogens.

REPRODUCTIVE HAZARDS AND BIRTH DEFECTS. The reproductive effects of solvents are not well researched. Those studies that do exist show there is reason for concern. For example, Scandinavian studies show higher rates of miscarriages, birth defects, and other reproductive problems among workers exposed to even relatively low levels of solvents.

Another study showing a connection between solvents and birth defects in humans was published in the *Journal of the American Medical Association* in March 1999. The researchers compiled data from Canadian working women employed in various jobs in which solvents are used, including artists and graphic designers. The authors claim the study indicates that ". . . women exposed occupationally to organic solvents had a thirteenfold risk of major malformations, as well as increased risk for miscarriages in previous pregnancies."

Two types of solvents in particular have been shown to atrophy animals' testicles and cause birth defects. These are:

- Glycol ethers or cellosolves (found in many photographic chemicals, liquid cleaning products, some paints and inks, and aerosol sprays)
- Glycidyl ethers (found in epoxy resin products)

Studies of one of the least toxic solvents—grain alcohol—have shown that babies born to drinking mothers may be of low birth weight and have varying degrees of mental retardation, including *fetal alcohol syndrome*. This syndrome also has been seen in babies born to glue-sniffing mothers.

Artists planning families are encouraged to read chapter 31 (Reproductive Risks to Artists) for further information.

EXPLOSION AND FIRE HAZARDS

Two properties that affect a solvent's capacity to cause fires and explosions are evaporation rate and flash point. In general, the higher a solvent's evaporation rate (see definition in table 9 below), the faster it evaporates and the more readily it can create explosive or flammable air-vapor mixtures.

Flash point is the lowest temperature at which sufficient amounts of vapor are created above a solvent's surface to ignite in the presence of a spark or flame. The lower the solvent's flash point, the more flammable it is. Materials whose flash points are at room temperature or lower are particularly dangerous.

The chlorinated hydrocarbons (see Chemical Classes below) are usually not flammable and have no flash points. However, some can react explosively on contact with certain metals, and heating or burning them creates highly toxic decomposition products, including phosgene gas. Hazardous amounts of these toxic gases can be created even by working with chlorinated solvents in a room where a pilot light is burning. Clearly, all solvents should be isolated from sources of heat, sparks, flame, and static electricity.

CHEMICAL CLASSES OF SOLVENTS

Solvents fall into various classes of chemicals. A class is a group of chemicals with similar molecular structures and chemical properties. Important classes of solvents are aliphatic, aromatic, and chlorinated hydrocarbons, alcohols, esters, and ketones. Table 9 shows various solvents and their properties by class.

RULES FOR CHOOSING SAFER SOLVENTS

1. Compare Threshold Limit Values. Choose solvents with high TLVs whenever possible. (See complete definition in chapter 3.)
2. Compare evaporation rates. Choose solvents with low evaporation rates whenever possible. In fact, some very toxic solvents that evaporate very slowly may not be as hazardous to use as less-toxic ones that evaporate very quickly.
3. Compare flash points. Choose solvents with high flash points whenever possible. Chlorinated solvents with no flash points, however, should still not be considered safe. (See the Explosion and Fire Hazards section above.)
4. Compare toxic effects. Although all solvents are toxic, some may be especially dangerous to you. For example, if you have heart problems, it makes sense to avoid solvents known for their toxic effects on the heart.
5. Compare within classes. Often, solvents in the same chemical class can be substituted for each other. Due to their similar chemical structures, many will dissolve the same materials or work the same way.

RULES FOR SOLVENT USE

1. Try to find replacements for solvent-containing products. New and improved water-based products are being developed. Keep abreast of developments in new materials.

2. Use the least toxic solvent possible. Use table 9 to select the safest solvent in each class. Consult Material Safety Data Sheets on the products you use, and choose those containing the least toxic solvents.

3. Insist on compliance with OSHA hazard communication laws at your workplace. This law requires a complete inventory of all solvents and solvent-containing products; complete labeling of all containers, even ones into which solvent products have been transferred; a file of Material Safety Data Sheets on all solvents, kept where it is available during all working hours; and formal training for all potentially exposed persons.

4. Avoid breathing vapors. Use solvents in areas where local exhaust ventilation is available. Dilution ventilation should only be used when very small amounts of solvents or solvent-containing products are used. (See chapter 7.) Use self-closing waste cans for solvent-soaked rags, keep containers closed when not in use, and design work practices to reduce solvent evaporation. Keep a respirator with organic cartridges or an emergency air-supplying respirator at hand in case of spills or ventilation failure.

5. Avoid skin contact. Wear gloves for heavy solvent exposure, and use barrier creams for incidental light exposures. Wash off splashes immediately with water and mild soap. Never clean hands with solvents or solvent-containing hand-cleaners. If solvents in amounts larger than a pint are used at one time, or if large spills are possible, have an emergency shower installed.

6. Protect eyes from solvents. Wear chemical splash goggles that meet ANSI standard Z87.1 whenever there is a chance a splash may occur. Install an eyewash fountain or other approved source of clean water that provides at least fifteen minutes' flow. Prominently post emergency procedures (usually near a telephone) for obtaining emergency medical advice and treatment if necessary.

7. Protect against fire, explosion, and decomposition hazards. Follow all local and federal codes for use, handling, ventilation, and storage. Never smoke or permit heat, flames, or sparks near solvents. Install sprinkler systems, fire extinguishers approved for solvent fires, or

other proper fire-suppression systems. Store amounts larger than a gallon in approved flammable-storage cabinets (this recommendation exceeds requirements). Do not use heat and/or ultraviolet light sources near chlorinated hydrocarbons. To prevent static electric discharge, ground containers from which solvents are dispensed. Local exhaust ventilation fans for solvent vapors must be explosion-proof.

8. Be prepared for spills. Check all applicable local and federal regulations regarding release of solvent liquids and vapors. If spills of large amounts are likely, use chemical solvent absorbers sold by most major chemical supply houses. Special traps or containment floor barriers may be required by law to keep solvent spills out of sewers.

9. Use and dispose of solvents in accordance with local or federal regulations. These vary around the country, depending on the type of sewage treatment systems, air quality problems, and other factors that determine how solvents may be used and discarded. You need to call a local department of environmental protection, publicly owned water treatment facility, and other governmental agencies to find out the rules in your area. In most locations in the country, solvents cannot go into drains leading to water treatment plants, leach fields, or storm drains. Release of large amounts of liquid or vapor of certain solvents must be reported to environmental protection authorities.

TABLE 9	COMMON SOLVENTS AND THEIR HAZARDS

COLUMN 1: SOLVENT CLASS designates the chemical group into which solvents fall. Under each class heading are listed individual solvents and their common synonyms.

COLUMN 2: THRESHOLD LIMIT VALUE—TIME-WEIGHTED AVERAGES are the ACGIH (American Conference of Governmental Industrial Hygienists) eight-hour, time-weighted Threshold Limit Values (TLV-TWA) for 2001 in parts per million (ppm). A notice of intended change (NIC) indicates the new value that ACGIH proposes for the TLV. When no TLV-TWA exists or when a more protective standard is available, this standard will be indicated—i.e., TLV-C, an OSHA Permissible Exposure Limit (PEL), or a Workplace Environmental Exposure Limit (WEEL) from the American Industrial Hygiene Association.

COLUMN 3: ODOR THRESHOLD (OT) in parts per million (ppm). These are the levels at which human volunteer test subjects have been able to detect the odor. Keep in mind

that people vary greatly in their ability to sense an odor, and you personally may not be able to detect the solvent at this level.

COLUMN 4: FLASH POINT (FP) in degrees Fahrenheit (F°). The FP is the lowest temperature at which a flammable solvent gives off sufficient vapor to form an ignitable mixture with air near its surface. The lower the FP, the more flammable the solvent. Some petroleum solvents exhibit a range of FPs.

COLUMN 5: EVAPORATION RATE (ER) is the rate at which a material will vaporize (volatilize, evaporate) from the liquid or solid state when compared to another material. ER is listed as FAST, MEDIUM (MED), or SLOW. The two common liquids used for comparison are butyl acetate and ethyl ether.

WHEN BUTYL ACETATE = 1.0
>3.0 =FAST
0.8–3.0 =MEDIUM
<0.8 =SLOW

WHEN ETHYL ETHER = 1.0
<3.0 = FAST
3.0–9.0 = MEDIUM
>9.0 = SLOW

COLUMN 6: COMMENTS about the particular toxic effects of the solvent. Symptoms listed here are in addition to the general solvent hazards common to all solvents, such as skin damage, narcosis, etc.

1	2	3	4	5	6
SOLVENT CLASS name synonyms	**TLV-TWA** (ppm)	**OT** (ppm)	**FP** (F°)	**ER**	**COMMENTS**
ALCOHOLS					One of the safer classes.
ethyl alcohol, ethanol, grain alcohol, denatured alcohol	1,000	84	55	MED	Least toxic in class. Denatured alcohol contains small amounts of various toxic additives.
isopropyl alchohol, propanol, rubbing alcohol	400 200 (NIC)	22	53	MED	One of the least toxic. Long-term hazards not fully studied.
methyl alcohol, methanol, wood alcohol	200	100	52	FAST	High doses or chronic exposure causes blindness. Skin absorbs.

SOLVENTS

1	2	3	4	5	6
SOLVENT CLASS name synonyms	**TLV-TWA** (ppm)	**OT** (ppm)	**FP** (F°)	**ER**	**COMMENTS**
ALCOHOLS (continued)					
n-propyl alcohol, n-propanol	200	5.3	59	MED	Causes mutation in cells. Not evaluated for cancer. Skin absorbs.
isoamyl alcohol, 3-methyl-1-butanol, fusel oil	100	0.03–0.07	109	SLOW	Irritation begins at the TLV.
n-butyl alcohol, n-butanol	50 (TLV-C) 20 (NIC)	1.2	95	SLOW	Respiratory irritation at well below the TLV. Lacrimator. Skin absorbs.
ALIPHATIC HYDROCARBONS					Many of these are mixtures of chemicals derived from petroleum.
kerosene	none	unknown	100–150	VERY SLOW	Low toxicity. Aspiration causes hemorrhages in the lungs and chemical pneumonia.
n-heptane, normal heptane, heptanes (mix of isomers)	400	40–547	25	FAST	One of least toxic in class. Good substitute for hexane and other fast-drying solvents.
VM&P naphtha, benzine, paint thinner	300	1–40	20–40	MED	One of the least toxic in class. Good substitute for turpentine. "Odorless" thinner has aromatic hydrocarbons removed.
mineral spirits, stoddard solvent, other petroleum fractions	100	1–30	>100	SLOW	Some fractions contain significant amounts of aromatic hydrocarbons.
n-hexane, normal hexane, commercial hexanes contain 55% n-hexane	50	65–250	-7	FAST	Do not use. Potent nervous system toxin causing multiple sclerosis–like disease. Extremely flammable. Substitute heptane.

1	2	3	4	5	6
SOLVENT CLASS name synonyms	**TLV-TWA** (ppm)	**OT** (ppm)	**FP** (F°)	**ER**	**COMMENTS**
ALIPHATIC HYDROCARBONS (continued)					
hexane isomers	500	Unknown	Varies	FAST	Low toxicity. Often contaminated with n-hexane.
Gasoline	300	0.3	-45	FAST	Do not use. Extremely flammable. May contain skin-absorbing benzene, organic lead compounds, or new toxic antipollution additives.
AMIDES/AMINES					Many are sensitizing.
dimethyl formamide (DMF)	10	0.5–100	136	SLOW	Try to avoid. Skin absorbs.
ethanolamine	3	2.6	185	VERY SLOW	Severe skin, eye, respiratory irritant. Narcosis, liver, and kidney damage reported.
diethanolamine	0.46	0.27	342	VERY SLOW	More toxic than ethanolamine. Severe skin and eye damage documented.
triethanolamine	5 mg/m³*	unknown	385	†	Hazards similar to ethanolamine. Avoid. An animal carcinogen.
AROMATIC HYDROCARBONS					A hazardous class, avoid if possible.
ethyl benzene, ethyl benzol, phenyl ethane	100	0.1–0.6	59	SLOW	Eye irritation begins at the TLV.
xylenes, xylol, dimethyl benzenes	100	0.08–40	81–90	SLOW	Highly narcotic. Causes liver and kidney damage. Stomach pain reported.

1	2	3	4	5	6
SOLVENT CLASS name synonyms	**TLV-TWA** (ppm)	**OT** (ppm)	**FP** (F°)	**ER**	**COMMENTS**
AROMATIC HYDROCARBONS (continued)					
toluene, toluol, methyl benzene, phenyl methane	50	2.9	40	MED	Highly narcotic. Causes liver and kidney damage. Skin absorbs.
styrene, vinyl benzene, phenyl ethylene	20	0.02–0.47	90	SLOW	Suspect cancer agent. Try to avoid. Skin absorbs.
diethylbenzenes, 1,3-DEB, 1,4-DEB	none	unknown	~130	SLOW	Narcotic and irritating. Not well studied.
trimethyl-benzenes, 1,2,3-TMB; 1,2,4-TMB; 1,3,5-TMB	25	2.4	~130	MED	Strong narcotic and irritant. Not well studied.
benzene, benzol	0.5	34–119	12	MED	Do not use. Causes leukemia. Skin absorbs.
CHLORINATED HYDROCARBONS					Many in this class cause cancer. Avoid.
1,1,1-trichloro-ethane, methyl chloroform	350	390	‡	FAST	Causes irregular heartbeat and arrest.
methylene chloride, di-chloromethane	50 25 (PEL)	160	‡	FAST	Avoid. Suspect cancer agent. Metabolizes to carbon monoxide in blood. Stresses heart.
trichloroethylene	50	82	‡	MED	Suspect cancer agent. Irregular heartbeat.
perchloroethylene, perc, tetrachloro-ethylene	25	47	‡	MED	Suspect cancer agent. Irregular heartbeat, liver damage, skin reddens after alcohol ingestion.

1	2	3	4	5	6
SOLVENT CLASS name synonyms	**TLV-TWA** (ppm)	**OT** (ppm)	**FP** (F°)	**ER**	**COMMENTS**
CHLORINATED HYDROCARBONS (continued)					
chloroform	10	133–276	‡	FAST	Do not use. Suspect cancer agent.
ethylene dichloride, 1,2-dichloroethane	10	6–185	56	MED	Strong intoxicant. Causes liver damage. Suspect cancer agent.
carbon tetrachloride	5	140–584	‡	FAST	Do not use. Cancer agent. Severe liver damage and death result when combined with alcohol. Skin absorbs.
ESTERS/ACETATES					One of the least toxic classes.
ethyl acetate	400	3.9	24	FAST	Least toxic in class.
methyl acetate	200	4.6	15	FAST	Similar to ethyl acetate.
isoamyl acetate, banana oil	50	0.22	64	MED	Used for respirator fit testing.
ETHERS, e.g., ethyl ether, methyl ether					Do not use. Extremely flammable. Form explosive peroxides with air.
GLYCOLS					Vary greatly in toxicity.
propylene glycol, 1,2-propanediol	50 (WEEL)	unknown	210	†	Least toxic glycol. May cause allergies. Use in cat/dog food causes blood damage.
ethylene glycol, 1,2-ethandiol	100 mg/m³* (TLV-C)	0.1–40	232	†	Lung and eye irritant. Neurological damage and blindness at high doses.

1	2	3	4	5	6
SOLVENT CLASS name synonyms	**TLV-TWA** (ppm)	**OT** (ppm)	**FP** (F°)	**ER**	**COMMENTS**
GLYCOLS (continued)					
diethylene glycol	50 (WEEL)	unknown	255	†	Probably more toxic than ethylene glycol, but does not cause blindness. Skin absorbs.
triethylene glycol, triglycol	none	unknown	350	†	Technically, a "glycol ether," which may be a reproductive hazard— see next section.
GLYCOL ETHERS (CELLOSOLVES) AND THEIR ACETATES					Try to avoid, especially if planning a family.
butyl cellosolve, 2-butoxyethanol, ethylene glycol monobutyl ether	20	0.1	141	SLOW	Affects blood, liver, kidneys. Not as toxic to reproductive system as others. Skin absorbs.
cellosolve, 2-ethoxyethanol, ethyl cellosolve, ethylene glycol monoethyl ether	5	2.7	110	SLOW	Reproductive hazard for men and women. Affects blood, liver, kidneys. Skin absorbs.
methyl cellosolve, 2-methoxyethanol, ethylene glycol monomethyl ether	5	2.4	102	SLOW	Same as above. Skin absorbs.
di- and tri-ethylene and propylene glycol ethers and their acetates	—	—	—	—	This is a large class, many of which are not well studied. Experts suspect some harm blood and reproductive systems.
KETONES					Toxicity varies widely.
acetone, 2-propanone dimethyl ketone	500	62	-4	FAST	Least toxic. Highly flammable. Irritating to respiratory tract.

1	2	3	4	5	6
SOLVENT CLASS name synonyms	**TLV-TWA** (ppm)	**OT** (ppm)	**FP** (F°)	**ER**	**COMMENTS**
KETONES (continued)					
methyl ethyl ketone, MEK, 2-butanone	200	5.4	16	FAST	Causes severe nerve damage when used in combination with n-hexane.
methyl isobutyl ketone MIBK	50	0.88	64	MED	May be more toxic when used in combination with n-hexane.
methyl butyl ketone MBK	5	0.07–0.09	77	MED	Do not use. Causes permanent nerve damage.
MISCELLANEOUS					
cyclohexane, hexamethylene	300 100 (NIC)	780	1.4	FAST	Not acutely toxic. Chronic effects unknown.
dioxane, 1,4-dioxane	20	12	65	FAST	Carcinogen. Skin absorbs. Avoid.
ethyl silicate	10	3.6	125	SLOW	Causes severe skin, eye, and respiratory system burns and irritation. Nervous system, liver, kidney, and red blood cells can be damaged on long-term exposure.
limonene, d-limonene, citrus oil, citrus turps, methadiene, dipentene	30 (WEEL)	unknown	unknown	VERY SLOW	A pesticide, cancer, drug, food additive. Acutely toxic by ingestion (rats). Inhalation causes kidney damage. Pleasant odor tempts children to drink it. More toxic than turpentine.
morpholine	20	0.011–0.07	100	SLOW	Avoid. Skin absorbs.

1	2	3	4	5	6
SOLVENT CLASS name synonyms	TLV-TWA (ppm)	OT (ppm)	FP (F°)	ER	COMMENTS
MISCELLANEOUS (continued)					
tetrahydrofuran	200	31	1.4	VERY FAST	Becomes explosive when old or exposed to air. Highly narcotic.
turpentine	100	50–200	95	SLOW	Causes allergies (dermatitis, asthma), kidney and bladder damage. Use odorless paint thinner instead.

* milligrams per cubic meter
† Hygroscopic: absorbs water and evaporates very slowly.
‡ These solvents do not have typical flash points. They dissociate with heat or ultraviolet radiation to form toxic gases, such as phosgene.

CHAPTER 10
PIGMENTS
AND DYES

Color is the basic element of many arts. And in most arts, color is obtained through the use of pigments and dyes.

WHAT ARE PIGMENTS AND DYES?

The origins of pigments and dyes are lost in antiquity, although we know that both sprang from common natural products, such as berries, roots, minerals, and insects. When mauve, the first synthetic dye, was created in 1856, it catalyzed the development of the whole organic chemical industry. Since then, over two thousand commercially available synthetic chemical dyes and pigments have been created.

The distinction between pigments and dyes is based on usage and physical properties rather than on chemical constitution. The principle characteristic of a pigment is that it is substantially insoluble in the medium in which it is used. Dyes, on the other hand, dissolve in the liquid in which they are applied, so that they can stain or react with the fiber to be dyed. But this is an arbitrary distinction. In fact, there are numerous colorants that serve as both dyes and pigments. For example, a water-soluble colorant that is insoluble in oil can serve as both a dye in water and a pigment in oil paint.

PIGMENT AND DYE IDENTIFICATION

Some manufacturers deliberately withhold the exact composition of their dyes and pigments by identifying them by traditional names (Prussian blue, Mars brown), simple colors (white, red), fanciful names designed to attract customers (peacock blue), or their own internal product numbers. Instead, they should provide Colour Index identification for each colorant.

THE COLOUR INDEX. The proper, internationally accepted system of dye and pigment identification is found in the Colour Index (C.I.).[1] This is a nine-volume set of books (or disks) published jointly by the Society of Dyers and Colourists in the United Kingdom and the Association of Textile Chemists and Colorists in the United States. The C.I. classifies and provides technical information on all colored materials, including all classes of dyes and pigments.

Complete Colour Index identification consists of two items: a) a C.I. name, and b) a constitution number.

C.I. Names. Examples of proper names are "C.I. Pigment Violet 23" and "C.I. Acid Red 5." These names and all other C.I. proper names consist of three pieces of information:

1. *Use.* The colorant's use—e.g., "Pigment," or a dye class such as "Acid" or "Reactive" dye.

2. *Color.* Pigments are all grouped under only ten basic colors: yellow, orange, red, violet, blue, green, brown, black, metal, and white. Colors other than these (e.g., turquoise) are not used in C.I. names. Dye colors are usually written out, but pigments are often abbreviated:

PB=Pigment Blue	PG=Pigment Green	PV=Pigment Violet
PBk=Pigment Black	PM=Pigment Metal	PW=Pigment White
PBr=Pigment Brown	PO=Pigment Orange	PY=Pigment Yellow
PR=Pigment Red		

3. *Constitution Number.* These numbers are divided by chemical class of the dye or pigment. The individual number is assigned sequentially to that class when the dye has been added to the Index. C.I. Constitution Numbers range from 10000–77999 and are assigned by chemical class. These numbers are the key to looking up the exact formula and structure of most dyes and pigments.

[1] Colour Index International, Society of Dyers and Colourists (Post Office Box 244, Perkin House, 82 Grattan Road, Bradford, West Yorkshire BD1 2JB, England, U.K.) and the American Association of Textile Chemists and Colorists (One Davis Drive, Post Office Box 12215, Research Triangle Park, North Carolina 27709-2215, U.S.A.), Volumes 1–4 and 6–9.

Examples of proper C.I. names, their constitution numbers, and common names are:

COLOUR INDEX NAME	CONSTITUTION NUMBER	COMMON NAME
C.I. Acid Red 173	C.I. 32390	————————
C.I. Reactive Blue 4	C.I. 61205	————————
C.I. Pigment Blue 15 (PB 15)	C.I. 77009	phthalocyanine blue
C.I. Pigment Red 83 (PR 83)	C.I. 58000	alizarin crimson
C.I. Pigment Orange 13 (PO 13)	C.I. 21110	pyrazonlone orange

Constitution numbers are also divided into sections that can provide rapid identification of the chemical class of the dye or pigment. For example:

C.I. NUMBER	CHEMICAL CLASS
11000–19999	Monoazo class dyes and pigments
58000–72999	Anthraquinone class dyes and pigments
77000–77999	Inorganic pigments (e.g., lead, cadmium, iron, etc.)

Many manufacturers already identify their colorants by C.I. name and number. Artists should patronize these companies exclusively whenever possible.

UNNAMED/UNNUMBERED DYES. Some newly discovered dyes, mostly in the fiber reactive class, have not yet been assigned C.I. names or numbers. In this case, both Commercial Trade names and Chemical Abstract Service numbers should be provided.

CHEMICAL ABSTRACT SERVICE. Another organization that identifies chemicals, including dyes, is the Chemical Abstracts Service (CAS). This service indexes articles and studies that are listed in *Chemical Abstracts,* a publication of the American Chemical Society.[2] The index number for each chemical

[2] Chemical Abstracts Service, Division of American Chemical Society, Box 3012, Columbus Ohio 43210. Phone (614) 421-3600.

is called the CAS registration number (CAS RN). These numbers are assigned sequentially, so they have no chemical significance. CAS RNs can prevent confusion between chemicals with very similar names. For example:

CHEMICAL NAME	CAS RN	TOXICITY
benzene	71-43-2	An extremely toxic solvent.
benzine	64475-85-0	One of the safer solvents.
benzidine	92-87-5	Highly toxic dye intermediate.

FDA CLASSIFICATIONS. The U.S. Food and Drug Administration has yet another set of classifications for dyes based on the use for which they are certified. An "FD&C" color may have food, drug, and cosmetic uses. A "D&C" color may be allowed only for limited use in certain drugs and cosmetics.

These names should not be considered proof of safety. The substance may be limited to uses that do not expose consumers. For example, an FD&C dye may only be allowed in food packaging after tests have shown that insignificant amounts migrate into food. These dyes are also batch-approved, which means that each batch the manufacturer makes must be analyzed and certified to contain only the extremely small amount of impurities allowed by the FDA for that particular colorant. The FDA classifications are not very useful for consumers of craft dye products.

CHEMICAL NAMES. Each dye has dozens of legitimate chemical names. They are very hard to research, and the names can be confusing to craft dyers and even to many chemists. An example of a single chemical dye name is:

disodium salt of ethyl [4-[p-[ethyl(m-sulfobenzyl)amino-α-(o-sulfophenyl)benzylidene]-2,5-cyclohexadien-1-ylidene] (m-sulfobenzyl) ammonium hydroxide.

This dye is also called: C.I. Food Blue 23, C.I. 42090, CAS RN 38444-45-9, or FD&C Blue No. 1. Clearly, the Colour Index classification is the most useful identification method for artists.

3 The original C.I. class of Food Dyes contained about 150 members. These are dyes that were used in food many years ago, before testing. Today, only six of these are still approved for food use. Never assume that the C.I. Food Dye classification indicates safety.

PIGMENTS AND DYE HAZARDS

The hazards of pigments have been known since 1713, when the Italian physician Ramazzini described illnesses associated with pigment grinding and painting. Many of the pigments used then are still among the several hundred pigments found in art and craft products today. Table 10 lists composition, Colour Index name and number, and hazard information for about 140 artists' pigments. Most of the pigments artists use should be listed somewhere in this table.

All of the artists' pigments in Table 10 also can be classified either as inorganic or organic chemicals.

Inorganic pigments come from the earth (ochres, for example), or they are manufactured from metals or minerals (like lead white or cerulean blue). These pigments have been used for many years, and their toxic effects are fairly well known. The lead-containing colors are especially toxic and have a long history of causing poisoning. For this reason, they are banned in consumer wall paints. But artists' paints and inks, boat paints, automobile paints, and metal priming paints may still employ them.

Organic pigments and dyes are either derived from natural sources—such as Alizarin crimson from madder root—or they are synthesized from organic chemicals. Examples of synthetic pigments include phthalo blue and the fluorescent colors.

There are hundreds of organic pigments used in art materials. Only a small percentage of either the natural or the synthetic pigments have been studied for toxicity or long-term hazards. Of those that have been studied, some have been shown to be toxic, some are not toxic, and some cause cancer in animals. Some synthetic pigments are also hazardous because they contain highly toxic impurities, such as cancer-causing dioxins or polychlorinated biphenyls (PCBs). These impurities are unwanted side products created during manufacture. Natural pigments may also contain contaminants from other plant or insect materials.

BENZIDINE DYES AND PIGMENTS. Benzidine is one of the chemical classes of organic dyes and pigments. Benzidine is known to cause bladder cancer. In the 1970s, hundreds of bladder-cancer cases were seen among benzidine dye–using Japanese kimono painters. More recent epidemiological studies of

artists, painters, and printmakers also found elevated incidence of diseases, especially bladder cancer.[4,5]

One would think that benzidine dyes and pigments would be banned in art materials. But here in the United States, they are commonly used by painters, costumers, printmakers, and other artists who may not even be aware that they are using them. Beginning in 2001, dyes that are known to be metabolized to release benzidine are listed in the National Toxicology Program's ninth edition of the *Report on Carcinogens* as "known to be human carcinogens." That means that soon, we should see cancer warnings on MSDSs for these dyes. But the benzidine pigments—especially those whose metabolites have not been studied—probably will not be covered. These still may be labeled "nontoxic" by some manufacturers.

It is is common sense that a dye or pigment that releases a known carcinogen when metabolized should be, itself, considered a carcinogen. And since 1995, Germany and some other European countries have accordingly banned about 120 dyes for use on textiles that have prolonged contact with the skin—materials such as clothing and bed sheets. These banned dyes metabolize to release benzidine or one or more of eleven other substances considered to be carcinogens. Artists who are interested in the list of banned dyes can contact ACTS and ask for the data sheet on "Azo and Benzidine Dyes" (see appendix A, part 1). The list of banned dyes includes an anthraquinone dye (Disperse Blue 1).

ANTHRAQUINONE DYES AND PIGMENTS. In 1994, a review committee of the National Toxicology Program (NTP) voted unanimously to accept the conclusions of a two-year feeding study of an anthraquinone vat dye—1-amino-2,4-dibromoanthraquinone—that clear evidence of toxicity and cancer were caused in both rats and mice at all doses administered.

This dye is one of six naturally occurring and synthetically produced anthraquinones chosen for study by NTP. Two other anthraquinones were

4 Miller, Barry A., D. T. Silverman, R. N. Hoover, and A. Blair. "Cancer Risk Among Artistic Painters." *American Journal of Industrial Medicine,* 1986, 9:281–287. See also Miller, Barry A., and Aaron Blair. "Cancer Risks Among Artists." Submitted for publication to *Leonardo (Journal of the International Society for the Arts, Sciences, and Technology),* New York, 1989.
5 "Occupational Risks of Bladder Cancer in the United States: I. White Men," *Journal of the National Cancer Institute,* Vol. 81, No. 19 (October 4, 1989). This study found elevated risk of bladder cancer among professional artists and printmakers.

already listed by NTP as carcinogens: 2-aminoanthraquinone and 1-amino-2-methylanthraquinone. An NTP scientist, J. E. Huff, said at that time that the study indicated that anthraquinones as a class are mutagenic and carcinogenic in animals. He predicts that anthraquinones will also cause cancer in humans.[6]

Two more anthraquinones, Disperse Blue 1 (C.I. 64500), which is 1,4,5,8-tetraaminoanthraquinone, and 1,8-dihydroxyanthraquinone, were also listed as "reasonably anticipated to be human carcinogens."[7] (This dye is one of the banned German dyes.)

Then, in May 1999, NTP reviewed and approved the conclusions of a study on the parent chemical, anthraquinone. According to NTP, anthraquinone clearly causes cancer in female rats and in both sexes of mice in the two-year, two-species feed test.[8]

This means that five anthraquinones are now considered carcinogens, and a sixth—anthraquinone itself—is expected to be listed in the near future. It seems clear that all anthraquinones should be suspect. However, most have never been studied and are usually sold to artists labeled as "nontoxic."

Anthraquinones are found in almost all dye classes, including fiber-reactive, acid, vat, disperse, leather, solvent, mordant, and sulfur dye classes. They are in Rit[RT] and many other household, hobby, and professional dyes.

Some pigments are also anthraquinones. The most well known is alizarin (C.I. Natural Red 9, C.I. 75330), which is 1,2-dihydroxyanthraquinone. It is significant that an extremely closely related pigment, 1,8-dihydroxyanthraquinone, is listed as a carcinogen by NTP. This chemical's structure is identical to alizarin's, with the exception of one hydroxy (-OH) group that is in a different position. In the absence of actual testing, it is wise to assume that both are carcinogens.

Other common anthraquinones are: C.I. Pigment Red 177 (65300), Yellow 108 (68420), and Red 168 (59300, an anthanthrone); indanthrone blues, including C.I. Pigment Blue 21, 22, 60, 64, and 65; Natural Red 4 (from cochineal-producing insects); and Natural Reds 6 and 8–12 (from madder or chayroot).

NATURAL DYES. Some natural organic dyes, such as indigo and various plant and animal extracts, are still in use today. There are a number of dyes

[6] *Bureau of National Affairs: Occupational Safety and Health Reporter* 24, no. 5 (June 29, 1994), 268.
[7] *Eighth Annual Report on Carcinogens*, National Toxicology Program, US DHHS (1998).
[8] *Bureau of National Affairs: Occupational Safety and Health Reporter* 29, no. 1 (June 2, 1999), 11–12.

derived from food plants that are safe enough even for children to use. However, many natural dyes are just as toxic as synthetic dyes. For example, alizarin dye (1,2-dihydroxyanthraquinone) is the same chemical, whether you buy it from a craft store or you laboriously grow your own madder plants and harvest it from the roots. There is absolutely no reason to assume that a natural dye is safer than a synthetic one.

ANILINE DYES. The first types of synthetic dyes were made from a chemical called aniline, which was derived from coal tar. Some manufacturers still call their dyes "aniline" or "coal tar" dyes. However, highly toxic aniline has been replaced, for the most part, with safer chemicals in the manufacture of this type of dye (azine type). Still, the term "aniline" is used by some dye sellers to refer to all dyes with some similar (azine) components and by others to refer to all types of synthetic dyes (even nonazine types). As it is used by dye sellers today, the term "aniline" is not very meaningful. It is more useful to refer to dyes by their classes.

DYE CLASSIFICATION BY USE

In addition to chemical classes, such as the anthraquinones and benzidines, dyes also can be classed according to how they function. These are the "use" classes, which designate how each type of dye reacts with certain fibers. For example, "direct dyes" are used for cotton, linen, and rayon, and they usually need to be applied using hot-water baths containing salt to react properly with the fabrics.

Dyes in the same use class usually have hazards in common, based on that part of the dye molecule that binds to the fiber. Table 11 lists the hazards of some use classes of dyes. But in addition to the hazards of the fiber-binding part of the molecule, the remainder of the dye molecule presents hazards related to the chemical class. For example, fiber-reactive dyes all seem to be allergens, but each individual fiber-reactive dye also belongs to any one of dozens of chemical classes, including the anthraquinone and benzidine classes.

RULES FOR WORKING WITH PIGMENTS AND DYES

1. Try to use techniques that employ premixed paints and liquid dyes. Pigments or dyes are easier to use safely once they are mixed with water or oil. Dusts from pigments and dyes in the powdered state are likely to be in the respirable range of particle size (see chapter 3), and they can be inhaled or contaminate hands and clothing.

2. Identify your pigments and dyes. Only use materials for which Material Safety Data Sheets are available. Avoid purchasing materials from companies that do not also provide Chemical Abstract Service numbers and/or Colour Index names and numbers.

3. Never use techniques that raise dust—methods such as sprinkling dry colors onto textiles or paper.

4. Weigh out, slurry, mix, or handle pigments and dyes only in local exhaust ventilation or in a glove box (see figure 12, page 113).

5. Avoid skin contact with pigments and dyes by wearing gloves or by using barrier creams. Should skin stains occur, never use bleach or solvents to remove them. (Bleaches are especially hazardous, because they may break complex colorant molecules in the skin into more toxic components.)

6. Wear protective clothing, including a full-length smock, shoes, and hair covering (if needed). Leave these garments in the studio to avoid bringing dusts home. Wash clothes frequently and separately from other clothes.

7. Clean the studio properly. Work on easy-to-clean surfaces, and wipe up spills immediately. Wet-mop or sponge surfaces and floors, or use HEPA vacuums. Do not sweep. Waste water contaminated with metalized dyes or pigments containing EPA-regulated metals (e.g., lead, copper, zinc, etc.) may not be put down drains in many areas of the country. These must be collected and disposed of as toxic waste.

8. Practice good hygiene, and do not eat, smoke, or drink in the studio.

9. Keep containers of pigments and dyes closed at all times when not using them.

10. If lead-containing pigments are used, blood tests for lead should be done regularly (at least once a year). If the studio is in a workplace or school, the OSHA Lead Standard must be followed.

11. All finely powdered metals used as pigments, such as powdered aluminum or bronze, should be considered flammable and/or explosive. Any spark or static discharge can set them off once they are open to the air. Use premixed metallic-pigmented paints, or buy metallic pigments sold in paste form instead. Store these pigments in the flammable-storage cabinet. (See chapter 11 for additional information.)

FIG. 12. Glove Box for Controlling Dust from Powdered Materials

TABLE 10	HAZARDS OF PIGMENTS

NOTE: This table lists the hazards of most of the common pigments used in paints and inks by their Colour Index (C.I.) names and numbers. These C.I. names are often found on product labels in their short form (e.g., C.I. Pigment Red 5 is "PR 5"). Users of pigmented materials should only accept products for which C.I. names are provided. Identification cannot be assured without the C.I. name. Each pigment may have dozens of common names, and only a few are included here. They must never be relied on for identification.

COLOUR INDEX NAME NUMBER *COMMON NAMES*	INGREDIENTS	TOXIC PROPERTIES
BLACK PIGMENTS (P.BLACK or PBk)		
P.BLACK 6 and 7 77266 *lamp or carbon black*	nearly pure amorphous carbon	In the past, it was contaminated with cancer-causing impurities. New manufacturing processes can produce the pigment with almost negligible contamination.
P.BLACK 8 (two types) 77268 1. birch or vine black carbon	carbon (50 to 90 percent) and minerals	No significant hazards known.
2. mineral black	carbon (15 to 85 percent) and silicates or iron oxides	No significant hazards known.
P.BLACK 9 77267 *Ivory or bone black*	charred animal bones	No significant hazards known.
P.BLACK 10 77265 *graphite gray* *stove black*	graphite	Synthetic graphite can cause black lung after years of heavy exposure by inhalation. Natural graphite may also contain free silica, which could cause silicosis.

P.BLACK 11 77499 *Mars black* *iron oxide black*	iron oxide (Fe_3O_4) may contain manganese and other impurities	No significant hazards known unless contaminated with toxic impurities. Often mixed with PBk14.
P.BLACK 14 77728	manganese dioxide	See Manganese in table 14.
P. BLACK 19 77017	gray hydrated aluminum silicate	No significant hazards.
P.BLACK 26 77494	manganese and iron spinel*	See Manganese in table 14.
P.BLACK 27 77502	iron, cobalt, and chrome spinel*	See Cobalt, Chrome in table 14.
P.BLACK 28 77428	copper and chrome spinel*	See Copper, Chrome in table 14.
P.BLACK 29 77498	Iron and cobalt spinel*	See Cobalt in table 14.
77050 (no name) *antimony black*	a black form of antimony sulfide	See Antimony in table 14. See Sulfides in table 15.
NATURAL BLACK 3 75290 *logwood*	hematoxylin from wood	Large amounts could poison.
SOLVENT BLACK 7 (also C.I. Acid Black 2) *nigrosine black*	an organic dye derived from aniline	Commonly contains nitrobenzene and other impurities. May cause allergies and dermatitis.

BLUE PIGMENTS (P.BLUE or PB)

P.BLUE 1 42595:2[†]	salt of an organic chemical dye	Low acute toxicity. Related to carcinogenic dyes.
P.BLUE 2 44045:2[†]	salt of an organic chemical dye	Unknown. Chemically related to carcinogenic dyes.

P.BLUE 3 42140:1[†]	salt of an organic chemical dye	Unknown. Chemically related to carcinogenic dyes.
P.BLUE 10 and 11 44040:2[†]	salt of an organic chemical dye	Unknown. Chemically related to carcinogenic dyes.
P.BLUE 15 74160 *phthalocyanine blue*	copper phthalocyanine	May be contaminated with PCBs[†] and dioxins,[†] which cause cancer and birth defects. See Copper in table 14.
P.BLUE 16 74100 *phthalocyanine blue*	metal-free phthalocyanine	Same as above.[†]
P.BLUE 17:1[†] 74200:1 74180:1	sulfonated phthalocyanine	Same as above.[†]
P.BLUE 21 and 22 69835 and 69810 *indanthrone blues*	complex anthraquinone vat dyes	Low acute toxicity. Closely related to cancer-causing anthraquinones.[§]
P. BLUE 24 42090:1[†]	barium precipitate (lake) of an organic chemical dye	A lake of a dye that causes cancer in animals (FD&C Blue 1). See also Barium in table 14.
P.BLUE 27 77510 *Prussian blue* *Milori blue*	ferric-ammonium ferrocyanide	Only slightly toxic, but can emit highly toxic hydrogen cyanide gas when exposed to acid, high heat, or strong ultra- violet light. New EPA rules require it be disposed of as cyanide waste.
P.BLUE 28 77346 *cobalt blue*	oxides of cobalt and aluminum or cobalt aluminate; color can range from blue to green.	See Cobalt in table 14.

P.BLUE 29 77007 *ultramarine blue*	artificial minerals of sodium, aluminum, and silica; colors range from blue to green to violet	No significant hazards known.
P.BLUE 30 77420	azurite, a natural copper-containing mineral	See Copper in table 14.
P.BLUE 31 77437	copper-calcium-silicate	See Copper in table 14.
P.BLUE 32 77365 *smalt*	potassium-cobaltous silicates of varying composition	See Cobalt in table 14.
P.BLUE 33 77112 *manganese blue*	barium manganate with barium sulfate	See Barium and Manganese in table 14.
P.BLUE 34 77450	cupric sulfide (CuS)	Irritating to skin and eyes. Highly toxic by ingestion. Can emit highly toxic hydrogen sulfide gas if exposed to high heat or acid. See also Copper in table 14.
P.BLUE 35 77368 *cerulean blue*	oxides of cobalt and tin or cobalt stannate	See Cobalt in table 14.
P. BLUE 36 77343 *cerulean blue chromate* *cobalt chromite blue* *cobalt chromite green* *cobalt turquoise*	oxides of cobalt and aluminum or cobalt chromite; ranges in color from blue to green	See Cobalt and Chrome III, VI in table 14.
P.BLUE 60, 64, 65 69800, 69825, 59800 *indanthrone blues*	complex insoluble anthraquinone vat dyes	Acute toxicity varies. Closely related to cancer-causing anthraquinones.§ (See note to P.BLUE 21.)

BROWN PIGMENTS (P.BROWN or PBr)

P.BROWN 5 15800:2† *BON/arylide browns*	copper salt of an azo organic pigment made from aniline	Unknown. See Copper in table 14.

P.BROWN 6 77499 *Mars brown* *iron oxide brown*	variety of natural and synthetic iron oxides; may contain toxic impurities	No significant hazards unless manganese or other toxic impurities are present.
P.BROWN 7 77491 or 77492 *burnt sienna* *burnt umber* *raw sienna*	variety of natural and synthetic iron oxides containing manganese calcined natural iron oxide natural iron oxide	No significant hazards unless manganese or other toxic impurities are present.
P.BROWN 8 77727, 77730	manganese minerals and/or manganese compounds	See Manganese in table 14.
P.BROWN 9 77430 *Vandyke brown*	treated Cassel earth containing 80 to 90 percent organic matter plus iron, alumina, and silica	No significant hazards known.
NATURAL BROWN 9 (2 types) no number assigned 1. sepiacalcium chloride and miscellaneous.	cuttlefish ink, calcium carbonate, calcium chloride, and any of a number of brown pigments	No significant hazards known.
2. sepia	mixture of burnt sienna/ lampblack	See PBr 6 and PBk 6.

GREEN PIGMENTS (P.GREEN or PG)

P.GREEN 1 and 4 42040:1[†], 42000:2 *brilliant green*	Insoluble precipitates of organic dyes	Low acute toxicity expected on the basis of tests on PG 1. Long-term hazards unknown. Closely related to a dye that causes cancer in animals.
P.GREEN 7 74260 *phthalocyanine green* *phthalo green*	chlorinated copper phthalocyanine	May be contaminated with small amounts of PCBs,[‡] etc. See also Copper in table 14.
P.GREEN 8 10006 *nitroso green*	iron azo complex structure not well studied	Low acute toxicity. Chronic hazards not well studied.

P.GREEN 10 12775 *green gold* *nickel azo yellow*	chloroaniline/nickel complex, a nickel chelated azo dye; color ranges from green to yellow.	Related to cancer- causing dyes. See also Nickel in table 14.
P.GREEN 12 10020:1†	barium precipitate of a dye (Acid Green)	Low acute toxicity. Acid Green causes cancer in animals. See Barium in table 14.
P.GREEN 15 77520 and 77600, 77601, or 77603	Mixture of P.YELLOW 34 (lead chromate) and P.BLUE 27	See P.BLUE 27 above. See Lead and Chrome in table 14.
P.GREEN 17 77288 *chromium oxide green*	chromic oxide (Cr_2O_3)	See Chrome III in table 14.
P.GREEN 18 77289 *Viridian* *permanent green deep* *(PG 18 precipitated with* *barium sulfate)*	hydrated chrome oxide $(Cr_2O(OH)_4)$	See Chrome III in table 14.
P.GREEN 19 77335 *cobalt green*	oxides of cobalt and zinc or cobalt zincate	See Cobalt and Zinc in table 14.
P.GREEN 20 no number assigned *verdigris*	copper dibasic acetate	See Copper in table 14.
P.GREEN 21 77410 *emerald green*	cupric acetoarsenite	See Arsenic and Copper in table 14.
P.GREEN 22 77412 *Sheele's green*	Cupric acetoarsenite (historically cupric arsenite)	See Arsenic and Copper in table 14.
P.GREEN 23 77009 *green earth* *terra verte*	natural ferrous minerals containing magnesium and aluminum potassium silicates, such as glauconite and celedonite.	No significant hazards known for most of the minerals. Some forms of celedonite are in needle/ fibrous form similar to minerals that cause cancer.

P.GREEN 24 77013 *ultramarine green*	mineral of sodium, aluminum, silica, and sulfur	No significant hazards. See P.BLUE 29.
P.GREEN 26 77344 *cobalt green*	chromic oxide, alumina, cobaltous oxide, cobalt chromite	See Chrome III, VI, and Cobalt in table 14.
P.GREEN 36 74265 *phthalocyanine green*	chlorinated and brominated phthalocyanine	See P. BLUE 15.
P. GREEN 36 (old usage) no number assigned	mixture of gamboge (a yellow tree resin) and various pigments	Unknown. Not used much today.
P. GREEN 50 77377 *light green oxide*	oxides of nickel, cobalt, titanium	See Nickel and Cobalt in table 14.
HOOKER'S GREEN no C.I. name	mixture of various pigments	Hazards depend on pigments used.

ORANGE PIGMENTS (P.ORANGE or PO)

P.ORANGE 1 and 2 11725, 12060 *hansa orange* *dinitro-aniline orange*	insoluble azo dyes	Low acute toxicity. Long-term hazards poorly studied.
P.ORANGE 5 12075 *dinitraniline orange* *hansa orange*	insoluble azo dyes	Low acute toxicity. Long- term hazards poorly studied. A suspect carcinogen, mutagen, and contains toxic impurities like those in P.RED 4.
P.ORANGE 13 21100 *benzidine orange* *diarylide orange* *arylamide yellow*	insoluble azo dye (di- or dis-azo pigment)	Low acute toxicity. Diarylide pigments may be contaminated with PCBs. Heating releases cancer-causing dichlorobenzine.

P.ORANGE 17 and 17:1[†] 15510:1, 15510:2	barium precipitate (lake) of an azo dye	Low acute toxicity. Long-term hazards unknown. See Barium in table 14.
P.ORANGE 20 77202, 77199 *cadmium (hue)*	cadmium sulfo-selenide and other cadmium salts; hues: yellow to deep orange	Carcinogen. Kidney damage. See Cadmium and Selenium in table 14. See Sulfides in table 15.
P.ORANGE 20:1[†] 77202:1 *cadmium-barium (hue)*	cadmium sulfo-selenide coprecipitated with barium sulfate; hues: yellow to deep orange	Carcinogen. Same as above. See also Barium in table 14.
P.ORANGE 21 77601 *chrome orange, red*	basic lead chromate	Carcinogen. See Lead and Chrome in table 14.
P.ORANGE 21:1[†] *chrome orange, red*	basic lead chromate on a silicate base	Carcinogen. See Lead and Chrome in table 14.
P.ORANGE 23 77201 *cadmium* *vermillion orange*	cadmium sulfide/mercuric sulfide complex; varies from orange to red (see P.RED 113)	Carcinogen. Kidney damage. See Cadmium and Mercury in table 14. See Sulfides in table 15.
P.ORANGE 23:1[†] 77201:1 *cadmium-barium* *vermillion orange*	P.ORANGE 23 precipitated on barium sulfate	Same as P.ORANGE 23. See also Barium in table 14.
P.ORANGE 36, 60, 62 11780, 11782, 11775 *benzimidazolone (hue)*	complex organic chemical	Unknown.
P.ORANGE 43 71105 *perinone orange*	complex organic chemical	Unknown.
P.ORANGE 45	basic lead chromate of a different particle size than P.ORANGE 21	See P.ORANGE 21.

P.ORANGE 48 and 49 no number assigned *quinacridone (hue)*	complex organic chemical	Unknown.

There are many other organic chemical orange pigments, most of whose hazards are unknown.

RED PIGMENTS (NATURAL RED and P.RED or PR)

NATURAL RED 3 75460 *crimson*	kermesic acid from coccus ilici insect	Unknown. Not used much today.
NATURAL RED 4 75470 *crimson* *carmine*	carminic acid from coccus cacti insect; carmine if laked with aluminum or calcium	Unknown. Not used much today.
NATURAL RED 6, 8–12 75330 and others *alizarin or madder*	alizarin or rubierythic acid from certain plant roots	Low acute toxicity. Related to cancer-causing anthraquinones. May cause alizarin allergies. See also P.RED83.
P.RED 1 12070 *para red*	insoluble azo dye	Ingestion can cause cyanosis (ties hemoglobin in methemoglobin complex). A suspected carcinogen and mutagen.
P.RED 2, 5, 7, 9, 10, 14, 17, 22, 23, 63, 112, 119, 146, 148, 170, 188, 63:1†, 63:2 *arylide, arylamide, BON, naphthol reds*	azo organic pigments	Those tested show low acute toxicity. Long-term hazards generally unknown. P.RED 23 is mutagenic, a suspected carcinogen, and damages kidneys in rats.
P.RED 3 12120 *hansa, segnale, or toluidine red*	azo pigment	Ingestion can cause cyanosis (ties blood hemoglobin in methemoglobin complex). Long-term hazards being studied. Suspected carcinogen.

P.RED 4 12085 *aniline red* *permanent red*	chlorinated-p-nitroaniline (monazo class); (D&C Red) 36	Low acute toxicity. Approved for drugs and cosmetics except near the eyes. May be weakly carcinogenic. May contain cancer-causing impurities.
P.RED 5, 7, 9, 14, 119 12490, 12420, 12460, 12380 *naphthol ITR* *naphthol AS-TR* *naphthol AS-OL* *naphthol AS-D* *naphthol red*	azo organic pigments	These are the most commonly used naphthol reds, with their names and constitution numbers in order. P.RED 119, naphthol red, has no C.I. number assigned. See the hazards above. (See also P.RED 170 below.)
P.RED 8, 12 12335, 12385	azo pigment	Low acute toxicity. Long-term hazards unknown.
P.RED 38 and 41 21120, 21200 *pyrazolone reds* *diarylide reds*	azo pigment	Low acute toxicity. May be contaminated with PCBs and will release benzidine- related compounds.
P.RED 48, 48:1†, 48.22, 48.32, 48.42, 52:1, 52.22 15865, 15865:1, 15865:2, 15865:3, 15865:4, 15860:1, 15860:2 *BON and lithol reds*	calcium, barium, mangan- ese salts of beta- hydroxynaphthanoic acid azo pigments	Low acute toxicity. See Barium and Manganese in table 14.
P.RED 49, 49:1†, 49:2 15630,15630:1, 15630:2 *lithol reds* *segnale reds*	sodium, barium, and calcium salts of a soluble azo pigment	Caused allergies when used in cosmetics. Suspected carcinogen. Some grades contain significant amounts of soluble barium (see table 14). May also be contami- nated with beta-naphthy- lamine, which is a bladder carcinogen.

P.RED 53 15585:1[†] and 15585:2 *red lake C*	metal salt precipitate of an azo dye (D&C Red 9)	Carcinogen. May contain some soluble barium (see table 14).
P.RED 57, 57:1[†], 57:2 15850, 15850:1, 15850:2 *lithol rubine*	azo pigment and its calcium salt	Low acute toxicity. Long-term hazards unknown.
P.RED 60 16105, 16105:1[†]	barium precipitate of an azo dye, or an insoluble azo dye.	Low acute toxicity. A suspected carcinogen.
P.RED 81 (two types) 1. 45160:1[†] *rhodamine red*	tungsten, molybdenum, and phosphorus salt of Basic Red 1.	Low acute toxicity. Long-term hazards not well-studied. Some grades may contain arsenic (see table 14).
2. 45160 *day-glo or fluorescent*	a dye (Basic Red 1) in plastic resin	Same as above.
P.RED 83 58000, 58000:1[†] *alizarin or madder*	synthetic anthraquinone (1,2-di- hydroxyanthra- quinone)	Low acute toxicity. Related to cancer-causing anthraquinone (see P.BLUE 21). May cause allergies.
P.RED 88 73312 *thioindigoid violet*	indigo-like dye containing sulfur and chlorine	Unknown.
P.RED 90 45380:1[†] *phloxine or eosine*	lead salt of a dye (eosine)	Eosine is known to cause dermatitis when used in cosmetics. See Lead in table 14.
P.RED 101 77015, 77491, 77538 *Indian red, Mars red light or English red oxide iron oxide violet Venetian red*	iron oxides; hues range from light red to violet	No significant hazards known.
P.RED 102 77015, 77492, 77538 *light red or red ochre*	calcined yellow ochre, mineral silicates, and impurities	No significant hazards. If large amounts were inhaled, it could cause silicosis.

P.RED 103 77601	basic lead chromate of a different particle size from P.ORANGE 21 and 45	See Lead and Chrome in table 14.
P.RED 104 77605 *molybdate orange*	lead chromate, lead sulfate, and lead molybdate	See Lead and Chrome in table 14.
P.RED 105 77578 *minium, red lead*	red lead (Pb_3O_4)	See Lead in table 14.
P.RED 106 77766 *vermillion, cinnabar*	mercuric sulfide (HgS)	Can be contaminated with lead and other impurities. See Mercury in table 14. See Sulfides in table 15.
P.RED 108 77202 *cadmium selenium red* *cadmium (hue)*	cadmium-seleno sulfide $(CdS, CdSe)$; hue: orange to deep red	Carcinogen. Kidney damage. See Cadmium and Selenium in table 14.
P.RED 108:1[†] 77202:1 *cadmium-barium (hue)*	cadmium seleno-sulfide co-precipitated with barium sulfate hues: orange to deep red	Carcinogen. Same as above. See also Barium in table 14.
P.RED 113 77201 *cadmium vermillion red:* *light, medium, or deep*	cadmium mercury sulfide	Carcinogen. Kidney damage. See Cadmium and Mercury in table 14. See Sulfides in table 15.
P.RED 113:1[†] 77201:1 *cadmium-barium* *vermillion: red light,* *medium, or deep*	cadmium mercury sulfide coprecipitated with barium sulfate	Carcinogen. Kidney damage. See Cadmium, Mercury, Barium in table 14. See Sulfides in table 15.
P.RED 122, 192, 202, 206, 207, 209 73915, 73907, 73900, 73905 *quinacridone (hue)*	complex organic chemicals; hues: yellow red, burnt orange, and other colors	These are the most commonly used quina- cridones with their C.I. names and numbers in order. P.RED 192 and 206 have no assigned consti- tution numbers. The quinacridones have low acute toxicity. Long-term hazards are unknown.

P.RED 123, 149, 179, 190 71145, 77137, 71130, 71140 *perylene (hue)*	complex organic chemicals	Low acute toxicity. Long-term hazards unknown.
P.RED 144, 166 20735, 20730 *microlith red*	azo organic pigment	Low acute toxicity. Long-term hazards unknown.
P.RED 168 59300 *brominated anthrone*	brominated anthrone	Hazards unknown.
P.RED 170 F3RK-70 and F5RK 12475 *naphthol red, crimson*	azo organic pigment	Hazards unknown.
P.RED 171, 175 12512, 12513 *benzimidazolone (hue)*	monoazo organic pigment	Hazards unknown.
P.RED 181 73360 *thioindigoid magenta*	indigo-like organic pigment	Hazards unknown.
P.RED 188 12467 *naphthol AS*	azo organic pigment	Hazards unknown.
P.RED 194 71100 *perinone red deep*	organic chemical dye	Hazards unknown.
P.RED 242 20067	disazo condensation	Hazards unknown.
P.RED 254, 255 73902 *pyrrole red scarlet*	complex organic dye, quinacridone-like	Hazards unknown.

There are many other organic reds. The hazards of most are unknown.

VIOLET PIGMENTS (P.VIOLET or PV)

| P.VIOLET 1
45170:2[†]
rhodamine B | pigment based on dye below | Low acute toxicity. May cause photosensitive dermatitis. A suspected carcinogen. |

P.VIOLET 1 45170 *day-glo/fluorescent*	a dye (Basic violet 10, FD&C Red 19) in plastic resin	Same as previous.
P.VIOLET 14 77360 *cobalt violet*	cobalt phosphate and/or cobalt arsenite	Today, P.VIOLET 14 is usually all cobalt phosphate (see Cobalt in table 14). Old P.VIOLET 14 may contain arsenite (see Arsenic in table 14).
P.VIOLET 15 77007 *ultramarine (hue)*	complex silicate of sodium and aluminum with sulfur, or sodium alumino-sulphosilicate	No significant hazards known. See also P.BLUE 29.
P.VIOLET 16 77742	manganese ammonium pyrophosphate	See Manganese in table 14.
P.VIOLET 19 73900 (46500) *quinacridone (hue)*	complex organic chemical; hue: red to violet	Low acute toxicity. Long-term hazards unknown.
P.VIOLET 23 51319 *dioxazine, carbazole*	complex organic chemical	May be contaminated with dioxins (see note for P.BLUE 15).
P.VIOLET 31 60010 *isoviolanthranone violet*	chlorinated isoviolan-thranone	Unknown.
P.VIOLET 38 73395	synthetic indigo derivative	Moderately toxic.
P.VIOLET 47 77363 *cobalt lithium violet*	mineral of cobalt and lithium	See Cobalt and Lithium in table 14.
VIOLET 48 77352	cobalt magnesium borate	See Cobalt and Boron in table 14.

WHITE PIGMENTS (P.WHITE or PW)

P.WHITE 1 77597 *flake white*	basic lead carbonate, small amount of barium sulfate or other extenders	See Lead in table 14.

P.WHITE 2 77633 *white lead*	basic lead sulfate with a small amount of zinc oxide	See Lead in table 14.
P.WHITE 4 (2 types) 77947 1. Chinese white *zinc white*	zinc oxide	May contain small amounts (1 to 3 percent) of lead and other impurities. See Zinc in table 14.
2. leaded zinc oxide *permanent white*	zinc oxide and lead sulfate	See Lead and Zinc in table 14.
P.WHITE 5 77115 *lithopone*	zinc sulfide and barium sulfate	Pure barium sulfate does not dissolve in body fluids and is not toxic. Some grades contain sol- uble toxic barium impuri- ties. See Zinc and Barium in table 14. See Sulfide in table 15.
P.WHITE 6 77891 *titanium white*	titanium dioxide, usually from the minerals rutile or anatase	No significant hazards. Some grades contain large amounts of zinc oxide (see P.WHITE 4).
P.WHITE 7 77975 *zinc white*	zinc sulfide	Highly toxic by ingestion (see Sulfide in table 15). See Zinc in table 14.
P.WHITE 10 77099	barium carbonate, often from whitherite mineral	See Barium in table 14.
P.WHITE 11 77052 *antimony white*	antimony oxide	See Antimony in table 14.
P.WHITE 16 77625	basic lead silicate	See Lead in table 14.
P.WHITE 18 (2 types) 1. 77220 *chalk, whiting*	calcium carbonate	No significant hazards.
2. 77713 *magnesite*	magnesium carbonate	No significant hazards. Ingestion of large amounts causes purging.

P.WHITE 19 77004	various aluminum silicate clays	All clays are inert dusts that can cause respiratory problems at high exposures. Some may contain free silica.
P.WHITE 20, 26 77019, 77718 *mica, pumice, talc*	various potassium, silica, alumina, and magnesium- containing minerals	Historically, asbestos minerals were used. Some minerals may still contain silica and asbestos impurities.
P.WHITE 21, 22 77120 *barites, blanc fixe*	barium sulfate from chemical and mineral sources	May contain soluble barium and other toxic impurities. See Barium in table 14.
P.WHITE 23 77122	aluminum hydroxide and barium sulfate aluminum	May contain soluble barium and aluminum. See Barium and Aluminum in table 14.
P.WHITE 24 77002	aluminum hydrate	May contain soluble aluminum. See Aluminum in table 14.
P.WHITE 25 77231 *gypsum, alabaster*	calcium sulfate	No significant hazards.
P.WHITE 27 77811	silica usually in the quartz form	Inhalation of large amounts could cause silicosis.

YELLOW PIGMENTS (P.YELLOW or PY)

P.YELLOW 1**, 2, 35, 4, 5, 6, 10, 60, 74, 75 *toluidine, arylamide, hansa, and arylide yellows*	complex azo organic pigments	Low acute toxicity expected on basis of tests on P.YELLOW 1, 5, and 74. Long-term hazards unknown, but some relat- ed to cancer-causing dyes.** Ingestion of some types can cause methe- moglobinemia.

P.YELLOW 3 11710 *arylide yellow 10G* *hansa yellow light* *arylide yellow*	complex azo organic pigments	This is a very commonly used arylide, and it is a suspected carcinogen.
P.YELLOW 12, 13, 14, 17, 20, 55, 81 *diarylide, arylamide, arylide,* *and benzidine yellows*	insoluble azo organic pigments	Low acute toxicity is expected from these arylides. P.YELLOW 12 was found negative on cancer tests. Others untested, but they are related to bladder cancer-causing benzidine dyes. Contamination with PCBs likely (see P.ORANGE 13). Heat releases cancer-causing 3,3-dichlorobenzidine from P.YELLOW 12, 14, 17, and 81.
P.YELLOW 31 77103	barium chromate	See Barium and Chrome in table 14.
P.YELLOW 32 77839 *strontium yellow*	strontium chromate	See Chrome and Strontium in table 14.
P.YELLOW 33 77223	calcium chromate	See Chrome VI in table 14.
P.YELLOW 34 77600, 77603 *chrome yellow*	pure lead chromate or mixed with lead sulfate	See Lead and Chrome in table 14.
P.YELLOW 35, 35:1[†] 77205, 77205:1 *cadmium (hue)*	cadmium sulfide and cadmium sulfide precipitated with barium sulfate	Carcinogen. Kidney damage. See Cadmium and Barium in table 14. See Sulfides in table 15.
P.YELLOW 36, 36:1[†] 77955, 77956	zinc/potassium chromate complex or coprecipitated on barium sulfate	See Chrome and Barium in table 14.

P.YELLOW 37, 37:1[†] 77199, 77199:1 *cadmium (hue)*	pure cadmium sulfate or coprecipitated with barium sulfate	Carcinogen. Kidney damage. See Cadmium and Barium in table 14.
P.YELLOW 38 77878	stannic sulfide	Toxic by ingestion. See Sulfides and Tin in table 15.
P.YELLOW 39 (3 types) 1. 77085 *realgar, orpiment*	arsenic trisulfide (As_2S_3)	See Arsenic in table 14. See Sulfide in table 15.
2. 77086	arsenic trisulfide or P.YELLOW 37 mixed with P.WHITE 4.	Formerly an arsenic pigment, but replaced by cadmium sulfide.
3. 77600	lead chromate	P.YELLOW 39 also used to refer to chrome yellow. See P.YELLOW 34.
P.YELLOW 40 77357 *aureolin* *cobalt yellow*	potassium cobalt nitrite	Ingestion can cause cyanosis due to methemoglobinemia. See Cobalt in table 14.
P.YELLOW 41 77588, 77589 *antimony yellow* *Naples yellow*[††]	pure lead antimonate or mixed with zinc and bismuth oxide	See Lead and Antimony in table 14.
P.YELLOW 42 77492 *Mars (hue)* *iron oxide (hue)*	synthetic or natural hydrated iron oxide and other iron compounds; hue: yellow to orange.	No significant hazards.
P.YELLOW 43 77492 *yellow ochre*	natural hydrated iron oxide	No significant hazards.
P.YELLOW 46 77577 *litharge*	lead oxide	See Lead in table 14.
P.YELLOW 53 77788 *nickel titanate yellow*	oxides of nickel, antimony, and titanium	See Nickel and Antimony in table 14.

P.YELLOW 57 77900	nickel/barium/titanium complex	See Nickel and Barium in table 14.
P.YELLOW 65, 73, 74, 97, 98 11740, 11738, 11741, 11767, 11727 *arylide yellow RN, GX, 5Gx,* *FGL, 10GX*	complex azo organic pigments	These are some common arylides in order of C.I. names and numbers. Hazards unknown. Low acute toxicity expected. Some related to cancer- causing arylide.
P.YELLOW 83 (HR70) 21108 *diarylide yellow HR70*	complex organic chemical dye containing a dichloro- benzidine moiety (unit)	May be contaminated with PCBs, and releases bladder-cancer-causing dichlorobenzidine when metabolized or heated.
P.YELLOW 104 15985:1[†]	aluminum salt of an azo dye	Hazards unknown. Allergic response to the azo dye on which it is based is documented.
P.YELLOW 108 68420 *anthrapyrimidine yellow*	complex organic chemical	Low acute toxicity. Long- term hazards untested, but there is an anthra- quinone group in the mol- ecule, making it suspect.
P.YELLOW 109, 110 56280 *isoindolinone Yellow G, R*	complex organic chemical	Hazards unknown. P.YELLOW 109 has no C.I. constitution number.
P.YELLOW 112 70600 *flavanthrone yellow*	complex organic chemical	Hazards unknown.
P.YELLOW 138 56300 *quinophthalone*	complex organic chemical	Hazards unknown.
P.YELLOW 139 no number assigned *isoindoline yellow*	complex organic chemical	Hazards and structure unknown.
P.YELLOW 150 no number assigned *nickel azo yellow*	nickel azo complex dye	Hazards and structure unknown.

P.YELLOW 151, 154, 175 13980, 11781, 11784 *benzimidazolone (hue)*	complex organic chemical	Hazards unknown.
P.YELLOW 153 no number assigned *nickel dioxine yellow*	complex organic chemical	Hazards and structure unknown.
INDIAN YELLOW No C.I. name	magnesium salt of euxaanthic acid from mango-fed cows' urine	No significant hazards known.

METALLIC PIGMENTS (P.METAL)

P.METAL 1 77000	powdered aluminum	Soluble aluminum released (see Aluminum in table 14). Highly flammable and explosive.
P.METAL 2 (4 types) 77400 1. copper powder	powdered alloy of copper with zinc, aluminum and tin	Flammable. See Copper, Zinc, Aluminum, and Tin in table 14.
2. bronze powder	powdered alloy of copper, zinc, and iron	Flammable. See Copper and Zinc in table 14.
3. dendritic copper	powdered alloy of copper, zinc, and traces of other metals	Flammable. See above, plus Copper, Zinc, and any other metals that may be present in table 14.
4. metallic copper	powdered copper	Flammable. See Copper in table 14.
P.METAL 3 77480	gold	No significant hazards.
P.METAL 4 77575	lead	Flammable. See Lead in table 14.

| P.METAL 5
77860 | tin | Flammable. See Tin
in table 14. |

| P.METAL 6
77945 | zinc | Flammable. See Zinc
in table 14. |

OTHER METAL ALLOYS can be powdered for metallic pigments, and their hazards vary with their composition.

* Spinels are natural or synthetic oxides used as both pigments and ceramic colorants. Most are very stable at high temperatures. Their solubility in body fluids has not been studied, and it should be assumed that they release metals.

† A constitution number followed by :1, :2, or a colon and some other number indicates that the structure has been altered in some very minor way. For example, an acid dye could be made basic, or it could be reacted with a metal to become a salt.

‡ Since 1982, phthalocyanine pigments with lower concentrations of PCBs (polychlorinated biphenyls) have been available. Highly contaminated pigments were being distributed as late as 1986 in the United States and my still be purchased, especially in imported products. Dioxins are a category of polychlorinated dioxins and dibenzofurans.

§ 2-aminoanthraquinone (a precursor to Pigment Blue 22) and three other important anthraquinones now have been listed as carcinogens by the National Toxicology Program (NTP). Experts at NTP suspect that whole groups of natural and synthetic anthraquinones are carcinogens.

** PY1 and PY3 are related to cancer-causing dyes.

†† Naples yellow today may be a mixture of other less toxic and less expensive yellow pigments.

TABLE 11	HAZARDS OF DYES BY CLASS

DYE CLASSIFICATIONS

Using general dye chemistry as the basis for classification, the Colour Index lists 14 categories or classes of textile dyes:

1. Acid dyes
2. Azoic dyes
3. Basic dyes
4. Direct dyes
5. Disperse dyes

6. Fiber-reactive dyes
7. Vat dyes
8. Oxidation dyes
9. Mordant dyes
10. Developed dyes

11. Sulfur dyes
12. Pigments
13. Optical/fluorescent brighteners
14. Solvent dyes

The first seven of these classes are those most often used in textile arts. Although each individual dye is unique, some general observations can be made about their toxicity based on their class.

1. Acid dyes can be used to dye acrylics, wool, nylon, and nylon/cotton blends. They are called acid dyes because they are usually applied in acid solutions. The three most important chemical types of acid dyes are azo, anthraquinone, and triarylmethane. They appear, in general, to be of low acute toxicity, but the long-term hazards of many are unstudied. Some cancer-causing benzidine and food dyes have been identified in this class.

2. Azoic dyes are used primarily on cellulosic fibers, such as cotton, silk, and acetates. Allergic reactions to these dyes have been reported, and some are considered carcinogens.

3. Basic dyes can be applied to wool, silk, and some synthetics. Fluorescent dyes usually belong to this class. Allergic reactions to these dyes have been reported, and some are considered carcinogens.

4. Direct dyes are applied from salt-containing baths to cellulosic materials, such as cotton. These dyes usually present few acute hazards, but many are considered carcinogens. Most of the cancer-causing benzidine dyes are in this class; it is still possible to find benzidine dyes among direct dyes sold for art and craft purposes.

5. Disperse dyes are used primarily to dye water-repellant fibers, such as polyester, nylon, and acetates. They are called "disperse dyes" because they disperse or absorb directly (colloidally) into the fiber. Some are applied at high temperatures. While many classes of dyes have caused dermatitis on direct skin contact, only disperse dyes have caused widespread dermatitis from contact with the finished product.

6. Fiber-reactive dyes are used most often with cellulosic fibers and wool. They can also be used with silk and nylon. The dyes derive their name from the fact that they form a chemical bond (covalent) with the fiber, becoming an integral part of it. They are the fastest-growing group of dyes, and many are so new that they have not been assigned Colour Index numbers. Industrial use has demonstrated the dyes' capacity to produce respiratory allergies and asthma. Their long-term hazards are poorly studied. However, one chemical class of fiber-reactive dyes (bromacrylamide) was shown to have a high percentage of positive mutagenicity tests in a 1980 study. Researchers suggested that a possible explanation may be that the small molecule size and the high reactivity of these dyes may enable them to react directly with genetic material (DNA). These tests indicate that cancer and birth defect studies should be undertaken.

7. Vat dyes are used primarily for cellulosic fibers, although some are suitable for wool and acetates. Lye, or caustic soda, is often used either in the bath or as a dye pretreatment. Pretreated vat dye powders are caustic and irritating to handle or inhale. Vat dyes also require an oxidation treatment after they have been applied. Some dyes oxidize in the air, but others require treatment with dichromate salts, which cause allergies (see Chromium in table 14, page 154). Some of the dyes themselves can also cause allergies. Certain vat dyes are sold as pigments. Using these is not recommended.

OTHER CLASSIFICATIONS

Food dyes are also a separate Colour Index group. Most are acid dyes, but many other classes are also represented among this group. Most dyes in this class were selected in the 1950s, because they were thought to be safe. Later tests required for food additives have shown that many of these dyes cause cancer or have other toxic effects. Even dyes found safe for use in food may contain highly toxic impurities if they are not carefully manufactured. Art materials sellers who claim that their products contain "food dyes" should be required to tell customers whether the dyes are currently approved for use in food and whether they are "food grade" chemicals.

All-purpose or union dyes are the common household dyes. These products contain two or more classes of dyes together with salt, so that a wide variety of fabrics may be dyed. Only the dye that is specific for the material will be "taken" by the fabric. Until the early 1980s, most all-purpose products contained cancer-causing benzidine dyes. Many of the new dyes are anthraquinone dyes, which are suspected to cause cancer.

TABLE 12	BENZIDINE-CONGENER DYES

BENZIDINE-BASED DYES

C.I. Acid Orange 45
C.I. Acid Orange 63
C.I. Acid Red 85
C.I. Acid Red 85, Disodium Salt
C.I. Acid Red 89
C.I. Acid Red 97, Disodium Salt
C.I. Acid Yellow 42
C.I. Acid Yellow 42, Disodium Salt
C.I. Acid Yellow 44
C.I. Acid Yellow 44, Disodium Salt
C.I. Direct Black 4
C.I. Direct Black 4, Disodium Salt
C.I. Direct Black 38
C.I. Direct Blue 158
C.I. Direct Blue 158, Tetrasodium Salt
C.I. Direct Blue 2
C.I. Direct Blue 2, Trisodium Salt
C.I. Direct Blue 6
C.I. Direct Blue 6, Tetrasodium Salt
C.I. Direct Brown
C.I. Direct Brown 1
C.I. Direct Brown 1, Disodium Salt
C.I. Direct Brown 111
C.I. Direct Brown 154
C.I. Direct Brown 154, Disodium Salt
C.I. Direct Brown 2
C.I. Direct Brown 2, Disodium Salt
C.I. Direct Brown 31
C.I. Direct Brown 31, Tetrasodium Salt
C.I. Direct Brown 59
C.I. Direct Brown 6
C.I. Direct Brown 6, Disodium Salt
C.I. Direct Brown 74
C.I. Direct Brown 95
C.I. Direct Green
C.I. Direct Green 1

C.I. Direct Green 1, Disodium Salt
C.I. Direct Green 6, Disodium Salt
C.I. Direct Green 8,
C.I. Direct Orange 1
C.I. Direct Orange 8
C.I. Direct Orange 8, Disodium Salt
C.I. Direct Red 1
C.I. Direct Red 1, Disodium Salt
C.I. Direct Red 10
C.I. Direct Red 10, Disodium Salt
C.I. Direct Red 13
C.I. Direct Red 13, Disodium Salt
C.I. Direct Red 28
C.I. Direct Red 28, Disodium Salt
C.I. Direct Red 37, Disodium Salt
C.I. Direct Red 89
C.I. Direct Violet 1
C.I. Direct Violet 1, Disodium Salt
C.I. Direct Violet 22
C.I. Direct Yellow 20
C.I. Mordant Yellow 26
C.I. Mordant Yellow 26, Tetrasodium Salt
*C.I. 22120
*C.I. 22130
C.I. 22145
C.I. 22155
C.I. 22195
*C.I. 22240
*C.I. 22245
*C.I. 22310
*C.I. 22311
C.I. 22345
C.I. 22370
C.I. 22410
C.I. 22480
C.I. 22570
*C.I. 22590

*C.I. 22610
C.I. 22870
C.I. 22880
C.I. 22890
C.I. 22910
C.I. 23900
C.I. 23910
C.I. 24555
C.I. 30045
*C.I. 30120
*C.I. 30140
*C.I. 30145
*C.I. 30235
*C.I. 30245
*C.I. 30280
*C.I. 30295
C.I. 30315
*C.I. 35660
*C.I. 36300

O-TOLIDINE-BASED DYES

C.I. Acid Red 114
C.I. Acid Red 167
C.I. Azoic Coupling Component 5
C.I. Azoic Orange 3
C.I. Azoic Yellow 1
C.I. Azoic Yellow 2
C.I. Azoic Yellow 3
C.I. Direct Blue 14
C.I. Direct Blue 25
C.I. Direct Blue 25, Tetrasodium Salt
C.I. Direct Blue 26
C.I. Direct Orange 6, Disodium Salt
C.I. Direct Red 2
C.I. Direct Red 2, Disodium Salt
C.I. Direct Red 39
C.I. Direct Red 39, Disodium salt
C.I. Direct Yellow 95
*C.I. 23365

*C.I. 23375
*C.I. 23500
*C.I. 23630
*C.I. 23635
*C.I. 23790
*C.I. 23850
*C.I. 31930
*C.I. 37090
*C.I. 37120
*C.I. 37610

DIANISIDINE-BASED DYES

C.I. Azoic Black 4
C.I. Azoic Blue 2
C.I. Azoic Blue 3
C.I. Azoic Coupling Component 3
C.I. Direct Black 114
C.I. Direct Black 91
C.I. Direct Black 91, Trisodium Salt
#C.I. Direct Black 118*
C.I. Direct Black 167*
C.I. Direct Blue 1*
C.I. Direct Blue 1, Tetrasodium Salt
#C.I. Direct Blue 100*
C.I. Direct Blue 15*
C.I. Direct Blue 15, Tetrasodium Salt
C.I. Direct Blue 22*
#C.I. Direct Blue 151*
C.I. Direct Blue 151, Disodium Salt
C.I. Direct Blue 156*
C.I. Direct Blue 160*
#C.I. Direct Blue 191*
#C.I. Direct Blue 218*
C.I. Direct Blue 269*
C.I. Direct Blue 22
C.I. Direct Blue 22, Disodium Salt
#C.I. Direct Blue 224*
C.I. Direct Blue 225
C.I. Direct Blue 229

#C.I. Direct Blue 267*

C.I. Direct Blue 269

#C.I. Direct Blue 76*

#C.I. Direct Blue 76, Tetrasodium Salt*

#C.I. Direct Blue 77*

C.I. Direct Blue 8*

C.I. Direct Blue 8, Disodium Salt

#C.I. Direct Blue 80*

#C.I. Direct Blue 90*

#C.I. Direct Blue 98*

#C.I. Direct Brown 200*

C.I. Direct Violet 93*

C.I. Direct Yellow 68*

#C.I. 23155*

C.I. 24140*

#C.I. 24175*

C.I. 24280*

C.I. 24315

C.I. 24400*

#C.I. 24401*

C.I. 24410*

#C.I. 24411*

C.I. 30400*

C.I. 37235*

C.I. 37575*

* Dyes in production as of 1983.
\# "Metalized dyes," which have a metal ion added to their chemical structure. Industry claims these dyes are less hazardous. Since NIOSH does not now have enough information to determine whether commercial-grade metalized dyes are safer, the classification should not be construed as NIOSH support for safety claims. In addition, these dyes may contain metals that are regulated as toxic waste and that, therefore, cannot be put down drains.

Information collected from *Preventing Health Hazards from Exposure to Benzidine-Congener Dyes*, U.S. Department of Health and Human Services (NIOSH) Publication No. 83-105.

CHAPTER 11
METALS AND METAL COMPOUNDS

Sculptors, smiths, jewelry makers, stained-glass artists, and foundry workers use a vast array of metals. Ceramicists, glass blowers, and enamelists also use many metallic oxides and other metal compounds. Even painters and printmakers use inorganic pigments that are metallic compounds and powdered metal pigments (see table 10, page 114). Even the rare-earth metals and other rare metals have found use in photo processes, as glass colorants and in patinas. Artists using these materials need to understand the nature of metals and their toxicology.

ALLOYS

Metals can be blended together into almost any combination. Sometimes, nonmetallic elements, such as silica and carbon, are also blended with metals. These blends are called alloys. They are formulated to have certain properties, such as a specific melting point, hardness, or color. In fact, almost all metals used in metalworking are alloys. Casting metals, solders, welding and brazing rods, and sheet metals are examples of alloys.

To assess metalworking hazards, then, it is necessary to know the composition of the alloys. For example, brass is an alloy that often contains lead and arsenic. Brass nonsparking tool metals contain highly toxic beryllium. Silver solders and brazing rods often contain cadmium and antimony.

Sometimes, the common names of products identify the metals in an alloy. Examples include silicon bronze, manganese steel, or nickel silver. Never assume these names identify all the metals in the alloy. Always obtain Material Safety Data Sheets or complete ingredient information on all metal products.

SKIN CONTACT

Historically, health professionals have always assumed that systemic exposure cannot occur from handling solid metals. However, a study in 1988 proved that powdered lead, lead oxide, and lead nitrate will absorb almost immediately through the skin.[1,2]

Although these lead substances were found to absorb rapidly through the skin, it was not possible to precisely quantify the hazard, because the lead does not absorb into the bloodstream, where its levels could easily be measured. Instead, the lead materials are absorbed into other tissues near the skin, and where they go from there is unknown.

Skin absorption of other solid metals and dusts is unstudied and unknown. But given the study of lead's skin absorption, one should suspect that the assumption that other metals do not skin-absorb is unwarranted at this time.

CORROSION PRODUCTS

Metal oxides and other corrosion products are always found on metal surfaces. You can see the formation of such compounds when metals like lead are polished or cut to expose a clean, shiny surface. After a few days, the metal will grow dull, as a coating of lead oxide begins to form. Silver tarnishes as black silver sulfide deposits form.

This phenomenon explains why merely touching or handling some metals provides sufficient contamination of the skin to cause systemic damage if the worker transfers these contaminants to the mouth by eating or smoking before washing up.

Larger amounts of metal corrosion products are created if metals are allowed to weather (especially in polluted city air) or come in contact with acids or other chemicals that attack the metal. Cleaning or brushing corroded metal surfaces may be hazardous to workers if dust control is not provided.

[1] *The Science of the Total Environment*, Elsevier Science Publishers, Amsterdam, 76 (1988) 267–278.
[2] "Skin Absorption of Lead," *The Lancet*, letters, July 16, 1988, 157–158.

The formation of a corrosion product due to contact with air is often called "oxidation." This process also occurs on the surface of particles of metal dusts and fumes.

However, soft metals like lead, even when they appear shiny and clean, will also shed particles. This phenomenon was documented when tests were done on workers stacking lead blocks.[3] These uncoated lead blocks are used as radiation shielding in research, manufacturing, and in nuclear medicine and radiology. The tests showed that workers stacking the blocks could be overexposed to lead dust by inhalation and that lead dust on the floor in the area where the blocks were handled was dramatically in excess of standards.

DUSTS AND POWDERS

Fireworks contain metal powders, so it should come as no surprise that metal dusts and powders are explosive and/or flammable in air. Aluminum powders are particularly reactive. The Aluminum Association publishes a bulletin called "Recommendations for Storage and Handling of Aluminum Powders and Pastes," which says:

> The U.S. Bureau of Mines . . . established the proportions required for an explosion . . . [and] very little powder is needed. Aluminum powder will ignite with as little as 9 percent oxygen present. Very small amounts of energy are required to ignite certain mixtures of aluminum powder and air. . . . The discharge of static electricity . . . electric switches, broken light bulbs, electric motor commutators, loose electric power connections—anything producing a spark can set off an explosion.

Bronze, copper, and other metals can also be ground into powders and used as paint and ink pigments. In general, the more finely divided the powder, the more quickly the material will "burn" in air—and the more explosive it will be. But even large particles will ignite under the right conditions. To use fireworks to illustrate the difference, the fine powders would produce a quick flash or a noisy blast, while the bigger particles would burn more slowly and produce that "flitter" or sparkle effect. But both the fast flash and the slower-burning flitter belong in the sky. They can be deadly inside a studio!

3 "Potential Health Hazards from Lead Shielding," *American Industrial Hygiene Association Journal* 57 (December 1996):1124–1126.

Metal dusts are also created when metals are ground, polished, and cut. These dusts can vary in size from large particles that drop immediately to surfaces to fine, respirable particles. These dusts should also be captured by ventilation systems and/or cleaned up frequently to keep them from accumulating.

FUMES

Metal fumes are created when metal is heated to its melting point or above. The fumes are generated when molten metal releases metal vapors, which react with oxygen in the air (oxidize) and then condense into tiny metal-oxide fume particles (see page 23). Since metal fumes are exceedingly small particles, they can float for hours in the air and settle as dust throughout a workspace, providing hours of exposure by inhalation.

Fumes from melting or cutting scrap or junk metals may be a serious hazard if highly toxic metals are present in the alloys. In industry, many deaths from cadmium oxide fumes have resulted from melting scrap metals.

INHALATION OF METAL PARTICLES

In general, the smaller the particle size, the deeper the dust can be inhaled, the more likely it is to be absorbed by the body, and the more toxic it is liable to be. For this reason, metal fumes and respirable dusts (particles under 10 microns in diameter) are often more toxic than dusts of the same metals. Regulations and standards commonly have different standards for "inhalable" particles and "respirable" particles. Examples of this can be seen in the standards for copper and cadmium in table 13.

When inhaled, respirable metal particles of metals such as lead and zinc will dissolve in the lungs' air sacs and then pass through the air sacs' membranes into the bloodstream. These metals are then free to travel throughout the body.

Other metals, such as cerium, beryllium, or titanium, dissolve very slowly and cannot pass through the air sacs' membranes. These particles will remain in the lungs a long time, perhaps a lifetime. Their effects are on the lungs themselves.

The larger, "inhalable" dusts will deposit in mucous on other lung surfaces and will be raised by the cilia and swallowed. In this way, these metal dusts are ingested.

METAL-CONTAINING GASES

Some metals, such as arsenic and antimony, emit highly toxic gases when in contact with acids. For example, this could happen when acid fluxes, cleaners,

or patinas are used with arsenic/antimony–contaminated metals or solders. When inhaled, metal gases pass easily through the air sacs' membranes and into the bloodstream.

METAL COMPOUNDS

When metals combine with other elements, these other elements can be called "radicals." Common examples of radicals include oxides (O), carbonates (CO_2), and sulfates (SO_4).

Oxides of metals are formed by corrosion processes or can be found in nature as metal ores. For example, iron oxidizes to form rust, but various iron oxides, from yellow ochre to red and black iron oxides, are found in nature. The toxicity of oxides will depend on the toxicity of the individual metal and how soluble the oxide is in body fluids. The effect of the oxygen molecule is negligible.

OTHER COMPOUNDS

When metals combine with elements other than oxygen, these other elements may affect the toxicity of the resulting compound. For example, rust (Fe_2O_3 or red iron oxide) is not very toxic, but iron arsenate—$Fe(AsO4)_2 \cdot 6H_2O$—is very toxic, because it combines the hazards of iron with those of arsenic.

In some cases, combination with radicals alters the toxicity of a compound, because it alters its solubility in body fluids. For example, barium carbonate ($BaCO_3$) is only slightly soluble, but releases enough highly toxic barium to be an effective rat poison. However, highly purified barium sulfate (BaSO4) is so insoluble that we can swallow large amounts of it prior to x-ray studies of the digestive system.

Chemistry handbooks, artists' textbooks, and manufacturers of metallic compounds often claim many metallic compounds are safe because they are insoluble. They may even provide data on the solubility of these materials obtained from tests in solutions of acid.

However, it has been shown that some chemicals that are insoluble in acid solutions may be quite soluble in body fluids, such as lung and digestive fluids. This is probably due to the combined actions of acids, bases, enzymes, and other physiological mechanisms. In addition, laboratory solubility tests are usually done on very pure chemicals. The chemicals used in art are often highly impure and contaminated.

For these reasons, it is prudent to consider all compounds containing toxic metals or radicals as potentially toxic. Table 14 on page 150 lists the hazards of

various metals, oxides, and other compounds. Table 15 lists the hazards of common radicals.

EXPOSURE STANDARDS

The American Conference of Governmental Industrial Hygienists (ACGIH) sets Threshold Limit Values (TLVs) for exposure to airborne concentrations of metal dusts and fumes (see pages 24–27). Table 14 also lists these TLVs when they are available.

The Threshold Limit Values for metals and metal compounds are usually expressed in milligrams per cubic meter (mg/m³). Ten mg/m³ is often referred to as a nuisance dust level. Even nuisance dusts may be harmful in concentrations greater than 10 mg/m³. TLVs that are lower than 10 mg/m³ indicate the material is more toxic. Table 13 lists examples of Threshold Limit Value–Time-Weighted Averages.

TABLE 13	EXAMPLES OF THRESHOLD LIMIT VALUES FOR METALS
SUBSTANCE	**THRESHOLD LIMIT VALUE–TIME-WEIGHTED AVERAGE (MG/M³)**
Calcium carbonate, whiting	10
Aluminum metal dust (inhalable)	10
Aluminum welding fume, pyro powders (respirable)	5
Tin metal dust	2
Copper dust	1
Copper fume	0.2
Arsenic	0.01
Cadmium dusts (inhalable)	0.01
Cadmium fume and dusts (respirable)	0.002
Beryllium and its compounds	0.0002*

* ACGIH has published a Notice of Intended Change in 2001 to reduce the beryllium TLV to this level.

TOXICOLOGY OF METALS AND METAL COMPOUNDS

There are certain occupational illnesses that are especially associated with metals and their compounds.

Skin Diseases. Handling metals usually does not harm the skin, unless the metal is radioactive or unusually toxic. For example, beryllium can produce skin tumors if it penetrates broken skin, and arsenic is corrosive to the skin and causes skin cancer.

Some metals and metallic compounds also cause skin allergies. Many people are so sensitized to certain metals that even wearing metal jewelry will cause a reaction. Nickel is especially known to cause such allergies. European countries have instituted a regulation called the "Nickel Directive," which requires manufacturers of jewelry or any other metal product that contacts the skin to document with laboratory tests that nickel will not be released in significant amounts.

Metal Fume Fever. Fumes of metals such as zinc, copper, magnesium, and iron can cause metal fume fever. This disease resembles the flu. It usually onsets two to six hours after exposure, and symptoms may include a fever, chills, and body aches. There appears to be no long-term damage to the body from episodes of metal fume fever caused by metals of low toxicity. However, when toxic fumes such as cadmium are inhaled, the early symptoms may be similar, but serious consequences or even death may result.

Nervous System Diseases. A number of metals are known to affect the brain and other nervous system tissues. For example, lead, mercury, and manganese can cause effects ranging from psychological problems at low doses to profound retardation and paralysis at higher doses. Chronic manganese exposure can cause a disease similar to Parkinson's disease.

Reproductive Effects. A number of metals are known to affect human reproduction at various stages. For example, the ability to impregnate or conceive may be impaired, pregnancy can end in miscarriage, the fetus may be affected, or birth can be complicated. Metals that are known to cause such effects include antimony, arsenic, cadmium, lead, manganese, mercury, and selenium. Many other metals are suspected of causing reproductive effects or are shown to cause them in animals. (See chapter 31 for further information.)

Respiratory System Diseases. Respiratory system diseases are usually caused by irritation or allergy to metals. Asthma diseases have been noted in workers grinding metals containing cobalt and chrome. Lung scarring (fibrosis) is associated with metals such as cerium or beryllium. In fact, a progressive and incur-

able lung disease called "beryllium disease" has been seen in dental technicians who grind tiny dental prostheses made of an alloy containing only 1 to 2 percent beryllium. Beryllium is also a lung carcinogen.

Systemic Poisoning. Once a metal or a metal compound is absorbed into the body, a great number of organs may be affected. Each substance has its own unique behavior in the body (see table 14).

LEAD TOXICITY—A SPECIAL PROBLEM

In recent years, research has increased our understanding of lead toxicity. It is now known that even the small amounts of lead we absorb from air pollution and contamination of food and water are causing health effects in us all and reduced mental acuity in our children.

Although lead has been used in art for hundreds of years, it is time we reconsider its use. For even if we manage to set up ventilation systems that will remove lead fumes and dust from our studios, it will contaminate the environment. The soil where your lead dust has settled will remain contaminated forever.

In addition, government regulations regarding the use and disposal of lead are incredibly strict and are getting tougher. There are now U.S. Environmental Protection Agency rules requiring reporting of any business that uses one hundred pounds of lead or more per year. And there are special standards in both the United States and Canada that protect workers in any workplace where lead is used. Most studios and schools simply cannot afford to comply with these laws.

As a result, schools and artists are often operating "outside" the law. Being caught could result in citations or lawsuits. The fines and damages could be especially severe because the violations are willful—that is, we know that what we are doing is dangerous and illegal.

The answer is to begin immediately to seek alternatives to lead, just as big business is finding substitutes for lead, for solvents that destroy the ozone layer, and for fuels that cause acid rain. Industry often resists making these changes, because the substitutes will not be exactly like the old materials, will cost more, be less convenient, and so on.

Each of us must decide if we will use these same arguments to justify our own use of lead.

RULES FOR WORKING WITH METALS

1. Identify your metals and alloys. Only use materials for which Material Safety Data Sheets are available. Use the MSDSs to eliminate highly toxic metals such as lead, cadmium, and beryllium from your work. If unidentifiable "junk" and "found" metals are to be used, plan the studio with the help of an industrial ventilation specialist to ensure that exposure will not occur.

2. Use ventilation systems to capture dusts from grinding and polishing and fumes from welding, brazing, casting, or soldering. Clean up dusts that escape such systems daily.

3. All finely powdered metals, such as powdered aluminum or bronze pigments, should be considered flammable and/or explosive. Any spark or static discharge can set them off once they are open to the air. Instead, use premixed metallic pigmented paints and inks, or purchase metallic pigments that are sold in paste form. Store powdered pigments in flammable-storage cabinets or in magazines with other fireworks ingredients, and mix and handle in explosion-proof ventilation systems.

4. Avoid skin contact with metals when possible. Wash hands regularly during and after work.

5. Wear protective clothing, including a full-length smock, shoes, and hair covering (if needed). Leave these garments in the studio to avoid bringing dusts home. Wash clothes frequently and separately from other clothes.

6. Clean the studio properly. Work on easy-to-clean surfaces, and wipe up spills immediately. Wet-mop or sponge surfaces and floors, or use HEPA vacuums. Do not sweep.

7. Practice good hygiene, and do not eat, smoke, or drink in the studio.

8. If lead is used in any form, blood tests for lead should be done regularly (at least once a year). If the metal shop is in a workplace or school, the OSHA Lead Standard must be followed.

9. If welding or cutting are done, follow all the OSHA regulations for welding and use of compressed gases.

| **TABLE 14** | HAZARDS OF METALS AND METAL COMPOUNDS |

KEY

TLV-TWA: These are the ACGIH (American Conference of Governmental Industrial Hygienists) eight-hour, time-weighted Threshold Limit Values for 2001 in milligrams per cubic meter (mg/m^3). A notice of intended change (NIC) indicates the new value that ACGIH proposes for the TLV. When no TLV-TWA exists or when a more protective standard is available, the standard will be indicated—i.e., TLV-C, an OSHA Permissible Exposure Limit (PEL), or a Workplace Environmental Exposure Limit (WEEL) from the American Industrial Hygiene Association.

Toxicity is divided into *local* and *systemic* effects:

- *Local* effects are restricted to the chemical's potential for damaging the skin, eyes, or respiratory system on contact through its toxic properties, such as alkalinity, sensitization, or effects on surface tissues. Mechanical effects of the chemicals will not be included. It is assumed that readers know that almost all finely divided chemical powders can cause mechanical damage to lungs and eyes and can dry or abrade skin. It is also assumed that readers know that many powdered metals are flammable and even explosive under certain conditions.

- *Systemic* effects are restricted to the effects on various organ systems, such as blood, kidneys, lungs, and brain. These effects are seen if elements are absorbed into the body after contacting the skin, respiratory system, or digestive tract. Only digestive tract absorption of very small amounts, such as from swallowing of material cleared from the lungs or hand-to-mouth contact, will be noted. Effects of massive ingestion are excluded.

NAME OF METAL (CHEMICAL SYMBOL) **TLV-TWA (MG/M³)**

common sources: name (formula), synonyms
Local toxic hazards
Systemic toxic hazards

ALUMINUM (AI)	
Alumina (Al_2O_3), alumina hydrate, aluminum oxide, corundum, emery;	fume and pyrotechnic powders: 5
	metal and oxide dusts: 10
Alumina hydrate ($Al[OH]_3$), alumina trihydrate, a chemically bound, nonhazardous constituent of clays and many minerals.	soluble salts: 2

Local: Inhalation of fume is associated with lung-scarring disease. Inhalation of oxides is associated with a form of pneumoconiosis (Shaver's disease).

Systemic: Generally assumed to have no significant hazards, but some experts suspect it plays a role in some chronic diseases, like Alzheimer's disease.

ANTIMONY (Sb)

Antimony oxide (Sb_2O_3), antimony trioxide, stibium oxide, C.I. Pigment White 11;

Antimony sulfide (Sb_2S_3), antimony black, C.I. 77050;

Lead antimoniate ($Pb_3[SbO_4]_2$), Naples yellow, C.I. Pigment Yellow 41 (see also Lead);

Stibine gas (SbH_3), antimony hydride.

metal and compounds: 0.5
stibine gas: 0.51

Local: Fume and dust are potent irritants to skin, eyes, respiratory tract. Can cause ulcers of skin and upper respiratory tract.

Systemic: Absorption causes metallic taste, vomiting, diarrhea, irritability, fatigue, muscular pain, and may result in anemia, kidney and liver degeneration. Some forms can absorb through the skin. Has adverse reproductive effects. The metal is often contaminated with significant amounts of arsenic.

ARSENIC (As)

Arsenic trioxide (As_2O_3), white oxide; asenous oxide;

Arsenic pentoxide (As_2O_5), arsenic acid;

Arsenic sulfide (AsS or As_2S_2), arsenic; disulfide, ruby arsenic or red arsenic glass, realgar;

Arsenic trisulfide (As_2S_3), arsenious sulfide, orpiment, C.I. Pigment Yellow 39;

Copper acetoarsenite ($[CuO]_3As_2O_3 \cdot Cu[Cu_2H_3O_2]_2$), C.I. Pigment Green 21, Paris Green;

Arsine gas (AsH_3).

metal and compounds: 0.01
arsine gas: 0.16, NIC: 0.006

Local: Corrosive to the skin, eyes, and respiratory tract. Can cause skin cancer.

Systemic: Absorption can cause gastrointestinal distress, hair loss, skin changes (depigmentation, thickening, ulceration), kidney and liver damage, nerve damage, cancer, and reproductive effects.

BARIUM (Ba)

Barium carbonate ($BaCO_3$), whitherite, C.I.
Pigment White 10;
Barium sulfate ($BaSO_4$), barite, barytes, blanc
fixe, C.I. Pigment White 21, Permanent
White, Lithopone (with zinc compounds);
Barium chromate ($BaCrO_4$), C.I. Pigment Yellow 31.

soluble compounds: 0.5
barium sulfate: 10

Local: The fume and the carbonate are slight irritants.

Systemic: Absorption by ingestion or inhalation of soluble barium compounds can cause muscle spasms and contractions, bladder contractions, intestinal spasms, ringing of ears, irregular heartbeat, heart rate may be slowed or stopped. Chronic low-dose exposure may be associated with high blood pressure, heart and kidney problems. Inhalation of insoluble barium sulfate causes fogging of lung x-rays.

BERYLLIUM (Be)

Beryllium oxide (BeO), beryllia;
Beryl ($3BeO \cdot Al_2O_3 \cdot 6SiO_2$), glucinum oxide.

metal and compounds: .002, NIC:
0.0002

Local: Causes skin and respiratory allergies. Irritates skin and can cause swelling and ulceration of nasal passages. Inhalation can cause severe hypersensitivity pneumonia (can be fatal). Penetration of broken skin (e.g., cuts from beryllium-coated glass of old fluorescent lights) has produced skin tumors.

Systemic: Chronic inhalation can cause a permanent lung disease called beryllosis, which can be fatal. This disease is often misdiagnosed as sarcoidosis. Absorption can cause liver and spleen dysfunction and lung cancer.

BISMUTH (Bi)

Bismuth trioxide (Bi_2O_3), bismuth oxide;
Bismuth nitrate ($Bi[NO_3]_3 \cdot 5H_2O]$), bismuth
subnitrate.

no TLVs except for a compound
used in the semiconductor industry:
bismuth telluride: 10

Local: No significant hazards.*

Systemic: Causes physiological response similar to lead, but much greater doses are required.

BORON (B)

Boric acid (H_3BO_3);
Borax ($Na_2B_4O_7 \cdot 10H_2O$)
Boron oxide (B_2O_3), boric oxide;
Component of borosilicate frits, Colmanite,
 Gerstley borate;
Boron nitride (BN).

borates (tetra and sodium)
anhydrous (no H_2O): 1
decahydrate ($10H_2O$): 5
pentahydrate ($5H_2O$): 1
boron oxide: 10

Local: Irritant to skin, eyes, and respiratory tract.

Systemic: Can cause skin rashes, nausea, stomach pain, vomiting, diarrhea, liver and kidney damage, and testicular damage. Lethal amounts of boric acid have been skin-absorbed from old burn treatment medications.

CADMIUM (Cd)

Cadmium sulfide (CdS), greenockite, cadmium
 yellow, C.I. Pigment Yellow 37;
Cadmium oxide (CdO);
Cadmium selenide (CdSe), (see also selenium).

metal and compounds:
dust (inhalable): 0.01
respirable particles: 0.002

Local: Irritant to skin, eyes, and respiratory tract. Chronic exposure can ulcerate the nasal septum, cause loss of the sense of smell, and yellow the teeth. Acute inhalation of fumes can cause pulmonary edema (fluid in the lungs) and early symptoms similar to metal fume fever (flu-like symptoms).

Systemic: Chronic exposure can cause lung, liver, and kidney damage; anemia; and cancer. Some cadmium compounds are insoluble in acid, but solubility is not directly related to bioavailability. All cadmium compounds should be considered highly toxic. Has adverse male and female reproductive effects.

CALCIUM (Ca)

Calcium carbonate ($CaCO_3$), calcite, whiting;
Calcium sulfate ($CaSO_4$ or $CaSO_4$, $2H_2O$),
 plaster, gypsum, C.I. Pigment White 25;
Common element in many ceramic chemicals.

carbonate, silicate, sulfate: 10
hydroxide: 5
oxide: 2
chromate: 0.001 (as Cr)

Local: No significant hazards.*

Systemic: No significant hazards.*

CERIUM (Ce)

Cerium oxide (CeO_2), ceric oxide, cerium dioxide, ceria;

Component of cerite, monazite, orthite.

Local: This is one of fifteen lanthanides, or rare-earth metals. There is very little data on them. Inhalation of the fume and dusts can cause a type of lung fibrosis (cer-pneumoconiosis).

Systemic: All lanthanides appear to be able to thin the blood (anticoagulants). Not much else known.

CESIUM (Cs)

Cesium bromide ($CsBr$);

Cesium chloride ($CsCl$);

Cesium fluoride (CsF);

Cesium hydroxide (the strongest base known).

hydroxide: 2

Local: Not well studied. Animal data shows hyperirritability, spasms, and death at high levels. The hydroxide, oxides, and halogenated cesiums are irritating or corrosive.

Systemic: No long-term studies exist in either animals or man. May have chronic effects similar to those of lithium. Short-term mouse studies showed chromosomal aberrations increasing linearly with dose. One study of mice from conception to weaning showed decrease in body, brain, and testes weights.

CHROMIUM (Cr)

Chrome oxide (Cr_2O_3), chromium III oxide, chromic oxide, chrome green, C.I. Pigment Green 17;

Chromium trioxide (CrO_3), chromium III trioxide, chromic acid;

Chromic oxide (Cr_2O_3), chromium II oxide;

Potassium dichromate ($K_2Cr_2O_7$), potassium bichromate, a chromium VI compound;

Iron chromate ($Fe_2[CrO_4]_3$), ferric chromate, (chromium VI);

Lead chromate ($PbCrO_4$), chrome yellow, C.I. Pigment Yellow 34 (chrome VI—see also Lead).

Cr metal: 0.5

Cr (II) compounds: 0.5 (PEL)

Cr (III) compound: 0.5

Cr (VI) water soluble compounds: 0.05

Cr (VI) certain water insoluble compounds: 0.01

Strontium chromate (C.I. Pigment 32): 0.0005

Local: Irritating to skin, eyes, and respiratory system. Can cause severe skin allergies and slow-healing ulcers of skin and nasal passages.

Systemic: Chronic exposure can cause asthma and lung cancer. Cancer is associated with chrome (IV) compounds and chrome fume. Some experts think all chrome compounds can cause cancer. Chromates are potent animal carcinogens, strontium chromate being the strongest.

COBALT (Co)

Cobalt oxides: cobaltous oxide (CoO), black cobaltic oxide (Co_2O_3), or cobalto-cobaltic oxide (Co_3O_4); Cobalt carbonate (Co_2CO_3).

metal and inorganic compounds: 0.02

Local: Mild skin, eye, and respiratory irritant. Can cause skin allergies.

Systemic: Inhalation causes asthma-like disease, pneumonia, and lung damage. Absorption causes vomiting, diarrhea, sense of hotness. An animal carcinogen.

COPPER (Cu)

Copper oxides: black copper oxide (CuO), red copper oxide (Cu_2O); Copper carbonate ($CuCO_3$), green copper carbonate.

fume: 0.2
dusts and mists: 1

Local: Irritates and discolors the skin. Respiratory tract irritant. Repeated inhalation of dust can cause sinus congestion and ulceration and perforation of the nasal septum. Contact with eyes can cause conjunctivitis and discoloration and ulcers of the cornea.

Systemic: May cause allergies in some people. Inhalation of fumes can cause metal fume fever (flu-like symptoms). Absorption can cause nausea, stomach pains. Deadly in small amounts by any route to people with Wilson's disease.

ERBIUM (Er)

Erbium chloride ($ErCl_2$); Erbium nitrate ($Er(NO_3)_3$).

Local: This is one of fifteen lanthanides, or rare-earth metals. There is very little data on them. Inhalation of the fume and dusts is expected to cause lung fibrosis. A skin irritant.

Systemic: All lanthanides appear to be able to thin the blood (anticoagulant). Not much else known.

GERMANIUM (Ge)

Germanium dioxide GeO_2;
Germanium tetrahydride (GeH_4);
Germanium chloride ($GeCl_4$).

germanium tetrahydride: 0.63

Local: Very little data exists. No effects noted on skin contact.

Systemic: Ingestion usually of low toxicity, but germanium-containing "health elixirs" have resulted in deaths from kidney failure. Inhalation of large amounts causes lung damage and chemical pneumonia. Unstudied for most chronic effects.

GOLD (Au)

Metallic gold and mercury/gold amalgams (in
 some lustres);
Gold chloride ($AuCl_3$), gold trichloride.

Local: Metallic gold has no significant hazards. Gold chloride and other gold salts may be irritating and cause allergies.

Systemic: Absorption of gold salts can cause anemia, liver damage, and nervous system damage.

IRON (Fe)

Iron oxides: magnetic iron oxide (FeO);
 ferrous oxide; ferric oxide (Fe_2O_3),
 hematite, Indian red, C.I.Pigment Red 101;
 ferrosoferric oxide (Fe_3O_4), black iron oxide,
 C.I.Pigment Black 11;
Yellow ochre ($2Fe_2O_3 \cdot 3H_2O$), limonite
Iron sulfate ($FeSO_4 \cdot 7H_2O$), crocus martis

dust and fume: 5
soluble salts: 1
iron pentacarbonyl: 0.2

Local: No significant hazards by skin or eye contact.* Inhalation can stain lung tissues, causing a disease called siderosis. This condition is considered benign, but it can fog lung x-rays.

Systemic: Inhalation of iron fume can cause metal fume fever (flu-like symptoms). Iron sulfate is irritating and toxic, due to the sulfate radical.

LEAD (Pb)

Lead monoxide (PbO), litharge, C.I.Pigment
 Yellow 46

Lead tetroxide (Pb_3O_4), lead oxide, red lead,
 mennige, minium, C.I.Pigment Red 105;

Lead carbonate $(PbCO_3)$, white lead, cerusite,
 C.I. Pigment White 1;

Lead sulfate $(PbSO_4)$, white lead, C.I. Pigment
 White 2;

Lead sulfide (PbS), galena, lead glance;

Lead frits, e.g., lead monosilicate, lead
 bisilicate, C.I. Pigment White 16;

Lead chromate (see also Chromium);

Naples yellow (see also Antimony).

dust, fume, compounds: 0.05
lead chromate: 0.012 (as Cr)

Local: No significant hazards.* Lead metals, lead oxide, and lead nitrate are known to absorb through the skin. Other compounds probably can absorb as well.

Systemic: Acute exposure can cause colic, convulsions, coma, and death. Chronic exposure can cause loss of mental acuity, psychological problems, brain and nervous system damage, anemia, and kidney damage. It accumulates in bones and tissues and may cause problems for prolonged periods of time. A hazard to the fetus and to reproductive capabilities of both males and females. Children are even more seriously affected than adults and at lower doses. Probable human carcinogen.

LITHIUM (Li)

Lithium carbonate (Li_2CO_3);

Lithium-containing minerals: lepidolite,
 petalite, spodumene, and amblygonite.

lithium oxide and hydroxide: 1
 (WEEL-Ceiling)

Local: Irritating to skin, eyes, and respiratory system.

Systemic: Absorption can cause symptoms ranging from fatigue, dizziness, and gastrointestinal upset to more serious complications, including tremors, kidney damage, muscular weakness, vision and hearing disturbances, coma, seizures, and death. Lithium carbonate is used medicinally to control manic-depressive personality disorders, which demonstrates that even milligram amounts can cause effects. Reproductive hazard.

MAGNESIUM (Mg)

Magnesium carbonate ($MgCO_3$), magnesite
 (mineral form of magnesium carbonate);
Magnesium sulfate ($MgSO_4$), epsom salt
 (hydrated form);
Magnesium silicate ($MgO \cdot SiO_2$, ratio variable).

magnesite: 10
magnesium oxide fume: 10

Local: No significant hazards.*

Systemic: No significant hazards, except inhalation of large amounts of fume could cause metal fume fever (flu-like symptoms). Ingestion of large amounts causes laxative effect.

MANGANESE (Mn)

Manganese dioxide (MnO_2), black oxide of
 manganese, pyrolusite, C.I. Pigment
 Black 14;
Manganese carbonate ($MnCO_3$).

fume, dust, and compounds: 0.2
Manganese cyclopentadienyl
 tricarbonyl,
(MMT) gasoline additive: 0.2 (as Mn)

Local: Mild irritant to skin and respiratory tract.

Systemic: Chronic inhalation can produce a degenerative nervous system disease similar to Parkinson's. Early symptoms include languor, sleeplessness, weakness, muscle spasms, headaches, and irritability. Can also cause metal fume fever. Adverse reproductive effects in experimental animals.

MERCURY (Hg)

Mercuric sulfide (HgS), cinnabar, vermillion,
 C.I. Pigment Red 106 (PR106);
Other mercury-containing pigments:
 C.I. PR 113, PO 23;
Metallic mercury and amalgams.

vapor, inorganic compounds: 0.025
organic mercury
aryl compounds: 0.1
alkyl compounds: 0.01

Local: Skin irritation and occasional skin allergies have been reported.

Systemic: Mercury and some of its compounds can be absorbed through the skin and can form vapors at fairly low temperatures, which can be inhaled. Early symptoms of absorption are psychological and emotional disturbances. Symptoms can progress to tremors, kidney disease, and nerve degeneration. Has adverse reproductive effects.

MOLYBDENUM (Mo)

Molybdenum trioxide (MoO_3);
Molybdosilicates ($Mo[SiO_2]_x$);
Molybdate orange, C.I. Pigment Red 104.

metal and insoluble compounds
inhalable: 10
respirable: 3
soluble respirable compounds: 0.5

Local: Not well studied. Slightly irritating to skin and respiratory system.

Systemic: Appears to be of a low order of toxicity. There have been reports of lung fibrosis in workers inhaling the metal dusts and fumes.

NEODYMIUM (Nd)

Neodymium metal;
Neodymium chloride $NdCl_3$.

Local: This is one of fifteen lanthanides, or rare-earth metals. There is very little data on them. Inhalation of the fume and dusts is expected to cause lung fibrosis. A skin irritant.

Systemic: All lanthanides appear to be able to thin the blood (anticoagulant). Not much else known.

NICKEL (Ni)

Nickel oxides: nickel monoxide (NiO), green
 nickel oxide; dinickel trioxide (Ni_2O_3),
 nickelic oxide;
Nickel carbonate ($NiCO_3 \cdot 2Ni[OH]_2 \cdot 4H_2O$), green
 nickel carbonate;
Nickel chloride ($NiCl_2$);
Nickel subsulfide (Ni_3S_3).

metal (inhalable): 1.5
insoluble (inhalable) compounds: 0.2
soluble (inhalable) compounds: 0.1
nickel carbonyl: 0.12
nickel subsulfide: 0.1

Local: Can cause very severe skin allergies, commonly called "nickel itch," which can lead to ulceration and chronic eczema. Also irritating to eyes and mucous membranes.

Systemic: Inhalation of fume is associated with metal fume fever and cancer. Ingestion of salts is associated with giddiness and nausea.

NIOBIUM (Nb)

Niobium metal (called "Columbium" by many
 metallurgists), often contaminated with
 tantalum;
Niobium chloride ($NbCl_5$).

Local: Eye and skin irritant. Effects not well studied.

Systemic: Known to cause kidney damage. Other effects not well studied.

PALLADIUM (Pd)

Palladium metal; none
Palladium chloride ($PdCl_2$).

Local: This is one of six transitional elements, all known as the "platinum metals." They are expected to have similar effects, but there is very little data. The chloride is a skin irritant. Palladium and its compounds may be skin sensitizers.

Systemic: There is very little human data, but animal tests show fetal damage, interference with use of energy by nerves and muscles, lung malfunction, and some evidence of carcinogenicity.

PLATINUM (Pt)

Platinum chloride ($PtCl_4$), platinum metal: 1
 tetrachloride, chloroplatinic acid; soluble salts: 0.002
Platinum black (finely-powdered metal).

Local: This is one of six transitional elements, all known as the "platinum metals." Skin contact with salts can cause severe allergies. Inhalation can cause nasal allergies and "platinosis," a severe type of asthma.

Systemic: Some lung scarring may occur from chronic inhalation. Ingestion hazards are unknown.

POTASSIUM (K)

Potassium carbonate (K_2CO_3), pearl ash, potash; K-hydroxide: 2 (ceiling/peak limit)
Potassium hydroxide (KOH), caustic potash;
Common constituent of many ceramic minerals;
 e.g., potash feldspars.

Local: No significant hazards.* The hydroxide and carbonate compounds are eye, skin, and respiratory irritants.

Systemic: No significant hazards.*

PRASEODYMIUM (Pr)

Praseodymium oxide (Pr_2O_3). none

Local: This is one of fifteen lanthanides, or rare-earth metals. There is very little data on them. Inhalation of the fume and dusts is expected to cause lung fibrosis. A skin irritant.

Systemic: All lanthanides appear to be able to thin the blood (anticoagulant). Not much else known.

RHODIUM (Rh)

Rhodium chloride ($RhCl_3$), rhodium trichloride.

metal, insoluble compounds: 1
soluble compounds: 0.01

Local: This is one of six transitional elements, all known as the "platinum metals." They are expected to have similar effects, but there is very little data. The chloride is a skin irritant, but not apparently a skin sensitizer.

Systemic: Not well studied. Slightly carcinogenic in animals. $RhCl_3$ is a potent mutagen.

RUBIDIUM (Rb)

Rubidium chloride ($RbCl$);
Aluminum rubidium sulfate (rubidium alum);
Rubidium iodide (RbI);
Rubidium hydroxide ($RbOH$).

Local: Do not appear to be sensitizers. The hydroxide is a strong corrosive to skin and eyes.

Systemic: Similar in function to lithium and may one day have use as an alternate treatment for manic depression. Its toxicity is not studied sufficiently for use at this time.

SELENIUM (Se)

Cadmium selenide ($CdSe$), C.I. Pigment Red;
 108 and Yellow 35 (see also Cadmium);
Hydrogen selenide gas (H_2Se).

compounds: 0.2

Local: Irritant to eyes, skin, and respiratory tract. When compounds come in contact with moisture or acid, they may release hydrogen selenide gas, which is a more potent irritant.

Systemic: Its toxicity is similar to that of arsenic, causing nausea, vomiting, nervous system damage, hair loss, and damage to the liver, kidneys, spleen, bone marrow, and thyroid. Symptoms of overexposure include a telltale garlic-breath odor. An animal carcinogen. Has adverse reproductive effects.

SILVER (Ag)

Metallic silver;
Silver chloride ($AgCl$);
Silver nitrate ($AgNO_3$);
Silver sulfide (Ag_2S), niello;
Silver/mercury amalgams (see also Mercury).

metal: 0.1
soluble compounds: 0.01

Local: Silver salts can stain skin and irritate mucous membranes. Silver nitrate is very caustic and burns skin and has caused blindness (stains the cornea) when splashed in the eyes. Silver fume can deposit in lungs to cause a benign pneumoconiosis, which can fog x-rays.

Systemic: Black silver deposits can migrate in the body to permanently stain the whites of the eye and the skin in a benign condition called "argyria."

SODIUM (Na)

Sodium carbonate (Na_2CO_3), soda ash, washing soda;

Sodium bicarbonate ($NaHCO_3$), baking soda;

Sodium bisulfite ($NaHSO_3$), sodium acid sulfite;

Sodium metabisulfite ($Na_2S_2O_5$);

Component of many ceramic chemicals and minerals.

Na bisulfite: 5
Na metabisulfite: 5
Na hydroxide: 2 (ceiling)

Local: No significant hazards.* Sodium hydroxide and sodium carbonate are corrosive to the skin, eyes, and respiratory tract.

Systemic: No significant hazards.*

STRONTIUM (Sr)

Strontium carbonate ($SrCO_3$) strontianite;

Strontium chromate ($SrCrO_4$), C.I. Pigment Yellow 32 (see also Chromium);

Strontium sulfate ($SrSO_4$), celestine.

none except for Sr chromate: 0.0005 (as Cr)

Local: No significant hazards.*

Systemic: No significant hazards.* The chromate is one of the most potent animal carcinogens ever studied.

TANTALUM (Ta)

Tantalum chloride ($TaCl_5$);

Tantalum oxide (Ta_2O_5).

metal and oxide dust: 5

Local: Industrial skin injuries have been reported. Not well studied.

Systemic: Systemic poisoning has not been demonstrated. Not well studied.

TELLURIUM (Te)

Tellurium oxide (TeO_2);
Tellurium chloride ($TeCl_4$);
Tellurium hexafluoride (TeF_6).

metal and compounds: 0.1
tellurium hexafluoride: 0.2

Local: Some compounds are skin and eye irritants or corrosives.

Systemic: There are no controlled inhalation studies and no bioavailability or cancer data. Once in the body, tellurium metal and some of the compounds are converted to dimethyl telluride, which imparts a garlic odor to the breath. Anorexia, nausea, depression, somnolence, itchy skin, and metallic taste are reported. Large doses are fatal. Experimental reproductive effects and birth defects reported.

TIN (Sn)

Tin oxides: stannous oxide (SnO); stannic
 oxide (SnO_2), cassiterite, white tin oxide;
Tin chloride ($SnCl_2$), stannous chloride, tin
 dichloride;
Tributy-l, triethyl-, diethyl-, dibutyl-tin, etc.

metal: 2
oxide and compounds: 2
organic compounds: 0.1

Local: No significant hazards* for the inorganic compounds. The fume deposits in the lungs to produce a benign pneumoconiosis, which fogs x-rays. The chloride salt is a skin, eye, and respiratory irritant.

Systemic: No significant hazards* for most inorganic compounds. However, the organic tin compounds are used as pesticides and biocides and are highly toxic by all routes.

TITANIUM (Ti)

Titanium dioxide (TiO_2), titania C.I. Pigment
 White 6;
Minerals containing titanium: rutile, anatase,
 illmenite, ferrous titanite, perowskite;
Titanium tetrachloride ($TiCl_4$).

titanium dioxide: 10

Local: No significant hazards.* The chloride is highly irritating, especially in the fume form.

Systemic: Generally thought safe, but some experts think it causes a type of pneumoconiosis.

TUNGSTEN (W)

Tungsten carbide (WC);
Tungsten trioxide (WO_3), tungstic oxide,
 tungstenic ochre, wolframic acid;
Components of minerals: scheelite, wolframite;
Component in some ceramic frits.

insoluble compounds: 5
soluble compounds: 1

Local: No significant hazards* to skin and eyes. Slightly toxic to respiratory tract.

Systemic: No significant hazards for insoluble compounds.*

URANIUM (U)

Uranium oxides: uranous oxide, UO_2; uranyl
 oxide, UO_3; triuranium octoxide, U_3O_8;
 Component in uranite, pitchblende;
 Uranium nitrate ($UO_2[NO_3]_2 \cdot 6H_2O$), uranyl nitrate
 "Depleted uranium" isotopes except for U-235.

soluble and insoluble compounds: 0.2
(natural uranium, not enriched
 uranium or a single isotope
 such as U-235)

Local: Radioactivity could affect skin to cause cancer. The nitrate is easily skin-absorbed. "Depleted uranium" is about 40 percent as radioactive as natural uranium, due to removal of one isotope.

Systemic: A radioactive carcinogen. Hazardous by inhalation. Absorption results in severe kidney damage.

VANADIUM (V)

Vanadium pentoxide (V_2O_5);
Many mason and ceramic stains.

respirable dust and fume: 0.05

Local: Highly irritating to skin, eyes, and respiratory tract. Heavy exposures have caused chemical pneumonia. Can cause allergies.

Systemic: Can cause anemia, kidney dysfunction, gastrointestinal disorders, nervous system damage, and lung problems, including asthma, bronchitis, and pulmonary edema (fluid in the lungs). A green tongue may be a sign of overexposure.

ZINC (Zn)

Zinc oxide (ZnO), Chinese white, C.I. Pigment White 4;

Zinc chloride ($ZnCl_2$), zinc dichloride;

Zinc chromate ($ZnCrO_4 \cdot 7H_2O$).

fume: 5
oxide dust: 10
chloride fume: 1
chromates: 0.01
stearate: 10

Local: No significant hazards.* The chloride is a potent irritant to skin, eyes, and respiratory tract.

Systemic: Inhalation of zinc fume can cause metal fume fever (flu-like symptoms).

ZIRCONIUM (Zr)

Zirconium oxide (ZrO_2), zirconium dioxide, Baddeleyite;

Zirconium silicate ($ZrSiO_4$), zircon.

compounds: 5

Local: No significant hazards.* Rare allergies to zirconium deodorant products have been reported.

Systemic: No significant hazards.*

* No significant hazards unless combined with radicals containing other hazardous elements. Radicals are elements or combinations of elements bound to the metal. For example, the toxicity of potassium hydroxide (KOH) is not caused by potassium (K-), but by the caustic hydroxide radical (-OH). (*See table 15.*)

TABLE 15	TOXIC EFFECTS OF COMMON RADICALS

A radical is an element or group of elements that combines with a metal to form a compound. Radicals may affect the toxicity, solubility, and other characteristics of metallic compounds.

CARBIDE (-C, carbon) radicals usually do not contribute to toxicity. Carbide radicals are found in some abrasives, such as silicon carbide (SiC) and tungsten carbide (WC). Diamonds are also a form of carbon. Carbon dioxide or carbon monoxide may be given off if carbides or carbon-containing materials are heated or fired.

CARBONATE (-CO_3) radicals usually do not contribute to toxicity. Carbon dioxide and toxic carbon monoxide may be given off if compounds are heated or fired.

CARBONYL (=C=O) compounds usually are very toxic. They may release carbon monoxide and are highly irritating and damaging to tissues in the lung. Welding of various metals and kiln-firing of metal-containing glazes are potential sources of carbonyls.

CHLORATE (-ClO_3) compounds are usually very toxic and reactive. They usually can cause methemoglobinema and destroy red blood cells. This may lead to kidney and heart-muscle damage. They also are usually fire hazards when in contact with flammable materials, and they can explode when shocked or exposed to heat—especially when contaminated with small amounts of organic matter such as sawdust , shellac, charcoal, etc.

CHLORIDE (-Cl) radicals usually increase solubility, reactivity, and irritant qualities. Heating or firing may release highly irritating hydrochloric acid gas or chlorine.

CHROMATES (-CrO_4). See Chromium in table 14, page 154.

CYANIDE (-CN) compounds should be avoided, because they are very soluble and toxic. When in contact with acids, heat, or gastric fluids, highly toxic hydrogen cyanide gas is formed. This gas stops the body's cells from receiving oxygen. The victim dies quickly of asphyxiation. Cyanides are usually not very irritating to the skin, but electroplaters who are repeatedly exposed to cyanide solutions often develop rashes and skin eruptions.

FERRI- AND FERROCYANIDE (-$Fe(CN)_6$) compounds release cyanide when exposed to strong ultraviolet light, acid, or heat. They are now known to release cyanide under neutral and alkaline conditions, like those found in the environment, and are regulated

as cyanide compounds. They release cyanide more slowly than true cyanides. (See Cyanide.) The National Toxicology Program has proposed studying potassium ferricyanide for cancer effects, due to its potential for redox cycling (alternating between being an oxidizer and reducer), which is a property of some other carcinogens.

FLUORIDE (-F) radicals usually increase solubility, reactivity, and irritant qualities. Fluorides may also produce long-term toxic reactions. Chronic fluorine poisoning, or "fluorosis," is seen among miners of cryolite and other fluorine-containing minerals. The disease consists of sclerosis of the bones; calcification of ligaments; mottling of the teeth; anemia; gastric, respiratory, and nervous system complaints; and skin rashes.

HYDROXIDES (-OH) can vary from being very soluble to very insoluble. Soluble hydroxides are caustic and irritating to skin, eyes, digestive tract, and respiratory system.

NITRATES (-NO$_3$) are most often very soluble, which usually makes the metals in nitrate compounds more available to the body. They are often highly toxic by ingestion. All nitrates are powerful oxidizing agents, and some can explode when exposed to heat or flame. Potassium, barium, and other nitrates are used in fireworks. They may emit highly toxic nitrogen oxide gases during firing or glass-making.

NITRITES (-NO$_2$) are usually very toxic and strong oxidizers. Avoid.

OXIDE (-O) radicals usually do not contribute to toxicity.

PHOSPHATES (-PO$_4$) vary greatly in solubility and toxicity. Heating or firing phosphates may release highly toxic phosphorus oxides. Large doses of some phosphates can disturb the metabolism.

SILICATES (-SiO$_2$) usually are not very toxic. Unlike silica (free SiO$_2$), silicates do not cause silicosis, although some silicates cause other less-virulent pneumoconioses (lung diseases). Naturally occurring silicates are often contaminated with significant amounts of free silica.

SULFATE (-SO$_4$) radicals usually do not contribute to toxicity. They may emit highly irritating sulfur oxides during firing or glass-making.

SULFIDES (-S) of metals are often insoluble. Many are irritating to the skin and eyes. Many sulfides are highly toxic by ingestion, because they react with gastric acid to produce hydrogen sulfide gas. They emit sulfur oxides on heating or firing. If water vapor is present, hydrogen sulfide may also be released.

SULFITES (-SO$_3$) and bisulfites (-HSO$_3$) usually are moderately toxic. They may emit sulfur oxides as they degrade with age or when heated.

CHAPTER 12
MINERALS

Minerals are used in almost all arts and crafts. Examples include all sculpture stones; gemstones; all clays and most ceramic chemicals; most abrasives; many paint, ink, and pastel extenders; some pigments; refractory and insulating materials for high-temperature equipment; and more.

NATURAL MINERALS

It took Mother Nature ages to make our minerals. And since Mother Nature was not concerned with "quality control," she allowed inclusion of impurities in most minerals. For example, organic materials such as coal or asphalt contaminate some fire-clay minerals. Sedimentary clays often contain a variety of organic matter deposited by ancient lakes and rivers with the clay.

Natural minerals may also contain inorganic metallic and mineral impurities. Trace metal impurities in gemstones, for instance, are often responsible for unique colors. Mineral talc (talcum) deposits usually contain significant amounts of other minerals, such as silica and/or asbestos. Mineral and metal impurities must often be considered when assessing the hazards of naturally occurring minerals.

SYNTHETIC MINERALS

Mother Nature is not the only mineral-maker. For thousands of years, potters have converted minerals from one form to another in their fires and kilns. Now, more sophisticated equipment is used to make minerals such as synthetic gemstones and mineral fiber insulation.

Synthetic minerals can be tailored to fit our needs. Some types of synthetic gemstones can be made to possess exactly the same chemical and physical properties as pure natural gemstones. Synthetic mineral fibers can be tailored to have the same insulating properties as natural asbestos.

It should not be surprising, then, that many synthetic minerals have health effects similar to those of natural minerals.

CHEMICAL VERSUS MINERAL HAZARDS

Like all matter, minerals are made of chemicals. In most minerals, these chemicals are arranged in a crystal structure with a definite chemical composition. Artists need information on both chemical composition (chemical analysis) and crystal structure (mineral analysis) of these materials, because both may affect health.

Some minerals contain very toxic chemicals. These toxic chemicals can affect the body if they are soluble—that is, are released from the mineral into body fluids.

The mineral's crystal structure may also affect health. For example, asbestos minerals are made of harmless chemicals, such as magnesium and calcium silicates. Asbestos is not soluble (inert) and does not release these chemicals in the body. But the asbestos minerals have microscopic, needlelike crystals, which can penetrate tissues and cause cancer.

SOLUBILITY OF MINERALS. For many years, a crude acid test was used to predict which minerals would release their toxic chemicals in the body. These tests place the mineral in contact with acid and water. It is now known that these tests do not relate to body-fluid solubility, because body fluids contain not only acids and water, but bases, enzymes, and other materials. And solubility may differ in various body fluids, such as digestive juices and lung fluids. For these reasons, the actual solubility of most minerals in various body fluids is not known unless animal or human tests have been done.

In addition, artists are often exposed to exceedingly fine particles of mineral powders or to fine dusts from abrasive processes. Fine particles present a large surface area from which toxic metals may be released to body fluids. If the particles are inhaled, they may be retained in the lungs for long periods of time, giving the body years to dissolve or react to them.

For all these reasons, minerals containing highly toxic metals such as lithium, barium, and beryllium should be treated with caution, regardless of laboratory solubility data. They may be considered in the same manner as metal-containing compounds, and their potential hazards can be looked up in table 14, page 150.

INSOLUBLE OR INERT MINERALS. Certain minerals are found to be present in the body years after they were inhaled. These minerals have not been dissolved by body fluids, because they are insoluble and inert. For example, once inhaled, asbestos fibers and silica crystals are known to remain essentially unaltered in the lungs for a lifetime. Inert minerals are often associated with specific types of illnesses.

TOXICOLOGY OF INERT MINERALS

Inert minerals are usually not very hazardous to ingest, and when inhaled, they all seem to dry and irritate the lungs to some degree. Their major effects, however, usually involve chronic lung diseases.

These diseases occur precisely because the minerals do not dissolve or break down in the lungs. Instead, they begin to accumulate in the lungs. The diseases they cause fall into certain categories.

Pneumonconioses (meaning "dusty lungs" in Greek) are diseases caused by inhalation of inert materials. Each type of pneumoconiosis is identified by the name of the dust that caused it. For example, talcosis is caused by talc inhalation.

Different mineral dusts cause diseases of varying severity. There are two major categories of pneumoconiosis: fibrogenic and benign.

Fibrogenic pneumoconiosis is caused when scar tissue forms in the lungs in response to the mineral dust. Minerals such as asbestos and silica cause severe forms of the disease. These diseases are untreatable at all phases, can progress even after exposure has ceased, and their severity can range from shortness of breath to disability or death. Typically, the disease results from small exposures to dust over many years.

However, even short exposures may be hazardous. Only a few weeks of heavy exposure to silica flour (400 mesh) have caused workers to die of silicosis a couple of years later. This form of the disease is called "progressive massive fibrosis."

Dusts that cause less severe fibrotic diseases and that require inhalation of greater amounts of dust include kaolin (clay uncontaminated with silica), alumina, and talc (uncontaminated with asbestos minerals). The diseases these cause are aptly named, respectively, kaolinosis, aluminosis, and talcosis.

Benign pneumoconioses do not result in lung scarring. However, some will alter the appearance of diagnostic lung x-rays, causing doctors to do unnecessary medical tests if the cause of the x-ray change is not known. It also may obliterate x-ray evidence of other lung diseases, causing other conditions to go untreated.

Examples of minerals that can cause benign pneumoconiosis include a barium sulfate mineral, barytes (causes baritosis), and ochres and other iron oxides such as rouge and rust (causes siderosis).

Lung cancer and mesothelioma (cancer of the lining of the chest, abdomen, or heart) are caused by inert, microscopic, sharp or needle-shaped particles, such as those of asbestos, synthetic mineral fiber insulation, and crystalline silica.

HAZARDS OF COMMON MINERALS

The type of damage a particular mineral causes depends on its unique characteristics. To complicate matters, some minerals exist in more than one crystal form. It is important to know about these forms to assess health risks and to comply with governmental exposure regulations. The minerals with which artists should be familiar include asbestos, silica, feldspars, and clays. For other minerals, see table 17 on page 178.

Asbestos causes asbestosis and is associated with a number of cancers, including mesothelioma and lung cancer. Even ingestion of asbestos may be hazardous, causing intestinal and kidney cancer as some needlelike fibers migrate through the body. Asbestos comes in a number of mineral forms:

1. *Chrysotile:* serpentine groups of minerals, white asbestos
2. *Amosite:* cummingtonite-grunerite minerals, brown asbestos
3. *Crocidolite:* blue asbestos
4. *Amphibole asbestos:* can be found in three mineral forms:
 a. Tremolite
 b. Anthophyllite
 c. Actinolite

Each of the amphibole minerals comes in two forms: fibrous and nonfibrous. The hazards of the fibrous forms are comparable with other forms of asbestos, but the hazards of the nonfibrous forms are being debated. Some people believe that these forms are not truly asbestos and that their dusts are far less toxic than asbestos. Others believe that nonfibrous amphiboles mill into sharp, thin cleavage fragments or occur in transitional fibers that cause illnesses like those caused by asbestos.

The United States Occupational Safety and Health Administration has reviewed studies of nonfibrous tremolitic talc miners and believes that this talc can be associated with increased risk of cancer. The risk appears to be less than

for asbestos workers, but they have indicated that they will continue collecting data on this finding to see if regulation is needed.

Exposure to all fibrous forms of asbestos is already regulated in both Canada and the United States. The United States Permissible Exposure Limit (PEL-TWA) is 0.1 fibers per cubic centimeter of air (f/cc).[1] Canadian standards vary, with the laxest regulations being in the asbestos-mining province of Quebec. Their standard (OEL-TWA) is 0.2 f/cc for amosite and crocidolite and 1 f/cc for actinolite, tremolite, anthophillite, and chrysotile.

Clearly, artists are not equipped to do air sampling and regulate their asbestos exposures. Until all the evidence is in, artists probably should avoid exposure to all types of asbestos, both fibrous and nonfibrous. Children certainly should never use any asbestos or non-asbestos fiber-contaminated materials.

Silica, or silicon dioxide (SiO_2), is one of the earth's most common minerals. When silica is bound in compounds or minerals, it is not usually hazardous. However, inhaling unbound or "free" silica can cause a serious, untreatable lung-scarring disease called "silicosis." An elevated risk of lung cancer has also been documented in people with silicosis. Free silica occurs in various crystalline and amorphous forms:

1. *Crystalline silica:* all forms have the same chemical formula (SiO_2), but the crystal structures differ.
2. *Quartz:* common constituent of sand, flint, and other rocks.
3. *Cristobalite:* can be formed from heat conversion of quartz geologically or when fired.
4. *Tridymite:* has roughly the same origins and hazards as crystobalite above.
5. *Amorphous silica or noncrystalline Silica:* the arrangement of silicon dioxide molecules is random and unorganized, whether natural or synthetic in origin. The synthetic silicas are manufactured and promoted as "safe" silica. There is considerable debate about their safety, and many experts recommend handling them with the same precautions used for free silica.

[1] A typical male doing light work will inhale about a cubic meter of air per hour. This would mean at 0.1 f/cc, a worker would inhale 800,000 fibers during an eight-hour period. Heavy work can triple these figures, because more air is inhaled. Many experts feel this standard does not provide sufficient protection for workers.

TABLE 16	AIR-QUALITY STANDARDS FOR SILICA

TYPE OF SILICA	TLV-TWA (MG/M^3)a
AMORPHOUS	
Diatomaceous earth (uncalcined)	inhalable[b]: 10
	respirable[c]: 3
Precipitated silica[d]	total dust[e]: 10
Silica gel (sodium silicate)[d]	total dust: 10
Silica, fume	respirable: 2
Silica, fused	respirable: 0.1
CRYSTALLINE[f]	
Cristobalite	respirable[b]: 0.05
Quartz	respirable[b]: 0.05
Tridymite	respirable[b]: 0.05
Tripoli (as quartz)	respirable[b]: 0.1

a. Threshold Limit Value–Time-Weighted Average in milligrams per cubic meter (mg/m^3) for the year 2001.
b. Inhalable: that portion of dust that can deposit anywhere in the respiratory system.
c. Respirable: that portion of dust that deposits deep in the lungs in the gas exchange area (alveoli).
d. A synthetic product.
e. Total dust: all sizes of particles.
f. All crystalline forms are also regulated as carcinogens.

Feldspars are a group of minerals that combine silica (SiO_2) and alumina (Al_2O_3) with metal (alkali) oxides. The most common of these are sodium (in soda spars), potassium (in potash spars), and calcium (in lime spars). These metals are usually relatively insoluble and are not very toxic, except for the caustic, irritating quality they may impart to the spar. Many other metals (such as magnesium [Mg], titanium [Ti], iron [Fe], barium [Ba], lithium [Li], and more) may also be present in the spar, and these may be soluble to varying degrees. Analyses of spars should be obtained to estimate their health hazards and to understand their behavior in glazes or glass.

The major hazard associated with spars is the common presence of free silica contaminants.

Kaolin and Other Clays. "Kaolin" is a term usually used to describe white clays containing the clay mineral kaolinite. However, the term "clay" refers to any of

a number of minerals that dry to a hard form that can be treated with heat to form a hard, waterproof material. The ones most commonly used in ceramics are minerals of various crystal structure arrangements of alumina, silica, and water. Other metals can be present in the structure of some clays.

The metal elements in clays are too well bonded to be soluble, and their hazards come from their crystal structures. It is suspected that many clays can cause lung-scarring diseases after years of heavy exposure, but the disease best documented is kaolinosis, which is seen in kaolin miners.

Since they are mined from the earth, clays usually contain many impurities. The major hazard associated with clay is the common presence of significant amounts of free silica contamination. (See chapter 18 for information on dioxin contamination of clays.)

SYNTHETIC MINERAL FIBERS

Synthetic mineral fibers include ceramic fiber, glass wool, slag wool, and rock wool. Research is beginning to show that microscopic, needlelike inert materials, whether of asbestos, glass, or ceramic origin, may cause lung diseases and cancer. In June 1987, the International Agency for Research on Cancer (IARC) recategorized glass wool, rock wool, slag wool, and ceramic fibers as being "possibly carcinogenic to humans" after evaluating data from laboratory experiments and from studies of workers in fiber-producing plants.

Ceramic fibers are also considered suspect carcinogens by IARC, and the ACGIH has set a standard for refractory ceramic fibers that is almost as protective as that for asbestos (0.2 f/cc). The ceramic fibers have also been shown to partially convert to cristobalite (see the section on silica above) when they are heated to 870°C (1600°F) or above. This means that ceramic fibers used as insulation in kilns and furnaces will convert as the equipment is used.

FRITS

Frits are used in ceramic glazes, enamels, and glass colorants for stained and blown-glass surfaces. They can be thought of as amorphous or as "less-structured minerals." Frits are made by melting metal compounds, silica, and other ingredients into a glass and reducing the glass to a powder. This is done in the mistaken belief that fritting makes the metals insoluble and safe. The theory is that if a frit is acid-insoluble, it will not be absorbed into the body.

LEAD FRIT SOLUBILITY. Lead frits were developed in Britain in the 1800s, in hopes of reducing the number of pottery workers' deaths from poisoning by highly soluble raw lead compounds such as litharge and white lead. Indeed, deaths from lead poisoning were greatly reduced after frits were introduced.

For almost a hundred years, the safety of these acid-insoluble lead frits was accepted uncritically and with essentially no supporting experimental data. No one assessed the effects of other measures that were introduced into potteries at precisely the same time, including ventilation, wet cleaning, hand washing, protective clothing, and other hygiene practices. Now, we know that these hygiene measures were the major reason that lives were saved.

ANIMAL DATA. In 1985, the acid solubility theory was tested directly. Investigators compared the solubility of lead disilicate and lead monosilicate frits with raw red lead in acid. Then, they exposed rabbits to these substances by ingestion and by inhalation and plotted the animals' blood lead concentrations against time (six days for exposure by ingestion, twelve days for exposure by inhalation). The study concluded:

> Those compounds which exhibit a lower solubility in acidic media do not behave differently in *in vivo* experiments from the other compounds and, in particular, from red lead. Moreover, the compounds which exhibit the lowest absorption levels via the . . . digestive system . . . do not show the lowest solubilities in acidic and biological media.
>
> Consequently, the *in vitro* solubility of each compound does not predict the degree of absorption *in vivo* by experimental animals. . . .[2]

The ceramic industry and their toxicologists did not accept this animal data. It took human poisonings to convince them.

HUMAN DATA. Poison control centers in the United States have reports of hundreds of human ingestions of lead glazes over the years. There were 318 cases reported in 1991 alone. These incidents occurred because teachers and

[2] Sartorelli, et al, (University of Siena). "Lead Silicate Toxicity: A Comparison among Different Compounds," *Environmental Research* 36 (1985):420–425.

occupational therapists believed the labels on these glazes that clearly said the lead frit glazes were nontoxic.

In 1992, another nursing-home patient swallowed some glaze labeled "lead-free." Unlike the previous ingestions, this patient's blood was tested, and it was proven that the lead had been absorbed.[3] The significance of this event was understood by Dr. Woodhall Stopford, toxicologist for the Arts and Creative Materials Institute, the largest certifier of art and hobby products in the United States. In fact, Dr. Stopford had routinely certified lead frit glazes as nontoxic.

In deposition in 1997 in a suit involving alleged lead-glaze exposure, Dr. Stopford referred to the 1992 nursing home incident in the following exchange:

> DR. STOPFORD: And at that time, one of the glazes that was being used was in the low-soluble category, and its ingestion was associated with an elevated blood lead level.
>
> Q: Say that to me again in layman's terms?
> DR. STOPFORD: . . . It appeared that the categorization between insoluble and soluble did not really have meaning from a toxicologic basis.
>
> Q: Did it have any meaning for the consumers?
> DR. STOPFORD: Well, it's apparent that they would be at risk if they ingested either soluble or insoluble lead glazes.[4]

Clearly, all lead frits should be considered toxic and sources of lead exposure by inhalation and ingestion.

NONLEAD FRITS. There is little or no data on the solubility of nonlead frits, yet these may contain barium, lithium, and other toxic metals. Prudence dictates that all frits be treated as if their metal ingredients are a source of exposure.

[3] "Morbidity and Mortality Weekly Report," Centers for Disease Control, Vol. 41, No. 42 (October 23, 1992): 781–783.
[4] Deposition: 4-1-97, page 69 (Ashley Rose Witt, a minor, by and through her mother and natural guardian, Patty Moore, and Ronald Witt versus Duncan Enterprises; American Art Clay Co.; Mayco Colors, Inc.; C and R Products, Inc.; and Robert R. Umhoefer, Inc., in the Circuit Court, Sixth Judicial Circuit of Florida, Pinellas County, Civil Division, No. 92-5392-CI-20). The plaintiffs alleged their child was brain damaged from exposure to lead glaze dust that had contaminated their home. The dust was transported to the home on shoes and clothing worn when the couple worked in their adjacent pottery studio. The case settled for about $865,000.

GLASS

Glass can be manufactured in an infinite variety of compositions. Natural glasses, like obsidian and pumice, also can vary in composition. Technically, fired ceramic glazes are also types of glass.

When powdered or ground fine, the hazards of these materials, like frits, will depend on the solubility of any toxic metals in the glass and on their ability to mechanically irritate eyes, skin, and the respiratory system. Dust from grinding lead glass, for example, can be both irritating and toxic.

TABLE 17	HAZARDS OF COMMON MINERALS USED IN CERAMICS, SCULPTURE, LAPIDARY, AND ABRASIVES

General information about common minerals is summarized in this table. Inhalation hazards are stressed, since artists are most often exposed to airborne dust from these materials. Silica, asbestos, feldspars, and clays are often found in these minerals. The hazards of these materials are found in the body of the chapter. When toxic metals are present, refer to table 14 in chapter 11.

AFRICAN WONDERSTONE (pyrophyllite, aluminum silicate). Hazards are unstudied.

AGATE (chalcedony, flint, silica). See the section on hazards of Silica, page 173.

ALABASTER (calcium sulfate). May cause eye and respiratory irritation. One of the least toxic stones. A nuisance dust.*

ALUMINUM OXIDE. See Corundum.

AMBER (an organic fossil resin). No significant hazards.

AMETHYST (quartz). See Silica, page 173.

ASURITE. See Malachite.

CALCITE (calcium carbonate, chalk). A nuisance dust.*

CARBORUNDUM (silicon carbide). Inhalation of large amounts may cause a type of pneumoconiosis. A nuisance dust.*

CERIUM OXIDE. No significant hazards in dust form (fume can cause cer-pneumoconiosis).

CHALCEDONY. See Agate.

CORNWALL STONE. A rock (feldspathoid) that contains feldspar (see page 174), quartz, kaolinite (see Kaolin, page 174), mica, and a small amount of fluorspar.

CORUNDUM (aluminum oxide). Inhalation of large amounts is associated with a type of lung scarring called "Shaver's disease." A nuisance dust.*

CRYOLITE (natural or synthetic sodium aluminum fluoride). Highly toxic, due to the fluorine present. Used also as a pesticide.

DIABASE. An igneous rock that contains various minerals. The term refers to different rocks in different countries. May contain feldspars and other minerals that are contaminated with silica.

DIAMOND (carbon). No significant hazards.

DOLOMITE (calcium magnesium carbonate). May contain some free silica.

ERIONITE. A fibrous mineral unrelated to asbestos. Has clearly been shown to cause the same diseases as asbestos in humans.

FLINT (quartz). See Silica, page 173.

FLUORSPAR (fluorite, calcium fluoride). A skin, eye, and lung irritant. Highly toxic, due to the fluorine present. Chronic inhalation can cause loss of appetite, weight loss, anemia, and bone and tooth defects.

GARNET (any of five different silicate minerals). May contain free silica. See Silica, page 173.

GLASS BEADS (various types of glass). Do not cause silicosis. The dust is mechanically irritating to eyes and respiratory tract. If the glass contains toxic metals such as lead, poisoning can result from exposure to the dust.

GRANITE. An igneous rock composed chiefly of feldspar and quartz, with one or more minerals such as mica included. Contains free silica.

GREENLAND SPAR. See Cryolite.

GREENSTONE. A basaltic rock having green color from the presence of chlorite, epidote, or other minerals. May contain free silica. Some stones sold as greenstone may contain asbestos minerals.

GYPSUM. See Alabaster.

ILMENITE. A titanium-containing iron ore (see Titanium and Iron in table 14).

JADE. Two common mineral forms of jade are jadeite, which has no significant hazards, and nephrite, which is felted, intergrown, fiber-like crystals of tremolite and actinolite (forms of asbestos). The term "jade" also may be incorrectly applied to Serpentine (see below).

JASPER (a black crystalline variety of quartz). See Silica, page 173.

LEPIDOLITE. A lithium-containing mica. See Mica below and Lithium in table 14.

LAPIS LAZULI is usually a mixture of minerals, with the principal mineral being lazurite, which contains aluminum, silicon, sodium, and sulfur. May cause skin and respiratory irritation. On ingestion, the sulfur in the mineral may be capable of forming highly toxic hydrogen sulfide gas with digestive acids.

LIMESTONE (calcium carbonate). May contain significant amounts of free silica.

MAGNESITE (magnesium carbonate). No significant hazards.

MALACHITE (hydrous copper carbonate, azurite). Can irritate the eyes, nose, and throat. Known to cause nasal congestion and, in severe exposure, can cause ulceration and perforation of the nasal septum. Chronic exposure can cause anemia.

MARBLE (calcium carbonate). May contain some free silica. A nuisance dust* if silica is not present.

MICA. Any of several silicates of varying chemical composition having a similar crystalline structure composed of thin sheets. Some natural micas contain free silica. Synthetic mica is also available.

NEPHELINE SYENITE. A mixture of feldspars, free silica, and other minerals.

OCHRES. Clays containing iron oxides and, occasionally, manganese oxides. See Kaolin, page 174, and iron and manganese in table 14.

ONYX. A variety of quartz. See Silica, page 173.

OPAL (silica). An amorphous silica, which should be of low toxicity to the lungs, but large amounts may cause some lung scarring.

OPAX. A frit of 92 percent zirconium dioxide, 6 percent lithium dioxide, and smaller amounts of titanium, iron, sodium, and aluminum. See Zircon and Lithium in table 14.

PEARL ASH. See Potash.

PERLITE. A natural, glass-like material that expands when heated. May contain significant amounts of free silica.

PETALITE. A lithium feldspar. See Feldspar, page 174, and Lithium in table 14.

PORPHYRY (conglomerate rock containing some feldspar). May contain significant amounts of free silica.

POTASH (potassium carbonate). Irritating and slightly caustic. A nuisance dust.*

PUMICE (a form of volcanic glass). May contain small amounts of free silica.

PUTTY (tin oxide). No significant hazards. Inhalation of large amounts can cause benign pneumoconiosis (see page 171).

REALGAR (arsenic disulfide). A highly toxic mineral causing skin irritation and ulceration. Inhalation can cause respiratory irritation, digestive disturbances, liver damage, peripheral nervous system damage, kidney and blood damage.

ROUGE (iron oxide). An abrasive, usually contaminated with significant amounts of free silica.

SAND, SANDSTONE (quartz). See Silica, page 173.

SERPENTINE (magnesium silicate). Usually is in the form of chrysotile asbestos. See Asbestos, page 172.

SILICON CARBIDE. See Carborundum.

SLAG (glass-like material from smelting operations). May contain small, but significant amounts of highly toxic metal impurities. May be contaminated with free silica.

SLATE (a rock formed from compression of clay, shale, etc.). May contain significant amounts of free silica.

SOAPSTONE. See Talc.

SODA ASH (sodium carbonate). Slightly irritating. No significant hazards.

SODA SPAR. Sodium-containing feldspars. See Feldspars, page 174.

SODIUM SILICATE, or water glass (sodium silicate). Some products contain free silica.

STEATITE. See Talc.

TALC. A magnesium silicate platy mineral responsible for the slippery feel of soapstone and steatites. Talc causes a disease called "talcosis" when inhaled in large amounts. Many talcs, soapstones, and steatites are contaminated with many other minerals, including amphibole asbestos and silica.

TIGER'S EYE. A compressed form of crocidolite asbestos.

TRIPOLI (silica). Primarily an amorphous silica, which should be of low toxicity to the lungs, but most varieties contain enough quartz to cause silicosis.

TRAVERTINE (calcium carbonate). See Limestone.

TUNGSTEN CARBIDE. A synthetic mineral assumed to be very low in toxicity. Sometimes, however, needlelike fibers of tungsten carbide are created, which may be hazardous.

TURQUOISE (mineral of copper, aluminum, and phosphate). May cause skin allergies and irritation of the eyes, nose, and throat. May be contaminated with significant amounts of free silica.

VERMICULITE. A platelike, hydrated magnesium-iron-aluminum silicate mineral capable of being expanded (puffed up) with heat. Often found contaminated with tremolite or chrysotile asbestos.

WHITING (calcium carbonate). Some natural sources contain free silica. When silica is not present, it is a nuisance dust.*

WOLLASTONITE. A fibrous mineral unrelated to asbestos that may have some potential to cause cancer. Not well studied.

ZIRCON OXIDES, or zirconia. See Zircon in table 14.

ZIRCONIUM SILICATE, or zircon. See Zircon in table 14.

ZONOLITE. See Vermiculite.

* The ACGIH nuisance dust level is 10 mg/m³.

CHAPTER 13
PLASTICS AND ADHESIVES

Plastics have revolutionized art. Artists now use plastics as vehicles in paints and inks, as casting materials, adhesives, structural elements, textiles, and much more. Plastics are created when a chemical called a "monomer" reacts to form a "polymer."

MONOMERS AND POLYMERS

A "polymer" is created when a chemical called a "monomer" reacts with itself to form large molecules, often in long chains. This reaction is called "polymerization." For example, when a monomer called methyl methacrylate is polymerized, it becomes polymethyl methacrylate, better known as Lucite®. These polymers are called "thermoplastics."

Most monomers are very toxic, but once polymerized, the polymer or resin is not usually hazardous. For example, methyl methacrylate is very toxic, but Lucite® solid plastic is essentially nontoxic.

Some polymers are capable of a second reaction, in which the long chains are linked together laterally (side-by-side). This reaction is called "cross-linking." For example, liquid polyester resin becomes a solid material when it is reacted with a cross-linking agent like styrene. Aging or heat will also cross-link some polymers. These polymers are called "thermoset plastics." An example of a thermoset plastic is the polyester body filler used to repair cars.

Thermoplastics and thermoset plastics possess different properties. Thermoplastics will usually deform or can be molded with heat into new shapes, and they can usually be redissolved in solvents. On the other hand, heat will not deform thermoset plastics. Instead, it will cause thermoset polymers to yellow, degrade, or burn. Age will also cause them to yellow and become brittle. And although solvents may soften them, thermoset plastics will not dissolve in solvents.

NATURAL POLYMERS

Natural substances, materials such as rubber and hardened linseed oil, can also function as polymers. All "setting oil" polymers, such as linseed, tung, and poppy seed oils, give off heat when they polymerize or harden. Rags and paper towels wet with these oils can spontaneously combust if not placed in air-tight containers, in water, or hung out to dry.

Natural substances also can cross-link with age, causing yellowing and brittling. Included are linseed oil, the animal glues, and shellac.

INITIATORS

Chemicals used to cause monomers and resins to react to form polymers or to cross-link are among the most toxic chemicals involved in plastics. These chemicals have many trade names, including activators, catalysts, curing agents, hardeners, driers, or initiators. In this book, the term "initiator" will be used in most cases.

There are also chemicals called "accelerators" that speed polymerization. Most chemical initiators and accelerators are not only toxic, they are often chemically unstable and may pose serious safety hazards. Even the initiators for natural resins such as linseed oil are metallic driers that may contain lead, manganese, or other toxic metals.

ADDITIVES

Even a water-clear piece of plastic is not "pure." In addition to the polymer itself, there are hosts of additives in plastics. These include antifoaming agents left over from manufacture, antioxidants to slow aging, ultraviolet light inhibitors to prevent yellowing in the sun, plasticizers to keep them soft, and more. The plastic products that have the greatest number of additives are the new water-based plastic paints, casting and molding resins, and adhesives.

WATER-BASED POLYMER EMULSIONS AND DISPERSIONS

Many polymer resins and paints are sold as water-based emulsions. Users should be aware that there are a great number of additive ingredients (see table 18) that will not be listed on the label or identified on the Material Safety Data Sheet. And many of these chemicals are unstudied, so their toxicological effects are unknown.

TABLE 18	ADDITIVES COMMON IN WATER-BASED EMULSIONS

Types of chemicals likely to be in water-based emulsion products include:

1. Adhesion promoters
2. Anti-sag and settling agents
3. Anti-skinning
4. Antistatics
5. Biocides (pesticides)—two types:
 a. to protect emulsion in the can
 b. to remain in the dry product
6. Defoamers
7. Dispersants driers
8. Emulsifiers
9. Flame retardants
10. Flash rust inhibitors
11. Flatting agents
12. Flow modifiers
13. Freeze-thaw stabilizers
14. Mar-and-slip aids
15. Moisture scavengers
16. pH (acid) control agents
17. Plasticizers
18. Rheology modifiers
19. Surfactants
20. UV absorbers
21. Wetting agents

Of these additives, the phthalate plasticizers have most recently been in the news.

PHTHALATE PLASTICIZERS

The phthalates are a class of chemicals added to several types of plastics to keep them soft and pliable. They are most often found in vinyl plastic. These plasticizers are used in such large quantities and in so many products that phthalates are found in the blood of almost all people on the planet.

There are many different phthalate plasticizers, but only two or three have been studied for long-term toxicity. Animal studies and human epidemiological studies appear to link some of the phthalates to cancer, others to premature breast development in six- to twenty-four-month-old girls, abnormal development of young boys, and other reproductive problems. The phthalates seem to function in the body as if they were the hormone estrogen.

Until it is clear which phthalates are safe to use, young children should not use products containing them—items such as soft vinyl teething toys. And older children and women planning families should not use products such as the polymer clays. These vinyl plastic, oven-cured products expose users by skin contact and inhalation (during firing) to phthalate plasticizers. For detailed

information on these products, see the Oven-Cured Polymer Clays data sheet in appendix A, part 1, or chapter 23, page 284)

GENERAL PRECAUTIONS FOR TWO-COMPONENT RESIN SYSTEMS

1. Prepare precautions in advance. Investigate the hazards of plastic resin systems before using them. Read Material Safety Data Sheet and product literature precautions, and be sure your shop is equipped with necessary protective equipment and ventilation. Be prepared to deal with spills and disposal of the materials.

2. Follow product directions precisely, and mix exactly in the proportions recommended. If directions are followed, the polymerization reaction should bind the hazardous chemicals into the solid plastic. If they are mixed in the wrong proportions, the resulting mass may never cure properly and may outgas toxic substances almost indefinitely. For example, mixing by weight when the directions ask to mix the components by volume has resulted in such problems.

POLYESTER RESIN CASTING SYSTEMS

Hazardous chemicals used in these systems include: the cross-linking agent, which is usually styrene; ketone solvents such as acetone used to dilute or clean up the resin; the initiator, which is an organic peroxide such as methyl ethyl ketone peroxide; and fiberglass for reinforcement.

Styrene is a highly toxic aromatic hydrocarbon solvent, which can cause narcosis, respiratory system irritation, and liver and nerve damage. Styrene is also an animal carcinogen. Acetone is a less toxic solvent, but it is extremely flammable. (See table 9, page 95.)

Methyl ethyl ketone peroxide and other organic peroxide curing agents are extraordinarily reactive and hazardous. See Organic Peroxides below.

Fiberglass dust causes skin and respiratory irritation and is a carcinogen. There are many other compounds in polyester resin systems that initiate, promote, or accelerate the reaction. The hazards of many of these chemicals are not known.

PRECAUTIONS FOR USING POLYESTER RESINS

1. Work only in local exhaust areas. Additional protection may be obtained by wearing a respirator with cartridges for organic vapors. Add a dust filter to the respirator if you use fiberglass or if you sand the finished plastic.

2. Wear gloves and chemical splash goggles when handling and pouring materials. Protection from some plastic resin chemicals requires special types of gloves. Ask the glove manufacturer for advice.

3. Wear clothing that covers your arms and legs. Remove clothes immediately if they are splashed with resins or peroxides. Always remove clothing completely after work, then take a shower.

4. Cover exposed areas of your neck and face with a barrier cream as protection in case of splashes.

5. Handle peroxides correctly by following the advice in the section on Organic Peroxides below. Be especially careful to avoid splashes in the eyes, and never mix peroxides with acetone.

6. Use acetone, not styrene, when you clean up. Cover your work area with disposable paper or plastic sheeting to make cleaning easier.

7. Follow all precautions for using solvents, such as cleaning up spills immediately, disposing of rags in approved, self-closing waste cans, and the like (see chapter 9).

8. When mixing small amounts of resins, use disposable containers and agitators, such as paper cups and wooden sticks. If you need reusable containers, use polyethylene or stainless steel containers.

PLASTIC MOLD-MAKING MATERIALS

SILICONE. Two types of silicone resin systems are commonly used to make molds. The first is a single-component system, which cures by absorbing atmospheric moisture. The second is a two-component system, which cures by means of a peroxide (see section on Organic Peroxides below). Both systems contain solvents such as acetone or methylene chloride.

Single-component systems may release acetic acid or methanol into the air. Acetic acid vapors are highly irritating to the eyes and respiratory tract. Methanol is a nervous-system poison (see table 9 on page 95). Two-component systems often contain chemicals that can damage the skin. Some also contain methylene chloride, which can cause narcosis and stress the heart (see table 9). Some two-component systems contain chemicals that can damage the skin or that are highly toxic, such as ethyl silicate (see table 9) and dibutyl tin dilaurate, which is an organic tin biocide (see organic tin compounds, under "Tin" in table 14).

SYNTHETIC RUBBER LATEX. The word "latex" means any plastic or polymeric substance in an essentially aqueous medium or water dispersion. The

polymer in the latex could be a polyacrylic plastic, butadiene rubber, urethane, or any other synthetic or natural polymer. The term "rubber" is applied to any of these natural or synthetic polymers having unique properties of deformation and elastic recovery. The synthetic "rubbers" are chemically unrelated to natural rubber.

The hazards of synthetic rubber and plastic latexes are primarily attributable to their many additives rather than to the plastic itself. The additives often include glycol ether solvents, formaldehyde preservatives, and stabilizers that release ammonia.

NATURAL RUBBER. Derived from latex sap drawn from Hevea trees, natural rubber can be considered a plastic resin manufactured by Mother Nature. It contains a chemical called isoprene, a monomer that can react with itself to form a polymer called *poly*isoprene. Water-based natural rubber latex systems are commonly used to make molds.

Mother Nature also put a lot of additives in the tree sap. Some of these are natural proteins that cause serious, sometimes life-threatening allergies (see chapter 6). Some types of natural rubber latex mold products also contain additional man-made additives, such as ammonia stabilizers and other toxic chemicals.

Solvent-containing rubber products are also on the market, including rubber cement and some types of contact cements. These products may contain very toxic solvents, such as hexane, which is especially toxic to the nervous system (see table 9, page 95).

PRECAUTIONS FOR USING SILICONE AND RUBBER
1. Do not use natural rubber latex products if you are allergic to rubber.
2. Use with sufficient ventilation to remove solvent vapors and other volatiles.
3. Wear protective gloves. Consult the manufacturer of the resin or latex about the proper gloves to use.
4. If any components are liquid, wear goggles when pouring or handling them.
5. Follow all solvent precautions when using products containing solvents.

EPOXY RESIN SYSTEMS
Epoxies are used for paint and ink vehicles, casting, laminating, and molding. They also are common adhesives and putties. Most are two-component systems. After they are mixed, the resulting epoxy gives off heat, which vaporizes

any solvents in it. An excess of hardener can cause the epoxy to heat to the point of decomposition and ignition.

Epoxy resins can irritate the skin. Epoxy hardeners are often amines, which are highly sensitizing to the skin and respiratory system. Almost 50 percent of industrial workers regularly exposed to epoxy develop allergies to them. Epoxies may also contain varying amounts of solvents. Common solvents in epoxy include the glycidyl ethers, which have caused reproductive and blood diseases in animals—including atrophy of testicles, damage to bone marrow, and birth defects.

Certain epoxy formulations contain chemicals that render the products unreasonably and unnecessarily hazardous to use. Check Material Safety Data Sheets, and screen out products that contain:

1. *Diaminodiphenyl sulfone* (4,4'-sulfonyldianiline), a chemical with questionable cancer data, experimental reproductive effects, and serious toxic effects on humans. It is used in leprosy treatment and is very toxic even in milligram amounts.
2. *Dimethyl aniline* (DMA), a highly toxic skin-absorbing chemical.
3. *Imidazole* (glyoxalin), a skin-absorbing pesticide that kills by blocking histamine.
4. *Glycidol* (2,3-epoxypropanol), an animal carcinogen and genotoxin (causes genetic damage) chemical.
5. *Methylene dianiline* (MDA), a highly toxic animal carcinogen and skin-absorbing chemical.
6. *Primary glycol ethers* (2-methoxyethanol, 2-ethoxyethanol, and their acetates), skin-absorbing, with human reproductive hazards for men and women.

There are plenty of epoxy products to choose from that do not contain these chemicals. Also, refuse to work with epoxy products whose ingredients are trade secrets.

PRECAUTIONS FOR USING EPOXY RESINS

1. Wear goggles and gloves when using large amounts of epoxy. Do not mold epoxy putties by hand without wearing gloves; barrier creams do not provide sufficient protection.
2. When using large amounts of epoxy, do so either with local exhaust (such as a spray booth) or in front of a window exhaust fan.

3. Use liquid epoxies (those containing special solvents) in local exhaust, and take special precautions to avoid skin contact. Check with glove suppliers to find the glove material that will resist penetration of the particular solvent.

URETHANE RESINS

Single-Component Systems. Polyurethane varnishes and paints that are single-component systems and that are simply painted on are usually not very toxic. Their toxicity is usually related to the solvents and other volatile chemicals that outgas during drying. Occasionally, poor quality urethane paints and varnishes will contain highly toxic residual monomers (isocyanates), which are highly toxic. Do not use products whose MSDSs indicate that these contaminants are present in significant amounts.[1]

Two-Component Systems. These polyurethane resin systems usually consist of a polyol polymer resins (which might also contain metal salts or amine initiators) and isocyanate cross-linkers. Foam casting systems also contain blowing agents such as freon. Examples of urethane resin systems include A-B Foam®, Great Stuff® (in aerosol can form), Insta-Foam®, Insta-Pak®, Ureol® systems, and Imron® paints.

Many artists, especially theatrical scene and prop makers, have used foam polyurethane casting systems. However, artists should avoid these systems for several reasons.

For starters, the isocyanate cross-linkers (which are related to the chemical that caused 2,000 deaths in Bhopal, India) are so irritating and sensitizing that they can cause acute asthma-like respiratory distress and other symptoms at very low levels. For this reason, the Threshold Limit Values (see pages 24–27 for definitions of TLVs) for the cross-linkers are so low that most studios and shops cannot manage to comply with them when such materials are used. For example, the TLV for one common isocyanate—toluene diisocyanate—is 0.005 ppm.

Secondly, expensive air-supplied respirators usually must be used with isocyanates, because the odor of the isocyanates is not strong enough to warn people when respirator cartridges are spent. OSHA allows the use of air-purifying respirators *only under two conditions:*

[1] The amount of isocyanate that is significant varies with the amount of material to be used, the way in which the product will be applied, the ventilation at the location of use, the health history of the users, and many other factors. Artists who need to know whether a particular product is safe for them to use can provide ACTS with the MSDS and ask for a risk assessment.

1. Air-purifying cartridges can be used if they have an end-of-service life indicator—e.g., they change color or show some visible change when they cease working. This option is excluded, since currently, there are no such indicators for the diisocyanates.

2. Cartridge respirators can be used if the employer has a change-out schedule for cartridge replacement based on *objective exposure data*. This data includes the concentration of airborne contaminant to which employees will be exposed as determined by personal-air monitoring of potentially exposed employees during *routine* tasks. This is not usually feasible for art and theater shops, since "routine" tasks are rare and most such shops could not afford to do regular air monitoring.[2]

For all intents, artists and schools cannot use air-purifying respirators for protection from products that release isocyanates. Local exhaust ventilation systems or air-supplied respiratory protection are the only real options.

Lastly, the final urethane plastic product is still hazardous. When heated or burned, it can give off hydrogen cyanide, carbon monoxide, acrolein, and other toxic gases. Even cutting, sanding, and finishing the final product have been associated with skin and respiratory problems.

PRECAUTIONS FOR USING URETHANE RESINS

1. Do not allow anyone who has a history of allergies, heart problems, or respiratory difficulties to be exposed to urethane resins.

2. Use them in a local exhaust system large enough to enclose the entire project. If you also need respiratory protection, use an air-supplied respirator with full-face mask.

3. Wear protective clothing and gloves during foaming and casting.

4. Use ventilation when sanding and cutting finished plastic, and wear protective clothing and gloves. Wear a dust mask and goggles if static electricity causes dust to cling to face and eyes.

OTHER RESIN SYSTEMS

There are a number of other resin systems that are occasionally used in the arts. For example, systems employing methyl methacrylate (MMA) alone or in com-

[2] For the full OSHA policy on this issue, see the July 18, 2000, Letter of Interpretation at *www.osha.gov.*

bination with other monomers are used occasionally. Some of these systems need special precautions, because they involve elevated pressures and/or temperatures.

Investigate the hazards of plastic resin systems before using them. Obtain Material Safety Data Sheets and other product information, and be sure your shop is equipped with necessary protective equipment, spill control, and ventilation.

ORGANIC PEROXIDES

Organic peroxides (do not confuse these with hydrogen peroxide, which is not as hazardous) are used to initiate many polyester, acrylic, and even some epoxy and silicone polymerizations. Examples are methyl ethyl ketone peroxide, cumene hydroperoxide, and benzoyl peroxide.

In general, organic peroxides burn vigorously and are both reactive and unstable. For example, pure methyl ethyl ketone peroxide (MEK-P) is a shock-sensitive and friction-sensitive explosive, which also cannot be extinguished once it starts to burn (it supplies its own oxygen). For example, if peroxides ignite after being spilled on clothing, the fire cannot be extinguished and will burn until spent.

For this reason, organic peroxide curing agents are usually sold in solutions that dilute and inhibit these effects. If they are stored too long or stored in exposure to air, excessive heat, or sunlight, they will again become explosive. In addition, the inhibited mixtures have been known to burn quietly until all the inhibitor is burned off; then, the fire intensifies.

Organic peroxides must not be mixed with many solvents. Even the inhibited MEK-P can form an explosive mixture with acetone and some other solvents.

The toxic hazards of organic peroxides are largely unknown. In general, their vapors may cause eye irritation, and many are sensitizers. They cause respiratory irritation, and there are no air-purifying respirators approved for them. MEK-P has even caused blindness when splashed in the eyes.

PRECAUTIONS FOR USING PEROXIDES

1. Obtain Material Safety Data Sheets and product information on peroxides. Pay special attention to information about reactivity, fire hazards, and spill procedures.
2. Keep date of purchase and date of opening on the container label. Dispose of peroxides after six months if unopened or after three months once opened. Never purchase peroxides if containers are damaged or irregular.

3. Store peroxides separately from other flammables and combustibles. Always keep peroxides in their original containers.

4. Do not store large amounts of peroxides without consulting fire laws and OSHA standards.

5. Do not heat peroxides or store them in warm areas or sunlight.

6. Never dilute peroxides with other materials or add them to accelerators or solvents.

7. Wear protective goggles when containers are open or when pouring peroxides.

8. When mixing small amounts of resins and peroxides, use disposable containers. Soak all tools and containers in water before disposing of them.

9. Clean up spills immediately in accordance with Material Safety Data Sheet directions. Inert materials, such as unmilled fire clay, are usually recommended to soak them up. Clean up peroxide-soaked material with nonsparking, nonmetallic tools. Do not sweep them; fires have started from the friction of sweeping itself.

10. If peroxide spills on your clothing, remove your clothes immediately, and launder them separately and well before wearing them again.

11. Call a toxic waste company to dispose of unused peroxides. Otherwise, unused peroxide can be reacted with resin and the solid, nonhazardous plastic discarded as ordinary waste.

FINISHED PLASTICS

Rather than working with resin systems, it is easier and safer to work with sheets, films, beads, or blocks of finished plastic. Even so, when plastics are cut or heated, decomposition products are released, and these products can be hazardous. Processes during which this can occur include sawing, sanding, hot-knife or wire cutting, press molding, drilling, grinding, heat shrinking, vacuum forming, plastic burnout casting, torching, and melting. In general, the gases and smoke produced from the finished plastics during high-heat processes are usually more dangerous than those produced at lower temperatures.

Some plastics are especially hazardous to cut or heat. Among these are polyvinyl chloride (which produces hydrochloric acid gas) and all nitrogen-containing plastics, such as polyurethane, melamine resins, urea formaldehyde, and nylon (which produce hydrogen cyanide gas).

In addition, the dusts of some plastics are very sensitizing, and this dust will contain many potentially hazardous additives, such as plasticizers (used to

achieve the desired softness), stabilizers, colorants (dyes and pigments), fillers, fire retardants, inhibitors, accelerators, and more. Some of the common plasticizers (some of the phthalate esters) are known to cause cancer in animals. However, the vast majority of these additives' hazards are unknown.

Some plastics adhesives also contain toxic solvents that require precautions (see table 9 on page 95).

PRECAUTIONS FOR WORKING WITH FINISHED PLASTICS

1. Use good dilution ventilation or local exhaust ventilation. Use water-cooled or air-cooled tools, if possible, to keep decomposition to a minimum. Use the lowest possible temperature, and provide ventilation when heat forming or vacuum forming.

2. Add vacuum attachments to sanders, saws, and other electric tools to collect dust.

3. Wear dust goggles and a dust mask if static electricity causes particles to cling to face and eyes. Remember that the dust mask provides protection only against particles. No mask will protect you from all the emissions from plastics. Organic vapor respirators will trap some decomposition gases and vapors. Acid gas cartridge respirators will collect hydrochloric acid gas from decomposing polyvinyl chloride plastics. However, there are no approved cartridges or filters for emissions such as hydrogen cyanide, isocyanates, and nitrogen oxides.

4. Clean up all dust carefully by wet-mopping or by using specially filtered vacuums. Do not sweep.

5. Follow precautions for solvents when using plastics adhesives.

GLUES AND ADHESIVES

Most glues and adhesives are either synthetic or natural polymers. Most are less hazardous than casting plastics, simply because smaller amounts are used. Some common ones are listed in table 19.

TABLE 19	HAZARDS OF ADHESIVES AND POLYMERS

ACRYLIC POLYMERS. Acrylate polymers and copolymers dissolved in solvents or suspended in dispersions and emulsions. Common monomers are methylmethacylate, ethylmethacrylate, and iso-butylmethacrylate. Trade names: Acryloid® B72 and B67, Lucite®, Elvacite®, Synocril®, Bedacryl®, Pliantex®. The monomers are respiratory irritants and sensitizers. When dissolved in solvents, the only hazards are the solvents. When in emulsions, there may be small amounts of dozens of other undisclosed chemicals present.

CYANOACRYLATES. The monomer is usually ethyl cyanoacrylate (occasionally methyl cyanoacrylate), and some products are extended with other dissolved acrylate polymers. The initiator for cyanoacrylate is water vapor in the air or on surfaces. Chemical accelerators can also be used. Trade names: Super Glue®, Krazy Glue®, Hot Stuff®, PaleoBond®, Zap®. The monomers are potent eye and respiratory irritants. Fast curing time can cause unplanned and inconvenient adhesion of body parts.

GLUE STICKS. Plastic and/or mucilage materials. No known significant hazards.

EPOXIES. See text above. Trade names: Araldite®, Abelbond®, Devcon®, Epo-Tek®, Hxtal®.

RUBBER CEMENT and **OTHER NATURAL AND SYNTHETIC RUBBERS.** See text above.

SILICONES. See text above.

UREA FORMALDEHYDE and **PHENOL FORMALDEHYDE.** These resins can be used as adhesives when dissolved in solvent solutions or suspended in water-based emulsions. They are also the most common plywood and pressboard adhesives. They off-gas formaldehyde gas. Phenol formaldehyde is more stable and releases less formaldehyde. Avoid if possible.

URETHANE RESINS. See text above.

VINYL RESINS (acetal and butyral). A family of resins resulting from the condensation of polyvinyl alcohol with an aldehyde. The three main groups are polyvinyl acetal, polyvinyl formal, and polyvinyl butyral. They are thermoplastic. The trade name for polyvinylacetal is Alvar® 1570. Polyvinyl formal compounds are not often used. See Vinyl butyral terpolymers below. None of the vinyl monomers are toxic because they are all pre-polymerized and in resin form. Their hazards are the solvents in which they are dissolved.

VINYL ACETATE RESINS (PVAC). Polyvinyl acetate resins are thermoplastic resins, which may be homopolymers or copolymerized with other monomers such as dibutyl maleate. Trade names for homopolymers: Mowilith®, Vinac® B-15 and B-25, Vinlylite®, AYAA®, AYAF®, AYAC®, Gelva®. Trade names for copolymer emulsions: Vinamul®, Mowilith® DM427, Jade®, Elvace®, Elmer's®, Sobo®, White Glue®, CM Bond®. When these emulsions are sold dissolved in solvents, the only hazards are the solvents. The emulsions may contain vinyl acetate monomer in small amounts. Vinyl acetate is an animal carcinogen.

VINYL ALCOHOL RESINS (PVA, PVAL, or PVOH). Made by alcoholysis of a vinyl acetate polymer. These have the same hazards as vinyl acetate resins (see above).

VINYL BUTYRAL TERPOLYMERS. Called polyvinyl butyrals, they are polyvinyl butyral, polyvinyl alcohol, and polyvinyl acetate resins. Trade names: Butvar® B98, B76, and B 72; Moewital®; and Rhovinal® B. The hazards are primarily those of the solvents in which they are dissolved.

VINYLIDENE CHLORIDE POLYMERS (PVDC). Trade name: Saran®. The solvents in the products and possibly the plasticizers are hazardous.

WALLPAPER PASTE. Usually made of wheat or methyl cellulose and preservatives. Wheat pastes in particular usually contain large amounts of pesticides and fungicides. Use wheat or methyl cellulose paste sold specifically for use by children. These should have no significant hazards.

WHITE GLUE. See Vinyl Acetate Resins above.

WHITE PASTE, LIBRARY PASTE. No significant hazards except for the preservative. This is most often wintergreen, which is toxic only in amounts more significant than could be obtained from library paste exposure.

PART III
PRECAUTIONS FOR INDIVIDUAL MEDIA

Using the information in Parts I and II on the hazards of basic types of materials and a general knowledge of precautions such as personal protective equipment and ventilation, it is now possible to provide more detailed precautions for various media, including

Painting and Drawing

Printmaking

Textile Arts

Leather and Other Animal Products

Ceramics

Glass

Stained Glass

Enameling

Ceramic, Glass, and Enamel Surface Treatments

Sculpture, Lapidary, and Modeling Materials

Metal Surface Treatments

Welding

Brazing, Soldering, and Casting

Smithing

Woodworking

Photography and Photoprinting

CHAPTER 14

PAINTING AND DRAWING

The diseases caused by painting and pigment grinding have been observed since Bernardino Ramazzini, the Italian physician, wrote about them in 1713. Back then, painters did not know about the chemical hazards in their paints as we do now.

OLD MATERIALS VERSUS NEW

The highly hazardous methods used in Ramazzini's time should only be demonstrated in art conservation schools in chemistry laboratories. These techniques employ turpentine and highly toxic pigments, because these were the only materials available in Ramazzini's time. The old masters surely would have embraced the safer solvents, purer pigments, and the wide variety of media and colors available today.

Unfortunately, there are artists today who still use eighteenth-century techniques. For example, there are artists working in the Maroger method, which involves cooking linseed oil with lead compounds, mixing raw pigments into a vehicle, composed of hot-leaded linseed oil, damar varnish in turpentine, and gum arabic.

There also are artists making their own pastels and encaustics out of raw pigments, tremolitic talcs, hot wax, and other ingredients. I have seen a home pastel studio so contaminated with mercuric sulfide (vermillion) that the dust was red.

This book will not suggest precautions for artists who work in these ways, because they need to find other ways to express their creativity.

WHAT ARE PAINTS?

Today, artists use a vast array of different paints; however, these products have many properties in common, because almost all of them contain pigments suspended in vehicles or bases.

Vehicles usually contain liquids such as oils, a solvent, and/or water. Cleaners and thinners for most paints are these same liquids or liquids that are compatible with them. For example, odorless paint thinner will thin and clean up oil paints.

WHAT ARE DRAWING MATERIALS?

Drawing materials are also pigments suspended in vehicles. Some drawing material vehicles include wax (crayons), inert minerals (pastels, conte crayons, chalks), and liquids (solvent- and water-based inks and marking pens). Pencils contain "leads" made of graphite and clay ("lead" pencils) or pigmented clay/binder mixtures (colored pencils).

The hazards of both painting and drawing materials arise from exposure to their pigments, vehicles, and solvents.

PIGMENT HAZARDS

There are only a few hundred pigments that are light-fast enough to be used in art. These pigments are used in oils, acrylics, alkyds, pastels, colored pencils, and all colored materials used in high-quality fine arts products. The hazards of these pigments are discussed in chapter 10.

Paints with fugitive pigments (those that fade with time or exposure to light) can be used for work that is not expected to endure many years—theatrical scenery or props, commercial art, or children's artwork. Artists who use untraditional paints, such as consumer wall paints, will also find that the pigments in these paints fade. Fugitive pigments are often complex organic chemicals whose long-term hazards are not well studied.

Inhalation is the route by which pigments are most hazardous. Processes during which pigments could be inhaled include working with raw powdered pigments, using dusty chalks or pastels, sanding or chipping paints, airbrushing or spraying paints, and heating or torching paints until pigments fume.

Skin contact with pigments is less hazardous. Pigments are usually not absorbed in significant amounts by skin contact. However, some contaminants in pigments, such as PCBs (polychlorinated biphenyls), could be absorbed through the skin. And some pigments can cause dermatitis or skin irritation.

Preventing skin contact through good hygiene can prevent these problems. Good hygiene can also prevent accidental ingestion of paint pigments.

VEHICLE HAZARDS

Common vehicles include oils, wax, water, egg yolk, casein, resins, and polymer emulsions and solvent solutions. Vehicles usually also contain additives, such as stabilizers (to keep ingredients in suspension), preservatives, plasticizers, antioxidants, fillers, wetting agents, retarders, and more. These additives affect paint characteristics, such as drying time and workability. The hazards of many of these additives have not been well researched. And manufacturers are often reluctant to divulge the identity of these additives.

Vehicle preservatives can be especially hazardous, since their purpose is to kill microorganisms. Common paint preservatives include formaldehyde (sometimes in the form of paraformaldehyde or formalin), phenol, mercury compounds, bleach, and a host of commercial fungicides and pesticides.

Even though these additives are present in small amounts, they have caused illness in artists. For example, a mural artist developed mercury poisoning some years ago from soluble mercury preservatives used in her paints.

Vehicle ingredients can be divided into volatile (will evaporate into the air) and nonvolatile components. Since nonvolatile ingredients do not become airborne, they usually present no significant hazard to artists, unless they are used in techniques that make them available to be inhaled, such as spray painting. Some resins and vehicle solids are associated with allergies.

Volatile vehicle ingredients, on the other hand, can be inhaled by artists while they work or while paints or inks are drying. Acrylic paints, for example, usually contain ingredients that release ammonia and formaldehyde gases while they dry. Permanent markers contain solvents that evaporate and that, therefore, can be inhaled.

SOLVENT HAZARDS

Solvents may be found in paints and inks or may be used to thin and clean up materials. Solvents are also found in products used with painting and drawing, such as varnishes, shellacs, lacquers, and fixatives. These products include resins, such as damar, mastic, copal, lac, shellac, acrylic, and other plastic resins, dissolved in solvents. (Some of these resins have been known to cause allergies.)

Solvents commonly used in paints, thinners, varnishes, and so on include turpentine, paint thinner, mineral spirits, methyl alcohol, ethyl alcohol, acetone,

toluene, xylene, ethyl and other acetates, and petroleum distillates. The hazards of these and other solvents are discussed in chapter 9.

GENERAL PRECAUTIONS FOR PAINTING AND DRAWING MEDIA

The hazards of each type of painting or drawing will depend on the toxicity of the ingredients of the materials and how much exposure occurs during use. The most hazardous exposure to paints will occur if they are airbrushed, sprayed, or otherwise made airborne. These processes always require local exhaust ventilation.

When paint and ink are applied by brushing, rollering, dipping, and other methods that do not cause pigments and vehicles to become airborne, precautions will vary, depending on the hazards of each paint or ink. See table 20 for precautions for specific media.

TABLE 20	VENTILATION AND PRECAUTIONS FOR PAINTING AND DRAWING MEDIA

The following hazards and precautions apply only to paint and ink techniques such as brushing, rollering, and dipping, all of which do not cause pigments and vehicles to become airborne.

ACRYLIC PAINTS (WATER-BASED EMULSIONS) are composed of synthetic acrylic resins and pigments with many additives, usually including an ammonia-containing stabilizer and formaldehyde preservatives. The small amounts of ammonia and formaldehyde released during painting usually bother only those people already sensitized to these chemicals. A low rate of dilution ventilation, such as that provided by a window exhaust fan, is usually sufficient for most people.

ACRYLIC PAINTS (SOLVENT-BASED) are synthetic acrylic resins and pigments dissolved in solvents. The solvents should be identified, and ventilation sufficient to keep the solvent's concentration at a safe level should be provided.

ALKYD PAINTS are alkyd resins and pigments dissolved in solvents. Provide dilution ventilation at a rate sufficient to keep solvents' concentrations at safe levels.

ARTIST'S OILS are pigments mulled into oils such as pre-polymerized linseed oil. Occasionally, small amounts of solvents are present in those colors that would be too

thick without some solvent. While most oil paints contain no volatile ingredients, oil paints are commonly thinned and cleaned up with solvents such as paint thinner. Dilution ventilation sufficient to keep solvent exposure low should be provided. Some people use oil paints without solvents and clean brushes and skin with baby oil followed by soap and water. This is a very safe way to work and requires no special ventilation. (See also Oil Sticks and Water-Washable Oil Paints below.)

CASEINS are made from dried milk, pigments, and preservatives. Some contain ammonium hydroxide, which can be irritating to the skin and eyes, and dust from the powdered paint should not be inhaled. There are usually very strong preservatives added, because the casein is a good source of food for microorganisms. When painting with brushes or rollers, ordinary comfort ventilation should be sufficient.

CHARCOAL has no known significant hazards.

CHALKS AND CONTE CRAYONS are pigments in binders and chalk (calcium carbonate), talc, barytes (barium sulfate mineral), or other powdered inert minerals. "Dustless" chalks and conte crayons can be used safely, because they contain binders, which prevent creation of respirable-sized dust particles (see page 24). If they are used in ways that create dust, however, it is possible for the dust to be inhaled into the upper portions of the lung, where it can cause irritation and then be ingested. (See also Pastels below.)

CONSUMER OIL PAINTS AND ENAMELS contain pigments, fillers, and a variety of solvents. A common solvent for these paints is paint thinner. Sufficient dilution ventilation should be provided.

CONSUMER LATEX PAINTS are primarily pigments and water emulsions of various plastic resins. Most also contain between 5 and 15 percent solvents. On occasion, these solvents are the highly toxic glycol ethers (see table 9 on page 95), which can be skin-absorbed and inhaled. Dilution ventilation and proper gloves should be provided. Men and women planning families and pregnant women should avoid exposure to paints containing the glycol ethers.

CRAYONS are pigments in wax. Most have no significant hazards, because the pigments are contained. Techniques that involve melting crayons may produce irritating wax decomposition products, which would require exhaust ventilation.

DRAWING INKS may contain hazardous dyes and solvents. Skin contact should be avoided. Ventilation is needed only if extraordinary amounts are used or if the solvents are especially toxic.

FRESCO consists of pigments ground in lime water (calcium hydroxide), which is corrosive to eyes, skin, and respiratory tract. Gloves and goggles should be worn.

ENCAUSTICS are dry pigments suspended in molten white refined wax, such as beeswax, along with drying oils, Venice turpentine, and natural resins. Working with dry pigments is very hazardous. Heating waxes can release highly irritating wax decomposition products such as acrolein and formaldehyde. Torching the wax surface also can cause pigments to fume. The solvents and wax and pigment fumes require local exhaust ventilation.

EPOXY PAINTS are two-part epoxy resin systems and contain highly toxic and sensitizing organic chemicals (see chapter 13) and diluents (solvents). Some contain highly toxic glycidyl ether solvents. Wear gloves and goggles, and avoid inhalation with local exhaust ventilation or respiratory protection.

GOUACHE is an opaque water color that contains pigments, gums, water, preservatives, glycerin, opacifiers, and other ingredients. The opacifiers may be chalk, talc, and other substances. Formaldehyde may be used as a preservative. Ordinary comfort ventilation should be sufficient, unless very large amounts are used.

MARKING PENS contain pigments or dyes in a liquid. The liquid may be water or a solvent. Water-based markers are safest. Of the solvent-based markers, those containing ethyl alcohol are the safest. Others may contain very toxic solvents. Solvent-based markers should be used with some ventilation.

OIL STICKS are artist's oil paints in stick form, which can be used without solvents. Painting methods that do not employ solvents are inherently safer.

PASTELS are pigments in vehicles such as talc, barytes (barium sulfate mineral), or other powdered inert minerals. It is essentially impossible to use dry pastels safely, because artists will be exposed to respirable-sized pigment and vehicle particles (see page 24). A HEPA-filtered dust mask and special ventilation may reduce exposure. Professional pastel artists can contact ACTS for a referral to a ventilation engineer that designs special systems for pastel studios. Oil pastels are easy to use safely, because they contain small amounts of oils and waxes, which keep dust from getting airborne.

PENCIL AND GRAPHITE drawing usually exposes artists to such small amounts of dust that they are not hazardous. Very large amounts of graphite can cause black lung disease, similar to that which afflicts coal miners.

TEMPERA PAINTS are pigments suspended in emulsions of substances such as oils, egg, gum casein, and wax. Preservatives are added to kill microorganisms that would feed on the vehicles. If no solvents are used in these paints, ordinary comfort ventilation should be sufficient for working with liquid paints.

WATERCOLORS (dry cakes) are composed of pigments, preservatives (often paraformaldehyde), and binders such as gum arabic or gum tragacanth. Liquid watercolors may also contain water, glycerin, glucose, and other materials. Both liquid and dry watercolors may give off small amounts of formaldehyde, but they generally need no exhaust ventilation.

WATER-WASHABLE OIL PAINTS contain oils that have been modified so that they can be diluted and/or cleaned up with water. While there is no long-term toxicological data on these modified oils, it is likely that they are safe, since they do not volatilize and since exposure could only be by skin contact and ingestion. Again, painting methods that do not involve solvents are inherently safer.

RULES FOR PAINTING AND DRAWING

1. Choose studio locations with safety in mind. Floors, tables, and shelving should be made of materials that can be easily cleaned. Isolate the studio from living spaces, unless you intend to use materials with no significant hazards—materials such as watercolors and pencils. Never use toxic paints, solvents, or drawing materials in kitchens, bedrooms, living rooms, etc.

2. Obtain Material Safety Data Sheets (MSDSs) on all paints, inks, thinners, varnishes, and other products. If paint pigments are not identified by their Colour Index names or numbers, ask your supplier for this information. Some suppliers' catalogs list the Colour Index names of their paint pigments. These suppliers should be favored over less-informative ones.

3. Use water-based products over solvent-containing ones whenever possible. If solvents must be used, choose the safest solvent. For example, avoid turpentine. Use instead Gamsol®, highly refined paint thinner, or some other solvent with a Threshold Limit Value of 300 parts per million or greater (see chapter 9).

4. Buy premixed paints, and avoid working with powdered pigments or dry pastels if possible. Pigments and paints are most hazardous and inhalable in a dry, powdered state.

5. Choose brushing and dipping techniques over spray methods whenever possible.

6. Use Material Safety Data Sheets and product labels to identify the hazards of any toxic solvents, preservatives, or other chemicals in paints and drawing materials. Look up the hazards of the pigments in table 10.

7. Plan studio ventilation to control the hazards of the materials and processes you use. For example, if solvents are used, provide sufficient dilution ventilation to keep vapors below their Threshold Limit Values (see pages 24–27). If powdered paints, pigments, or pastels are used, mix powders in a glove box (figure 12), plan local exhaust ventilation (such as the system shown in figure 6), or have an industrial ventilation engineer design a special system.

8. Avoid dusty procedures. Sanding dry paints, sprinkling dry pigments or dyes on wet paint or glue, and other techniques that raise dust should be discontinued or performed in a local exhaust environment or outdoors.

9. Spray or airbrush only under local exhaust conditions, such as in a spray booth. A proper respirator may provide additional protection. Select the appropriate respirator for the type of paints and the method of application (see chapter 8).

10. Follow all solvent safety rules if you use solvent-containing products (see chapter 9), and give extra attention to studio fire safety.

11. Avoid skin contact with paints and pigments by wearing gloves or using barrier creams. Use gloves when using dyes. Wash off paint splashes with safe cleaners like baby oil followed by soap and water, nonirritating waterless hand cleaners, or plain soap and water. Never use solvents or bleaches to remove splashes from your skin.

12. Wear protective clothing, including a full-length smock or coveralls. Leave these garments in your studio to avoid bringing dusts home. Wash clothing frequently and separately from other clothing. Wear goggles if you use caustic paints or corrosive chemicals.

13. If respirators must be used, follow all rules regarding their use (see chapter 8).

14. Avoid ingestion of materials; eat, smoke, or drink outside your workplace. Never point brushes with your lips or hold brush handles in your teeth. Wash your hands before eating, smoking, applying makeup, and handling other personal hygiene procedures.

15. Keep containers of paint, powdered pigments, solvents, etc., closed when you are not using them.

16. Work on easy-to-clean surfaces, and wipe up spills immediately. Wet-mop and sponge floors and surfaces. Do not sweep.

17. Follow Material Safety Data Sheet advice, and purchase a supply of materials to control spills and for chemical disposal (e.g., kitty litter, solvent spill kits).

18. Dispose of waste solvents, paints, and other materials in accordance with health, safety, and environmental protection regulations. Refer to chapter 9 (solvents) and chapter 10 (pigments and dyes) for rules for disposing of these materials.

19. Always be prepared to provide your doctor with precise information about the chemicals you use and your work practices. Arrange for regular blood tests for lead if you use lead-containing paints or pigments.

CHAPTER 15
PRINTMAKING

All printmaking techniques rely on the use of inks of various types. There are five basic printmaking techniques: screen printing, lithography, intaglio, relief, and photoprint-making.

PRINTING TECHNIQUES

Screen printing uses a fine-meshed framed screen on which areas have been stenciled or blocked with a resist. Ink is then drawn (squeegeed) across and through the screen to the paper or other material that is being printed.

Lithography involves acid etching on smooth limestone surfaces on which areas have been blocked with wax pencils or crayons. Oil-based ink is rollered onto the damp stone. It adheres to the waxy areas and is repelled by the wet stone. The print is then made by running the stone through the lithographic press.

Intaglio is done by engraving or etching an image onto a metal plate. Ink is then forced into the grooves and depressions, the unetched areas are wiped clean, and the plate and a sheet of dampened paper are run through an etching press.

Relief is done by carving away parts of a material, such as wood (see chapter 28) or linoleum, with knives and gouges. The remaining raised surface is inked and pressed onto paper.

Photoprint-making is done by exposing a plastic (polymer) plate to ultraviolet light and then printing with intaglio or relief methods. For the hazards of making these plates, see chapter 29.

WHAT ARE PRINTMAKING INKS?

Traditionally, printmaking inks are oil-based or water-based materials that dry or set by evaporation, by polymerization, or by penetrating the material on which they were printed. In recent years, new inks have come into use that cure

with heat, infrared, or ultraviolet light. In addition, special inks have been developed that glow, puff up, or sparkle.

However, both traditional and modern printmaking inks are made up of two basic components: pigments and vehicles.

PIGMENTS

Pigments used in printmaking are essentially the same as those used in painting. Artists are sometimes not aware of this, because printmakers and painters may use different names for the same pigment. For example, bone black, which is made from charred animal bones, is called "Frankfurt black" by printers and "ivory black" by painters.

Printmakers who make their own inks are at the greatest risk from pigments. The hazards of pigments can be found in table 10 (page 114).

TRADITIONAL VEHICLES

The most common vehicles are mixtures of oils, mixtures of solvents and oils, and polymer emulsions. The oil base of lithography and etching inks is linseed oil and burnt plate oil (boiled linseed oil and driers).

Vehicles also contain additives, such as stabilizers (to keep ingredients in suspension), chemical driers, preservatives, plasticizers, antioxidants, antifoaming chemicals, fillers, and more. The hazards of many of these chemicals have not been well researched.

Printmaking vehicles are quite complex, because they must have exactly the right physical properties for the particular printmaking technique. The properties that must be controlled include drying time, tack, flow, stiffness, and more. For this reason, printmakers often alter their vehicles by adding oils, solvents, chemical driers, retarders, and the like to change ink performance. Printmakers usually refer to these chemicals as "modifiers."

Ink modifiers include: nontoxic tack reducers and stiffeners, such as Crisco, Vaseline, cup grease, magnesium carbonate, and aluminum stearate; moderately toxic tack oils, such as oil of cloves and oil of lavender; toxic solvents, such as petroleum distillates; and highly toxic lead and manganese driers and aerosol antiskinning agents.

SOLVENTS

Many solvents are used in printmaking, including ink components, modifiers, and clean-up products.

Common printmaking solvents might include kerosene, benzene, mineral spirits, gum turpentine, denatured alcohol, and acetone (see table 9). The water-based inks may also contain toxic solvents, such as the glycol ethers.

Cleaning presses, rollers, plates, screens, and the like can cause hazardous amounts of solvents to become airborne. Press and blanket-wash solvents are various mixtures of other solvents. The Material Safety Data Sheet is needed to determine the actual composition of these solvent products.

Water can be used to remove water-based inks from silkscreens. However, screens may need large amounts of solvents for washing out oil-based inks or resists used with some water-based screen-printing methods. Often, it is cheaper and safer to use inexpensive screens and discard them after use.

RESISTS AND BLOCK-OUT STENCILS

Both water-based and solvent-containing materials can be used to resist inks in various printmaking methods. Water-based materials usually have no significant hazards. Included are water-soluble glues, liquid wax (wax emulsions), latex rubber, and water-based friskets.

Solvent-containing resists and block-outs include tusche (contains a very small amount of solvent), lacquers, shellac, polyurethane varnishes, and caustic enamels. These products all create toxic solvent vapors during use.

Stencil films may be adhered to screens or plates or removed from them with water-based or solvent-containing adhering fluids and film removers. Solvents commonly found in these materials include acetates, alcohols, and acetone.

Printmaking techniques have expanded in recent years to include photographic processes that can be used to create resists for screen printing or etching. The hazards of many of the chemicals involved in these new photoprint chemicals are not well known. What is known will be covered in chapter 29.

ACIDS AND ETCHES

There are two processes that can be used to etch metal:

1. An acid is used to "eat" into the plate by converting the metal to a soluble salt.
2. An electrolyte is used in which the electron potential between the type of metal in the plate and the metal compound in the solution is strong enough to cause the plate metal to dissolve.

The second method is clearly the safer of the two.

The acids and corrosive chemicals used in intaglio, lithography, and some photo processes can be very damaging to the eyes, skin, and respiratory system. They are most toxic in their concentrated form.

Hydrochloric acid and **nitric acid** used in etching and lithography, can cause skin and eye burns and respiratory system damage. There is no effective air-purifying respirator for nitric acid, so local exhaust ventilation must be used. Nitric acid in particular has a number of special hazards:

1. Nitric acid mixed with sawdust, paper, or any other cellulosic material will spontaneously combust.
2. Hydrochloric acid and nitric acid combined are called "aqua regia." This acid mixture, in contact with other chemicals (which it can oxidize), can produce nitrosyl chloride (NOCl), a highly irritating gas.
3. Combinations of nitric and concentrated acetic acid can explode. Nitric acid can also ignite or explode with many solvents.

Dutch mordant (potassium chlorate/water/hydrochloric acid) is highly corrosive. During the mixing of the mordant, highly toxic chlorine gas is generated. (See Miscellaneous Chemicals below for more information on potassium chlorate.)

Copper sulfate solutions in various concentrations can be used to etch zinc. They are much safer than the acid etches.

Ferric chloride solutions can be used to replace strong acids in many etching processes. Ferric chloride etching requires only a small amount of ventilation to remove gases created during etching.

Ferric nitrate is also being used experimentally by some etchers trying other plate metals.

Citric acid is added to ferric chloride solutions by some misguided teachers to make a solution called "Edinburgh etch." They often tout citric acid as "natural" and safe. However, citric acid has three hydrogen ions (-H) on each molecule, and ferric chloride ($FeCl_3$) possesses three chloride ions. This means that every molecule of citric acid produces three potential molecules of hydrochloric acid in solution. This defeats the purpose of using ferric chloride.

Phosphoric acid, used for cleaning stones, is corrosive to the skin, eyes, and respiratory tract.

Phenol (carbolic acid) is highly toxic by both skin absorption and inhalation. Skin contact with concentrated phenol for even several minutes can be fatal. Dilute solutions can cause severe skin burns.

ROSIN* HAZARDS

Aquatint boxes deposit a finely-divided rosin or asphaltum dust on plates. When confined in the boxes, a spark, flame, or static discharge can cause rosin or asphaltum dust to explode (similar to grain elevator explosions). The boxes should be not be placed near electrical outlets, plumbing pipes that could act as a ground, hot plates, or other electrical and heat sources.

In addition, rosin causes allergic reactions in many people. Aquatint boxes should be as tightly sealed as possible or put in a vented enclosure to capture escaping dust.

MISCELLANEOUS CHEMICALS

Caustic soda. Also known as sodium hydroxide, caustic soda is sometimes used for stone cleaning. It is highly caustic to skin and eyes.

Potassium chlorate. A particularly hazardous chemical (see Dutch mordant above), having the following hazards:

1. Potassium chlorate forms an explosive or violently reacting mixture with nitric acid and with combustible substances, e.g., sugar, rosin, charcoal, sawdust, and sulfur. It is used this way in matches, fireworks, and blasting caps. It doesn't take much dust or contaminants falling into a jar to make it unstable.
2. When potassium chlorate is mixed with hydrochloric acid during the making of Dutch mordant, highly toxic chlorine gas is given off.
3. Potassium chlorate mixed with sulfuric acid creates the strongest simple acid known: perchloric acid. A mere drop of perchloric acid on paper has been known to detonate.

* The words "rosin" and "resin" are confusing. A resin is any organic chemical liquid that can be converted to a solid. Synthetic resins are the plastic monomers such as styrene and epoxy. Natural resins include shellac, copal, and dammar. And, in fact, rosin is a resin!

Bleach. Common bleach is also a product that must be stored carefully. It can burst into flame when in contact with many organic chemicals (solvents), and it releases chlorine gas when mixed with hydrochloric acid. Bleach also releases highly toxic gases when mixed with ammonium-containing products.

French Chalk. Some kinds of French chalk (talc) are contaminated with asbestos.

Copy Machine Toner. Many artists are experimenting with powdered toners. These are now associated with lung damage in copy-shop workers. The powders also are explosive if their dusts or powders are exposed to a source of ignition or electric discharge.

Ferri- and Ferrocyanides. Some printing processes involve the use of ferric ferrocyanide (Prussian Blue), potassium ferricyanide (cyanotype), and other ferricyanides. These chemicals release cyanide gas in strong ultraviolet light, when heated, or when in contact with strong acids. The EPA recently determined that they also release cyanide in the environment and must be disposed of as cyanides by toxic waste companies.

STORAGE

Planning storage for printmaking is especially important. Most of the printmaking chemical storage units should be equipped with locks, because the chemicals are so hazardous, they must be used only by trained people. It would be wise to consult fire, safety, and waste-disposal experts when designing a studio. Some considerations include:

1. Store chlorates separately from all other chemicals.
2. Store acids in acid-storage cabinets. Separate cabinets may be needed for certain of the acids.
3. Store nitric acid separately from other chemicals. Safety supply companies can provide small nitric acid cabinets. If large acid-storage units are used, safety companies sell nitric acid inserts that will isolate the nitric acid from the other acids within the cabinet.
4. Glacial acetic acid is flammable and reacts with certain solvents. Don't purchase it in its concentrated form at all, because you don't need it. Glacial acetic acid must be diluted with water before you can use it, so it is better to purchase it already diluted to 50 percent or greater. In these concentrations, it can be stored in the acid cabinet. Otherwise, the concentrated glacial acetic acid should be stored separately from other chemicals in its own flammable-storage cabinet.

5. A caustic cabinet can be used to store ammonium hydroxide, sodium hydroxide, ammonia-containing cleaners, and other caustic (basic) materials.

6. Bleach in household strength can be stored under the sink or at some other location away from other chemicals such as ammonium hydroxide, solvents, etc.

PRECAUTIONS FOR PRINTMAKING

1. Get a safety consultant involved when planning a studio. There are too many materials and too many local and federal regulations applying to these materials for artists to be aware of them all.

2. Floors, shelving, tables, and other surfaces should be made of materials that can be easily cleaned. Smooth concrete is a good choice for floors. Purchase acid-resistant rubber mats for areas where artists must stand. Floors must be capable of supporting heavy presses. Drains usually cannot be put in these floors, because EPA-regulated toxic substances may be used.

3. Isolate studio from eating, recreation, or living areas.

4. Install ventilation that is appropriate for the processes you will do. For example, use window exhaust fans for dilution of small amounts of solvent and kerosene vapors. Install chemical fume hoods or slot hoods for acid baths.

5. Obtain Material Safety Data Sheets (MSDSs) or ingredient information on all products used. If ink pigments are not identified by their Colour Index names and numbers or by Chemical Abstracts Service numbers, ask your supplier for this information.

6. Use Material Safety Data Sheets and product labels to identify the hazards of any toxic solvents, acids, or other chemicals in products, and choose the least toxic materials.

7. Reduce solvent use. Use water-based inks and other products whenever possible. Use disposable screens for screen printing, rather than cleaning them with solvents. Use water-based film-adhering fluids or film removers when possible.

8. Follow all solvent safety rules if you use solvent-containing products (see chapter 9). Pay special attention to solvent fire safety rules in the studio.

9. If respirators are worn, follow all regulations regarding their use (see chapter 8).

10. Protect against acids, caustics, or other irritating chemicals by wearing chemical splash goggles, gloves, aprons, and other protective clothing as needed. Use these chemicals with local exhaust systems. Install an eyewash fountain (and emergency shower if large amounts are used). Have first aid equipment on hand for chemical burns, and have emergency procedures posted.

11. Keep containers of inks, pigments, solvents, acids, and other materials closed, except when you are using them.

12. Avoid working with powdered materials. Buy premixed inks and other products. If toxic powders must be handled, weighed, or mixed, perform these processes where local exhaust ventilation is available, or use a glove box (see figure 12).

13. Avoid dusty procedures. French chalk, wood, or rosin should be used in ways that raise as little dust as possible. If dust cannot be avoided, wear a toxic dust respirator.

14. Use aquatint processes that do not release dust whenever possible. One such method uses non-aerosol, pump-sprayed rosin solution. Otherwise, construct rosin boxes with nonsparking parts to avoid dust explosions. Do not place flame, heat, or electrical sources near the box. If compressed air is used to stir up rosin, provide ventilation to capture the dust that escapes the box.

15. Avoid aerosol spray products whenever possible. If they must be used, provide local exhaust conditions, such as a spray booth and/or a proper respirator.

16. Provide local exhaust, such as slot hoods or recessed canopy hoods, for heating or burning processes—heating plate oil, wood-burning tools, etc. Have first aid burn treatments handy.

17. Keep all tools sharp and all machinery in good working order. Use presses with stops to keep the beds in place. Provide local exhaust ventilation systems, guards, and lockouts for table saws and other machinery. Have first aid equipment for trauma on hand. Post and practice emergency procedures.

18. Avoid ingestion of materials by eating, smoking, or drinking outside the studio. Wash your hands before eating, smoking, applying makeup, or performing other personal hygiene tasks.

19. Avoid skin contact with inks by wearing gloves or using barrier creams. Avoid wiping plates with your bare hands. Wash off ink splashes with safe cleaners like baby oil followed by soap and water,

nonirritating waterless hand cleaners, or plain soap and water. Never use solvents or bleaches on your skin.

20. Wear protective clothing, including a full-length smock or coveralls. Leave these garments in your studio to avoid bringing dusts home.

21. Clean up spills immediately. Follow Material Safety Data Sheet advice, and have handy proper materials for controlling spills and for chemical disposal, especially for acids and solvents.

22. Wet-mop and sponge floors and surfaces. Do not sweep.

23. Dispose of all inks, pigments, solvent, and other chemicals in accordance with health, safety, and environmental protection laws. Dispose of oily rags in airtight containers that are removed from the studio daily. Waste materials and water from cleaning the floors or from spills will probably have to be contained and disposed of as toxic waste. See chapters 9 and 10 for more information about disposal of these materials.

24. Dispose of spent acids in accordance with health, safety, and environmental protection laws. It is not acceptable to merely neutralize these acids (e.g., using neutralizing tanks containing marble chips), because spent etching acids contain EPA-regulated metal ions, such as zinc and copper. Metal ions are not removed by neutralization, and liquids containing them must be disposed of as toxic waste in most areas in the country.

25. Always be prepared to provide your doctor with precise information about the chemicals you use and your work practices. Arrange for regular blood tests for lead if you use lead-containing paints or pigments.

CHAPTER 16
TEXTILE ARTS

Batik dyers, costume makers, scene painters, weavers, and other artists who work with dyes and textiles are at risk of exposure to dye chemicals and fiber dusts.

DYE HAZARDS

Although there are thousands of commercial dyes, less than a hundred have been studied for long-term effects. Of those few tested, many were found to cause cancer, birth defects, and other toxic effects. The chemistry and hazards of dyes are discussed in chapter 10, pages 109–112.

Many dyes also must be used with hazardous dye-assisting or mordanting chemicals. These chemicals are added to dye baths to help dyes react with fabrics properly. A list of common dye-assisting chemicals and their hazards can be found in table 21, Hazards of Mordants, Dye-Assisting, and Discharge Chemicals, page 228.

Modern textile artists also color fabrics with paints and silkscreen inks. The hazards of these materials are discussed in chapters 14 and 15.

EXPOSURE TO DYE PRODUCTS

Dyes are most hazardous in the powdered state. Skin contact and inhalation of even very small amounts of dyes in this concentrated form should be avoided.

Dyes sold in liquid form are safer to handle. Liquid dyes can still be hazardous, because they have strong preservatives and inhibitors in them to keep the dye from degrading. Some also contain solvents, including acetone, toluene, xylene, carbitol (diethylene glycol ether), and other solvents.

Dyes applied in hot baths release steam, which may contain small amounts of toxic chemicals from dye impurities and decomposition products. Local exhaust ventilation should be installed above hot-dye baths.

Even exposure to dyes on washed dyed fabrics may be hazardous. In 1996, Germany banned about 120 dyes for use on textiles that have prolonged contact with the skin, such as clothing and bed sheets. These dyes are known to break down with time to release cancer-causing substances. While most of these dyes are in the benzidine chemical class, some are not. And some of the banned dyes fall in a number of use classes, including acid, azoic, basic, direct, and disperse classes.

Theoretically, artists who cannot sign a statement that none of these dyes have been used on their fabrics cannot sell clothing to clients in Germany and some other European countries that have also banned these dyes. The problem for U.S. and Canadian textile artists is that most of their dye suppliers do not even provide the Colour Index identification of the dyes they sell. Professional dyers interested in this problem and the list of banned dyes can contact ACTS and ask for the data sheet on Azo and Benzidine Dyes (see appendix A, part 1).

DYE TECHNIQUES

Dyes are used by artists in batik, tie-dyeing, discharge dyeing, and a number of other techniques.

Batik dyeing traditionally employs fiber-reactive dyes (see table 11) on silk. However, batik techniques are now used with a number of different dye classes on many fabrics, paper, and other materials.

The batik process uses wax (beeswax, paraffin, etc.) as a dye resist. The wax is heated to melting and applied to the fabric. After the resisted fabric is dyed, the wax is removed by ironing the fabric between sheets of newsprint or by applying solvents, such as dry cleaning fluids, mineral spirits, etc.

Heated wax is a fire hazard. Hot wax or the vapors rising from wax pots can explode into flame easily, so open flames, gas burners, and the like should not be used to heat wax. Instead, equipment such as electric stoves, crock pots, and electric frying pans may be used, if their controls can be set accurately at the lowest temperature at which the wax remains liquid.

Heated wax also emits highly irritating chemicals, including acrolein and aldehydes such as formaldehyde. Wax emissions require exhaust ventilation, because there are no suitable air-purifying respirators for acrolein. Some artists avoid using heated wax by applying cold wax emulsions, which are suitable for some purposes.

Irons for pressing wax out of fabrics should also be set at the lowest temperature required for wax removal. Exhaust ventilation, such as table-level win-

dow exhaust fans, should be provided. If solvents are used for wax removal, all the rules for solvent use should be followed (see chapter 9). Some artists boil fabrics to remove most of the wax and then send them to professional dry-cleaners for complete removal.

For some purposes, much safer vegetable-matter batik resists, which can be washed out with strong soap and water, are now being developed and sold.

Tie-dyeing is done by applying dyes to fabrics that have been tied tightly. Concentrated dye solutions are usually used, making exposure to these solutions more hazardous by skin or eye contact.

Discharge dyeing, stripping, and bleaching involves applying chlorine bleaches or other harsh chemicals to dyed fabrics. These chemicals remove dyes by destroying their chemical bonds. In the process, dyes may be broken down into even more-hazardous chemicals. For example, benzidine dyes may be broken down to free benzidine, and aniline (azine) dyes may release highly toxic aniline.

Using bleach to remove dye stains from your skin would have the same effect. Bleach also irritates and damages the skin. Skin contact with dyes should be avoided, but in case of accidental contact, it is best to let stains wear off.

Some of the highly toxic breakdown products of dyes are volatile and can be made airborne, especially if dyeing is done in hot baths. Some of these chemicals are likely to be absorbed through the skin. Gloves and ventilation must be provided when dye stripping or discharge dyeing.

PRECAUTIONS FOR DYERS

1. Plan the dye room with health and safety in mind. Floors and surfaces should be made of materials that are easily sponged clean and that will not stain. General ventilation rates should not be so high that dusts are stirred up.

2. Install ventilation systems appropriate for the work done. For example, provide local exhaust, such as slot hoods or recessed canopy hoods, for heating dye pots, reverse dyeing, wax heating and removal, and all other processes that release toxic airborne substances. Connect clothes dryers to flexible-hose exhaust ventilation systems.

3. Obtain Material Safety Data Sheets (MSDSs) on all dyes and textile paints. If dyes and pigments are not identified by their Colour Index names and numbers or by their Chemical Abstracts Service numbers, ask your supplier for this information. Try not to use dyes without at least knowing their classes. Look up hazards of each dye class in table II, page 135.

4. Use Material Safety Data Sheets and product labels to identify the hazards of any toxic solvents, acids, or other chemicals in dyes, paints, inks, mordants, or other materials. If solvents are used in dyes or for removal of wax, follow all precautions for solvents (see chapter 9), and pay special attention to fire safety.

5. Choose water-based products over solvent-containing ones whenever possible.

6. Buy premixed dyes if possible. Dyes packaged in packets that dissolve when dropped unopened into hot water can also be handled safely. Dyes and pigments are most hazardous and inhalable in a dry, powdered state.

7. Weigh or mix dye powders or other toxic powders where local exhaust ventilation is available, or use a glove box (see figure 12).

8. Keep containers of powdered dyes and pigments, solvents, etc., closed when you are not using them.

9. Avoid procedures that raise dusts or mists. Sprinkling dry dyes or pigments on wet cloth, airbrushing, and other techniques that raise dusts or mists should be discontinued or performed in a local exhaust environment, such as a spray booth.

10. Avoid skin contact with dyes by wearing gloves. If skin staining does occur, wash skin with mild cleaners, and allow the remainder to wear off. Never use solvents or bleaches to remove dye splashes from your skin.

11. Melt and remove wax at the lowest possible temperatures. Do not heat wax with open flames, such as those that burn on gas stoves. Use devices like electric stoves or fry pans with good heat control mechanisms. Use wax emulsion products when possible. Irons used to remove wax should be set as low as possible. Sending fabrics to professional dry-cleaners is a viable, but expensive alternative. Investigate non-wax resists as substitutes.

12. Wear protective clothing, including a full-length smock or coveralls. Leave these garments in your studio to avoid bringing dusts home. Wash clothing frequently and separately from other clothes.

13. Protect eyes by wearing chemical splash goggles if you use caustic dyes or corrosive chemicals. Install an eyewash fountain (and emergency shower if large amounts are used).

14. Clean up spills immediately. Follow Material Safety Data Sheet advice, and have handy proper materials to handle spills and disposal. Wet-mop and sponge floors and surfaces. Do not sweep.

15. Avoid ingestion of materials by eating, smoking, or drinking outside your workplace. Never point brushes with your lips or hold brush handles in your teeth. Never use cooking utensils for dyeing. A pot that seems clean can be porous enough to hold hazardous amounts of residual dye. Wash your hands before eating, smoking, applying makeup, or performing other personal hygiene procedures.

16. Dispose of dyes, mordants, and other chemicals in accordance with health, safety, and environmental protection laws. Metalized dyes containing EPA-regulated metals may not be put into drains leading to water treatment plants, leach fields, or storm sewers in most locations in the country.

17. Be prepared to provide your doctor with precise information about the chemicals you use and your work habits. Arrange for regular blood tests for lead if you use lead-containing textile paints or pigments.

FIBER HAZARDS

For centuries, occupational diseases such as dermatitis, skin and pulmonary anthrax, and weaver's cough (brown lung) have been associated with exposure to some vegetable and animal textile fibers. Now, new man-made fibers and chemical treatments of textiles have added some occupational hazards to the list.

VEGETABLE FIBER HAZARDS. Fiber from plants such as flax, hemp, sisal, and cotton have been associated with a debilitating disease commonly called "brown lung," or byssinosis. It is usually only seen among heavily exposed textile factory workers. Its early symptoms, including chest tightness, shortness of breath, and increased sputum flow, commonly appear when the worker returns to work after being away a few days. The condition is reversible if exposure ceases, but after ten or twenty years of exposure, the disease can progress without further exposure and may be fatal.

Long years of exposure to hemp, sisal, jute, and flax dusts are associated with chronic bronchitis, emphysema, and various allergic conditions. Some of these illnesses may be caused by mildew, fungus spores, dyes, and fiber treatments (like permanent press or sizing) rather than by the fiber itself. Artists noticing recurring symptoms when working with fibers should investigate the possible causes of such reactions and see their doctors.

SYNTHETIC FIBER HAZARDS. Very little is known about the hazards of synthetic fibers such as rayon, acetate, nylon, acrylics, and so on. But there are enough individual cases to suggest that these fibers are hazardous, too.

For example, nylon flocking (the velvet-like fibers glued to a substrate) has been shown in studies in Canada and Rhode Island to cause a disabling variety of interstitial lung disease called "flock worker's lung."[1] And a thirty-seven-year-old nonsmoker exposed only two days to polyethylene fiber used as a theatrical "snow" effect required medication, turbinate bone surgery, and lavage (a mechanical washing of the lungs) over an eleven-month period of time to correct the lung problems from inhaled fibers.[2]

Prudence dictates treating all fiber dusts as potentially toxic and providing a work environment as that is as dust-free as possible.

ANIMAL FIBER HAZARDS. Fibers used by artists may include wool, silk, hair from goats, horses, rabbit, dogs, and other animals. Allergies to such fibers or animal dander are well known and can affect fiber artists. But many reactions to animal fibers are from mold, mildew, spores, and the like, which can contaminate fibers.

There are other contaminants as well. For example, greasy wool can contain sheep-dip. Uncarded or dirty wool or hair can contain little twigs and grass seeds, which can cause injury to weavers and spinners.

Zoonoses—diseases that can be transmitted from animals to man—may also afflict users of animal fibers. For example, inhalation of invisible anthrax spores from wool or hair harvested from diseased animals can cause a virulent, often fatal, infectious disease.

Artists should also encourage stricter government enforcement of import regulations and testing of all animal products to prevent contaminated products from entering their countries. Failure to detect a shipment of anthrax-contaminated Pakistani wool in the United States resulted in the death of an artist-weaver in 1976. And currently, there are outbreaks in various countries of

[1] Kern, David G., MD, MOH. "The Unexpected Result of an Investigation of an Outbreak of Occupational Lung Disease," *International Journal of Occupational and Environmental Health* 4, no. 1 (Jan-Mar 1998): 19–32.

Washko, Rita, MD, Joe Burkhart, CIH, and Chris Piacitelli, IH. NIOSH Health Hazard Evaluation (HETA) 96-0093-2685, Microfibres, Inc., Pawtucket, Rhode Island, April 1998.

[2] Sue, Michael A., MD. *The New England Journal of Medicine,* Letter section, March 18, 1999.

foot-and-mouth disease (which can only be passed to other animals) and a group of fatal brain (spongiform encephalitis) diseases that can be transferred to humans—such as mad cow, scrapie (affecting sheep, primarily), American elk wasting disease, and more. The significance of these diseases to fiber artists is unknown, but we should err on the side of caution by using only fibers known to be from uninfected animals.

Other diseases that affect those working with animal products include Q fever, mange, lice, and more. Even working with dog hair can be hazardous, since dog tapeworm larva can cause hyatids (cysts) to form in the liver, skin, and other areas of the body.

Cleaning animal fibers will remove some of these hazards, but not all. It is safer to buy prewashed, disinfected fibers. Artists using suspect materials may wish to be immunized for anthrax, although the shots also cause side effects, which must be considered.

FIBER TREATMENT HAZARDS.
Many fiber treatments, such as formaldehyde-emitting permanent-press treatments, sizing, fire retardants, stain-guarding chemicals, moth-proofing, and the like, have been shown to cause allergies and other effects. Many of these chemicals have not been well studied. The complex organic chemical fire retardant called "tris" was not found to be a carcinogen until years after it was in common use in children's sleepwear.

Artists who have unusual reactions to working with particular materials should also consider fiber and fabric treatment as a possible source of the difficulty. When applying fiber treatments themselves, artists should obtain as much information about the chemicals as possible.

FLAME RETARDANTS.
Several textile artists have lost commissions when they have attempted to install works in public buildings, only to find out that they must provide building managers with a current fire certificate showing that the textile installation meets fire-retardant standards. Curtains, draperies, and textile artwork installed in buildings for public occupancy are generally regulated by local or state fire authorities. The most widely used test that the textiles must pass is described in the National Fire Protection Association's Standard Methods of Fire Tests for Flame-Resistant Textiles and Films (NFPA 701). (See appendix A, part 3.)

In some cases, the artist can use fabric or fibers that are already treated or certified to meet this test. Otherwise, they may choose to treat the work themselves and send out representative swatches to laboratories that will provide a

certificate. Some fire-retardant chemicals are toxic and require careful handling and application. Included are compounds based on bromine, antimony, chlorine, phosphorus, molybdenum, and nitrogen. The safer ones are usually those based on alumina trihydrate, magnesium hydroxide, and boron.

MOTH REPELLANTS. These are usually pesticides and require care when they are used. Two chemicals commonly used for mothballs and crystals are paradichlorobenzene (PDB) and naphthalene. Threshold Limit Values for PDB and naphthalene are both 10 parts per million. Studies suggest both chemicals may be carcinogens. The most recent data on naphthalene in particular found clear evidence of carcinogenicity in both male and female rats.[3]

One difference between the chemicals is that PBD is more toxic to certain people of African, Mediterranean, and Semitic origins with genetic glucose-6-phosphate dehydrogenase deficiencies. Naphthalene can cause severe anemia in these people.

However, both chemicals are in the same range of toxicity, and both are likely to be listed as suspect cancer agents. It might be time for industry to look for a better way to protect fabrics from insect damage.

WEAVING, SEWING, AND OTHER FABRICATION TECHNIQUES

Weaving, spinning, sewing, knitting, macrame, embroidery, tapestry, and similar processes involve sitting or remaining still and using the hands in repetitive actions for long periods of time. Such tasks require careful positioning of the body. For example, looms must be properly tuned, and chair heights and sewing machine foot pedals must be adjusted to fit the individual artist.

Frequent breaks should be taken and posture should be varied as often as possible. Many weavers find that exercising to relieve strain is helpful.

Eyes can also be strained if lighting is not of the proper intensity and direction. Ergonomic problems, eyestrain, and other health effects from exposure to video display terminals may result if weavers use computers to generate patterns.

3 "Toxicology and Carcinogenesis Studies of Naphthalene in F344/N Rats" (Inhalation Studies), National Toxicology Program, 2000.

PRECAUTIONS FOR FIBER ARTISTS

1. Fibers and textiles should be purchased from reliable suppliers who will provide information about the origin of the materials, the dyes or fiber treatments that have been applied, and so on.

2. Purchase cleaned or washed fibers or textiles when possible. If raw, uncleaned materials are used, get advice on the best methods for cleaning and disinfecting fibers.

3. Do not use mildewed or musty materials. Store fibers in clean, dry places to avoid growth of microorganisms.

4. Avoid dust. For example, use proper-sized needles in loom shuttles. Damp-mop or sponge up dusts rather than sweeping or vacuuming. Shake out fabrics away from the workplace.

5. Obtain information on mothproofing, sizing, permanent press, and other treatments that have been applied to your materials. If the work is to be installed in a public building, be able to provide a certificate showing the materials meet fire-retardant standards. When applying treatment chemicals yourself, obtain Material Safety Data Sheets and/or ingredient information, and follow precautionary instructions.

6. Adjust looms, chair heights, etc., for ergonomic comfort. Take breaks (perhaps five minutes each half hour), stretch, and exercise to relieve strain.

7. Provide proper lighting for weaving and other work (see pages 32–33).

8. Follow precautions for computer use.

9. Needles, pins, X-acto® blades, or any other small, sharp object that penetrates that accidentally punctures the skin should be considered to be blood-contaminated. These sharps should either be discarded as medical waste or sterilized before being reused.

10. Artists exposed to fiber dusts should have pulmonary function tests periodically. Weavers using raw animal fibers should keep up with their tetanus shots and consult with experts about other immunizations appropriate for the raw materials used. Always be prepared to provide your doctor with precise information about the materials you use and your work practices.

TABLE 21	HAZARDS OF MORDANTS, DYE-ASSISTING, AND DISCHARGE CHEMICALS

Many dyes need other chemicals to set the dye, change the pH (acidity) of the dye bath, or assist the dye process. The hazards of many of these chemicals are listed below. The entries with asterisks (*) can be poisonous if ingested and should be keep out of reach of children.

ALUM (potassium aluminum sulfate). Some people may be allergic to it, but no special precautions are needed when using it.

***AMMONIA** (ammonium hydroxide). Avoid concentrated solutions. Household-strength ammonia is diluted and less hazardous. Inhalation of its vapors can cause respiratory and eye irritation. Wear gloves and avoid inhalation.

AMMONIUM ALUM (ammonium aluminum sulfate). Hazards are like those of alum (see above).

***CAUSTIC SODA** (lye, sodium hydroxide). Very corrosive to the skin, eyes, and respiratory tract. Wear gloves and goggles.

***CHLORINE BLEACH** (household bleach, 5 percent sodium hypochlorite). Corrosive to the skin, eyes, throat, and mucous membranes. Wear gloves and goggles. Mixing with ammonia or urea results in the release of highly poisonous gases (nitrogen trichloride, nitrogen oxides, chlorine, etc.). Mixing with acids releases highly irritating chlorine gas.

CITRIC ACID. No significant hazards.

***CLOROX.** See Chlorine Bleach above.

***COPPER SULFATE** (blue vitriol). May cause allergies and irritation of the skin, eyes, and upper respiratory tract. Chronic exposure to copper sulfate dust can cause ulceration of the nasal septum.

CREAM OF TARTAR (potassium acid tartrate). No significant hazards.

***FERROUS SULFATE** (copperas). Slightly irritating to skin, eyes, nose, and throat. No special precautions necessary.

***FORMIC ACID** (methanoic acid). Highly corrosive to eyes and mucous membranes. May cause mouth, throat, and nasal ulcerations. Wear gloves and goggles.

***GLAUBER'S SALT** (sodium sulfate). Slightly irritating to skin, eyes, nose, and throat.

***LUDIGOL** (monosodium salt of nitrobenzene sulfonic acid). A severe skin and eye irritant.

***NITROBENZENE SULFONIC ACID.** A severe skin and eye irritant. Decomposes violently at ~390°F. When possible, use instead the sodium salt of this compound. See Ludigol or Sitol.

***OXALIC ACID.** Skin and eye contact may cause severe corrosion and ulceration. Inhalation can cause severe respiratory irritation and damage. Wear gloves and goggles.

***POTASSIUM CARBONATE** (potash, pearl ash). Moderately irritating to skin and eyes.

***POTASSIUM DICHROMATE** (potassium bichromate, chrome). Skin contact may cause allergies, irritation, and ulceration. Chronic exposure can cause respiratory allergies. A suspect carcinogen. Wear gloves and goggles.

***SALT** (sodium chloride). Some all-purpose dyes contain enough to be toxic to children by ingestion. No other significant hazards.

***SITOL.** See Ludigol.

***SODIUM ACETATE.** A skin and eye irritant. Reacts violently with potassium nitrate and several other chemicals.

SODIUM ALGINATE. No significant hazards.

***SODIUM BISULFATE** (sodium acid sulfate). Corrosive to skin, eyes, and mucous membranes. Mutation data reported, reacts with moisture to form sulfuric acid. Incompatible with bleach and many other common chemicals.

***SODIUM CARBONATE.** Corrosive to the skin, eyes, and respiratory tract.

***SODIUM CHLORIDE.** No significant hazards.

***SODIUM HEXAMETAPHOSPHATE** (Calgon®, polyphos). No significant hazards. Like all phosphates, it promotes algae and bacterial growth in septic systems or bodies of water. This chemical is sold by Prochem as "Metaphos." This is a very misleading, since the name "Metaphos" is a registered trademark for a highly toxic pesticide. Telling an

emergency room doctor or poison control center that you were exposed to Metaphos could result in the wrong treatment.

***SODIUM HYDROSULFITE** (sodium dithionite). Irritating to the skin and respiratory tract. Stored solutions decompose to give irritating and sensitizing sulfur dioxide gas. Mixtures with acids will release large amounts of sulfur dioxide gas.

***SULFURIC ACID** (oleum). Highly corrosive to the skin and eyes. Vapors can damage respiratory system. Heating generates irritating and sensitizing sulfur dioxide gas. Wear gloves and goggles.

***SYNTHRAPOL** (isopropyl alcohol plus detergent). Corrosive to the skin and eyes. Vapors can irritate respiratory system, cause narcosis. Wear gloves and goggles.

***TANNIN** (tannic acid). Slight skin irritant. Causes cancer in animals. Handle with care.

***THIOUREA** (thiocarbamate, thiocarbamide, isothiourea). Poison, carcinogen, reproductive hazard, skin irritant, allergen.

THIOUREA DIOXIDE (Thiox®). This is an outdated name for formamidinesulfinic acid. There is very little data on this chemical, except that it is an irritant, and one MSDS says that animal studies showed depressed thyroid activity. Like all amides, it is probably a sensitizer. Wear gloves and goggles.

***TIN CHLORIDE** (tin, stannous chloride). Irritating to the skin, eyes, and respiratory tract.

***UREA.** Adverse reproductive and fertility effects when in amounts higher than normal in the body. Reacts with hypochlorites (bleaches) to form toxic and explosive gas (nitrogen trichloride).

VINEGAR (dilute acetic acid). Glacial (pure) acetic acid is highly corrosive, and the vapors are irritating. Vinegar (about 5 percent acetic acid) is safer. Mildly irritating to the skin and eyes.

CHAPTER 17
LEATHER AND OTHER ANIMAL PRODUCTS

For centuries, occupational diseases, including zoonoses and allergies, have been associated with the use of animal products such as leather, horn, bone, ivory, and shell. In recent years, statistical studies of leather workers have shown high rates of bladder and nasal sinus cancer.

HARVESTING AND TANNING

Workers harvesting leather from animals and birds are exposed to a host of zoonoses—diseases that can be transmitted from animals to man. Many of these diseases are discussed in chapter 16, pages 224–25. In the United States and Canada, rabies is also known to be transmittable during harvesting.

Once harvested, leather is preserved with tanning chemicals. Extracts from certain plants that are natural sources of tannic acid are still used for "vegetable tanning" of sole and heavy-duty leathers.

Many other leathers are tanned with minerals, such as the sulfates of chromium, aluminum, or zirconium. Many synthetic chemicals are now used to tan leather. Some of these are sulfonated phenol or naphthols condensed with formaldehyde. A few special leathers and skins for taxidermy and natural history specimens may also be treated with arsenic and powerful pesticides.

HAZARDS OF TANNING CHEMICALS

Tannin is a suspect carcinogen. Chrome sulfates and some other chrome compounds are sensitizers and suspect carcinogens. Synthetic tanning chemicals

such as sulfonated phenols are very toxic. The use of these toxic and sensitizing tanning chemicals may explain in part why workers exposed to leather dusts have high rates of cancer and other occupational illnesses.

Tanners should also remember that human skin can be tanned. Tanning chemicals should be kept off the skin.

LEATHER WORKING

Tools such as knives, awls, punches, and a host of specialized tools are used in each type of leather work. Care should be taken to keep these tools in good repair and sharp and to use them safely.

Sanding of leather can be done by hand or with electric sanders. This sanding dust contains leather, tanning chemicals, dyes, and glues. Dust exposure should be prevented with local exhaust ventilation and/or respiratory protection. Goggles should be worn to prevent eye injury.

DYEING

Leather dyes, like textile dyes, tend to be hazardous chemicals (see chapter 10). Traditional leather dye products contain solvents from very toxic classes, such as chlorinated hydrocarbons, glycol ethers, and aromatic hydrocarbons (see table 9). Some leather dyes are dissolved in ethyl alcohol. These are safer to use.

Safer still are the new water-based acrylic leather dyes. Although there may be small quantities of water-miscible solvents in these products, it is assumed that these dyes are the least toxic.

CEMENTING

There are a number of leather glues on the market. Barge cement and rubber cements are the most common. Barge cement contains toluene and petroleum distillates (see table 9). Rubber cements may contain normal hexane (n-hexane), which is a potent nerve toxin (see chapter 9). Inhalation and skin contact with all solvent-containing glues should be avoided.

Some new water-emulsion glues for leather have been developed. Choose these when ever possible.

CLEANING AND FINISHING

Cleaning can be done with oxalic acid or saddle soaps. Saddle soap has no significant hazards, unless it is preserved with strong pesticides. Oxalic acid is cor-

rosive to skin, eyes, digestive, and respiratory tracts. Once absorbed, oxalic acid is damaging to the kidneys.

Finishes for leather may consist of oils such as neat's-foot oil and waxes, most of which have no significant hazards. Other types of leather finish are lacquers and resins dissolved in solvents. Skin contact and inhalation of these is hazardous.

ANTIQUE LEATHER AND TAXIDERMY

Craftspeople who restore old leather items or who used taxidermied animals as components in their found-object sculptures should treat these items as potentially toxic. Taxidermied animals and birds often shed small amounts of dust, and old leather sometimes develops a whitish surface deposit called "sprue."

The components of the dusts from taxidermied animals and the sprue on leather may be very toxic, because old tanning and taxidermy chemicals often included arsenic, mercury compounds, and highly toxic pesticides. One common leather treatment product used well into the 1980s, called Renaissance Leather Reviver, contained a highly toxic pesticide called pentachlorophenol laureate, a substance now banned for this use. Some taxidermied animals were stuffed with asbestos.

In the past, these strong preservatives were used because animal material is subject to insect and mold infestation. So, if the pesticides are not present, then the molds may be. These molds can cause allergies, and some are toxic.

Control any dust from old leather and preserved animal materials. Do not use taxidermied animals as objects for children to touch in educational programs, unless the taxidermist has preserved them especially for this purpose.

OTHER ANIMAL PRODUCTS

Bone, antler, ivory, and horn are used in many crafts. Toxic solvents are used to dissolve fats and oils from these materials when they are freshly harvested. Harvesting and tooling these materials has also been associated with zoonoses. There are known cases of anthrax resulting from harvesting and working with these materials, including a fatal case of anthrax contracted while tooling ivory into piano keys.

The most common diseases associated with these materials is irritation and allergic response to their dusts. Dusts from abrasives used to sand these materials may also be hazardous (see table 17).

Shells, including mother-of-pearl, abalone, and coral, are commonly ground and sanded. Dust from these processes causes respiratory allergies, especially if the shell is not properly washed and contains organic matter.

Inhalation of mother-of-pearl dust can cause fevers, respiratory infections, and asthmatic reactions. Years ago, repeated inhalation of mother-of-pearl dust by adolescents working in the pearl button industry caused defects and lesions of the long bones of their arms and legs.

Feathers for crafts and for pillow stuffing can cause "feather-picker's disease," which is characterized by chills, fever, coughing, nausea, and headaches. These symptoms usually abate when the individual develops a tolerance for feathers. Tolerance may take weeks or even years to develop. Some people become permanently allergic to feathers.

Moth repellants, such as paradichlorobenzene or naphthalene, are commonly applied to feathers (see chapter 16). Allow mothball odors to dissipate before working with feathers.

PRECAUTIONS FOR WORKING WITH LEATHER AND OTHER ANIMAL PRODUCTS

1. Obtain Material Safety Data Sheets on all chemicals, and choose the safest products when possible.
2. Work on easy-to-clean surfaces, and wipe up spills and dust immediately. Follow Material Safety Data Sheet advice, and have handy proper materials for controlling spills and for chemical disposal. Wet-mop and sponge floors and surfaces. Do not sweep.
3. Practice scrupulous personal hygiene. Do not eat, smoke, or drink in the workplace. Wash hands and change out of work clothing before leaving the studio. Wash work clothes frequently and separately from other clothes.
4. Avoid skin contact or inhalation of tanning chemicals by using exhaust ventilation and/or respiratory protection and gloves. Use chemical splash goggles when using corrosive chemicals. Purchase pretanned leather when possible.
5. Keep tools sharp and all machines in good repair. Prepare for accidents by having first aid materials for trauma and post-emergency procedures. Keep tetanus immunization up-to-date.
6. Clean leather with saddle soaps or other detergent and soap cleaners when possible. Avoid oxalic acid cleaners.

7. Clean shell, bone, horn, antler, and other animal products well before working with them. Buy precleaned materials when possible.

8. Control sanding dusts of all leather and animal products with local exhaust ventilation and/or respiratory protection. Be especially careful to control dusts from antique leather and taxidermied animals.

9. If dyes are used, follow all precautions for dyers (see chapter 16). Choose acrylic, water-based leather dyes or dyes dissolved in ethyl alcohol when possible.

10. Follow all rules for solvent use when working with solvent-containing dyes, glues, and finishes (see chapter 9).

11. Always be prepared to provide your doctor with precise information about the materials you use and your work practices.

CHAPTER 18
CERAMICS

Occupational illnesses, such as lung disease (silicosis) and lead poisoning, have been associated with pottery-making for hundreds of years. Unfortunately, these illnesses and others still are seen in ceramic artists and hobbyists and their families. The exposures that cause these and other ceramic-related illnesses can occur during three basic processes: working with clay, glazing, and firing.

CLAY HAZARDS

Most art and craft potters use one of two methods when making clay objects:

1. Manipulating wet clay by methods such as hand-building or wheel-throwing
2. Slurring the clay into a liquid slip and casting it with molds

HAZARDOUS INGREDIENTS. Whether clay is hand-formed or slip-cast, the term "clay" has come to mean any mineral material that can be used to make ceramic or porcelain objects. Most of these "clays" are composed of a number of mineral ingredients mixed together to produce a body that will fire at a particular temperature and have particular qualities.

Some ingredients in these "clays" include true clays (such as fire clay, china clay, and red clays), sources of silica (such as powdered flint, quartz, or sand), and many other minerals, including feldspar, talc, and wollastonite. Most clays will also have small amounts of additives, such as barium compounds to control scumming; bentonite to increase plasticity; grog (ground fire brick), vermiculite, or perlite to give texture; metal oxides to impart color; and the like. Slip clays' additives may include stabilizers, such as gum arabic, to keep the mixture in suspension and biocides to control mold and bacteria.

Those clays and minerals that are mined from the earth usually contain many impurities. The actual composition of a particular ingredient may vary

greatly from place to place in the mine or deposit. Researching the hazards of these ingredients usually means getting their chemical and mineral analyses. This information should be readily available from your suppliers, because they need it for their right-to-know programs for their workers.

Once you have identified all the ingredients of your products, the hazards can be looked up. Almost all clays and clay mixtures contain significant amounts of silica (see page 173, and table 16, page 174). Hazards of other minerals, such as talc and wollastonite, can be found in table 17, page 178. Metal compounds, such as barium sulfate, can be looked up in table 14, page 150.

DIOXIN IN CLAY. In 1997, high levels of a highly toxic and cancer-causing dioxin were found in Tyson chicken. The Food and Drug Administration (FDA) banned shipments of the contaminated chicken and egg products. Dioxins are a group of seventy-five related chemicals often produced as by-products of industrial processes, but they can also be generated by natural combustion processes, such as forest fires and volcanic action.

The dioxin in the chicken was traced back to small amounts of ball clay, which was used as an anticaking ingredient in the chicken feed. Samples taken from ball clay mines in Tennessee, Kentucky, and Mississippi were all found contaminated with elevated levels of dioxin. And, it appears, this contamination was naturally occurring.

It is now known that both raw (straight from the mines) and processed (purified and bagged for potters) ball clays are contaminated with significant amounts of various dioxins.[1] Potters report that there are now dioxin warnings on the bags of dry clay. I e-mailed David Cleverly, a staff member at EPA, about these warnings, and he replied:

> The ball clay used in ceramics is not "pre-fired" [to remove dioxin].
> . . . To date, no Agency of the U.S. Government has studied potential dioxin exposures to persons using ball clay to make clay pottery and other artifacts. For example, pottery workers may be exposed to dioxin-contaminated dust.[2]

[1] Ferrario, Joseph B., Christian J. Byrne, and David H. Cleverly. "2,3,7,8-Dibenzo-p-dioxins in Mined Clay Products from the United States: Evidence for Possible Natural Origin," *Environmental Science and Technology* 34, no. 21: 4524–4532.

[2] *Cleverly.David@epamail.epa.gov*, April 30, 2001.

Dioxin was also found in minerals other than ball clay. In 1998, the EPA tested more samples of mined clay samples for all of the toxic dioxin congeners (chemicals in the same dioxin class). Nine of fifteen samples were found to contain detectable dioxins—some in ranges of concern. The fifteen new samples were not ball clay. The samples were labeled "montmorillonite," "bentonite," "ground clay," and even "silicate" and "lime."[3]

Ceramicists wishing to know more of the details about the types and amounts of dioxins found in the various samples can contact ACTS and ask for a copy of the article written for *Clay Times* in the July/August 2001 issue.

I'm not sure what the answer is to this problem. One potter I know who has already had cancer is switching to a porcelain body that does not contain ball clay. And certainly, teachers must tell students about the presence of dioxins in their materials, so they can make an informed choice. It certainly is even more imperative to follow the precautions listed at the end of this chapter to reduce exposure to clay dust.

PHYSICAL HAZARDS. In addition to toxic chemicals, there are physical hazards from mixing and working with clay.

Overuse and Strain Injuries. There are many overuse injuries that can occur while wedging, throwing, or hand-building with clay. Many potters have acquired injuries such as carpal tunnel syndrome, a condition involving compression of the median nerve at the wrist. Often, wedging and/or throwing are the cause.

Hand, back, and wrist muscle injuries can also occur from sitting at the potter's wheel for too long, especially if posture is incorrect. Injuries from lifting sacks of clay, molds, and the like are common among both potters and ceramicists (see chapter 4).

Noise. Noise loud enough to damage hearing may be created by machinery, such as pug mills and badly installed kiln ventilation. Wearing hearing protection, such as earplugs, should prevent hearing loss (see chapter 4).

Skin problems. Conditions noted among clay workers include chapping and drying of the skin and bacterial and fungal infections of the skin and nail beds.

3 "Dioxin in Anti-Caking Agents Used in Animal Feed and Feed Ingredients." Guidance for Industry from the U.S. FDA and the Center for Veterinary Medicine, October 6, 1999, *www.epa.gov/ncea/pdfs/dioxin/part1and2.htm.*

Since wet clay commonly harbors bacteria and molds, some people may develop allergies to clay dust, and people with preexisting asthma and allergies may find that their conditions worsen with exposure to clay. Avoiding dusty procedures is always advisable to prevent development of allergies. People with severe allergies would be wise to choose a different craft.

Disease Transmission. Wet clay is also a good medium of exchange for disease-causing bacteria and viruses. It is not recommended for hospital and institutional art or therapy programs if patients are carriers of infectious diseases, such as impetigo, shigellosis, and hepatitis A.

GLAZE HAZARDS

Common glazes are a mixture of minerals (see table 17), metallic compounds (see table 14), and water. Commercial glazes usually contain frits and additives, such as gum stabilizers and preservatives. Preservatives in commercial glazes are usually small amounts of toxic pesticides or bactericides. Gum stabilizers are not very toxic, but some people are allergic to them.

HAZARDOUS INGREDIENTS. In general, metallic elements function in glazes as fluxes (causing the glaze to melt properly) and colorants. Their toxicity varies greatly. Some very safe ones are iron, calcium, sodium, and potassium. Some low-fire glazes contain very toxic fluxes and colorants, including lead, cadmium, antimony, and arsenic. Middle-range and high-fire glazes may have large amounts of highly toxic fluxes, such as barium and lithium. Toxic colorants, which can be in both high- and low-fired glazes, include uranium, chromium, cobalt, manganese, nickel, and vanadium. Some lustre glazes also contain highly toxic mercury and arsenic.

Lustre glazes usually contain metallic alloys and compounds, highly toxic solvents such as chloroform and other chlorinated or aromatic hydrocarbons (see table 9), and tack oils such as oil of lavender. Tack oils are hazardous primarily when they decompose during firing (see Carbon Monoxide and Other Organic Decomposition Products in table 22 below.)

Glazes are often used in conjunction with colorant materials, such as metallic oxides, stains (e.g., Mason stains), underglazes, engobes, ceramic decals, and the like. These materials rely primarily on metallic compounds for coloring (see table 14).

There are also new ceramic paints on the market that look like fired ceramic glazes when dry. These usually contain plastic resins and solvents. The hazardous ingredients in these glaze paints are solvents and resins (see chapters 9 and 10).

LEAD GLAZES. There are excellent substitutes for lead glazes. Those who choose to continue using lead should consider the health effects of lead, the solubility of lead frits, and the leaching characteristics of lead glazes (see Finished Ware Hazards below). They also need consider the expense of compliance with (or being caught in violation of) Canadian or United States occupational and environmental lead laws (see page 261). Lead glazes should be phased out of art and craft work.

WORKING WITH GLAZES. Glazes, even those free of lead, are potentially hazardous at all stages of use—during glaze-making, application, firing, and when glazed pottery is used as food utensils.

1. **Glaze-making** is one of the most hazardous tasks potters perform, because it involves weighing and mixing the powdered ingredients. Methods of controlling the dust should be employed (see chapter 7).
2. **Application** of glazes can be done by brushing, dipping, spraying, airbrushing, and occasionally by dusting dry ingredients onto wet ware. Brushing and dipping methods are preferred, because they produce less dust. Spraying, airbrushing, and dusting should be done only in a spray booth or outdoors.

Many other glazing processes are potentially hazardous and should be evaluated for safety. For example, melting paraffin to use as a glaze resist can be a fire hazard and result in exposure to toxic wax decomposition products. Local exhaust ventilation should be provided for this process, direct flame should not be used to heat the wax (e.g., use an electric hot plate, and put the wax in a double boiler), and the temperature of the paraffin should be kept as low as possible. Water/wax emulsions that are applied without heat are safer.

FIRING HAZARDS

VENTILATION. When clays and glazes are fired, they release various gases, vapors, and fumes. Some common emissions from kilns include carbon monoxide, formaldehyde and other aldehydes, sulfur dioxide, chlorine, fluorine, metal fumes, nitrogen oxides, and ozone (see table 22 below).

For this reason, all firing processes require ventilation. One of the best types of ventilation for electric kilns is the negative pressure system (see figure 13). Different types of firing need different types of ventilation. Some types can be done safely only outdoors. All indoor kilns, whether electric or fuel-fired, need exhaust ventilation.

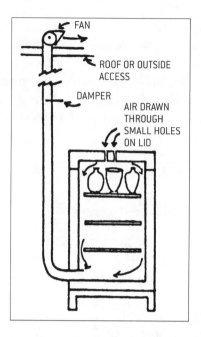

FIG. 13. Negative Pressure Ventilation System

TABLE 22	SOURCES OF TOXIC KILN EMISSIONS

CARBON MONOXIDE. This gas is formed when carbon-containing compounds are burned in limited-oxygen atmospheres, such as when gas, wood, or other fuels are burned in kilns. Reduction firing produces the greatest amounts of carbon monoxide. Electric kilns also produce carbon monoxide from the burning of organic matter found in most clays and in many glaze materials, from wax resists, from stabilizers in slip clays, from tack oils in lustres, and from other organic additives in clays and glazes. Amounts of carbon monoxide over the Threshold Limit Value have been measured near electric kilns.

OTHER ORGANIC DECOMPOSITION PRODUCTS. In addition to carbon monoxide, large numbers of other chemicals are created when organic matter burns. A class of chemicals called aldehydes and certain other organic chemicals emitted by kilns are known to be toxic. Formaldehyde, for example, has been measured in significant amounts near electric kilns. Some dioxins and related chemicals will also be emitted from kilns firing objects made from ball clay and certain other minerals.

SULFUR OXIDES. Many clays and glaze ingredients contain significant amounts of sulfur-containing compounds. When these are fired, they give off sulfur oxides, which form sulfurous and sulfuric acids when they combine with water. These acids etch the metal kiln parts above ports and doors and are also highly damaging to the respiratory system.

CHLORINE AND FLUORINE. These gases are released when fluorine- and chlorine-containing clay and glaze chemicals such as fluorspar, iron chloride, and cryolite are fired. Both gases are highly irritating to the respiratory tract. Fluorine is also associated with bone and tooth defects.

METAL FUMES. Fumes are formed when some metals and metal-containing compounds are fired. Complex reactions that occur during glaze firing make it difficult to predict precisely at what temperature metals will volatilize and oxidize to form a fume. Some toxic metals that commonly fume include lead, cadmium, antimony, selenium, copper, chrome, and nickel. The fumes may be inhaled, or they may settle on surfaces in the studio. Some fumes can contaminate the kiln and leave deposits on ware in subsequent firings.

NITROGEN OXIDES AND OZONE. These gases are produced by decomposition of nitrogen-containing compounds or by the effect of heat and/or electricity on air in the kiln. They are strong lung irritants.

OTHER EMISSIONS. One of the strongest arguments for venting all kilns is the unpredictability of emissions. Trade magazines and textbooks often suggest projects that result in the firing of nails, paper, plastic, wood, wire, and many other items. One magazine even suggested throwing mothballs into hot electric kilns to create reduction atmospheres. This practice would release highly toxic emissions, including cancer-causing benzene. Projects such as these, combined with the unpredictability of clay and glaze composition, make ventilation absolutely necessary.

FIRE/ELECTRICAL SAFETY. Fire hazards should be considered when planning pottery or ceramic studios. Consult local fire officials or other experts to be sure your studio meets all local fire regulations and electrical codes.

Large kilns should be located in areas in which there are no combustible or flammable materials. Even small electric kilns should be at least three feet from combustible materials such as paper, plastic, or wood. Electric kilns should also be raised at least a foot above the floor to allow air to circulate underneath. Wooden floors under small electric kilns can be protected by asbestos-substitute fiberboards or by refractory brick.

To prevent fires and damage to ware, electric kilns should be equipped with two automatic shut-offs in case one fails. Three types to choose from are pyrometric shut-offs, cone-operated shut-offs, and timers.

Radiation in the infrared region is produced in significant amounts whenever metals or ceramic materials are heated to the point where they glow. The hotter they are, the more infrared radiation is produced. Infrared radiation can damage the eye and can cause a type of cataract and retinal damage.

Protective lenses should be worn when looking into glowing-hot kilns. Unfortunately, some eyewear sold to potters was developed primarily for protection from ultraviolet and will not protect them from infrared. For example, didymium lenses, which block the bright yellow glare, will only make exposure worse. Potters must demand that sellers provide a transmission spectrum for their lenses that shows they block a very high percentage of radiation in the infrared range (800 to 6,000 nanometers wavelength, and even higher if possible). Standard welding lenses of shade number 3 or 4 will do a good job, but they are dark.

KILN BUILDING. Many potters choose to build their own kilns. This process may expose potters to many hazards, including asbestos substitutes (some are suspect carcinogens), fire brick dust (usually contains silica), heavy lifting, and noise (if hard bricks are wheel-cut).

If dust-producing tasks cannot be done in local exhaust or outdoors, respiratory protection approved for toxic dusts should be used. Hearing protection should be used if brick cutting or other noisy processes are done (see chapter 4).

Connecting kilns to gas or electric lines should be done or approved by licensed electricians and/or gas company employees.

FINISHED WARE HAZARDS

Potters and ceramicists often are not aware that they may be liable if the ware they sell harms someone. Potters, like commercial chinaware makers, could be held responsible for injuries or damages incurred if their ovenware shatters from heat or if lead or other toxic metals from their glazes contaminates food.

LEACHING. The problem of glaze solubility (leaching) is complex. Leaching glazes solubilize, slowly releasing all their ingredients into food (albeit sometimes at varying rates). Most glazes leach faster in acid solutions, such as orange juice. Standard laboratory leaching tests are done in acid solutions. But there is

TABLE 23	DRINKING WATER STANDARDS COMPARED TO FEDERAL AND CALIFORNIA LEAD AND CADMIUM GLAZE LEACHING STANDARDS		
CHEMICAL	**DRINKING WATER STANDARDS***	**FDA PITCHER GUIDELINES**	**FDA/ CALIFORNIA LABEL GUIDELINES**
Aluminum	0.2 mg/L†	none	none
Antimony	0.006 mg/L	none	none
Arsenic	0.01 mg/L	none	none
Barium	2.0 mg/L	none	none
Beryllium	0.004 mg/L	none	none
Boron	0.6 mg/L	none	none
Cadmium	0 mg/L	0.25 mg/L	none
Chromium	0.1 mg/L	none	none
Copper	1.3 mg/L	none	none
Cyanide	0.2 mg/L	none	none
Fluoride	4.0 mg/L	none	none
Lead	0 mg/L‡	0.50 mg/L	0.1 mg/L
Mercury	0.002 mg/L	none	none
Manganese	no standard	none	none
Nickel	0.1 mg/L	none	none
Selenium	0.05 mg/L	none	none
Silver	0.1 mg/L	none	none
Thallium	0.002 mg/L	none	none
Uranium	0.03 mg/L	none	none
Zinc	2.0 mg/L	none	none

*Maximum Contaminant Levels (MCL) and Health Advisory Levels (HAL) from the Environmental Protection Agency's drinking water standards.
† Milligrams per liter.
‡ The MCL for lead is zero, but there is an action level of 0.015 mg/L at which remedial actions must be taken.

reason to believe that some may solubilize faster in contact with alkaline foods, such as beans or some green vegetables.

Many factors influence glaze solubility, including composition of the glaze, small amounts of certain impurities, heating and cooling cycles during firing, fumes from other glazes fired in the kiln, and more. Commercial producers

have found that testing programs are the only way to guarantee glaze performance. Potters should use them as well (see Testing below).

Some ceramicists have relied on premixed glazes, which are sold as "lead-safe." Manufacturers of these glazes say they will not leach more lead or cadmium into food than the Food and Drug Administration (FDA) allows if all the firing and application of the glazes are done properly. However, over- or underfiring, application over an unsuitable underglaze (such as one containing copper), the contamination of a glaze from using an unclean brush, and many other factors can render a "lead-safe" glaze dangerous. These glazes also need to be tested.

Potters often think that only low-fire glazes leach lead. Now, it is known that some high-fire glazes can leach dangerous amounts of other metals, such as barium, lithium, chrome, and other metals. In recognition of this problem, the FDA called for data in 1989 on leaching of other metals from lead-free glazes to investigate their safety. But there are still no standards set for other metals.

For a number of years, I have suggested that potters have their ware tested anyway and compare the results to the maximum contaminant levels and health advisory levels for drinking water (see table 23). Clearly, if the glaze doesn't leach more metals into the food than would be allowed in a glass of rather bad municipal water, the glaze is not very harmful. While this method is not toxicologically very sophisticated, it has a certain common sense.

If potters don't want to test, they can use glazes that contain no toxic metal-containing ingredients. These safer glazes employ only glaze chemicals containing sodium, potassium, calcium, and magnesium fluxes, and colorants would be limited to iron compounds and tin opacifiers.

LEAD LEACHING LAWS. In the United States, producers of ceramic pieces that look like food ware, but which will not meet lead- and cadmium-leaching guidelines, are required by the FDA to comply with a newly revised regulation [21 CFR 109.16(b)(1)], which says that the piece must bear both a conspicuous stick-on label and a permanent fired or molded warning (the law specifies type size) on the base of the piece. The wording must be chosen from one of the following:

1. Not for Food Use. May Poison Food.
2. Not for Food Use. Glaze Contains Lead. Food Use May Result in Lead Poisoning.
3. Not for Food Use—Food Consumed from This Vessel May be Harmful.

Additional wording, placed after the required statement, may also be included: "Decorative" or "For Decorative Purposes Only." A one-inch-diameter symbol may also be used to on the temporary label or on the base of the piece:

Ceramicists do not have to comply with the rules above if they drill a hole through a food contact surface to render the object unusable for food service.

FIG. 14. Lead Warning Symbol

TESTING. There are some lead test kits sold at hardware stores for paint testing that can be used. These are not accurate enough to replace proper laboratory tests, but they can usually identify gross lead leaching.

Glazes can be tested properly if the potter sends pieces to certified laboratories for a standard acid leach test, often referred to as ASTM C 738. Usually, cups are easiest to ship and test by this method. The cost may run from as little as $30 to as high as $400. Look for laboratories that will test for metals other than lead and cadmium if you do not use these metals in your products.

One good low-cost testing laboratory that will test for almost any metal on request is:

Alfred Analytical Laboratory
4964 Kenyon Road
Alfred Station, New York 14803-9703
(607) 478-8074
Contact: Dr. Roland Hale

RULES FOR WORKING WITH CLAY AND GLAZES

1. Plan studios with cleanup procedures in mind. Floors should be sealed and waterproof. Drains may not be allowed in floors in areas where EPA-regulated chemicals such as glaze chemicals are mixed or applied. Use nonslip coatings, flooring, or mats for areas where water is likely to spill. Tables, shelving, and equipment should be made of materials that can be easily sponged clean. Enough space should be left between tables and equipment to make cleaning easy.

2. Construct kilns from refractory brick and castables. Avoid asbestos and ceramic fiber insulation. Wall off any existing fiber insulation

with brick or metal barriers. Repair or dispose of fiber insulation with precautions similar to those required for asbestos abatement. Follow all occupational and environmental regulations when disturbing, repairing, or disposing of asbestos-containing materials.

3. Install proper ventilation for each type of kiln. Negative pressure systems are usually best for electric kilns. Ventilation systems for all types of kilns must exhaust to the outside. For more information, obtain the Keeping Clay Work Safe and Legal data sheet, listed in appendix A, part 1.

4. Install two types of kiln shut-off mechanisms for backup.

5. Install carbon monoxide detectors in the kiln area.

6. Keep all tools, machinery, and potter's wheels in good condition. Be especially vigilant about electrical equipment, since water is always present. Place ground fault interrupters on outlets used for potter's wheels and other electric tools.

7. Use hand grinders and Dremel® tools for removing dripped glaze from pottery. Bench grinders can't be used for this purpose. When the grinder is the guard, tool rest, and breakout plate are in place as OSHA requires, there is not enough space to place the pot on the wheel. Exhaust grinding dusts to the outside.

8. Plan fire protection carefully. Locate kilns in areas free of combustible materials and at least three feet away from combustible walls. Consult fire officials or other experts for advice on proper fire-fighting systems and/or extinguishers.

9. Use proper eye protection. Wear clear impact goggles when grinding or chipping. Wear infrared-blocking goggles when looking into glowing kilns. The lenses should be welding shade number 3 or 4, or their transmission spectrum should show that radiation between 600 and 6,000 nanometers or higher is blocked.

10. Use proper protective equipment, such as asbestos-substitute gloves, when handling hot objects, aprons to avoid splashes, and work shoes (do not wear sandals or work barefoot).

11. If masks or respirators are used, all OSHA regulations applying to respirator use should be followed (see chapter 8).

12. Be sure all materials are labeled with the name of the substance, all required hazard warnings, and the name and address of the manufacturer. The best way to do this is to purchase chemicals in small quantities and to keep them in their original containers.

13. In addition to Material Safety Data Sheets, obtain mineral and chemical analyses of clays, glazes, and other minerals from suppliers. Avoid materials containing highly toxic ingredients such as lead and asbestos.

14. Avoid using highly toxic ingredients such as lead, cadmium, and uranium. (Uranium is still used by many potters. Artists and regulators interested in this problem may contact the author for further information.)

15. If lead is used on the job, employers must be prepared to meet complex OSHA Lead Standard regulations in the United States or the OHSA Regulations respecting lead in Canada. Disposal of lead-containing materials must also meet toxic waste rules.

16. Practice good hygiene. Wash hands carefully, and use a nail brush after glazing. Work on surfaces that are easily cleaned with a damp sponge, and wipe up spills immediately. Don't eat, drink, smoke, apply cosmetics, or store food in ceramic areas. Eating and recreating must be done in separate rooms maintained in a sanitary condition.

17. Avoid skin problems. Keep broken skin from contact with clay and glazes. Wash hands and apply a good emollient hand cream after work. People with skin problems can wear surgical or plastic gloves while working.

18. Wear protective clothing, such as smocks, tightly woven coveralls, and hair covering. Avoid flammable synthetic fabrics. Change clothing when leaving the pottery, rather than carrying dusts home. Wash clothing frequently and separately from other clothes.

19. Avoid ergonomic injuries. Make repetitive and/or forceful movements of the hands and arms in short bursts, and take frequent rests. Never work to the point of exhaustion or pain. Change positions frequently. When wedging, keep the wrist in a neutral or mid-joint position, and use the weight of the body rather than just the muscles of the upper arm. In general, maintaining good posture, keeping fit (especially avoiding being overweight), and exercising to keep muscles strong are all useful practices to prevent overuse injuries.

20. Avoid lifting injuries. Buy most chemicals in twenty-five-pound quantities or less. Store heavy materials at heights (on benches or shelves) where lifting can be done without bending the back. Storage on trolleys may even help you avoid the need to lift. When lifting is necessary, it should be done with the legs, keeping the back straight to avoid injury.

21. Avoid processes that create airborne toxins such as mixing clay (purchase premixed clay instead), sanding greenware (tool when the leather is hard), spraying glazes (apply with a brush), and similar processes. When these processes can't be avoided, install local exhaust systems. For example, have a spray booth for glaze spraying, hoods for mixing clay or using powdered chemicals, collection systems on grind wheels, fume exhaust for wax pots, and the like (see chapter 7, Ventilation).

22. Use cold-wax emulsions when possible. If wax is melted for glaze resist, provide ventilation, electric heating (no open flames), and a double boiler to keep wax from being heated above 100°C.

23. Clean floors without creating dust. Do not sweep. Wet-mop, or use a HEPA vacuum instead.

24. Dispose of all old clays and glazes, grinding dusts, and other waste materials in accordance with occupational and environmental protection regulations. Waste materials and water amassed from cleaning the floors—especially in glaze mixing and application areas—will probably have to be contained and disposed of as toxic waste. Chemicals containing EPA-regulated metals may not be put into drains leading to water treatment plants, leach fields, or storm sewers in most areas of the country.

25. Keep the pottery floors and surfaces as dry as possible to prevent infestation of molds and fungus. Clay dust itself usually carries enough mold particles to cause allergies in some people. Cover pieces of pottery with plastic or a damp cloth to retard drying, rather than setting up a damp room where standing water is always present.

26. Always be prepared to provide your doctor with precise information about the chemicals you use and your work practices. Have lung function tests included in your regular physical examinations. Arrange for regular blood-lead tests if you use lead-containing frits, glazes, or other materials.

27. Provide customers with food-safe ware, either by using glazes that contain no toxic substances or by engaging in regular laboratory testing programs.

28. Keep children out of areas where there are glazes and glaze chemicals, clay dusts, heavy flywheel potter's wheels, and other equipment or materials that are hazardous. Children's classes must be taught in classrooms that are "childproofed" as well as your own home would be. Even most "nontoxic" glazes are not suitable for children in grade six or under.

CHAPTER 19

GLASS

Studies have shown that a large percentage of glassblowers develop lung problems, significantly decreased lung capacities, and are at elevated risk for cancer.[1] The cause or causes of these health problems are unknown. And it is likely that the cause will remain unknown, because glasswork hazards are complex and involve exposure to small amounts of a host of toxic metals.

GLASS INGREDIENTS: A SPECIAL PROBLEM

Safety cannot be planned without identifying the toxic ingredients in the materials used. This is more difficult for glass workers than most other artists because of the large number of metals used in glassmaking. The main body, or "melt," of the glass may be fluxed with lead, lithium, boron, and other metals. Common metal colorants include cadmium for opaque yellow color, arsenic for off-white, chromium compounds for green or yellow, and so on.

Even esoteric metals such as erbium, tellurium, iridium, and germanium have been used. For example, germanium mixed with copper will produce a red glass. The hazards of many of these rare metals are not well known.

In addition, glass workers sometimes can't find out what metals are present in their glass. Some suppliers still do not provide Material Safety Data Sheets (MSDSs) on glass products. Two rationales used by these suppliers to defend their refusal to supply MSDSs are: 1) MSDSs are not needed, because the toxic metals are "bound" in the glass, or 2) the products are imported, and they don't have MSDSs.

[1] "Epidemiologic studies of occupational cancer as related to complex mixtures of trace elements in the art glass industry," Wingren, Gun; Axelson, Olav, *Scand. J. Work, Environ. Health* (1993) p. 95–100.

BOUND METALS. The myth that metals are bound in glass should have been completely abandoned by the glass industry after the following story made national headlines.

In 1993, Oregon Steel Mills Incorporated received the Governor's Award for Toxic Use Reduction in recognition of its process of taking toxic steel slag, mixing it with glass ingredients, making it into a frit that bound the toxic metals in the glass, and selling it as roofing granules. Then, two years later (July 26, 1995), the Oregon Occupational Safety and Health Division cited Oregon Steel Mills and proposed $1.4 million in penalties for selling these same roofing granules as an abrasive blasting grit.

An investigation by the Oregon OSHA determined that workers using this blasting grit could be exposed to five to ninety-nine times the permissible exposure limit (PEL) for lead and two to sixteen times the PEL for cadmium. But the MSDS for the grit stated that the only health hazard associated with the blasting grit was nuisance dust exposure.[2]

In other words, toxic metals are not "bound" in glass if glass workers are exposed to its dust or fumes.

IMPORTER'S MSDSs. Companies that do not provide MSDSs because they are selling imported glass are violating U.S. laws. The importer is the "manufacturer of record" in the United States. It is the importer's duty to investigate the hazardous ingredients in the products and prepare and provide MSDSs to their customers.

This problem was first addressed by the Washington State Department of Labor, Division of Industrial Safety and Health (WISHA), in 1999, when they cited Olympic Color Rods for a number of items, including:

> **Citation 1 Item 1a** SERIOUS (62-05407(1)). **The importer failed to evaluate chemicals imported by them to determine if they are hazardous.**
>
> **Citation 1 Item 1b** SERIOUS (62-05413(1)). **The importer failed to develop a material safety data sheet (MSDS) for each hazardous chemical they import.[3]**

[2] Bureau of National Affairs. *Occupational Safety and Health Reporter* 25, no. 9 (August 2, 1995): 368–369.

[3] Department of Labor, Division of Industrial Safety and Health (WISHA), Inspection No. 302174032, March 1–August 6, 1999.

While Olympic Color Rods was cited by WISHA, I want to make it clear that they were only doing what *all* the glass importers were doing at the time. In fact, this problem was so pervasive that many glassblowers convinced themselves, their students, local regulators, court judges, and people living near their studios that they were not using lead and other toxic metals. These glassblowers were unaware that the majority of colored rods, frits, and granules they were buying contained between 25 and 60 percent lead.

PHYSICAL HAZARDS

Glass workers also develop physical problems that are associated with the materials and processes encountered during four basic stages in glassblowing:

1. Making glass
2. Working (blowing) the glass
3. Annealing
4. Finishing

The hazards of lamp-working and slumping will also be discussed.

MAKING GLASS. Because glass is a "supercooled liquid" rather than a compound or mineral, there is no limit to the varieties and mixtures of glass ingredients possible. Adding a pinch or two of another ingredient to a mixture will produce a "different" glass.

However, there are several basic divisions or classifications of glass. These are usually referred to by the names of their primary fluxes (components that cause the glass to melt). For example, glasses called "borosilicates" employ boron compounds as their major fluxes.

The most common types of clear glass are lead/potash, borosilicates, and soda/lime. White or opal glasses usually come in two varieties, calcium phosphate/silica and alumina/silica/fluorine glass. Other chemicals are also added to glass melts to alter their properties.

The common glass-forming chemicals are the same ingredients used in ceramics. For example, silica, feldspars, lead compounds and frits, boron, and zinc compounds are used. The hazards of these minerals and metal-containing compounds can be looked up in table 14, page 150, and table 17, page 178.

Glass colorants are often added to the melt. These also are generally the same chemicals used to color ceramic glazes and enamels. They may include

compounds of cadmium, chrome, cobalt, copper, gold, iron, manganese, silver, and uranium. The hazards of these metals can be looked up in table 14.

These glass-making and coloring compounds are weighed and put in the glass furnace to melt. The powdered chemicals can be inhaled while weighing and charging the furnace. The melting of the glass causes toxic gases and fumes to be given off. Gas furnaces may also give off carbon monoxide gas. Excellent dust control and exhaust ventilation for the furnace are needed.

A safer way to obtain glass is to purchase premixed glass or glass cullet (scrap glass) from glass factories. Some batch companies also sell glass mixtures that have been partially fused into lumps to reduce the dust. Some glass blowers recycle scrap glass bottles. Using glass from these sources eliminates handling toxic powders and reduces formation of toxic gases and fumes in the furnace.

Furnaces must also be vented to reduce heat in the work area. Fatigue, rashes, and stroke from heat are common problems among glassblowers. Hot, glowing furnace brick and molten glass give off infrared radiation. Protective infrared goggles should be worn to prevent infrared cataracts, which historically have been called "glassblower's cataract."

WORKING THE GLASS. Glassblowing is heavy physical work in a hot, hazardous environment. The glass is worked while molten and glowing. Sharp glass splinters and shards are created when pieces are discarded, transferred to the pontil, or knocked off the pontil into the annealing oven. Avoiding cuts, burns, and accidents takes constant vigilance, and glass workers should be prepared to treat burns and cuts. Some glassblowers keep ice cubes on hand to treat small burns.

Wet wooden tools are often used to form glass, and they can smoke from overheating—this smoke can be inhaled while working. Some practices, such as marvering powdered colorants into the glass (rolling the hot glass on a metal surface where the colorants have been placed), will cause hot toxic gases and fumes to be created.

Work surfaces and benches, especially on older equipment, may be insulated with asbestos board. Dust raised when these surfaces are abraded has been associated with asbestos-related disease in glassblowers.

ANNEALING. Annealing is done at lower temperatures than melting. Annealing ovens add heat to the work space, but the amount of heat should be easily dissipated by the shop's general ventilation system. However, if fuming

(putting metal chlorides into the oven to create iridescent surfaces) is done in the annealing oven, the irritating fumes created require local exhaust, such as a movable canopy hood.

Fiber insulation, such as asbestos or ceramic fiber (see page 175), used in annealing ovens is likely to become disturbed and made airborne as glass is continually put in and removed. Refractory brick contains some free silica, but is much safer.

Annealing is done to relieve physical stresses in the glass caused by rapid cooling. Improperly annealed glass may crack or shatter, often without warning. There are polarized lights and other instruments that can detect unrelieved stress. Having glass shatter while polishing it can be dangerous. Having it shatter in a show room is not only dangerous—it is embarrassing.

FINISHING GLASS. Dry grinding and polishing of glass can create abrasive dust. Some of the least toxic abrasives and polishing compounds are alumina, tin oxide, silicon carbide, diamond, and cerium dioxide (see table 17).

Dry grinding also produces glass dust. This dust is a mechanical irritant to the eyes and respiratory system. It also may be toxic, depending on the type of glass being ground. For example, lead/potash glass dust, like a lead frit, can be a source of lead poisoning. Glass colored or opacified with highly toxic chemicals such as arsenic or antimony can also produce hazardous dust.

Wet grinding and polishing methods should be used when possible to reduce exposure to grinding dusts. Some dust will be suspended in the water mist that rises from these tools. Breathing this mist should be avoided. In addition, the mist settles on surfaces, dries, and becomes a dust, providing yet another source of exposure.

Mist from these tools may also contain disease-causing microbes. Hazardous microorganisms, such as those causing Legionnaires' disease, have been isolated from wet-grinding water reservoirs. Frequent cleaning keeps these organisms from establishing themselves in the reservoir.

Both wet and dry grinding and polishing dusts containing highly toxic components may be costly to dispose of properly. Consult local environmental protection authorities for further information.

DECORATING GLASS

Glass can also be decorated by etching, sand blasting, painting, and other techniques. These processes are discussed in chapter 22.

BUILDING AND REPAIRING OVENS AND FURNACES

Furnaces, glory holes, annealing ovens, and other studio equipment are often constructed of hazardous materials. The safest materials are refractory brick and castables. A wide variety of these are on the market. High alumina refractories are extremely resistant to glass. Soft insulating brick is not, but it can be protected from direct contact with a layer of hard brick or alumina refractory.

Other construction and insulation materials include asbestos, ceramic, and other synthetic fiber products (see page 175). Repair or disposal of equipment constructed with these fiber products can release large amounts of highly hazardous dusts. Repair and disposal of asbestos-containing materials must be done in accordance with occupational and environmental protection regulations. Complying with these regulations is usually costly, but being caught violating them can be even more costly.

LAMP-WORKING

Lamp-workers use small torches (usually propane, butane, methane, or natural gas and oxygen) to heat glass rods and tubes to form or "blow" them into objects and figures. While lamp-workers use much smaller amounts of materials and flame, they work much more closely and intimately with them. Lamp-working hazards include thermal burns, cuts, infrared radiation, fire hazards, and toxic chemicals in some colorants and surface treatments. The hazards of surface treatments can be found in chapter 22. Lamp-workers can follow the Precautions for Glass-Working" (below) that are applicable.

SLUMPING AND FUSING

Glass slumping is the process of changing the shape of glass by heating it to temperatures exceeding 530° Centigrade (1000° Fahrenheit), so that it will soften and bend under its own weight. Fusing is the process of heating pieces of glass together until they adhere.

These processes are usually done in electric kilns. Follow all precautions for using ceramic kilns, including ventilation (see pages 241–244).

Slumping hazards include burns and cuts, the use of colorants and surface treatments (see chapter 22), thermal shock shattering of improperly annealed glass or of fused incompatible glasses, and exposure to mold-release powders, fiber paper, kiln washes, and the like. Artists doing glass slumping may also follow the Precautions for Glass-Working below.

The materials used for molds or to protect forms are of several types. Included are shelf primers, kiln washes, and ceramic fiber mats and papers. Most kiln washes and primers contain sources of free silica, such as flint. Firing may convert the silica to more-toxic cristobalite (see page 173, and table 16, page 174). Obtain ingredient information, and use suitable precautions. Avoid inhalation of dust from these materials, and practice good dust control.

Avoid ceramic fiber mats and papers. These may be associated with asbestos-like illnesses, and after repeated firing, they partially convert to cristobalite. Thin layers of refractory materials or insulating brick can be substituted in some cases.

PRECAUTIONS FOR GLASS-WORKING

1. Plan studios with health and safety in mind. Floors should be cement or other noncombustible material. The floor surface should be smooth enough to be easily wet-cleaned. Walls should be fire resistant. Ceilings should be high enough to accommodate swinging blowpipes. Construct adjacent bathroom facilities and a walled-off recreation area. Artists should be able to clean up and retire to a clean room to drink fluids to replace those lost through perspiration, to rest, and the like.

2. Construct furnaces and other equipment from refractory brick and castables when possible. Avoid asbestos and synthetic fiber insulation. Wall off existing fiber insulation with brick or metal barriers. Repair or dispose of fiber-insulated equipment with precautions like those required for asbestos abatement. Follow all occupational and environmental regulations when disturbing, repairing, or disposing of asbestos-containing materials.

3. Plan fire protection carefully. Eliminate all combustibles from the area, and provide a source of water on the premises. Do not install water sprinkler heads above furnaces, electric annealing ovens, and similar hot and/or high-voltage equipment. Consult fire marshals or other experts for advice on proper fire-fighting systems and/or extinguishers that meet local and federal safety codes. Post fire procedures, and hold drills.

4. Provide excellent local exhaust for the furnace to remove heat and toxic gases. Gas furnaces will need both stack and canopy exhausts. Vent electric annealing ovens if fuming or lustre glazing is done in them.

5. Install carbon monoxide detectors near furnaces and glory holes.

6. Provide good general ventilation for the work space to reduce heat. Follow rules to avoid heat stress and repetitive strain injuries (see pages 35–36).

7. Provide local exhaust for any processes that create toxic emissions, such as hot marvering of colorants, etching, or fuming (see chapter 22 for precautions for glass surface treatments).

8. Use cullet or second-melt glass if possible to avoid the hazards of making glass. Handle shards of broken glass cullet with great care, or purchase special "chain mail" safety gloves, which protect glass handlers from cuts.

9. Obtain Material Safety Data Sheets, formulas, and analyses of your glass-making and/or colorant ingredients. Look up their hazards, and use the safest materials possible. Especially try to avoid highly toxic ingredients, such as arsenic, antimony, cadmium, and uranium colorants, cyanide reducers, and fluorine compounds.

10. If lead is used on the job, employers must be prepared to meet complex OSHA Lead Standard regulations in the United States or the OHSA Regulations respecting lead in Canada. Disposal of lead-containing materials must also meet toxic waste rules.

11. Avoid exposure to powdered glass ingredients or colorants. Weigh them in local exhaust areas or outdoors, or use respiratory protection. Transfer them carefully to avoid creating dust. Clean up spills immediately. Prepare for spill control and chemical disposal.

12. Protect eyes by wearing infrared-blocking goggles, which are also impact-resistant, whenever looking at glowing-hot materials, working with materials that might shatter, or whenever eyes are at risk. (See figures 3 and 4.) Insist that suppliers provide the transmission spectrum for the lenses, and be sure they block infrared (600 to 6,000 nanometers or higher if possible). Many types of eyewear being sold for glasswork are not protective against infrared, especially didymium lenses.

13. Wear protective clothing similar to welders'. For example, do not wear polyester or other synthetic fibers, which will melt to the skin at high heat. Avoid pockets, trouser cuffs, and socks, which can catch hot chips. Remove jewelry, and tie back hair or wear a hair covering. Wear shoes with soles not easily penetrated by broken glass. Leave clothing in the studio to avoid tracking dusts home. Wash clothing frequently and separately from other clothes.

14. Take frequent work breaks when doing hot work, and drink plenty of water (with one teaspoon of salt added per gallon if replacing water lost by perspiration). People with heart or kidney disease, who are very overweight, or who have impaired reflexes, dexterity, or strength should not engage in glassblowing.

15. Avoid ingestion of materials on the premises—eat, smoke, and drink in a separate facility outside the work area. Wash hands before eating, applying makeup, and performing other hygiene tasks.

16. Keep containers of cool water and ice handy for cooling tools and treating small burns. Have a first aid kit equipped with treatments for burns and cuts. Post and practice emergency procedures.

17. Practice constant good housekeeping to prevent cuts caused by stepping on broken glass. Never allow trip hazards in the work area.

18. Clean the studio with methods that do not raise dust. Acceptable methods include wet-mopping or hosing down.

19. Use polarized light sources or other equipment to check finished glass for stress, and adjust annealing temperatures and time accordingly.

20. Dry grinding and polishing wheels should also be equipped with local exhaust. All wet and dry grinding and polishing wheels should have machine guards and face guards. Wear impact-resistant goggles when grinding.

21. Use wet-grinding equipment rather than dry whenever possible. Wet-grinding equipment should be cleaned while wet to avoid dust exposure. Water tanks should be cleaned often to keep microorganisms from establishing themselves.

22. Obtain Material Safety Data Sheets on grind wheels and abrasives. Avoid those containing silica and other toxic substances when possible.

23. Dispose of all grinding and polishing dusts, used chemicals, waste glass, and other materials in accordance with good hygiene and waste-disposal regulations. If lead, cadmium, copper, zinc, or other EPA-regulated chemicals are used, it will probably be necessary to design the floor so that spills, dust, and wash water from cleaning can be captured for toxic waste disposal. In most areas in the country, chemicals such as these cannot go directly into drains leading to water treatment plants, leach fields, or storm drains.

24. Always be prepared to provide your doctor with precise information about the chemicals you use and your work practices. Have lung-function tests included in your regular physical examinations. If lead materials are used, arrange for regular blood tests for lead.

CHAPTER 20
STAINED GLASS

Lead is the major hazard in stained glass work. It is used in traditional stained glass to bind pieces of glass together in frames of lead came (channeled lead strips) or in lead-soldered seams with a layer of copper foil between the solder and the glass.

LEAD SUBSTITUTES

Traditional lead solders are increasingly being replaced by the new lead-free solders. This is due to the increasing enforcement of lead laws and regulations in the United States and Canada. In the United States, the OSHA Lead Standard requires any work place where lead is used more than thirty days per year to do air sampling. If these tests are above a certain limit (0.03 milligrams per cubic meter), then regular air monitoring, medical surveillance, special ventilation systems, and many other costly provisions must be met.

In addition, a new Environmental Protection Agency (EPA) regulation now requires all businesses (including studios and schools) that use more than a hundred pounds of lead per year to report annually. Any release or spill of significant amounts of lead must also be reported.[1]

Many glass studios cannot afford to meet the OSHA and EPA standards. Fortunately, these studios can stay in business legally by switching to some of the new lead-free solders. They are not quite as easy to use, but more and more stained-glass craftspeople are turning to them. The solders are available from most craft and hardware outlets.

[1] *66 Federal Register* 7701, January 24, 2001 and *66 Federal Register* 10585-10586, February 16, 2001.

The best solders for stained glass work are made of silver, tin, copper, and zinc. Those that contain antimony and arsenic are too toxic. Lead-free solders cost about twice what lead solders cost, but they are cheaper than the cost of meeting the lead laws.

Some craftspeople are also changing from lead came to channels of zinc and other metals. With these lead-free materials and certain other precautions, it even may be possible to do stained glass in college and hobby workshops safely.

TRADITIONAL LEAD CAME AND SOLDER HAZARDS

Many traditional stained glass artists and production studio workers still use lead and must consider its toxicity.

LEAD. Cases of lead poisoning among stained glass workers and hobbyists in the medical literature confirm the major hazard of this craft. In some cases, family members and children who did not participate in stained glass work were poisoned by the activities of a professional artist or hobbyist in the family. This phenomenon is similar to that observed among the children and wives of industrial lead workers who were affected by small amounts of lead dust and fumes carried home on work clothes and shoes.

There are a number of ways stained glass workers and their families may be exposed to lead. For example, handling lead came will transfer small, but significant amounts of lead oxides to the hands. This contamination can be transferred to clothing, food eaten while working, or to other people who are touched. Cutting the came and cleaning or polishing it with whiting creates tiny lead flakes and dust, which can be blown or tracked into other areas.

Soldering can also result in contaminating the whole home or studio with lead. Iron soldering or touching solder seams (e.g., copper foil method) creates invisible lead fume, which can remain airborne for hours and later may settle on surfaces at a considerable distance from the operation.

OTHER HAZARDOUS METALS. Traditional lead/tin solders may also be a source of other hazardous metals. Some of these solders contain significant amounts of highly toxic arsenic and antimony. These metals contaminate lead ore and are still present in many inexpensive solders.

Not only are the fumes of arsenic and antimony highly hazardous to inhale during soldering, but in contact with acids—such as the acid fluxes or patina

chemicals—they form extremely toxic arsine and stibine gases. Though the amounts of the metals and their gases may be small, their extreme toxicity can make exposure to them significant.

FLUXES. The solder fluxes themselves, such as zinc chloride and other acid fluxes, are skin, eye, and respiratory irritants. Rosin fluxes are not used much in stained glass work, but they can cause allergies and asthma. Fluoride fluxes are especially toxic and should be avoided if possible. For more detailed information, see chapter 24.

INSULATION. Asbestos board tabletops, gloves, and other insulated materials may also be a hazard. These should be replaced with asbestos substitutes (see chapter 12).

SURFACE-TREATING CAME AND SOLDER

METAL COATINGS. Lead came and solder seams are often coated with other metals for the visual effect or for their preparation for treatment with patinas. Using copper foil over melted solder seams provides a copper-coated surface. Copper may also be electroplated onto lampshades from highly toxic chemical baths, which may even employ cyanide. (See Electroplating and Anodizing in chapter 24.) Or areas may be "tinned" to give them a coating of solder. Tinning solder fluxes usually contain fluorides and can be very hazardous to use.

Lead surfaces must be scrupulously cleaned in order to be coated with metal or patina. Some of these metal cleaners contain strong caustics, strong acids, chemicals that release hydrofluoric acid, or solvents including the glycol ethers (see table 9).

PATINAS. Once the surface is prepared, the patina can be applied. Patinas are generally of two types:

- Those that react with the metal surface to form metal compounds such as sulfides or oxides
- Those that dissolve metal from the metal surface and replace it with a different metal deposited from the patina chemicals

Both types are composed of chemicals of varying toxicity, and they usually produce toxic gases or vapors during application.

Common patina chemicals include copper sulfate and acid solutions, which give off sulfur dioxide during use; selenium-containing patinas, which may give off highly toxic hydrogen selenide gas; and patinas containing highly toxic antimony sulfide. Unusual patinas may contain rare-earth metal compounds, such as tellurium sulfide. (For further information, see Patinas and Metal Colorants in chapter 24, and table 14.)

WORKING WITH GLASS

Scoring and breaking glass is obviously a safety hazard. Hands and eyes are most at risk from injury. Other glass-shaping methods involve mechanical cutting and grinding for purposes such as beveling and precision cutting. Dry-grinding methods produce dust that can be hazardous to inhale. Glass dust, like enamels and frits, may cause mechanical injury to tissues and may release their toxic elements in body fluids. For example, lead glass dust could be a source of lead poisoning.

Wet-grinding, polishing, and cutting tools are somewhat safer. However, the fine mists from wet processes can be inhaled. In addition, the wet mists settle on surfaces, dry, and become a fine glass dust, which can be a source of further exposure. Slumping and fusing glass are covered earlier in this chapter.

DECORATING GLASS

All glass, whether free-blown, lamp-worked, slumped, fused, or cut for stained glass, can be decorated. There are many glass-decorating methods, including abrasive blasting (sand blasting), fuming, painting, hydrofluoric acid etching or frosting, and electroplating. The hazards of these procedures are described in chapter 22.

PRECAUTIONS FOR STAINED GLASS WORK

1. Plan studios and shops with health and safety in mind. Floors and surfaces should be made of materials that are easily sponged and mopped clean. If lead will be used, the studio must be completely isolated and separate from living areas. Never allow children into areas where lead or other toxic chemicals are used.
2. Plan for fire safety and emergencies. Install proper fire extinguishers, and post and practice evacuation procedures.
3. If lead is used in a studio that has even one employee, the employer must comply with complex OSHA Lead Standard rules in the United States or the OHSA Regulations respecting lead in Canada.

4. Install ventilation systems appropriate for the work to be done. (See chapter 7.)

5. If ventilation is not feasible, respiratory protection might be used. For lead dusts and fumes, use 100-percent-efficiency HEPA filters. (See chapter 8.)

6. Obtain Material Safety Data Sheets (MSDSs) on all glass, solders, abrasive grits and wheels, patinas, and other products. Use lead-free solders if possible, and avoid solders containing significant amounts of arsenic, cadmium, antimony, and other highly toxic metals.

7. Read product literature and MSDSs on metal cleaners and patinas to determine which require special gloves, goggles, ventilation, and respiratory protection. Have materials on hand for spill control and chemical disposal.

8. Wear protective eyewear that is rated for both impact and dust exposure for cutting, grinding, and/or polishing glass. If kiln firing is done, use eyewear that blocks infrared radiation. Insist that sellers provide a transmission spectrum for the eyewear to ensure the lenses block infrared radiation (600 to 6,000 nanometers, and even higher if possible).

9. Provide local exhaust ventilation for dry-grinding and glass-polishing equipment. Equip grind wheels with guards and exhaust.

10. Use wet grinding, polishing and cutting methods whenever possible. Grinders must be ventilated to capture the mists from grinding. Any dried mist seen around wet grinders must be washed up immediately. Abrasive wheel equipment should have face guards. Wet grinding equipment should be cleaned when wet to avoid dust exposure. Water reservoirs should be cleaned often to remove scum or other microbe growth.

11. Dispose of all grinding and polishing dusts, filters from ventilation systems or respirators, spent or neutralized acids, and other waste chemicals in accordance with health, safety, and toxic waste regulations. Water from wet grinding, from acid etching, and from cleaning the floors will almost surely contain EPA-regulated substances and may not be put down drains leading to water treatment plants, leach fields, or storm sewers in most areas of the country. These wastes must be contained and disposed of as toxic waste.

12. Unused came, solder, and other metallic lead scrap should be sent to lead recycling facilities.

13. Have first aid treatment handy for cuts and accidents. Post emergency procedures. Special "chain mail" safety gloves can be used for especially hazardous procedures. If chemicals or processes that can cause eye damage are used, an eyewash station must be present. If large amounts of such chemicals are used, an emergency shower will be needed.

14. Do not eat, smoke, or drink in the studio. Wash hands before eating, applying makeup, and performing other hygiene tasks.

15. Wear protective clothing, such as a smock or coveralls, shoes, and hair covering. Leave work clothing, hair covering, and shoes in the studio to avoid taking dusts home. Wash clothing frequently and separately from other clothes.

16. Clean the studio with methods that do not raise dust—wet-mopping is safe in this respect. Clean floors, and sponge surfaces frequently. Clean up shards and scraps as you work.

17. Replace or encapsulate all asbestos and ceramic fiber materials and insulation. Follow all health, safety, and environmental protection regulations whenever disturbing, repairing, or disposing of asbestos or asbestos-containing materials. Treat ceramic fiber as you would asbestos.

Always be prepared to provide your doctor with precise information about the chemicals you use and your work practices. If lead is used, arrange for regular blood tests for lead. Keep your tetanus immunization up-to-date.

CHAPTER 21
ENAMELING

Enamelers are exposed to several hazards, including infrared radiation, acids, and powdered glass enamels. Enameling is usually done on copper, silver, or gold. However, there are enamels for other surfaces, including steel, aluminum, ceramic, and glass.

WHAT ARE ENAMELS?

Enamels are essentially powdered colored glass frits. The glass-making frit ingredients may include silica, borax, lead compounds, lithium compounds, and other fluxes. The enamel colorants and opacifiers may include many different metal salts.

It is possible for artists to manufacture their own enamels from these materials. However, grinding and mixing these raw chemicals is hazardous. Commercially manufactured enamels are safer and easier to obtain and use.

The composition of the enamel will determine the material to which it can be fused (depending on its coefficients of expansion with heat). Most art and craft enamels are designed to remelt at low temperatures (730°C, 1350°F) and to adhere to copper or silver.

Lead-bearing and lead-free are the two major types of enamels. Lead-bearing types are the most common and can cause lead poisoning. Lead-free enamels are often borosilicate glass, and usually only their colorants are hazardous. However, neither type is suitable for use with children, since they are both ground glass, most of which contains some toxic metals.

Colorants and opacifiers are metal compounds that are usually fused into frits during manufacture. Enamel manufacturers rarely divulge the identity of these chemicals.

Common colorants include cadmium, cobalt, copper, manganese, antimony, selenium, chrome, and nickel. Most opaque lead enamels are opacified with arsenic. In the past, manufacturers used radioactive colorants, such as uranium

and thorium. Examples include Thompson's Forsythia and Burnt Orange enamels, which have been discontinued. Sale of radioactive enamels is now banned in the United States. Old stocks of such enamels should be discarded.

ENAMEL SOLUBILITY

Some enamels are so soluble in water that they dissolve (degrade) even in humid air. These enamels are easily recognized as those that must be washed before use—otherwise, they will produce cloudy or otherwise inferior results. These are the most soluble types, but all enamels are soluble in varying degrees. For this reason, all enamels that contain toxic metals should be treated as very toxic materials.

Finer particles of enamel dust present more surface area and, hence, are more soluble and toxic. Although most enamels are sieved to forty or eighty mesh (too large to be airborne), much finer particles are also present in the enamel. These can be seen as a dust that floats up when enamels are transferred from one container to another.

Once fired, enamels are usually still too soluble to be used for eating utensils. Lead, cadmium, barium, and other toxic metals can leach into food or drink. Have enameled utensils tested as you would ceramics if you wish to use or sell them (see page 247).

ENAMELING HAZARDS

Enameling is potentially hazardous during:

1. Application of enamels
2. Kiln firing
3. Preparation of metal to receive enamels
4. Soldering
5. During many specialty processes, such as hydrofluoric acid etching of fired enamels and electroplating

These processes are used with many different enameling techniques. Some of these include:

1. Cloisonné (soldered wires are used to separate the enamel colors)
2. Champlevé (enamels fired in acid-etched depressions)
3. Basse-taille (etched, engraved, chased, or stamped metal covered with layers of transparent enamels)

4. Pallion (fusing gold or silver foil into enamel)
5. Grissalle (white and gray shades of enamel fired on a black background)
6. Limoges (enameling that looks like porcelain)
7. Plique-a-jour (transparent enamels fired without backing to give a stained glass effect)
8. Repoussé (metal forming by hammering on the reverse side and chasing on the front surface, which can then be enameled)
9. Sgraffito (scratching or gouging metal to form depressions to hold the enamel)

Each phase of the enameling process carries its own hazards.

APPLICATION. The degree of hazard during enamel application is related to the degree to which the enamel can be inhaled or contaminate hands, hair, or clothing. Least hazardous are methods that do not raise dust, such as wet-charging damp enamel with spatulas or dipping and painting enamels that are mixed with resin and solvents (here the hazards are primarily the solvent vapors). Far more hazardous methods include dusting the powder onto the metal by hand or through a screen and spraying or airbrushing enamels.

The hazards of various enamel adhesives and fixatives are related to their composition and the degree to which the user is exposed to these ingredients. Spray products containing solvents are the most hazardous and should be used with local exhaust ventilation. Obtain ingredient information, and use accordingly.

Grinding and polishing of fired enamel surfaces is often done with carborundum or other abrasives under water. Such methods do not raise dust, but waste enamel material should be discarded carefully.

KILN FIRING. Toxic metal fumes from enamel ingredients may emanate from kilns, especially if enamels are over-fired or if bits of enamel flake onto kiln furniture or elements. During the firing process, heat can cause burns, and long-term exposure to infrared radiation can cause cataracts.

METAL PREPARATION. The metal surface that is to be enameled must be prepared to receive enamel. Metal preparation techniques include cleaning, pickling, etching, engraving, chasing, grinding, filing, and more.

Cleaning is done to prepare metal for enamels and to remove fire scale. Mechanical methods of cleaning metal can be done with pumice, steel wool, wire brushes, or buffers. These methods are the safest.

Pickling hot metals in acid solutions is a more hazardous way of cleaning metal. Acid vapors constantly arise from acid baths. During pickling, still greater amounts of vapors and mists are created. Pickling solutions are usually dilute sulfuric acid, nitric acids, or solutions of sodium bisulfate. Some commercial jewelry-cleaning methods employ cyanide solutions; these should never be used. Sodium bisulfate (often sold as Sparex®) is the least hazardous, but it, too, releases irritating and sensitizing sulfur dioxide gas.

Acid etching for techniques such as champlevé is especially hazardous. Nitric acid is commonly used to etch copper. This method liberates highly dangerous nitrogen dioxide gas, which, when inhaled, can cause serious lung damage, including chemical pneumonia. Hydrochloric acid also etches copper, but it can be replaced with ferric chloride solutions. Ferric chloride etching is slower, but considerably safer. Ferric nitrate can be used to etch silver.

Other processes such as engraving, chasing, grinding, buffing, and cutting may be done. Machine tools can be purchased that have guards and exhaust ventilation connections. Cutting, engraving, and similar processes can result in cuts, eye injuries, and the like.

Further information on the hazards of these and other metal-working processes may be found in chapter 24.

SOLDERING

Soldering creates metal fumes and emissions from fluxes. Lead, gold, and silver solders are commonly used in enameling. Lead fume is very hazardous (see page 23). Silver and gold solders often contain cadmium, which is released as cadmium fume when heated. Cadmium in this form is associated with lung and kidney damage and lung cancer. Cadmium-free silver solders usually contain antimony, which is somewhat less toxic, but can still cause serious health effects (see table 14).

Fluxes for soldering may be zinc chloride and other chlorides, fluoride compounds, or organic resins such as rosin. Of these, fluoride fluxes are most acutely toxic and cause long-term hazards, such as bone and tooth defects. Zinc and other chloride fluxes release respiratory irritants. Rosin is known to cause allergies.

SURFACE TREATMENTS

Altering the surface of enamels by creating matte or etched surfaces with hydro-fluoric (HF) acid is a occasionally done. Paste forms of HF are safer than liquid acid solutions, but they are still sources of HF exposure. Follow all HF precautions (see chapter 22).

Electroplating of metal enamel pieces with gold, copper, and other metals is also done. Cyanide plating baths are too toxic for use by most artists. The hazards of other bath chemicals should be researched carefully before embarking on plating (see chapter 24).

PRECAUTIONS FOR ENAMELING

1. Choose a studio location that is compatible with all necessary fire protection equipment and ventilation needed for the type of enameling you will do. Never locate studios in or near living or eating areas. Floors and surfaces should be made of materials that are fire-resistant and easily mopped and sponged clean.

2. Provide all kilns with ventilation, such as recessed canopy hoods, or place them near a window exhaust fan.

3. Keep areas around kilns and other hot processes free of flammable and combustible materials. Sufficient work space should be provided around kilns. Fire extinguishers or other approved fire control equipment should be installed. Post and practice emergency fire procedures.

4. Replace all asbestos and ceramic fiber pads, soldering blocks, gloves, and other materials. Instead, use new refractories, insulating brick, and other nonfibrous replacements for pads and blocks. Follow all health, safety, and environmental protection regulations whenever disposing of asbestos or asbestos-containing materials. Use the same precautions for ceramic fiber.

5. Protect against burns by wearing asbestos-substitute or leather gloves. Avoid wearing synthetic clothing, loose sleeves, or other items that could melt, burn, or catch fire from radiated heat. First aid kits should be stocked with appropriate thermal burn treatments. Post emergency burn treatment procedures.

6. Provide sufficient space around kilns for the user to work safely and comfortably.

7. Wear protective clothing, such as a smock or coveralls and work shoes. Leave shoes and work clothing in the studio to avoid taking dusts

home. Wash work clothes frequently and separately from other clothes.

8. Protect eyes during firing with infrared-blocking goggles. Welding goggles of shades 2 through 6 will work. If these shades are too dark, buy lenses designed specifically to block infrared (radiation from 600 to 6,000 nanometers or higher).

9. Do not eat, smoke, or drink in the studio. Wash hands before eating, applying makeup, and performing other hygiene tasks.

10. Investigate the composition of your enamels, fixatives, and all other products you plan to use by obtaining Material Safety Data Sheets and other product information from suppliers.

11. Choose the safest enamels. Lead-free should be chosen over lead-based. Reject enamels colored with radioactive metal salts. Avoid, or handle with extra care, enamels colored with highly toxic metals such as arsenic and cadmium.

12. Examine methods of applying enamels, and choose those that control dust best and employ the least toxic adhesives, fixatives, etc. Wash enamels if possible. Dusting, spraying, or airbrushing methods should be avoided or only done in local exhaust.

13. Clean up enamel spills immediately. Use wet-cleaning methods to avoid raising dust. Do not allow dust to remain on floors to be tracked into other areas.

14. Select metal cleaning and pickling methods that can be done safely in your studio. Mechanical hand-rubbing with steel wool or pumice is the safest method. Never use cyanide cleaning methods. Sodium bisulfate (Sparex®) is one of the least hazardous pickles. If acids or Sparex® are used, follow precautions for acids (see next rule).

15. Use of acids requires installation of eyewash fountains. Emergency showers must be installed if large amounts of strong acids (more than a quart) are stored or used. Acid baths for cleaning, pickling, or etching require local exhaust (such as chemical fume hoods or working near window exhaust fans). Respirators equipped with acid-gas cartridges may be worn as backup to ventilation for most acids except nitric acid. Other personal protective equipment includes chemical splash goggles, aprons, and gloves.

16. Stock a first aid kit with appropriate acid burn treatments (see hydrofluoric acid precautions, pages 278–79). Post first aid and emergency procedures.

17. Prepare for spills of acids and other chemicals in advance with supplies of neutralizing chemicals, absorbants, etc. Spills of some kinds of acid and other chemicals must be reported to local environmental authorities. Check federal and local (state, provincial, municipal) regulations.

18. Have especially hazardous work, such as electroplating, done professionally off-site when possible. Otherwise, have safety experts help plan and design studio equipment, ventilation, and emergency facilities for hazardous processes.

19. If soldering is done, provide local exhaust ventilation; work close to a window exhaust fan or on a slot-vented table. Obtain reliable ingredient information on solders, and choose the safest ones. Avoid solders containing cadmium, arsenic, and antimony. Avoid fluorine fluxes when possible.

20. All dry buffing and grinding wheels require machine guards, face guards, and local exhaust ventilation. Heavy equipment also needs lockout mechanisms. Impact-resistant goggles should be worn when working.

21. Obtain Material Safety Data Sheets on abrasive grits and wheels. Choose those free of silica and other toxic minerals when possible.

22. When sawing, cutting, and doing other mechanical metal work, keep tools sharp and employ safe techniques. Stock a first aid kit with supplies to treat cuts and abrasions.

23. Dispose of all spent or neutralized acids, waste enamels, grinding and polishing dusts, and the like in accordance with health, safety, and environmental protection regulations. In large studios or classrooms, liquid wastes such as water from washing enamels, water from wet polishing of enamel surfaces, liquids from acid etching, and water from cleaning the floors will probably have to be contained and disposed of as toxic waste rather than released to sink or floor drains.

24. Do not make enameled items for use with food or drink, unless the piece has passed laboratory tests for release of toxic metals. Other pieces should have the warning "Not for Food Use, May Poison Food" fired permanently on the bottom.

25. If lead is present in solders or any enameling materials, arrange for regular blood tests for lead. Always be prepared to provide your doctor with information about the chemicals you use and your work practices.

26. The amounts of lead used in most enameling operations is very small. Yet, theoretically, the OSHA Lead Standard must be followed. The best way for an enameling studio employer to deal with this regulation is to have air sampling done during "worse case" work (the maximum number of employees doing the most hazardous processes). These tests are likely to establish that the action level for the standard is not exceeded. A copy of this air-sampling report should satisfy OSHA if they visit.

CHAPTER 22
CERAMIC, GLASS, AND ENAMEL SURFACE TREATMENTS

The surfaces of ceramics, glass, and enamels can be treated in many ways to produce artistic effects. Some of these treatments are hazardous.

CUTTING AND GRINDING

These methods can be used for purposes such as beveling, cut-glass techniques, and incising. Dry grinding and cutting wheels and tools produce dust that can be hazardous to inhale. Dust from glass, enamels, and glazes may cause mechanical injury to tissues and may release their toxic elements in body fluids. For example, dust from grinding lead glass or glazes can be a source of lead poisoning. Dust from grinding fired ceramics contains silica (cristobalite—see page 173).

Wet grinding, polishing, and cutting tools are safer. But some produce dust-containing water mists, which are hazardous to inhale. Water reservoirs may also become contaminated with disease-causing microorganisms that can be inhaled with the mist. Running-water lubrication systems are more sanitary.

ABRASIVE BLASTING

This method is currently a popular decorating technique. Handheld blasting guns and enclosed cabinet blasting are two methods in use. Both direct a blast

of abrasive material against a surface to etch it or clean it. Common abrasives include sand, metal, slag, garnet, aluminum oxide, silicon carbide, glass beads, and organic substances such as walnut shells, sawdust, apricot pits, plastic, and the like. See table 17 for the hazards of common abrasives.

Sand and other sources of free silica should not be used for abrasive blasting, because they are such serious health hazards. Abrasive blasting with sand produces large amounts of very fine silica dust that has been shown to cause a type of rapidly-developing silicosis (progressive massive fibrosis), which can be contracted in as little as a few weeks of exposure and is usually fatal within a year or two. For this reason, sand blasting is outlawed in many countries (not in the United States or Canada).

In addition to the adhesive, the toxic ingredients of the substance being abraded must be considered. Abrasive blasting of lead glass, for example, contaminates the abrasive with lead dust.

Regardless of the toxicity of the abrasive and of the substrate, all inert dusts are hazardous in quantity. Protective measures must be devised. One method is to use blasting cabinets, which are sealed and kept under negative pressure. In this case, the user needs no additional protective gear, except when dust is released during processes such as changing the abrasive. However, the cabinet will provide protection only as long as it is well maintained. Unfortunately, it is common to see blasting cabinets in schools and studios in poor repair and leaking toxic dusts.

Handheld blasting equipment usually requires the user to wear protective gear and work in an isolated or outdoor environment. Protective gear for large work may include air-supplied respiratory protection, eye protection, gauntlet gloves, and protective clothing and shoes.

FUMING

Fuming metallic salts (usually chlorides) onto surfaces to create an iridescent look is a technique popularized by Tiffany. It is the process of depositing a thin layer (only a molecule or two) of metal on the glass surface, giving an "oil on water" appearance. Different metals will produce different colors. Metals that have been used in fuming include tin, iron, titanium, vanadium, cadmium, and uranium.

Fuming can be done by introducing the metal compounds into an annealing oven or by spraying a water solution of the chlorides and acids onto surfaces when hot. Both methods cause the metal compounds to fume and to dissociate.

The resulting emissions are highly irritating to the respiratory system and eyes. Cadmium and uranium are too toxic for use in this manner by studio artists. Vanadium is also very toxic and probably should not be used. Superb ventilation is needed for these processes.

GLASS PAINTING

Painting on glass and ceramic surfaces can be done with a number of materials. Some "glass paints" are really enamels fired onto glass. These paints are usually lead frits and metal colorants, whose dust can be hazardous. Some are premixed in solvents and tack oils. See chapter 21 for precautions.

Lustres and metallic paints, which are similar to lustre glazes, contain metal alloys and compounds. Some may even contain amalgams of mercury. Often, these are mixed with solvents and oils. See chapter 18 for lustre glaze precautions.

Glass stains are usually silver nitrate, gamboge, or water and gum arabic. Mirroring is done with solutions containing ammonia, silver compounds, and reducing compounds such as Rochelle salts.

Vapors given off during painting of solvent-containing paints and lustres are toxic. Silver nitrate can cause skin burns and can damage the eyes. The emissions during firing of paints and enamels include metal fumes and decomposition products of organic chemicals, such as tack oil, gum arabic, etc.

There are also new glass and ceramic paints that do not need firing. These are polymer materials, which dry to look like glazes or enamels. Most contain toxic solvents that can be inhaled during painting.

Sometimes, paints and lustres are silkscreened onto surfaces. The resists can be photo-etched. Many of the solvents, emulsions, and cleanup materials for these processes are toxic. See chapter 29 for the hazards of photochemicals.

HYDROFLUORIC ACID (HF) ETCHING

Etching or frosting with HF is one of the most hazardous processes in surface decorating. This acid is insidious, because it does not cause pain on contact. Later, often hours later, severe pain commences, indicating that the acid has penetrated the skin and is destroying tissues deep beneath the point of entry. Surgery and amputation are sometimes needed.

In addition, the absorbed fluorine from the acid can cause systemic poisoning. A splash of concentrated HF covering only 2 percent of the body can be fatal. This means that a splash wetting a 5" × 5" patch of skin can kill.

The onset of the symptoms varies with the acid's concentration:

1. *Concentrations greater than 50 percent:* Immediate burns appear, with rapid destruction of tissue as noted by a whitish discoloration, usually proceeding to blisters, accompanied by severe pain.
2. *Concentrations of 20 to 50 percent:* Burn symptoms can be delayed one to eight hours.
3. *Concentrations of less than 20 percent:* Redness (erythema), burning, or pain may not show up until several minutes or even many hours (up to twenty-four hours) have elapsed. Thus, the surface area of the burn is not predictive of effects.
4. *Concentrations as low as 2 percent:* May cause serious symptoms if the skin contact is long enough. (This applies even to the glass-etching creams—see below.)

The acid can also harm the lungs. Vapors rising from an HF acid bath can be inhaled and can cause chemical pneumonia. Long-term exposure by inhalation is associated with kidney, liver, bone, and tooth damage.

Etching surfaces of glazes, enamels, or glass that contains arsenic and/or antimony can result in the formation of extremely toxic arsine and stibine gases. Though the amounts of the metals and their gases may be small, their extreme toxicity can make exposure to them significant.

ETCHING CREAMS. Glass-etching creams are often touted as "nontoxic" because they don't contain hydrofluoric acid. However, they generate this acid when in contact with glass, and they are highly toxic by skin contact and ingestion. A fifty-six-year-old man died after ingesting a spoonful of glass-etching cream (20 percent ammonium bifluoride and 13 percent sodium bifluoride). If a spoonful can kill an adult male, clearly children are at extreme risk from even small amounts. The Consumer Product Safety Commission has proposed requiring childproof packaging for any product containing 0.5 percent elemental fluoride or more, a range that would include the etching creams.

HF PRECAUTIONS. As soon as HF acid is ordered for use, the local hospital should be alerted, so that it can have treatments on hand. The facility should also train its own personnel in the special emergency procedures. Training should also be done if etching creams are used. Schools for students of high school age or younger should not have the acid or the creams on the premises.

MEDICAL TREATMENT. If HF is used, the proper medical treatments should be purchased, and personnel should be trained to follow treatment guidelines. The best source I have found for these guidelines is AlliedSignal's booklet, "Recommended Medical Treatment for Hydrofluoric Acid Exposure." It can be obtained from AlliedSignal Inc., Post Office Box 1053, 101 Columbia Road, Morristown, New Jersey 07962-1053. Write or fax (973) 455-6141.

The booklet points out that treatment for HF exposure is different from that of all other acids. Most acids require flushing with water for at least fifteen minutes before treatment. That may be too late for HF. Instead, flushing should last about five minutes, and then immediate treatment with special solutions of calcium gluconate or benzalkonium chloride must be initiated by someone trained to use them. Treatment procedures vary, depending on the location of the burn and the amount of skin involved. Delaying treatment even minutes can be fatal.

PRECAUTIONS DURING USE. Special precautions for HF acid etching include the use of gloves resistant to HF, goggles, a face shield, and protective clothing and shoes. Some glass workers use two pairs of gloves as extra protection against leaks. An eyewash fountain and emergency shower should be installed near the operation. HF burn treatment should be handy and personnel taught how to use it. Emergency procedures should be understood by all personnel. Local exhaust is needed to remove the gases and vapors created during etching.

ELECTROPLATING

Although this technique is usually done on metals, it can also be applied to ceramics, enamels, and glass under certain circumstances. See chapter 24 for details.

SPECIAL PRECAUTIONS FOR SURFACE TREATMENT PROCEDURES

1. Obtain Material Safety Data Sheets and other reliable ingredient information on surface treatment chemicals. Material Safety Data Sheets will often recommend the use of special gloves, goggles, ventilation, and respiratory protection. Follow Material Safety Data Sheet advice, and have handy materials for spill control and chemical disposal.

2. Use MSDS information to try to avoid products containing highly toxic ingredients such as lead and hydrofluoric acid. (See special precautions for hydrofluoric acid above.)

3. Also obtain detailed information about the surface to be treated. Avoid treating or acid-etching surfaces of glazes, enamels, or glass containing significant amounts of lead, arsenic, antimony, or other highly toxic metals. These metals may volatilize from the surface during some treatments. Abrasive blasting of such surfaces creates highly toxic dust.

4. Provide excellent ventilation, such as slot vents or a window exhaust fan at worktable level, for dry cleaning (with whiting) or polishing, applying acids, or any other operation that produces toxic emissions. Dry grinding and polishing equipment should have built-in local exhaust systems.

5. Use wet grinding, polishing, and cutting methods whenever possible. Wet-grinding equipment should be cleaned when wet to avoid dust exposure. Water reservoirs should be cleaned often to remove scum or other microbe growth.

6. Have highly hazardous processes, such as HF acid etching or electroplating, done professionally, if possible. Otherwise, have safety experts help plan and design studio equipment, ventilation, and emergency facilities.

7. Dispose of all HF-related waste as toxic. Spent HF contains fluoride ion plus any metal ions from the etched glass, enamel, or glaze surface. Neutralization of the acid does not remove these EPA-regulated substances. The spent, neutralized acid, the wash waters, and any other HF-related liquid must be collected for waste disposal, rather than released to sink or floor drains.

8. Dispose of all grinding dusts, spent abrasives, and other waste materials in accordance with health, safety, and environmental protection regulations. Some wastes containing only relatively small amounts of highly toxic chemicals, such as cadmium and arsenic, can be very expensive to dispose of properly.

CHAPTER 23

SCULPTURE, LAPIDARY, AND MODELING MATERIALS

Stone, cement, plaster, self-hardening clays, plasticine, wax, and papier-mâché are commonly used to sculpt and model.

STONES

Many stones used in sculpture and lapidary are the same minerals that are used in ceramics, glass, and abrasives. For example, flint, steatite, dolomite, and fluorspar stones can be used for sculpture. When these same stones are ground to a powder, they can be used to make ceramic glazes and glass. For another example, garnet may is used as both a gem and a sandpaper abrasive.

Artists are exposed to dust and flying chips when stones are shaped for sculpture or lapidary work by chipping, carving, grinding, and polishing. These operations can be done by hand or with electric tools. Electric tools produce large amounts of dust. Hand operations are the least hazardous, but flying chips still can damage eyes. In addition, hand tools can slip, and large stones can fall, causing injuries. Lifting heavy stones and tools can lead to strain injuries.

Electric tools are also associated with vibration syndrome, or "white fingers" disease. It is a progressive circulatory system disease that constricts flow of blood to the hands (sometimes also to the feet), causing pain and numbness.

Noise from percussive hammering, electric tools, and other equipment can also damage hearing.

The toxicity of dust from sculpture stones varies. Some stones contain significant amounts of asbestos. These are too hazardous to use under the conditions found in craft and sculpture studios. Other stones may contain hazardous ingredients, including free silica, talc, or caustic metallic compounds.

In order to choose stones whose dust will be the least toxic, artists need both chemical and mineral analyses of the stones, including the amounts of impurities in them. Abrasives used in grinding and polishing stone may also produce hazardous dusts. The hazards of many common minerals used in sculpture, lapidary, and abrasives are listed in table 17.

CEMENT

Cement is a mixture of finely ground lime, alumina, and silica, which will set to a hard product when mixed with water. Other chemicals commonly found in cement include various iron compounds, traces of chrome, magnesia, sodium, potassium, and sulfur compounds.

In addition to these naturally occurring contaminants, there are many substances added to cement to improve adhesion, strength, flexibility, curing time, and water evaporation. Usually these are plaster, various plastic resins, and latex solids.

The primary hazards of cement are skin and respiratory irritation from the alkaline compounds. Skin burns are a common problem among cement workers, and severe ulcers can develop from contact with wet cement.

Allergies to cement dust are also commonly seen in cement and construction workers. A major cause is reaction to small amounts of chromium compounds in some cement mixtures, especially in Portland cement. Some researchers also feel that the statistically significant number of cases of lung cancer seen among cement workers is caused by chromium (hexavalent type) in cement.

PLASTER

Plaster, or plaster of paris, is calcium sulfate. It occurs in nature as gypsum and as alabaster. Plaster dust is irritating to the eyes and slightly irritating to the respiratory system. Plaster may also contain additives, such as lime, that make the dust more irritating. Ventilation or respiratory protection should be used to reduce exposure to excessive amounts of dust.

Heat is produced during the setting reaction. Severe burns have resulted when children and adults cast their hands in plaster.

RULES FOR WORKING WITH STONE, CEMENT, AND PLASTER

1. Wear impact/dust goggles when shaping or chipping materials. See figures 3 and 4.
2. Wear steel-tipped shoes with heavy materials or equipment.
3. Move all heavy stones and other objects in accordance with correct lifting and carrying procedures.
4. Obtain mineral and chemical analyses of sculpture stones. Use the least toxic varieties that meet your artistic needs. Avoid stones containing asbestos or radioactive elements.
5. Purchase electric grinding and polishing tools that are equipped with local exhaust connections for removing dust from the studio. To control other sources of dust, practice good hygiene and cleanup.
6. If respiratory protection is needed, match the respirator filters to the type of dust produced. Do not expect air-purifying respirators to contend with heavy amounts of dust (over ten times the Threshold Limit Value). For high dust levels, air-supplied respirators may be needed.
7. Avoid skin contact or wear gloves when working with wet cement.
8. Purchase electric tools with low vibration amplitude and comfortable handgrips. To reduce risk of vibration syndrome, do not grip tools too tightly, take frequent work breaks, and do not work in cold environments.
9. Purchase quiet tools and exhaust fans, or wear hearing protection (see pages 29–31).
10. Do not cast body parts in plaster unless provisions are made for dissipation of heat. There should also be a barrier of Vaseline or similar material between the skin and any casting material.

MODELING MATERIALS

Modeling can be done with many products, including papier-mâché, nonhardening clays such as plasticine, air-setting and oven-setting clays, and wax. (The hazards of sculpture clays such as terracotta are the same as those of ceramic clays—see chapter 18.)

Papier-mâché that is formed of plain paper pieces and white glue has no significant hazards. It would be hazardous only if paper with toxic inks or an unsafe glue were used.

Powdered or instant papier-mâché, however, may contain very hazardous ingredients. Many papier-mâché powders, even those for children, used to be asbestos-and-glue mixtures. Some products may still be made with asbestos-contaminated talcs.

Now, some papier-mâché powders are ground-up magazines mixed with glue and fillers. The problem with these products is that slick magazine paper contains talc and other fillers, and the inks may contain lead, cadmium, and a host of organic pigments of varying toxicity. Although the amounts of the toxic chemicals are fairly small, the materials are usually ground so finely that considerable amounts can be inhaled.

To use papier-mâché safely, obtain reliable ingredient information, and choose the safest product. There are good papier-mâché products that employ ground, clean (uninked) cellulose. Avoid inhaling dust by providing ventilation for any mixing or sanding operations.

Nonhardening clays, such as plasticine, are usually made of clays mixed with oils and petrolatum. Other ingredients may include sulfur dioxide and other preservatives, vegetable oils, aluminum silicate, and very small amounts of turpentine. The colored clays contain pigments or dyes.

A few reports of skin allergies and respiratory symptoms have been reported among users of plasticine, due to the presence of turpentine or to the addition of too much sulfur dioxide preservative. In general, however, these are usually very safe materials. Discontinue use if skin or respiratory reactions occur.

Self-Hardening Clay. Some of the self-hardening clays are very safe mixtures of plaster and polymers that dry in contact with the air. Most manufacturers of these products will not reveal all of their contents. Those that harden in air and do not smell of solvents are probably safe enough for even children to use. To be certain, obtain and evaluate the Material Safety Data Sheet.

Oven-Cured Polymer Clays. Oven-cured "polymer clay" modeling compounds, such as Sculpey® and Fimo®, are made of vinyl chloride plastic and additives. These additives include plasticizers, colorants, inert fillers such as calcium carbonate or clay, and antioxidants to resist discoloration. The bulk of the additives are the plasticizers, which compose about 15 percent of the product. Users come into skin contact with the plasticizer when they hand-mold polymer clays. The plasticizers can actually be seen as a greasy stain if the unfired product is set on a piece of paper for a while.

For many years, Sculpey®'s and Fimo®'s plasticizer was di(2-ethyl-hexyl)phthalate, or DEHP. Artists have surely inhaled DEHP vapor along with other highly toxic emissions from the vinyl chloride plastic when ovens over-heated. Some DEHP volatilizes even when recommended curing temperatures are not exceeded. DEHP contamination of food subsequently cooked in the ovens might also happen. Small amounts of DEHP may also absorb very slow-ly through the skin. The extent of exposure to DEHP from all these routes has never been assessed.

Exposure to DEHP is worrisome, because it causes liver cancer and birth defects in test animals. DEHP has been listed as a carcinogen by the International Agency for Research in Cancer (IARC) since 1982. Three U.S. agencies also consider it a carcinogen. After the Labeling of Hazardous Art Materials Act became effective in 1989, products containing DEHP required cancer warnings on their labels. Whether for this reason or for general product safety, DEHP was removed from Sculpey® and Fimo®.

Around 1990, Polyform Products replaced the DEHP in Sculpey® with a chemical called di(2-ethylhexyl)terephthalate, or DEHTP. Eberhard Faber replaced the DEHP in Fimo® with a mixture of three phthalate plasticizers. All of these chemicals are very similar to DEHP, but have never been stud-ied for cancer effects. Unfortunately, the Labeling of Hazardous Art Materials Act allows products containing these untested chemicals to be labeled "nontoxic."

The phthalate plasticizers are in the news today, because it is now known that all of us have these chemicals in our blood. Some experts think that some of the phthalates cause cancer and that others may be related to reproductive effects in young children (see chapter 13).

To work safely with oven-fired clays, first try to obtain reliable ingredient information on these products—especially on the plasticizers. Gloves are sug-gested, but the problem is finding gloves that will not absorb the plasticizers. Consult your glove manufacturer. Provide ventilation for the firing, such as range hoods that exhaust to the outside. Do not use kitchen ovens or other equipment or utensils that will be used subsequently for food. Do not use these products with children.

Wax used in sculpture, jewelry, and candle-making is safe when it is cold. Wax only becomes hazardous when heated or burned. All waxes emit similar substances when heated, because waxes are actually mixtures of similarly struc-tured organic chemicals. And because they are mixtures, it is also difficult to predict the exact temperature at which they begin to decompose.

Decomposition occurs when heat breaks down large wax molecules into many smaller ones. Almost no decomposition takes place when wax is just warm enough to melt. As the temperature increases, decomposition accelerates, creating more and more small molecules. Some of these are very toxic gases that are released into the air. They account for the typical "hot wax" odor we smell. Among these gases are acrolein and aldehydes, such as formaldehyde and acetaldehyde.

Acrolein and the aldehydes are irritants that can damage the respiratory tract, leaving artists susceptible to colds and infections. More serious problems, such as bronchitis and chemical pneumonia, may develop in people who are exposed to larger amounts of these chemicals.

Besides being an irritant, formaldehyde causes cancer in animals, probably causes cancer in humans, and is known to cause allergies in many people. Acrolein, acetaldehyde, and other aldehydes are not well studied, but many experts suspect they cause effects similar to those caused by formaldehyde, including cancer.

Wax molecules also vaporize and recondense above hot wax to form tiny airborne wax particles called "wax fume." These small fume particles can be inhaled deep into the lungs' air sacs, where the body finds it difficult to remove them. Wax fume is usually invisible, but when wax is greatly overheated, it appears as a fog hovering around the wax surface. This fog can explode or flash into fire if a spark or flame is present.

Formaldehyde, acrolein, and paraffin fume are regulated in the workplace by the Occupational Safety and Health Administration (OSHA) and have workplace limits assigned to them by the American Conference of Governmental Industrial Hygienists (ACGIH). Some of these limits are in table 24 below.

TABLE 24	THRESHOLD LIMIT VALUES FOR SOME WAX EMISSIONS
EMISSION	**AIR-QUALITY LIMITS***
Acrolein	0.1 ppm TLV-TWA
Formaldehyde	0.3 ppm TLV-C
Paraffin fume	2.0 mg/m^3 TLV-TWA

* See threshold limit values (TLVs).

Processes that can produce sufficient heat to dissociate wax include candle dipping, lost wax casting, sculpting wax with hot tools, ironing out batik wax, and heating wax for ceramic glaze resists. I once inspected a tourist candle-making facility that smelled of pleasing aromatic scents. However, air-sampling data showed that both acrolein and paraffin fume at levels over the TLV were present in the air.

Since there is no respirator cartridge approved for acrolein, local exhaust ventilation is the best option.

CANDLE HAZARDS

Using the finished candles may also be hazardous. In the last few years, literally hundreds of thousands of candles have been recalled as fire hazards by the Consumer Product Safety Commission (CPSC). There are several reasons for these recalls, and each is relevant to those designing and making candles.

LARGE FLAMES. Some candles were recalled because they suddenly flared and burned with a tall flame. This can occur if too much aromatic oil or the wrong type of oils are used in the candle. It also occurred in candles that contained too much potpourri, lavender, dried flowers, or similar combustible materials.

In other cases, candles made with more than one wick were recalled when consumers found that the wicks were close enough to each other to burn with one large flame. The best example was a recalled wax candle shaped like a hand, whose flames reached eight inches high as the candles melted down to the palm, where the wicks of the five fingers burned together. (An individual observing the candles noted that as the fingers all burned down, the longest-lasting finger was, appropriately, the middle one.)

FAULTY HOLDERS. Some candles were recalled because their holders caught fire. Various plastic, wooden, and painted holders ignited when the flame burned down to it. An expensive silver holder with a leather strap over it got so hot that the leather caught fire. Some ceramic holders also caught fire! Porous terracotta or bisque holders first soaked up the hot wax, and then the entire holder burned fiercely.

Many others have been recalled because their ceramic or glass holders shattered when hot. Some glass holders would actually explode with heat. Glass holders covered in plastic resin were also recalled for shattering explosively.

DAMAGE TO AIR QUALITY. Candles also release many toxic substances when they burn. Research done by Robert B. Bailey of Bailey Engineering Corporation in Palm Beach Gardens, Florida, has shown that about twenty volatile organic chemicals (VOCs) were emitted by the aromatic candles he tested (see table 25).[1]

TABLE 25	SOME CHEMICALS EMITTED BY TWO BRANDS OF SCENTED CANDLES	
• Acetone	• Trichloroethene	• Phenol
• Benzene	• Tetrachloroethene	• Cresol
• Trichlorofluoromethane	• Toluene	• Cylcopentene
• Carbon disulfide	• Chlorobenzene	• Lead
• 2-Butanone	• Ethylbenzene	• Carbon monoxide
• 1,1,1-trichloroethane	• Styrene	• Soot
• Carbon tetrachloride	• Xylene	• Particulate Matter

LEAD FUME. Some candle manufacturers and some candle-making kits sold to hobbyists still use lead-core wicks that contain a thin lead wire to help stiffen the wick. The wire volatilizes during normal candle burning, resulting in lead fume emissions. The Consumer Product Safety Commission (CPSC) announced that their research indicates the following:

1. CPSC studies showed that lead-wicked candles could present a lead poisoning hazard to young children. Some candles emitted lead levels in excess of 2,200 micrograms per hour (μg/hr)—about five times the rate of 430 μg/hr, which could lead to elevated levels of lead in a child. Burning lead-wicked candles four hours per day for fifteen to thirty days could result in blood lead levels over the 10 μg/deciliter health-concern level for young children.

2. The emitted lead presents a risk to children who are exposed through inhalation and from ingestion of lead that may settle on surfaces in the room. This deposited lead can remain accessible for extended periods of time and allow exposure through mouthing of surfaces or objects or by hand-to-mouth contact.

[1] Robert Bailey can be contacted via e-mail: *IAQPEng@aol.com.*

3. Despite a 1974 voluntary industry agreement not to use lead wicks in the United States, CPSC found that a small percentage of candles sold today still contain lead in their wicks. CPSC staff investigation has shown that importers of candles have not followed this voluntary agreement, nor has it been followed universally by manufacturers within the United States.

4. It is not possible for consumers to tell if the wicks of candles they use contain lead. There is no accurate "home test."

5. The hazard cannot be avoided by labeling. The only way to avoid the hazard is to forgo burning—the candle's intended use.

6. Sophisticated laboratory tests conducted by CPSC staff showed that there is no correlation between the amount of lead in the candlewick and the quantity of lead emitted during burning.

7. CPSC analysis shows that metal wicks, some of which could contain lead, are most likely to be used in container, pillar, votive, and tea-light candles.[2]

The CPSC advises consumers either not to burn or to throw away all candles that have a metal wire in their wicks. Clearly, a better approach would be to ban candles with lead wicks. ACTS would like to see the ban extended to candle-making kits and wicks sold to hobbyists.

[2] CPSC Press Release #01-083, February 14, 2001. Contact: Jane Francis or Scott Wolfson at (301) 504–0580.

CHAPTER 24
METAL SURFACE TREATMENTS

Metals can be treated by many of the same processes that are used for nonmetal surfaces (see chapter 22). For example, metals can be etched and photoetched, abraded and sandblasted, or painted. This chapter will consider procedures that are used primarily on metal surfaces, including cleaning and degreasing, applying patinas, using fluxes, electroplating and anodizing, gilding, and niello work.

CLEANING AND DEGREASING

Metals must be very clean if solders are to adhere, if patinas are to take, and so on. Metals must be cleaned again after soldering, brazing, forging, and similar processes to remove flux residues, fire scale, and the like. For these purposes, many different metal cleaners are used.

Most metal cleaners and degreasers are solvents, hydroxides, ammonia, acids, or combinations of these. Other cleaners for metals include hand-rubbed abrasives, such as putty and whiting, or Sparex® and other acidic solutions for cleaning fire scale off hot metals. Cyanide cleaners are also used for cleaning cast metal. The hazards of these types of cleaners are listed in table 26.

PATINAS AND METAL COLORANTS

Patinas and metal colorants usually employ very toxic chemicals. Toxic gases and vapors may be emitted during the reaction with the metal as well.

One of the most common colorants is liver of sulfur (potassium sulfide). When applied to metals, this compound will darken the metal and release highly toxic hydrogen sulfide gas. This gas can be identified by its "rotten egg" odor. Many of the patinas and colorants rely on sulfides, and similar reactions may occur.

TABLE 26	METAL CLEANSERS AND DEGREASERS

ACIDS such as hydrochloric, sulfuric, and nitric acid are used in some metal cleaners. These are highly irritating; can damage eyes, skin, and respiratory system; and should not be mixed with other cleaners unless it is known they will not react.

AMMONIA is a respiratory irritant and may be found in both solvent and hydroxide cleaners. Ammonia can react with bleach and inorganic acids, such as hydrochloric acid, to release highly toxic gases. Care should be taken not to mix ammonia-containing products with acid cleaners, fluxes, and acid-containing patinas or with scouring powders that contain dry bleach.

CYANIDE cleaning mixtures are in common use in the jewelry industry for cleaning cast metal. Mixing cyanide with concentrated hydrogen peroxide is called "bombing." This method produces extremely toxic hydrogen cyanide gas and should not be used.

HYDROXIDES, such as potassium and sodium hydroxide (caustic soda), are very corrosive to the skin and eyes.

PUTTY (tin oxide) is sometimes used to polish or clean metal. It has no significant hazards, except chronic inhalation could cause a benign pneumoconiosis.

SOLVENTS used in cleaning are likely to be the glycol ethers, which can penetrate the skin and rubber gloves, are toxic, and may be reproductive hazards.

Other common cleaning solvents are the chlorinated hydrocarbons (see table 9), and these are toxic and usually cancer-causing. In addition, if the chlorinated hydrocarbons are used around heat or ultraviolet light (such as that emitted during welding), they can decompose to emit highly irritating phosgene gas.

SPAREX® (sodium bisulfide) is a milder acidic solution that can be used to clean fire scale off hot metal. Like acids, Sparex can damage skin and eyes on contact. It emits irritating sulfur dioxide gases on contact with hot metal.

WHITING (calcium carbonate) is a mild abrasive sometimes used to polish or clean metal. It has no significant hazards.

Many other metals are used in patinas. One particularly toxic patina I investigated contained tellurium sulfide in solution with hydrochloric acid. The user reported that his breath developed the garlic odor associated with tellurium exposure.

When planning to use patinas, research the hazards of both the patina and the by-products of its reaction with metals. Be aware that some patina Material Safety Data Sheets do not list the hazardous by-products created during use of the product. The hazards of some common patinas and metal colorants are found in table 27.

FLUXES

Many fluxes today are very complex mixtures of chemicals. Many types of chlorides, fluorides, and borates may be found in fluxes. Organic fluxes may contain a variety of organic chemicals, including stearic acid, glutamic acid, oleic acid, other fatty acids, and organic amines and organic sulfates. Rosin fluxes may be "activated" with bromides and chlorides. There are also other compounds that are used in vehicles such as petroleum gel, polyethylene glycol, alcohols, and water.

Some of these compounds are toxic in and of themselves. And all of them release irritating or toxic emissions when they are used. The plume of smoke rising from soldering or brazing should be considered very toxic.

Fluxes can be categorized by their main ingredients into the following groups:

1. *Acid* fluxes (and acid core solders), usually zinc, ammonium, or other chlorides
2. *Borax* fluxes containing boron compounds
3. *Fluoride* fluxes containing fluoride compounds
4. *Organic* fluxes containing fatty acids
5. *Rosin* fluxes (and rosin core solders) containing pine rosin (colophony)

A number of the chemicals in these fluxes and their hazards are listed in table 27. In general, acid fluxes are the safest to use for most art processes, while fluoride fluxes are among the more hazardous.

RULES FOR USING DEGREASERS, PATINAS, AND FLUXES

1. Protect skin and eyes by wearing gloves, aprons, and chemical splash goggles when handling acids, caustics, solvents, and other irritating chemicals. Install eyewash fountains near where such chemicals are used. If large amounts of caustics or acids are used, install emergency showers.

TABLE 27	FLUX, PATINA, AND METAL COLORANT CHEMICALS

ALIPHATIC AMINE HYDROGEN CHLORIDES. Sensitizing and release irritating, sensitizing, and toxic emissions when heated.

AMMONIUM CHLORIDE. With heat, ammonium chloride fume will become airborne. It is moderately irritating. Some of it may break down into highly irritating ammonia and hydrochloric acid gases, especially if overheated.

ANTIMONY SULFIDE. See Antimony in table 14.

BORIC ACID, POTASSIUM BORATES, AND OTHER BORON-CONTAINING COMPOUNDS. Moderately toxic. Boric acid and some other boron compounds can be absorbed through the skin.

BROMIDES. Moderately toxic, but highly toxic hydrogen bromide and other gases may be released when heated.

COPPER SULFATE. In some patina formulas, will release irritating and sensitizing sulfur dioxide gas.

FERRI- AND FERROCYANIDES. Only slightly toxic, but will release cyanide gas when used with acid or heat, when exposed to strong ultraviolet light such as sunlight, or in the neutral and alkaline conditions found in the environment.

FLUORIDE COMPOUNDS (potassium bifluoride, boron trifluoride, etc.). Highly irritating and release highly toxic gases. Fluorides can severely damage lung tissue and can cause long-term systemic damage to bones and teeth. Fluxes and patinas containing fluorides should be avoided when possible.

HYDROCHLORIC (MURIATIC) ACID. Highly irritating and can damage eyes, skin, and respiratory system.

LEAD ACETATE. See information on lead in table 14.

NITRATES (ferric, copper, etc.). Can explode under certain conditions when exposed to heat. They also emit highly toxic nitrogen oxides that can severely damage lungs.

NITRIC ACID. Highly irritating and can cause severe skin and eye damage. Nitric acid releases highly irritating nitrogen oxides when it reacts with metals. These nitrogen oxides can cause severe lung damage.

OLEIC ACID AND OTHER FATTY ACIDS. These are not toxic, but like all organic compounds, when decomposed by heat, they emit many irritating, sensitizing, and toxic gases and vapors.

ROSIN (colophony). Associated with respiratory allergies and asthma. When burned, it releases many toxic gases, such as formaldehyde.

SELENIUM COMPOUNDS. Except for highly toxic selenium dioxide, these are usually only slightly toxic, but in acid-containing patinas, highly toxic and irritating hydrogen selenide gas may be released. Severe lung damage, liver, and kidney damage could result. Selenium also is associated with adverse reproductive effects.

SODIUM SULFATE. Not toxic, but like all organic compounds, when decomposed by heat, it emits many irritating and toxic chemicals.

STEARIC ACID. Not toxic, but like all organic compounds, when it is decomposed by heat (as during soldering), it emits many irritating, sensitizing, and toxic gases and vapors.

SULFURIC ACID. Highly irritating, and in some patinas also releases sulfur dioxide gas.

SULFIDES (potassium sulfide, ammonium sulfide, barium sulfide). Irritating to skin and eyes. They emit sulfur oxides when heated. When heated in the presence of water or when reacted with metal, highly toxic hydrogen sulfide gas is released.

TELLURIUM COMPOUNDS. Found in some patinas. See information on tellurium in table 14 and on sulfides in table 15. When hydrochloric acid is also in the patina, tellurium dichloride and other tellurium compounds may be released.

THIOSULFATES. Usually not toxic, but release highly irritating and sensitizing sulfur oxides when heated.

WETTING AGENTS, SURFACTANTS, ETC. Varying toxicity, and many have not been studied well. Like other organic compounds, they release toxic emissions when burned.

ZINC CHLORIDE. With heat, zinc chloride fume will be airborne. A moderately irritating fume. Very heavy exposure also could cause metal fume fever.

2. Provide local exhaust ventilation by working in front of a window exhaust fan, a slot hood, or a similar system. (Most degreasers, patinas, and fluxes give off toxic gases and vapors.)
3. Choose the safest materials by comparing Material Safety Data Sheet information. In general, acid fluxes are the least toxic. Avoid fluoride

fluxes if possible. Try to avoid patinas containing sulfides (which release hydrogen sulfide gas). Avoid cleaners containing cyanides.

4. Follow directions for use carefully.

5. Never mix different types of fluxes. Some mixtures can produce especially toxic emissions, and most will not perform properly. Never mix different cleaners or patinas unless you understand fully the chemical reactions that may occur.

6. Remove all residue from degreasing before soldering or heating metal (some will release highly toxic gases such as phosgene on heating).

ELECTROPLATING AND ANODIZING

Electroplating relies on depositing a metal out of an electrolyte solution by running a current from a metal anode to the object to be plated, which acts as a cathode. Even materials that do not conduct electricity can be made to plate by sealing them with wax or lacquer and then coating them with a conductive material like graphite or metal paint.

Anodizing is an electrolytic process in which certain metals (aluminum, magnesium, and several others) that naturally produce a film of metal oxide on their surfaces can be made to accept even thicker and more stable metal oxide coatings. A number of different metals can be employed to produce the coating, including titanium and niobium. These metallic oxides will also accept dyes and pigments, making it possible to obtain finishes in many colors, including black. The lustre of the underlying metal gives the coating a metallic sheen.

Many different electrolytic solutions are used in plating and anodizing. Copper can be plated from a solution of copper sulfate and sulfuric acid. Many other types of plating, such as gold and silver, employ cyanide solutions. Anodizing electrolytes are usually sulfuric, oxalic, and chromic acids.

Sulfuric, oxalic, and chromic acid baths are highly irritating to the skin, eyes, and respiratory system. Cyanide baths are moderately toxic by skin contact and highly toxic by inhalation or ingestion. Acid, heat, and even carbon dioxide from the air will cause the formation of deadly hydrogen cyanide gas from cyanide solutions. Acute inhalation of either cyanide salts or hydrogen cyanide gas can be fatal.

Before being treated, metals must be scrupulously cleaned. Skin- and eye-damaging cleaners are used, such as caustic soda and other hydroxides (see table 26). Once in the bath, large electrical currents are applied, which can cause electric shocks. If lacquers or metal paints are used, these may contain toxic solvents.

PRECAUTIONS FOR ELECTROPLATING AND ANODIZING

1. Protect skin and eyes by wearing gloves, aprons, and chemical splash goggles when handling acids, caustic soda, and solvents. Install eyewash fountains. If large amounts of caustics or acids are used, install emergency showers.

2. Try to avoid using cyanide salts. If they must be used, consult safety experts when designing and installing equipment and local exhaust ventilation for the baths. Train all personnel about the hazards and emergency procedures. Keep a cyanide antidote kit available (if someone on staff is qualified to use it) or notify the local hospital to be prepared for cyanide poisoning. If local hospitals are not prepared, a cyanide kit should be taken with a victim to the hospital.

3. Avoid spraying lacquers or solvent-containing paints. If they must be sprayed, use a spray booth or wear a proper respirator.

4. Instruct all personnel about electrical hazards. Install ground fault interrupters and other electrical safety features.

5. Look up the hazards of the metals and metal compounds used (see table 14), especially some of the rare metals employed in some anodizing procedures.

GILDING

Metal gilding (as opposed to gold-leaf gilding of wood and plaster) may be done with gold and silver amalgams. The amalgams are made by mixing or heating mercury and gold or silver together. These amalgams are applied to the metal and heated until the mercury vaporizes, leaving the gold or silver on the surface.

This gilding method is not recommended for studio work. Mercury is highly toxic and can be absorbed by the skin, and the vapor can be inhaled (see table 14). If the method is used, first investigate and comply with all applicable toxic substance regulations. Avoid skin contact with mercury, and heat mercury amalgams only under excellent local exhaust ventilation.

Work on a tray or on a surface designed to contain spilled mercury. Since mercury vaporizes at room temperature, it must be stored in sealed containers. When in use, constant ventilation must be provided. Mercury spills must be scrupulously cleaned up. Small amounts of spilled mercury left in sink traps or floor cracks can produce significant amounts of mercury vapor.

Mercury spill kits containing ferric chloride or other chemicals that will react with mercury should be available. Do not vacuum (except with vacuums specially developed for mercury spills).

NIELLO

In this process, silver, copper, and lead are melted and poured into a crucible with sulfur. The mixture is remelted, sintered, and ground finely. Then, it is mixed with ammonium chloride into a paste, applied to the metal, and heated.

Lead poisoning can result from inhaling lead fumes during heating or lead sulfide dust during grinding of the mixture. All procedures should be done in local exhaust ventilation, and excellent hygiene should be practiced. The work must also comply with lead regulations.

CHAPTER 25
WELDING

All methods of welding or cutting metal rely upon heat from either burning gas or electric arc to do the job. Over eighty different types of welding exist, and they use these basic heat sources in various ways. But in art, the types most commonly used are oxyacetylene welding, ordinary arc welding, gas metal arc welding (metal inert gas, or MIG), and gas tungsten arc welding (tungsten inert gas, or TIG). All types of welding can be extremely hazardous.

TRAINING

Safe welding requires knowledge, training, and comprehension of applicable health and safety codes and regulations. Art welders in the United States and Canada should at least be familiar with their state/provincial and federal industry standards.

Neither this book nor any other secondary source of information should be considered inclusive of welding health and safety practices. Instead, welders and welding teachers must follow the precautions mandated by their federal, state, and provincial industry standards. They also need to follow the safety standards of three primary standard setting organizations: the American National Standards Institute (ANSI), the American Welding Society (AWS), and the National Fire Protection Association (NFPA) (addresses are in appendix A). Readers should obtain publications lists and order applicable standards, including:

1. ANSI 49.1: Safety in Welding and Cutting
2. NFPA 51: Oxygen Fuel Gas Systems for Welding, Cutting, and Allied Processes
3. NFPA 51B: Cutting and Welding Processes

Learning about these regulations and becoming proficient at welding takes time. The American Welding Society considers 125 to 150 hours of professional

training necessary to qualify for oxyacetylene welding, brazing, and flame cutting. Another 250 to 300 hours' training are required to qualify for arc welding. Ideally, art welders should obtain this certification.

UNTRAINED WELDERS. Instead of getting formal training, most artists pick up welding "by the seat of their pants," by observing other (usually unqualified) welders. In addition, they often weld with old, poorly maintained equipment housed in unventilated spaces, which are located near other activities and are not compatible with fire and electrical requirements imposed by welding.

Those who teach welding certainly should be certified to teach the types of welding they teach. However, this is almost never the case. It is ironic that schools that wouldn't dream of hiring art history teachers without degrees in art history will hire teachers who have never had a day of technical training in welding to teach this dangerous craft.

In addition to certification, welding instructors should have formal training in welding health and safety. Such courses are regularly scheduled at various locations around the United States and Canada. Two organizations that teach such courses are:

American Welding Society (AWS)
550 N.W. LeJeune Road
Miami, Florida 33126
(800) 443-9353

Hobart Institute
400 Trade Square East
Troy, Ohio 45373
(800) 332-9448

CERTIFIED TRAINING. What is needed to fix this problem is the development of a special certification course for university welding teachers. It should be taught through the AWS, the Hobart Institute, or one of the other recognized welding certifiers. This course should cover all the safety material covered in the eight-hour AWS safety course plus modules on the five major types: oxyacetylene, arc, MIG, TIG, and plasma arc welding and cutting. The welding modules should cover both theory and hands-on training. In my opinion, a course like this could be structured to take two weeks (eighty hours). Teachers who want to teach additional methods could take additional hours of training.

SAFETY PRECAUTIONS

Welding safety is an extraordinarily complex subject, and the safety rules differ depending on the type of welding, the kind of work, and on the shop or on-site conditions. Certain general rules, however, are basic to common types of welding.

GOOD HOUSEKEEPING. Welding shops should be kept scrupulously organized and clean. Only necessary items should be kept in the shop. Combustible materials should be eliminated from the area or covered with fireproof tarps or other protective materials. The space should be organized to keep floors free of trip hazards, because the welder's vision is often limited by face shields or goggles.

ELECTRICAL SAFETY. Most shocks caused by welding equipment are not severe. But under the right conditions, they can cause injury or even death. Mild shocks can cause involuntary muscle contractions leading to accidents, and moderate amounts of current directed across the chest may stop the heart. Here are some basic ways to avoid these hazards:

- Use only welding equipment that meets standards.
- Follow exactly all equipment operating instructions.
- Keep clothes dry (even from excessive perspiration), and do not work in wet conditions.
- Maintain all electrical connections, cables, electrode holders, etc., and inspect each before starting to weld.

COMPRESSED GAS CYLINDER SAFETY. Compressed gas cylinders are potential rockets or bombs. If mishandled, cylinders, valves, or regulators can break or rupture, causing damage as far as a hundred yards away.

The different kinds of gases inside the cylinders are themselves hazards. There are three basic types of hazardous gases:

- *Oxygen.* It will not burn by itself, but ordinary combustible materials like wood, cloth, or plastics will burn violently or even explode when ignited in the presence of oxygen. Never use oxygen as a substitute for compressed air.
- *Fuel gases.* Acetylene, propane, and butane are some fuel gases. They are flammable and can burn and explode.

- *Shielding gases.* These are used to shield processes such as MIG and TIG welding and include argon, carbon dioxide, helium, and nitrogen. They are inert, colorless, and tasteless. If they build up in confined spaces, such as enclosed welding areas, they replace air and can asphyxiate those in the area.

Some basic rules regarding compressed gas cylinders that all art welders should know are the following:

1. Accept only cylinders approved by the Department of Transportation for use in interstate commerce. Do not remove or change any numbers or marks stamped on cylinders.
2. Cylinders too large to carry easily may be rolled on their bottom edges, but never dragged.
3. Protect cylinders from cuts, abrasions, drops, or striking each other. Never use cylinders for rollers, supports, or any purpose other than intended by the manufacturer.
4. Do not tamper with safety devices in valves.
5. Return empty cylinders to the vendor. Mark them "EMPTY" or "MT" with chalk. Close the valves, and replace valve protection caps.
6. Always consider cylinders as full (even when empty), and handle them with due care. Accidents have resulted when containers under partial pressure have been mishandled.
7. Secure cylinders by chaining, tying, or binding them, and always use them in an upright position.
8. Store cylinders in cool, well-ventilated areas or outdoors in vertical positions (unless the manufacturer suggests otherwise). The temperature of a cylinder should never exceed 130° Fahrenheit. Store oxygen cylinders separately from fuel cylinders or combustible materials.

FIRE SAFETY. Many fires are started by welding sparks. These "sparks" are actually molten globules of metal that can travel up to forty feet and still be hot enough to ignite combustible materials. Welding shops must be planned carefully to avoid combustible materials, such as wooden floors, or any cracks or crevices into which sparks may fall and smolder.

Most importantly, welding operations must be completely separated from woodworking shops. The Occupational Safety and Health Administration (OSHA) regulations require that welding be kept at least thirty-five feet away from any area where wood dust and chips may be located or created.

The same precautions must be taken when portable welding units are taken to locations other than the shop. On-site welding requires a number of precautions, including giving advance notice before welding, curtailing all other activities in the area, removing all combustibles within thirty-five feet of the operation or installing special fireproof curtains and coverings to shield combustibles that cannot be removed, clearing and dampening floors, and assigning a fire watcher with extinguisher at the ready during the welding operation. The fire watcher should remain for half an hour after welding has been completed.

Fire extinguishers must also be on hand in welding shops, because overhead sprinkler systems may not be present or they may have been installed high above workers. Systems installed many feet above the floor will activate only when enough heat from a fire below reaches the sprinkler head. By this time, workers below may not survive.

Sprinkler systems may also be limited in use according to the types of welding that are being done. Imagine the results if an electric arc welder were suddenly deluged with water. Each welder should have hands-on training in the use of the type of extinguishers in the shop. Emergency procedures should be posted and practiced in routine drills.

ACCIDENTS. Prepare for accidents and burns by keeping first aid kits stocked with burn and trauma treatments. Post emergency procedures. Ideally, someone on-site should have first aid and CPR (cardiopulmonary resuscitation) training.

HEALTH HAZARDS

Hazards to welders' health are less obvious than welding safety hazards, and they vary among different types of welding. In general, the hazards are radiation, heat, noise, fumes, gases from welding processes, and gases from compressed cylinders.

Radiation generated by welding takes three forms: visible, infrared, and ultraviolet.

1. *Visible* light is the least hazardous and most noticeable radiation emitted by welding. Although intense light produces only temporary visual impairment, eyes should be protected from strong light.
2. *Infrared (IR)* radiation is produced when metal is heated until it glows. IR can cause temporary eye irritation and discomfort. Repeated exposure can cause permanent eye damage, including retinal damage and infrared cataracts. These effects occur slowly, without warning.

3. *Ultraviolet (UV)* is the most dangerous of the three types of radiation. All forms of arc welding produce UV radiation. Eye damage from UV, often called a "flash burn," can be caused by less than a minute's exposure. Symptoms usually do not appear until several hours after exposure. Severe burns become excruciatingly painful, and permanent damage may result.

UV can also damage exposed skin. Chronic exposure can result in dry, brown, wrinkled skin and may progress to a hardening of the skin, a condition called "keratosis." Further exposure is associated with benign and malignant skin tumors.

Heat can harm welders by causing burns (from IR radiation to the skin or from hot metal) and by raising body temperature to hazardous levels, causing "heat stress."

Noise can damage a welder's hearing. Fortunately, most welding processes used in the arts produce noise at levels below the level at which hearing is damaged. (Air carbon arc cutting is one possible exception.) If you wear earplugs, make sure they are fire-resistant. Several cases of eardrum damage have been reported when overhead sparks fell into ear canals that were either unprotected or contained a combustible plug.

Fumes and gases are produced during the welding process. They can sometimes be seen as a smoky plume rising from the weld. Fumes come from the vaporized metals. Gases can come from gas cylinders or can be created when substances burn during welding. Gases can also form when some types of welding rods are being used. Material Safety Data Sheets on welding rods will identify the emissions expected during normal use.

Many occupational illnesses are associated with substances found in welding fumes and gases, including metal fume fever (see page 147) and a variety of chronic lung diseases, including chronic bronchitis. Lung and respiratory system cancer are associated with metal fumes such as chrome, nickel, beryllium, and cadmium. Lead poisoning from welding lead-painted metals is also frequently documented.

HEALTH PRECAUTIONS
(For safety precautions, see above.)

1. Get formal training in welding, preferably by recognized schools of welding.

2. Plan welding shops for areas that are at least thirty-five feet away from all flammable and combustible materials, such as woodworking or painting activities.

3. Obtain Material Safety Data Sheets on all materials, including compressed gases and welding and brazing rods. Obtain complete information on the composition of metals to be welded. Avoid materials that will emit highly toxic metal fumes, such as beryllium, thorium, cadmium, antimony, etc. Never work with metals of unknown composition, painted metals, or junk or found metals unless ventilation is certain to provide total removal of the welding plume.

4. Provide ventilation for protection from gases, fumes, and heat buildup. Equip shops with local exhaust ventilation systems, such as downdraft tables or flexible-duct fume exhausts, to capture welding fumes and gases at their source. These local exhaust systems should be combined with dilution systems to remove gases and fumes that escape collection and to reduce heat buildup. A simple exhaust fan may suffice for open-area welding, while enclosed MIG and TIG welding booths may need floor-level dilution systems to prevent layering of inert gases.

 Do not rely on working outdoors for protection. Many documented cases of illness have resulted from cutting and welding outdoors, even in windy conditions.

5. Use respiratory protection if appropriate. Keep in mind that no single air-purifying respirator will protect wearers from all the contaminants in welding plumes. The HEPA filters will stop metal fumes, but they offer no protection from gaseous contaminants.

 Some air-supplied respirators can provide welders with fresh air. These are costly pieces of equipment that need constant maintenance and training to be used effectively.

6. Isolate the welding area. Isolation keeps other workers from being exposed to either direct or reflected radiation. Walls, ceilings, and other exposed surfaces should have dull finishes such as can be obtained from special nonreflective paints. Portable, fire-resistant, UV-impervious screens or curtains can be purchased to isolate welding areas and to separate individual welding stations.

7. Use eye protection such as goggles or face shields to protect each welder for the type of welding he or she does (see figures 3 and 4). Welders who use methods that leave a slag coating on the weld

should wear safety glasses under their shields. A common injury occurs when welders raise their hoods to inspect a weld and the slag pops off unexpectedly.

Face and eye protective equipment should be cleaned carefully after each use and inspected routinely for damage, especially for light-shield damage. A scratched lens will permit radiation to penetrate it, and it should be replaced.

Visitors and other workers nearby should avoid looking at welding and should wear safety glasses. Visitors' safety eyewear can be made from clear glass or a special clear plastic, because UV is weakened by distance and can be easily stopped by clear lenses.

8. Protect hearing by wearing fire-resistant earplugs, muffs, or other devices if needed.

9. Wear protective clothing. Pants and long-sleeved shirts can protect legs and arms. Many welders prefer wool fabrics, because they insulate welders from temperature changes and because they emit a strong warning odor when heated or burned. Treat cotton clothing with a flame retardant. Never wear polyester or synthetic fabrics that melt and adhere to the skin when they burn. Pants and shirts should not have pockets, cuffs, or folds into which sparks may fall.

 Shoes should have tops into which sparks cannot fall. Wear safety shoes with steel toes if heavy objects are being welded. Hair should be covered or, at the very least, tied back. Wear gloves when arc welding. Leather aprons, leggings, spats, and arm shields may be needed for some types of welding. Do not use asbestos protective clothing.

10. Practice good housekeeping. Control dust by vacuuming with specially filtered vacuums that can trap fume particles or by damp-mopping (being careful not to create an electrical hazard). Sweeping with large amounts of sweeping compound may also be acceptable.

11. Dispose of waste metals and other chemicals in accordance with health, safety, and environmental protection regulations.

12. Arrange for good medical surveillance. Always be prepared to provide your doctor with information about the materials you use and your work practices.

CHAPTER 26
BRAZING, SOLDERING, CASTING, AND SMITHING

Brazing is the process of filling a joint or coating a metal surface with a non-ferrous metal, such as silver or copper. Soldering is a method of filling a joint or seam with metal alloys that will melt at lower temperatures than the metals being soldered. Tinning is a special kind of soldering in which areas of metal are covered with a solder surface.

HAZARDS OF BRAZING AND SOLDERING
Brazing alloys can contain an array of metals, some of which are toxic. Silver and copper brazing alloys may contain cadmium, antimony, and arsenic. Material Safety Data Sheets for brazing alloys should identify all the metals present in them.

Solders can contain a large number of metals, including lead, tin, cadmium, zinc, arsenic, antimony, beryllium, indium, lithium, and silver (see table 14). Solders made for use on copper water pipes and cooking utensils are safer, because these alloys must not contain significant amounts of lead. Material Safety Data Sheets that identify all metal constituents should be available on solders.

Prior to soldering or brazing, the metal must be cleaned and degreased. Cleaners and degreasers usually contain toxic solvents, caustics, and acids (see table 26).

Fluxes are used when soldering and brazing. Inorganic acid fluxes, such as those containing zinc and other chlorides, are used most widely. Organic solders containing fatty acids will work well on lead and copper. Rosin solders are used primarily for copper electrical work. Only rosin fluxes activated with toxic bromide compounds will work on lead, brass, or bronze (and then only if it is very clean). Fluoride fluxes work very well on many metals and are usually used with tinning solders. However, these fluxes are very toxic (see table 27).

During soldering, a plume of "smoke" rises and can be inhaled. The plume will contain a variety of decomposition products from materials in fluxes and metal fumes. These substances can cause eye and respiratory irritation, allergies, and, in some cases, metal poisoning.

The temperature at which brazing or soldering is done affects the amount of toxic materials in the plume. Lower temperatures vaporize less metal. Methods employing soldering guns or electric soldering irons vaporize less metal than methods using torches to heat soldering irons or to fill joints (as in the copper foil method in stained glass). Open pot tinning, in which metal objects are dipped in molten solders, can product very large amounts of metal fumes.

The heat created during soldering can cause burns. When the metals glow with heat, they are giving off infrared radiation, which can cause eye damage.

Once the metals are brazed or soldered, the seams are often cleaned of the residual flux chemicals. Cleaning products can contain toxic solvents, acids, caustics, or ammonia. Some cleaning products generate toxic gases when mixed (see table 26). Polishing soldered and brazed metals with putty (tin oxide) or whiting (calcium carbonate) is less hazardous.

PRECAUTIONS FOR SOLDERING AND BRAZING

1. Obtain Material Safety Data Sheets and complete alloy composition for all solders and brazing metals. Choose the safest ones for the work to be done. Avoid highly toxic metal-containing alloys, such as those containing arsenic, cadmium, and beryllium.
2. Avoid using lead solder. If lead solders are used on the job, employers must be prepared to meet complex and expensive OSHA Lead Standard regulations in the United States or the OHSA Regulation respecting lead in Canada.
3. Obtain ingredient information on fluxes. Choose the safest flux for the job. Avoid fluoride fluxes. Do not mix fluxes.
4. Wear goggles that will protect the eyes from infrared radiation and irritating vapors. (See figures 3 and 4.) Use gloves when working with

solvents, acids, or caustic cleaning agents. Minimize skin contact with fluxes. Wear clothing resistant to heat (see chapter 25).

5. Have first aid treatment, cool water, and ice on hand for minor burns. Post emergency procedures.

6. Provide local exhaust ventilation for the plume.

7. Braze at the lowest temperatures at which good results are obtained. Use gun or electric soldering iron methods over open-flame joining or heating of irons. Avoid open dip pot tinning, unless excellent local exhaust can be installed.

8. Obtain ingredient information on metal cleaners and degreasers, and choose the safest ones. Provide local exhaust for products that emit toxic gases and vapors. Do not mix cleaning agents, unless you are sure they cannot react adversely with each other. Use putty or whiting to clean when possible.

9. Practice good housekeeping. Wet-mop floors and sponge tables and surfaces to control dust, which may be contaminated with metal fume particles.

10. Dispose of all spent cleaning and polishing materials, fluxes, and metal waste in accordance with health, safety, and environmental protection regulations.

11. Always be prepared to provide your doctor with information about the chemicals you use and your work practices. If lead is used, arrange for regular blood tests for lead.

METAL CASTING AND FOUNDRY

Metal casting involves forcing molten metal (by gravity or centrifugal force) into a mold. In the construction of some molds, a positive form of wax or plastic is burned out to leave room for the metal.

Metals can be cast in any size, from tiny jewelry pieces to large, foundry-cast sculptures. Foundry work is especially hazardous and should not be attempted unless workers are prepared to comply with all applicable occupational health and safety laws and regulations.

The hazards of all types of metal casting include exposure to mold materials, burning out patterns, and working with molten metals.

MOLD-MAKING HAZARDS

Channel molds are made by carving into tufa (a soft porous rock) or investment plaster mixed with pumice. Free silica can be found in investment plasters and in some pumice and tufa.

Cuttlebone molds are made by pressing small shapes (usually jewelry pieces) into cuttlebone (the internal shell of the cuttlefish). The mold is then painted with borax flux and water glass (sodium silicate). Cuttlebone can cause respiratory irritation and allergies; borax is moderately toxic and can be absorbed through broken skin; and some grades of sodium silicate contain some free silica. All of these dusts are eye and respiratory irritants.

Sand molds are made from foundry or casting sand, which is usually silica and binders. Some silica mold sands are cristobalite (see pages 173–174). The sands are very hazardous, unless they are treated with binding chemicals, which also prevent respirable dust from becoming airborne.

The binders in foundry sands can be a number of organic chemicals, such as glycerin and linseed oil. These harden when heated in an oven.

Cold-setting, high-silica sands also are used. The binders in these sands are usually synthetic resins. Many different resins are now used, including urea-formaldehyde, phenol-formaldehyde, urethanes, and other plastics. The resins and the catalysts that set them can be highly toxic, and toxic gases may be emitted when the resins burn off during casting (e.g., hydrogen cyanide and isocyanates).

Mold releases may include silica flour, French chalk (talc), or graphite. Some French chalk is contaminated with asbestos. Silica flour is an especially toxic source of silica because of its small particle size.

Molds for lost wax casting are made with investment plasters, which contain silica flour or cristobalite, plaster, grog (fired clay), and clay. In the past, asbestos was added to this material. Asbestos or ceramic fiber may be used to line investment containers. Shell molds are made with slurries of water and silica, fused silica, or zircon, and sometimes with ethyl silicate. The resulting mold is heated in a kiln to form a ceramic-like shell.

Cristobalite, silica flour, and fused silica can cause silicosis. Asbestos in any form can be a cancer hazard. Ceramic fiber may also cause asbestos-related diseases (see pages 172–73). Ethyl silicate is highly toxic by inhalation and eye contact. It is an irritant and may cause liver and kidney damage.

Burning-out patterns for metal casting molds can be made of wax, Styrofoam, and other plastics. These materials can be burned out of the mold with a torch or a furnace. Styrofoam is often burned out when the molten metal is poured into the mold.

There are many types of wax, including beeswax, carnauba, tallow, paraffin, and microcrystalline wax. When these waxes burn, they release many toxic and irritating compounds, including acrolein and formaldehyde. Acrolein is an exceedingly potent lung irritant; formaldehyde is a sensitizer and suspect carcinogen.

Wax additives may include rosin, petroleum jelly, mineral oil, solvents, and dyes. These organic chemicals will also release carbon monoxide and other toxic decomposition products when burned.

Burning Styrofoam (polystyrene) will produce carbon monoxide and other toxic emissions. Burning out nitrogen-containing plastics, such as urethane foam or urea formaldehyde, will release hydrogen cyanide gas in addition to other toxic gases.

MELTING AND POURING

Small amounts of metal for centrifugal casting can be melted with torches. Centrifugal casting equipment can be dangerous. If it is unbalanced, metal can be thrown out. Most shields around centrifugal casters probably would not be able to protect bystanders if the arm should break during casting.

Furnaces are needed for larger castings. Furnaces can be heated with gas, coke, coal, or electricity. Fuel-fired furnaces produce carbon monoxide and other combustion gases.

Many metal alloys may be used in casting. The compositions of a few common alloys are listed in table 28. Some of these alloys are hazardous to cast, because they give off toxic fumes, such as lead, arsenic, nickel, and manganese. For example, nickel fume, which is considered a carcinogen (with a Threshold Limit Value–Time-Weighted Average of 1 mg/m^3) is given off when nickel silver is cast.

Lead in particular should not be used in metal casting formulas in art foundries. If lead is used, art foundries must follow the expensive precautions required under the OSHA Lead Standard. They should not think they may escape OSHA's notice because they are small operations. I know of two small foundries that were fined for Lead Standard violations. One of these foundries had only two employees.

In addition, highly toxic gasses can be released when mold-binding chemicals are burned off while in contact with the hot metal. Heat from molten metal during pouring of large amounts can cause serious burns. Infrared radiation accidentally caused permanent scarring of an art student who was helping to pour bronze. Infrared can also cause eye damage.

Heat from molten metal during pouring of large amounts can cause serious burns. Infrared radiation accidentally caused permanent scarring of an art student who was helping to pour bronze. Infrared can also causes eye damage.

TABLE 28	COMPOSITION OF COMMON ALLOYS

BRASS. Copper/zinc alloy with small amounts of lead, arsenic, manganese, aluminum, silicon, and/or tin

BRITANNIA METAL, PEWTER, AND WHITE METAL. Two basic types: tin/lead/copper or tin/antimony/copper.

BRONZE. Copper/tin and sometimes small amounts of lead, phosphorus, aluminum, and/or silicon.

GOLD. Alloyed with other metals for white, yellow, and other gold jewelry colors.

LEAD. Type lead, lead pipe, battery lead, and various kinds of scrap lead have been used for sculpture.

MONEL METAL. Nickel/copper alloys with small amounts of carbon, manganese, iron, sulfur, and silicon.

NICKEL SILVER. Alloys of nickel/silver/zinc.

PEWTER. See Britannia Metal.

SILVER. Sterling is silver alloyed with at most 7.5 percent other metals, usually copper. Other silver alloys are usually even less pure.

WHITE METAL. See Britannia Metal.

PRECAUTIONS FOR CASTING

1. Be prepared to comply with all workplace occupational safety and health regulations regarding foundry work and metal casting.
2. Obtain Material Safety Data Sheets and ingredient lists for all metals, molds, and pattern materials used. Choose the least toxic products.
3. Choose foundry sands over cold-setting sands and resin binders. Replace silica flours and cristobalite with non-silica materials such as zircon when possible. Do not use asbestos.

4. If ethyl silicate is used, work with local exhaust ventilation and wear eye protection.

5. Provide dust control, ventilation, and/or respiratory protection against irritating, sensitizing, and silica-containing mold materials. Dust goggles should also be worn if dust is raised.

6. Use the safest mold-release agents, such as graphite or asbestos-free talcs.

7. Provide local exhaust ventilation for burn-out of any pattern materials. Be especially careful about generation of hydrogen cyanide gas from nitrogen-containing plastic patterns.

8. Furnaces and ovens for mold-setting, burn-out, and melting metal should be equipped with local exhaust ventilation, such as a canopy hood. Provide exhaust ventilation for all pouring operations.

9. Avoid alloys containing significant amounts of highly toxic or carcinogenic metals such as arsenic, antimony, cadmium, nickel, or chrome when possible.

10. Avoid casting in lead. If lead is used on the job, employers must be prepared to meet complex and expensive OSHA Lead Standard regulations in the United States or the OHSA Regulation respecting lead in Canada.

11. Wear protective clothing appropriate to the type of casting done. For foundry work, follow protective clothing regulations. Wear infrared goggles whenever working with glowing materials (see figures 3 and 4). If molten metals may splash, wear a face shield, a long-sleeved, high-necked wool shirt, insulated leggings, jacket, apron, gloves, and shoes (steel-toed if heavy materials are being lifted). Tie back hair or wear hair covering.

12. Have first aid treatment, cool water, and ice on hand for burns. Post emergency procedures.

13. Post fire emergency and evacuation procedures, and train workers in use of fire extinguishers (sprinkler systems cannot be used in foundries or other places where furnaces or molten metal are used). Hold regular fire drills.

14. Install carbon monoxide detectors in areas where fuel-burning equipment, such as furnaces and burnout kilns, is located.

15. When centrifugal casting, make sure the equipment is well balanced and that the protective shield is in good condition.

16. Wear respiratory protection when breaking up and disposing of silica-containing molds. Practice good housekeeping. Wet-mop floors and

sponge tables and surfaces to control dust that may be contaminated with mold materials or metal dust.

17. Dispose of all mold materials and metal waste in accordance with health, safety, and environmental protection regulations.

18. Always be prepared to provide your doctor with information about the chemicals you use and your work practices. If lead is used, arrange for regular blood tests for lead.

HAZARDS OF SMITHING

Smithing, or forging, is the process of hammering hot or cold metals into shape. Blacksmiths work with iron, silversmiths forge silver, and so forth. The tools used in these processes are hammers, mallets, metal blocks, and anvils. Furnaces used for hot forging burn coal, coke, oil, or gas.

Percussive hammering on metal produces noise that is very destructive to hearing. Even in the 1700s, Bernardino Ramazzini (the father of occupational medicine) observed that tinsmiths went deaf from hammering noise.

Toxic combustion products, such as carbon monoxide gas, are emitted by forging furnaces. Ventilation systems such as canopy hoods can only provide partial protection from these gases, because the bellows used to fan the coals will also blow some emissions away from the hood intake area.

Other hazards include infrared radiation, given off by furnaces, and hot metal, which can damage the eyes and burn the skin. Heavy work in a hot environment can cause heat stress. Some kinds of smithing also use acid pickling solutions to clean hot metal.

Fires are a constant threat. Train workers in fire emergency procedures and the use of extinguishers (other controls, such as overhead sprinklers, cannot be used in hot forging areas).

Cold forging metals like silver and tin involve hammering metal into or over forms. Small anvils, dapping blocks, and other objects can be used to pound the metal into shapes. Repoussé is a special method whereby one shapes the metal by hammering and chasing while it is supported by a bowl of a material made of pitch, plaster of paris, and tallow. When shaping is done, the pitch can be removed by a solvent or burned off in a furnace or with a torch.

PRECAUTIONS FOR SMITHING

1. Install fireproof, sound-absorbing materials in the floors and walls of the shop where possible.

2. Provide good stack exhausts and canopy hood ventilation for forges and furnaces. Additional general shop ventilation will be needed for blacksmithing and other hot forging to reduce heat and to exhaust toxic gases that are blown out of the hood's capture range by the bellows.

3. Install carbon monoxide detectors in areas where forges and furnaces are located.

4. Plan fire protection carefully. Eliminate all combustibles from areas around forges and furnaces. Do not install sprinkler heads above hot processes. Consult fire marshals and other experts for advice on appropriate fire-fighting systems and extinguishers.

5. Provide bathroom facilities and a separate, clean room for work breaks. It is necessary that smiths be able to wash up and retire to a clean area to drink fluids to replace those lost through perspiration, to have lunch, and the like.

6. Provide first aid supplies and cold water or ice for treatment of minor burns. Post emergency procedures. Water should also be available to drink frequently, to quench metal, etc.

7. Obtain ingredient information on all materials used in the work, and use proper precautions. For example, if solvents are used—for removal of pitch from repoussé, for example—follow all solvent safety rules (see pages 93–95).

8. Practice good housekeeping. Wet-mop or sponge floors and surfaces. Never allow trip hazards in the work area.

9. Wear earplugs or other suitable hearing protection. If the facility is a school or a business, the employer must monitor employees' exposures and set up a formal OSHA hearing protection program.

10. Wear goggles to protect eyes from infrared radiation (see figures 3 and 4).

11. Wear protective clothing: long-sleeved, close-woven cotton or wool shirts, leather gloves, and safety shoes. Tie back hair or wear hair covering. Leave clothing in the shop to avoid tracking dusts home. Wash clothes frequently and separately from other clothes.

12. Wear gloves and goggles when handling acids, caustics, or solvents. If hot metal is dipped or cleaned in acid or Sparex®, provide gloves, goggles, protective clothing (e.g., rubber aprons), and ventilation to exhaust gases rising from the bath.

13. Install an eyewash station near areas where acids, caustics, or solvents are used. If the smith is outside or in an area where there is no plumbing, use portable eyewash stations that supply fifteen minutes of continuous washing, as the ANSI standard requires.

14. Dispose of all spent acids, metal waste, and other materials in accordance with good hygiene and waste disposal regulations.

15. Always be prepared to provide your doctor with information about the chemicals you use and your work practices.

CHAPTER 27
PAPERMAKING

Papermaking can be one of the safer projects in the arts, as long as those few potential hazards associated with the process are understood and precautions taken.

MAKING PULP

Paper can be made from almost any water-wetable fiber pulp. The Chinese, who invented the papermaking process, boiled vegetable fibers with lye. Today, artists can purchase ready-made cotton linters. And some artists and teachers use clothes dryer lint for the same purpose.

However, if beaters, macerators, or blenders are available, paper can be made from a host of materials, including old magazines and newsprint, construction paper, and almost any plant with strong fibers, such as gladioli leaves, dried iris, and ginkgo leaves. The paper materials can be merely soaked and beaten into pulp. The plant materials will have to be boiled first.

It is important to consider the composition of the raw pulp materials. For example, colored print in magazines and newspapers may contain lead or cadmium inks. Slick magazines contain both toxic inks and fillers such as talc and silica. Many plants contain chemicals that will cause allergies or are toxic. Know as much as possible about the composition of the starting material for paper.

SOAKING. Reused paper fibers may only take a few hours to soak up water and become pulp, but plant fiber may take anywhere from twenty-four hours up to six weeks of soaking. Soaking, in these cases, is not just wetting. Changes are occurring in the plant fiber that are due in part to the action of bacteria and other microorganisms that establish themselves in the standing water. The metabolic activities of the microorganisms will also cause the water to have a bad odor and cause small gas bubbles or foam to appear on the surface. The water must be changed frequently.

It is impossible to predict precisely which organisms will establish themselves in any particular pot of fiber, since there are literally thousands of microorganisms that can seed the soaking pot. They can come from the air, from the water itself, from the hands of the papermaker, and from residual organisms on the plant material. One toxic organism commonly established under such condition is *Legionnella* (the bacteria that causes Legionnaires' disease). Fungi are less likely, but may also be established. *Stachybotres chartarum* (a cellulose-eating mold that is so toxic it was used in germ warfare) theoretically would thrive in these conditions.

Although some of the organisms that might grow in the water can cause diseases, they will be killed when the fibers are cooked. People with allergies should know that molds and bacteria (and/or the toxins and substances they produce) can cause allergic symptoms whether the organisms are alive or dead. To work safely with soaking fibers:

1. Change the water regularly.
2. Clean up spills promptly.
3. Wash hands after contact.
4. Keep children and pets away from the pots.
5. Soak fibers in areas other than kitchens and food preparation areas. Don't use papermaking pots and utensils for food.

COOKING. Fibers must be cooked with a material that will strip away all the soluble organic matter, leaving the fibers free. Cooking fibers with washing soda or trisodium phosphate (TSP) is safer than using lye, as the ancient Chinese did, but all these compounds are corrosive to skin and eyes.

1. Wear gloves and splash goggles when working with washing soda for protection from splatters. Either provide ventilation or wear respiratory protection (see chapter 8).
2. Always add washing soda to water before the water boils. Don't add boiling water to washing soda or vice versa, because it could spatter and burn you.
3. Cook the fibers outdoors on an electric hot plate or in a locally ventilated area. Don't breathe the fumes.
4. Never cook fibers with these alkaline substances in aluminum, tin, or iron pots. The pots react with alkalis and produce a gas. Instead, use stainless steel or enamel-coated pots.

DRYING. When the pulp is put in deckles and transferred to felt or some other material to dry, the pulp is damp enough to support rapid mold and bacterial growth. The faster the water is removed and the paper dried, the shorter the opportunity for organisms to proliferate.

CLEANUP

1. Thoroughly clean the area. The TSP that can be used in boiling the fibers will also make an excellent cleanser.
2. Sponge or wet-mop. Do not use a vacuum, since small particles such as those in powdered dyes will go through ordinary vacuum filters.
3. If solvents are needed to clean up or dilute paper colorants, use only the safer ones. These include denatured ethanol, rubbing alcohol (isopropyl alcohol), acetone (e.g., in nail polish remover), and some types of odorless paint thinner. See chapter 9 for more complete precautions.

STORAGE

1. If large amounts of pulp are made and held for later use, a freezer dedicated for this purpose should be used. If a home freezer must be used, store only cooked, sterilized fiber. Never store pulps or fibers that contain dyes or other toxic substances in kitchens or in refrigerators or freezers used for food. Label all refrigerated or frozen pulps, so that they are not accidentally consumed.
2. Store all chemical products in accordance with the Material Safety Data Sheets (MSDSs). Store reactive chemicals, such as potassium ferricyanide, separately from other chemicals. Store bleach and ammonia in different cabinets. Store amounts of more than a couple of gallons of solvent-containing products in flammable-storage cabinets, a garage, an outbuilding, or some other space away from communal living areas. Never store solvents near sources of heat, electrical sparks, or flame. If young children can access the work area, lock all storage units.

COLORING AND MARBLING

Paper pulp can be colored by adding various paints, pigments, and dyes ranging from food colors or food substances, such as tea and onion skins, to synthetic commercial dyes. All classes of dyes and pigments and the products containing them should be handled as highly toxic (see chapter 10).

Marbling of the finished paper surface can be done with commercial marbling colors or with acrylic or gouache paint thinned with water. The paints are floated on a layer of carrageenan gel on water. The marbled paints will adhere to paper better if the paper is first sponged with an alum solution.

Use dyes, pigments, and paints with the following precautions:

1. Purchase pigments, dyes, and paints only from manufacturers who identify the colorant by chemical name or Colour Index name (see chapter 10). Select the safest colorants.
2. Ask the manufacturer to provide an MSDS on each colorant. These sheets provide details of the product's hazard and will help you plan use and storage.
3. Take all the precautions necessary to avoid exposure. See chapter 10 for more precautions.

CHEMICALS COMMONLY USED IN PAPERMAKING

Alum (potassium aluminum sulfate). Some people may be allergic to it, but no special precautions are needed when using it.

Aluminum Acetate. Hazards are like those of alum (see above).

Ammonia (ammonium hydroxide). Avoid concentrated solutions. Household-strength ammonia is diluted and less hazardous. Inhalation of its vapors can cause respiratory and eye irritation. Wear gloves, and avoid inhalation.

Ammonium Alum (ammonium aluminum sulfate). Hazards are like those of alum (see above).

Carrageenan. A gel-forming mucilage extracted from seaweed with no known hazards.

Chlorine Bleach (household bleach, 5 percent sodium hypochlorite). Corrosive to the skin, eyes, throat, and mucous membranes. Wear gloves and goggles. Mixing with ammonia results in the release of several highly poisonous gases. Mixing with acids releases highly irritating chlorine gas.

Ferric Ammonium Citrate. Not very toxic, but it should not be ingested or inhaled. Provide ventilation, or wear a mask.

Hydrogen Peroxide. Hydrogen peroxide for household use usually contains about 3 percent hydrogen peroxide plus a little phosphoric acid as a stabilizer. It can burn the skin and eyes if it is in prolonged contact. Chemical companies sell concentrated hydrogen peroxide that is highly corrosive and shouldn't be used.

Madder. Natural alizarin (1,2-dihydroxyanthraquinone) from madder root is in a class of dye chemicals (anthraquinones) that cause cancer. Use with caution.

Natural Colorants. Like madder and many other naturally derived substances, might include:

1. Chestnut
2. Cochineal (carminic acid)
3. Cutch
4. Fustic
5. Indigo

6. Logwood (hematin)
7. Madder
8. Osage Orange
9. Pomegranate
10. Quebracho

These substances have never been studied for long-term hazards and should not be considered "safe" merely because of their natural origins. (See information on Madder, above.)

Potassium Ferricyanide. When used in sun printing, has the potential to release hydrogen cyanide gas if it is exposed to strong acids, high heat, or strong ultraviolet light. It can also be explosive when mixed with ammonia, chromium trioxide (a green pigment), and a number of other substances. Always store this chemical away from other chemicals and out of direct sunlight.

Potassium ferricyanide has never been studied for long-term health hazards, and the National Cancer Institute has proposed it for study, because they think it may be a carcinogen. Ferricyanides and ferrocyanides are now considered "cyanide waste" by the EPA, and they must be disposed of as toxic waste.

Rubber Cement. There are now water-based rubber cements that can be used. If you use solvent-based rubber cements, use those containing heptane rather than the more-toxic hexane solvent. See chapter 9 for more precautions.

TSP (trisodium phosphate). Irritating to the skin and eyes. Wear gloves and eye protection, or work near a source of water. It is, however, a good and relatively safe detergent to use to clean up the work space.

Vinegar (dilute acetic acid). Glacial (pure) acetic acid is highly corrosive, and the vapors are irritating. Vinegar (about 5 percent acetic acid) is only mildly irritating to the skin and eyes.

Washing Soda (sodium carbonate). Washing soda is alkali and is corrosive to the skin, eyes, and respiratory tract. Use ventilation or a mask if dust is raised.

PRECAUTIONS FOR PAPERMAKING

1. Floors and surfaces should be made of materials that are easily sponged clean and that will not stain. Mats or grates that elevate workers above spills can also be useful.

2. General ventilation should not be so rapid that dusts are stirred up. Local exhaust ventilation systems should be provided when needed. For example, slot hoods or recessed canopy hoods should be installed where pulp is boiled, where pulp bleaching is done, where wax is heated, and for all other processes that release toxic airborne substances. If machine dryers are used, they also should be vented.

3. Since water is involved in so many steps in papermaking, all electrical equipment must be in good repair, and all outlets should be ground fault circuit interrupted.

4. Guard all moving parts of equipment, such as beaters, macerators, and blenders.

5. Obtain Material Safety Data Sheets (MSDSs) on chemicals used in the process. If dyes and pigments are used, ask your supplier for their Colour Index names and numbers. Use MSDSs and product labels to identify the hazards and plan precautions.

6. Choose water-based products over solvent-containing ones whenever possible.

7. Avoid powdered materials if possible. Buy premixed dyes if possible. Dyes packaged in packets that dissolve when dropped unopened into hot water can also be handled safely. If powdered materials are used, weigh or mix them in ways that prevent them from becoming airborne, or use a local exhaust ventilation system or a glove box. Keep containers of powdered chemicals, solvents, etc., closed, except when you are using them.

8. Avoid procedures that raise dusts or mists. Sprinkling dry dyes or pigments on damp pulp, airbrushing color onto paper, and other techniques that raise dusts or mists should be discontinued or performed in a local exhaust environment, such as a spray booth.

9. Avoid skin contact with dyes, washing soda, bleach, and other corrosive or stain-producing chemicals by wearing gloves. If skin is stained, wash skin with mild cleaners, and allow the remainder to wear off. Never use solvents or bleaches to remove dyes from your skin.

10. If wax is used, do not heat it with open flames, such as on gas stoves. Use devices such as electric hotplates and double boilers. Use cold wax emulsion products when possible.

11. Wear protective clothing, including a full-length smock or coveralls. Leave these garments in your studio to avoid bringing dusts home. Wash clothing frequently and separately from other clothes.

12. Protect eyes by wearing vented chemical splash goggles when working with corrosives, such as washing soda, bleach, and lye. Install an eyewash fountain (and emergency shower if large amounts are used).

13. Clean up spills immediately. Follow MSDS advice and have handy proper materials to handle spills and disposal. Wet-mop and sponge floors and surfaces. Do not sweep.

14. Avoid ingestion of materials by eating, smoking, or drinking outside your workplace. Never point brushes with your lips or hold brush handles in your teeth. Never use cooking utensils for dyeing. A pot that seems clean can be porous enough to hold hazardous amounts of residual dye and other chemicals. Wash your hands before eating, smoking, applying makeup, or performing other personal hygiene procedures.

15. Dispose of toxic chemicals in accordance with health, safety, and environmental protection laws.

16. Be prepared to provide your doctor with precise information about the chemicals you use and your work habits. Arrange for regular blood tests for lead if you use lead-containing paints or pigments or if you are exposed to dust from fibers from colored magazines and newsprint, which may contain lead pigments.

CHAPTER 28
WOODWORKING

Virtually any type of wood may end up in art, including hard and soft woods, exotic woods, plywood, composition board, and so on. Often, art studios and school shops are filled with the sounds of noisy machines and clouds of sawdust.

WOOD DUST HAZARDS

Many artists consider wood dust as nothing more than a nuisance. It is far more than that. Wood dust has caused countless fires and explosions. A spark or static discharge is sufficient to detonate fine airborne sawdust. In addition, some wood dusts cause allergies, some are toxic, and others contain highly toxic pesticides, preservatives, flame retardants, and other treatments. Some trees deposit significant amounts of toxic silica in their heartwood. It has also been established that certain types of cancer are related to wood-dust exposure.

CHEMICALS PRODUCED BY TREES

Trees are just big plants. Like all plants, they are chemical factories, producing great numbers of chemicals. Just how complicated the chemical components of plants can be is well illustrated in the following excerpt, taken from an article that appeared in the *American Journal of Industrial Medicine:*

> Extractable components of wood consist of terpenes, paraffins, fatty acids, phenols, phthalic acid esters, sterols, stilbenes, flavonoids, and cyclic or acyclic tannins. Very few wood components have been adequately tested for their biological effects. The constituents of wood

are chemically complex, and effects observed with a single compo-
nent of a complex mixture do not necessarily represent the effects of
the whole.[1]

Some of these chemicals, however, are known to be pharmacologically
active:

> When pharmacologically active substances are absorbed through the
> skin, the respiratory tract, or orally, systemic symptoms like
> headache, nausea, vomiting, giddiness, disturbance of vision, drowsi-
> ness, weakness, nosebleeding, salivation, thirst, loss of appetite,
> colic, muscular cramps, and cardiac arrhythmia may occur.
> Pharmacologically active constituents such as alkaloids and glyco-
> sides are characteristic of Yew, Oleander, Mansonia, Afrormosia,
> Laburnum, and certain species of the Apocynaceae family, e.g., cyti-
> sine, N-methylcytisine, and strychnine. The compounds may be
> absorbed from wooden containers, spoons, grill sticks, and spits. But
> these more extreme conditions of poisoning are rare.[2]

Historically, the hazards of extraction of toxic substances from wood was
well known. For example, *lignum vitae* wood used to be made into goblets,
because there were enough extractants for users to get high from drinking from
them. However, the toxic chemicals in woods have been identified only in rela-
tively few species. And it is really not known which of these extract in signifi-
cant amounts, under which conditions, and what effects they have. Some wood
extractants are also dyes. Dyeing with wood chips is a technique still done by
craft dyers. Purple heart, walnut, and the darker woods are usually used.

It is unlikely that many wood extractants will be studied in detail in the near
future. Time and research dollars are limited, and the research would be com-
plicated by the large numbers of chemicals in wood. In addition, the chemicals
in wood vary with each different species and subspecies, with soil conditions,

[1] Nylander, Leena A., and John M. Dement. "Carcinogenic Effects of Wood Dust: Review and
Discussion," *American Journal of Industrial Medicine* 24:619–647 (1993), 636.

[2] Bjorn Hausen. *Woods Injurious to Human Health: A Manual.* New York: Walter de Gruyter, 1981,
p. 6.

and other effects. The differences can be likened to the difference between marijuana and hemp. Both are the same species, but only one has THC (tetrahydrocannabinol) in significant quantities.

OCCUPATIONAL ILLNESSES

The chemicals in wood also are associated with a variety of occupational illnesses that are seen in wood-dust-exposed individuals.

DERMATITIS. There are two common types of wood-related skin diseases. One of these is irritant dermatitis. It is caused most often by exposure to the sap and bark of some trees. It will affect artists if they cut trees, saw raw timber, or work with unusual woods, such as cashew.

The other major wood-related skin disease is sensitization dermatitis. It results from an allergy to sensitizing substances present in some woods. The symptoms may start as redness or irritation and may proceed to severe eczema, fissuring, and cracking of the skin. The condition may arise anywhere on the body that the sawdust has contacted.

Some exotic woods have even caused dermatitis in persons exposed only to the solid wood, not to its dust. Rosewoods are one such type. Prolonged contact with rosewood or cocobolo musical instruments, bracelets, or knife handles has been known to cause sensitization dermatitis. Should you suspect that a skin problem has been caused by a particular wood, a doctor can conduct a patch test on your skin. Although one can become allergic to almost any wood, be especially suspicious of dark and exotic woods. The darker the color, the more chemicals are likely to be in the wood. This is because the major ingredient in wood is cellulose, which is white. And cellulose is not an allergen.

RESPIRATORY SYSTEM EFFECTS. Respiratory system effects, such as damage to the mucous membranes and dryness and soreness of the throat, larynx, and trachea, can be caused by some woods, especially sequoia and western red cedar. These effects may proceed to nosebleeds, coughing blood, nausea, and headache. Eye irritation usually occurs as well.

Lung problems, like asthma and alveolitis (inflammation of the lungs' air sacs), affect a minority of workers exposed to irritant sawdusts. However, these are serious diseases, and a few woods, such as sequoia and cork oak, can cause permanent lung damage. The symptoms may not appear until several hours after sawdust exposure, making diagnosis diffi-

cult. Any persistent or recurring lung problems should be reported to a physician familiar with wood-dust hazards.

CANCER. The most prevalent cancer related to wood dust is cancer of the nasal cavity and nasal sinuses. Early symptoms of nasal sinus cancer may include persistent nasal dripping, stuffiness, or frequent nosebleeds.

A recent twelve-country survey showed that an astonishing 61 percent of all such cancer cases occurred among woodworkers. Hardwood dusts are definitely associated with cancer, and early results from studies on workers exposed to softwoods indicate that both woods are implicated. Epidemiologic studies of furniture workers (hardwood) have indicated an excess of cancer of the lung, tongue, pharynx, and nasal passages.

Most artists are exposed to much less dust than the professional woodworkers in the study, so their risks are lower. They need not give up wood as a material, but they must reduce their sawdust exposure to a minimum.

TOXIC EFFECTS. Some woods contain small amounts of toxic chemicals that may be absorbed through the respiratory tract, intestines, or occasionally through skin abrasions. These chemicals may cause symptoms such as headache, salivation, thirst, nausea, giddiness, drowsiness, colic, cramps, and irregular heartbeat. In exceptional cases, poisoning has occurred from food containers, spoons, or spits made from woods such as yew or oleander.

If you suspect that your symptoms are related to a particular wood, inform a physician, and have the wood identified.

LAWS AND STANDARDS APPLICABLE TO EXPOSURE

The wood-dust standards are currently unnecessarily complex, due to the ongoing battle between what is safe and what is economically advantageous for the wood industry. This conflict is illustrated by the standards of the Occupational Safety and Health Administration (OSHA) versus those of the American Conference of Governmental Industrial Hygienists (ACGIH).

The ACGIH has, since 1970, set various Threshold Limit Values (eight-hour time-weighted averages) for wood dust. The current active standards are 1 mg/m³ for hardwood and 5 mg/m³ for softwood. In their recommendations, ACGIH notes that:

... principal health effects reported from exposure to wood dust are dermatitis and increased risk of upper respiratory tract disease. Epidemiologic studies of furniture workers have indicated an excess of lung, tongue, pharynx, and nasal cancer. . . . Certain exotic woods . . . contain alkaloids that can cause headache, anorexia, nausea, bradycardia, and dyspnea on inhalation.[3]

In 1989, OSHA set Permissible Exposure Limits for all wood dust at 5 mg/m³, except that of western red cedar, which has a limit of 2.5 mg/m³. These limits (and hundreds of others) were vacated by the courts over a legal issue related to economic impact and risk assessments. This leaves OSHA with no standard for wood dust at all. Currently, some major wood industries have entered into voluntary agreements with OSHA to adhere to the 5 mg/m³ limit.

Then, on April 13, 1994, OSHA published in the Federal Register (59 FR 17478–9) some technical amendments to their Hazard Communication Standard. These amendments clearly state that the law applies to wood products that are to be processed in a manner that creates wood dust or that results in exposure to hazardous wood-treatment chemicals. Previously, the wood industry did not accept this interpretation of the OSHA rule and did not supply Material Safety Data Sheets (MSDSs) for all wood and wood products.

OSHA explained that MSDSs are not needed if the "manufacturer or importer can establish that the only hazard [the wood products] pose to employees is the potential for flammability or combustibility" (hazards that are common knowledge). Materials exempt from the MSDS rule would include precut products intended to be glued or nailed into place. But if wood is to be sawed or sanded, workers must be warned if the wood dust is known to cause dermatitis, respiratory diseases, or is associated with cancer. And if the wood is toxic or chemically treated, these hazards also must be addressed on the MSDS. OSHA has now amended the Hazard Communication Standard (CFR 1910.1200(b)(6)(iv)) to codify this requirement for MSDSs on wood.

All this time, ACGIH has been looking harder at epidemiological data from wood-exposed workers. In 2001, ACGIH published the proposed standards that appear in table 29.

3 ACGIH. *The Documentation of TLVs and BEIs.* 6th ed. Cincinnati: ACGIH, 1997, p. 1728.

TABLE 29	PROPOSED WOOD DUST STANDARDS*	

TYPE OF DUST	TLV-TWA (MG/M³)†	CANCER STATUS
Beech and oak	1	A1—confirmed human carcinogen
Birch, mahogany, teak, walnut	1	A2—suspect human carcinogen
Western red cedar	0.5	A4—not classifiable
Non-cancer, non-allergy-causing wood dusts	2	A4—not classifiable
Wood dusts that can cause allergy or other respiratory problems	1	No class

* These standards were published by the ACGIH as notices of intended change (NIC) in 2001. All standards are for inhalable wood dust, since wood dust is not often created in the respirable range of particle size.
† Threshold Limit Value–Time-Weighted Averages in milligrams per cubic meter.

Clearly, artists and teachers working in wood need to consider these standards and recommendations when planning dust control and other safety measures.

TREATED WOOD

Almost every imported wood and most domestic woods in the United States and Canada have been treated with some kind of additive. These can include fire retardants, pesticides, and preservatives. These chemicals range in toxicity from relatively safe to highly toxic. The most hazardous of the additives are pesticides applied to wood intended for use in contact with the outdoor elements.

It is usually difficult to find out exactly what chemicals have been used on wood. Three common outdoor-use wood preservatives are pentachlorophenol (PCP) and its salts, arsenic-containing compounds, and creosote. These three types of preservatives are associated with cancer, birth defects, and many other hazards. Art workers should avoid wood treated with them. There are many other more-suitable preservatives on the market. Two types are metal naphthanates and various boron compounds.

PLYWOOD AND COMPOSITION BOARDS

Many health effects can also be caused by wood glues and adhesives. Plywood, pressboards, and many other wood products contain urea-formaldehyde or phenol-formaldehyde resins. These glues release formaldehyde gas, which is a strong eye and respiratory irritant and allergen. Formaldehyde is also a suspect carcinogen, known to cause nasal sinus cancer in animals.

Some manufacturers are turning to other adhesives, such as urethane plastics. It is hoped that these binders will be more stable and less hazardous.

MEDICAL SURVEILLANCE FOR WOODWORKERS

1. Prevent wood-dust-related diseases by avoiding toxic or allergy-provoking woods or woods treated with PCP, arsenic, creosote, or other highly toxic chemicals when possible.
2. For occupational health problems, consult a doctor who is board certified in occupational medicine or one who is familiar with wood-related illnesses.
3. Have baseline lung function tests done early in your woodworking career. Then, have your physician compare this test with subsequent pulmonary-function tests done in your regular physical examinations in order to detect lung problems early.
4. Have your physician pay special attention to your sinuses and upper respiratory tract. Report symptoms like nasal dripping, stuffiness, or nosebleeds.
5. Know the symptoms and diseases your woods can cause. If these symptoms occur, report them immediately to your physician.
6. Be able to give your doctor a good occupational history. Always be prepared to provide your doctor with information about the chemicals you use and your work practices. Keep records of recurring symptoms and chemical/wood exposures.
7. Suspect that a health problem may be related to your work if the problem is alleviated on weekends or during vacations.
8. Should symptoms or illness occur and persist even after treatment, seek a second opinion.

WOOD SHOP REGULATIONS

Exposure Standards. In addition to following standards for wood-dust exposure (see table 29 above), check to see if the dust also contains other regulated chem-

icals. For example, the silica standards will apply if the wood contains it. Formaldehyde exposure limits may also be enforced if plywood or other composition materials are used.

Woods treated with preservatives containing arsenic, PCP, and creosote should be precut at the lumberyard rather than in the artist's studio, shop, or outdoors near shops or homes.

Ventilation. Essentially, the wood-dust regulations make it necessary to equip all woodworking machines with local exhaust. The preferred dust-control method involves a central collection system to which each machine is connected. These systems work best if the air they draw from the machines is expelled from the shop (not filtered and recycled). For shops unable to afford such systems, portable collectors that can be moved from machine to machine may suffice.

Good housekeeping and hygiene must also be practiced if wood shops are to meet the regulations.

Respiratory Protection. Protective respirators may be used in some cases to reduce employee exposure to wood dust. However, respirators provide very limited protection, and ventilation methods are preferred.

Machine Guards. United States and Canadian standards require guards on woodworking equipment. Yet, machines in art schools and studios are commonly found unguarded.

People who use guarded saws for the first time may find them awkward. However, workers accustom themselves quickly and soon would not be without them. It takes much longer for artists to adjust to using hands with fewer than ten fingers.

Other Regulations. Additional regulations include lockouts to prevent the start-up or release of energy during maintenance or repair of machines, central power switches to shut down all machinery in emergencies, and many other rules. Artists should get copies of applicable regulations from their local occupational health and safety offices.

OTHER WOOD SHOP HAZARDS

Glues and Adhesives. Many skin conditions and allergies can be caused by wood glues and adhesives. See table 19 for hazards and precautions related to these materials.

In general, polyvinyl acetate (PVA) emulsion glues or white glues are exceedingly safe compared to many other types of wood glue. These glues require longer setting times than some of the solvent adhesives and epoxies, but you should use them as often as possible.

Safe use of more hazardous adhesives requires avoiding skin contact, sparing and careful use, keeping containers closed as much as possible during application, and good general shop ventilation.

Fire Hazards. Woodworking shops harbor many fire hazards. As previously mentioned, fine wood dust in a confined area can explode with tremendous force if ignited with a spark or match. Combining wood dust, machinery, and flammable solvents greatly increases the hazard.

Fire prevention authorities agree that adequate ventilation is the best way to curb the risk of fire. Ventilation should be combined with safe solvent handling, good housekeeping, and regular removal of dust and scraps.

Vibrating Tools. A significant number of persons who use vibrating tools are now known to be at risk from a more permanent condition commonly called "white hand," "dead fingers," or "vibration syndrome." This disease can lead to severe pain, ulcerations, and even gangrene (see page 32).

Noise. Saws, planers, routers, sanders, and the like can easily produce a cacophony of ear-damaging sound waves. Poorly designed ventilation systems can also produce hazardous amounts of noise (see pages 29–31).

Prevent hearing loss by purchasing well-engineered machines that run quietly. Some machines can also be purchased with dampening equipment, such as mufflers and other sound-absorbing mechanisms. All machines will run more quietly when they are well oiled and carefully maintained. Mounting machinery on rubber bases will reduce vibration transmission and rattling.

If noise levels are still high in your shop, wear ear protection. For lighter noise, special and readily available earplugs can suffice (do not improvise with cotton or other materials). Use the protectors that look like earmuffs for heavy noise exposure. A physician should evaluate people with preexisting hearing loss before they are exposed to noise that may cause further impairment.

Solvent-Containing Products. Finishes, adhesives, paints, paint removers, and the like may contain solvents. All solvents are toxic, and most are flammable (see chapter 9).

PAINT STRIPPING

Woodworkers often must remove paints from objects or reclaimed lumber. Paint removers are either highly toxic solvent mixtures or strong caustic removers. Gloves, goggles, protective clothing, and ventilation are needed. Some new methods may be less hazardous. One involves applying a caustic material, covering the material with a special cloth, and later removing the cloth and adhered paint as one flexible sheet.

Other methods of removing paint include chipping, sanding, or heating with torches or heat guns. These methods are all hazardous, especially if the paint being removed contains toxic pigments such as lead.

Dust from chipping and sanding is toxic to inhale or ingest. If removal of paint from walls is being done, precautions are similar to those for asbestos removal. First, the area should be isolated with taped walls of plastic sheeting. Then, an exhaust fan should be installed to draw air out of the isolated area to keep it under negative pressure (so air cannot escape back into outer areas). In addition, respiratory protection, use of protective clothing, and scrupulous hygiene should be practiced.

Torching or heat-gunning paint is just as hazardous. These methods create toxic paint decomposition products. Torching or heat-gunning lead paint also produces a fine lead fume, which has been shown to cause lead poisoning in those removing the paint. Fine lead dust or fume can also cause health effects for years afterward if it contaminates living areas.

"Safe" Strippers. In the late 1980s, several companies began touting the dibasic acid esters (DBEs) as "nontoxic" paint strippers. The most common DBEs used in paint stripping are dimethyl or diethyl adipates, glutarates, or succinates.

The only label warnings on products containing the DBEs were for mild irritation, when, in fact, there were no data on the long-term hazards of these chemicals at all. In 1995, the Environmental Protection Agency (EPA) asked manufacturers to submit specific testing proposals for these paint stripping chemicals:

> Testing is needed for three dibasic esters (DBEs), specifically, dimethyl adipate, dimethyl glutarate, and dimethyl succinate . . . Consumers can be significantly exposed to DBEs during use of these formulations. This potential for significant exposures, a reported adverse human effect—blurred vision—resulting from the use of DBE-based paint strippers, and the results of limited toxicity testing (rats) form the foundation for the Agency's concern. . . .4

Long-term testing is reportedly underway, but to date, results are still not available. Artists should use products containing DBEs with the same caution as they do other solvents.

4 60 Federal Register 15143–15144, March 22, 1995.

Sanding Stripped Wood. Usually, stripping raises the grain of the wood, and sanding is necessary. This sanding dust, however, is likely to carry some residue of the strippers and even some of the paint ingredients.

In 1998, the California Department of Health Services and a county health department investigated cases of lead poisoning in six furniture workers and their families. All six workers and a number of their family members had elevated blood-lead tests. It was found that dust from sanding the stripped furniture contained enough to harm family members when the dust was inadvertently taken home on shoes and clothing.[5]

GENERAL PRECAUTIONS FOR WOODWORKING

1. Prevent fires by providing good shop ventilation, dust collection and control, sprinkler systems or fire extinguishers, and emergency procedures and drills and by banning smoking. Clean wood-dust deposits off of surfaces, ducts, and beams regularly.

2. Obtain Material Safety Data Sheets on all wood products, glues, and other materials. Choose the safest ones.

3. Try to purchase wood from suppliers who know a good deal about the kinds of wood they sell, where it is from, and how it was treated.

4. Avoid wood treated with PCP, arsenic, or creosote. Some of the arsenic-preserved woods can be identified by their greenish color.

5. Equip all woodworking machinery with local exhaust dust collection systems. Ideally, these systems should vent to the outside, rather than return air to the shop.

6. Prevent hearing damage by purchasing quiet machines that use dampening equipment, such as mufflers or rubber mounts. Keep machines well oiled and maintained. Use earplugs or muffs if needed. Have a baseline hearing test and periodic hearing tests as often as your doctor suggests. Employers in wood shops must set up formal OSHA hearing protection programs.

7. Prevent vibration syndrome by using tools that are ergonomically designed and produce low-amplitude vibrations, working in normal and stable temperatures (especially avoiding cold temperatures), taking ten-minute work breaks after every hour of continuous exposure, and grasping tools without too tight a grip.

5 Centers for Disease Control and Prevention. *Mortality and Morbidity Weekly Report* 50(13) (April 16, 2001): 246–248.

8. Wear dust goggles and a NIOSH-approved dust mask when dust cannot be controlled easily, such as during hand sanding. Follow all laws and regulations regarding goggles and respirator use.

9. Wear protective clothing to keep dust off your skin. Wear gloves or barrier creams when handling woods known to be strong sensitizers.

10. Practice good hygiene. Wash and shower often. Keep the shop floors clean and free from sawdust and chips. Vacuum rather than sweep dusts.

11. Follow all rules for use of solvents when using solvent-containing paints, glues, etc.

12. Be prepared for accidents: Know your blood type, and keep up your tetanus shots. Keep first aid kits stocked. Post and practice emergency procedures.

13. Dispose of treated woods, lead-painted wood, and other toxic wood products in accordance with health, safety, and environmental protection regulations.

14. Follow all medical surveillance rules for wood-dust exposure (see above).

WOODEN FOOD ITEMS

Many craftspeople make wooden bowls, spoons, cutting boards, and other items to be used with food. There are special rules for making these items safe for consumers:

1. In the past (1900–1930), food utensils were commonly made from maple, birch, or beech. There's a long history of use with at least no apparent short-term effects. Beech and birch are respiratory carcinogens, but there is no way of knowing if these woods leach toxins into food.

2. Never use dark-colored woods, because they contain more chemicals. Use light-colored heartwoods.

3. Never use open-grained woods in which bacteria and food particles can lodge.

4. If you use a sealant, remember that it may provide hazards of its own. Cooking oils don't do a good job of sealing the wood. Some sealants, like linseed oil, may contain toxic lead or manganese driers. Marine varnishes usually contain toxic pesticides for control of molds and barnacles.

5. Before using a sealant, get an MSDS and require that either the product's label says it is safe to use on food or that the manufacturer will put in writing that 1) the product is safe to use on food surfaces, and 2) all the product's ingredients are certified by the FDA for use in contact with food.

6. Tell your customers which kind of cleaning method is proper for wooden food items. A good salesperson should also be a good teacher. Some experts suggest that cutting boards can be moistened and placed in an 800-watt home microwave oven at high heat for ten minutes. If you want to give advice for cutting boards that can't be questioned, follow the FDA recommendations:

 1. Use smooth cutting boards made of hard maple or plastic and that are free of cracks and crevices. These kinds of boards can be cleaned easily. Avoid boards made of soft, porous materials.

 2. Wash cutting boards with hot water, soap, and a scrub brush to remove food particles. Then, sanitize the boards by putting them through the automatic dishwasher or rinsing them in a solution of one teaspoon (five milliliters) of chlorine bleach in one quart (about one liter) of water. You may want to keep a ready supply of the solution in a spray bottle near the sink.

 3. Always wash and sanitize cutting boards after using them for raw foods, such as seafood, and before using them for ready-to-eat foods. Consider using one cutting board only for foods that will be cooked, such as raw fish, and another only for ready-to-eat foods, such as bread, fresh fruit, and cooked fish.[6]

[6] *FDA Consumer,* Nov/Dec 1997, p. 17.

CHAPTER 29
PHOTOGRAPHY AND PHOTOPRINTING

Unfortunately, many art photographers develop and print in unsafe locations, such as converted bathrooms, kitchens, and other inadequate spaces in their own homes. And art schools and universities often teach photography without proper ventilation.

Photographers and teachers who try to improve their facilities are sometimes taken advantage of by certain firms that sell reasonably priced ventilation systems for photo darkrooms that look like they should work. In fact, these systems draw so little air that they are essentially useless. They violate the basic principles of industrial ventilation. Buyer beware.

Photographers may also operate in violation of environmental protection rules if they flush solutions containing silver ion into ordinary drains. Many other photochemicals, such as selenium toners and cyanotype chemicals (ferrocyanides), can also no longer be put down drains that lead to water treatment facilities, storm drains, or leach fields.

HEALTH HAZARDS

Vast numbers of substances, many of them very complex organic chemicals, are involved in photographic processes. Many of these are known to be hazardous, while the hazards of many others are unknown and unstudied. In addition, new photochemicals are developed frequently whose long-term hazards are unknown.

For these reasons, it is impossible in the scope of this book to discuss all photochemicals.

Instead, it is easier to look at the effects of photochemical exposure.

DISEASES ASSOCIATED WITH PHOTOCHEMICALS

Photochemicals are particularly associated with skin diseases and respiratory allergies. It is not uncommon to know of photographers who have had to change careers because they have developed these occupational illnesses.

SKIN DISEASES. Many types of dermatitis have been seen in photographers, including:

1. Irritant contact dermatitis and chemical burns from exposure to irritating chemicals, such as acids and bleaches
2. Allergic contact dermatitis from many developer chemicals, such as metol and p-phenylenediamine
3. Hyper- and hypopigmentation (dark and light spots) from exposure to developing chemicals, such as hydroquinone
4. Lichen planus (an inflammatory condition characterized by tiny reddish papules that may darken and spread to form itchy, scaly patches and ulcerations) thought to be caused by some color developers
5. Skin cancer from exposure to ultraviolet light sources, such as carbon arcs (There also is a potential for cancer to develop in lichen planus.)

RESPIRATORY DISEASES. Photochemical baths emit substances that are recognized by their typical darkroom odor. These substances may also be responsible for many of the respiratory diseases associated with darkroom work. Table 30 lists some of these airborne substances and their hazards.

Darkroom chemicals can cause a variety of respiratory diseases. Low doses of irritating chemicals can cause slight damage to respiratory tissues that may leave photographers more susceptible to colds and respiratory infections.

Heavy exposures to irritating chemicals may cause acute bronchitis or chemical pneumonia. Such serious effects are most likely to occur if highly irritating substances such as concentrated acid vapors are inhaled or if significant amounts of the dusts from dry chemicals are inhaled. Many photochemicals in the dry, concentrated form are powerful irritants and sensitizers.

TABLE 30	COMMON DARKROOM AIR CONTAMINANTS	
CHEMICAL	**MAJOR SOURCES**	**PRIMARY HAZARDS**
Acetic acid	Stop baths	Irritant
Formaldehyde	Hardeners and preservatives	Sensitizer, irritant, and animal carcinogen
Hydrogen sulfide	Emitted by some toners	Highly toxic to nervous system, irritant
Sulfur dioxide	Breakdown of sulfites in baths, some toners	Respiratory irritant and sensitizer
Various solvents	Color chemistry and film cleaners	Irritants, toxic to nervous system (see table 9)

Chronic diseases from years of exposure to darkroom chemicals can lead to chronic bronchitis and emphysema. In fact, these diseases are seen frequently among darkroom technicians.

Allergic diseases such as asthma and alveolitis may result from exposure to sensitizing substances, such as sulfur dioxide or formaldehyde, or from dust inhaled while mixing powdered photochemicals.

Many experts believe that respiratory system cancers may also be associated with exposure to formaldehyde. Photographers who smoke are certainly at risk for lung cancer and are at greater risk for most of the other diseases associated with photochemicals.

SYSTEMIC DISEASES. Some photochemicals are also toxic to other bodily systems. For example, if significant amounts of some photochemicals are inhaled or ingested, they can cause methemoglobinemia, a disease in which the chemical damages the blood so that it can no longer carry sufficient oxygen. Exposure to bromide-containing chemicals and solvents may harm a developing fetus. Material Safety Data Sheets should alert users to these kinds of hazards.

Photochemical products that contain extremely toxic substances should be replaced with safer materials. Some extremely toxic chemicals include chromic

acid bleaches, lead toners, mercury vapor (daguerreotype), mercury intensifiers and preservatives, uranium nitrate toners, and cyanide reducers and intensifiers.

GENERAL PRECAUTIONS

1. If dilution ventilation is planned for black-and-white developing, design the systems to provide roughly ten room exchanges per hour for very large gang darkrooms to up to twenty room exchanges per hour for small, individual darkrooms.

2. If gang darkroom ventilation tables or individual darkroom sinks are to be vented with local exhaust systems, get copies of mechanical drawings of the systems and obtain second opinions on their efficacy from industrial ventilation engineers or industrial hygienists. There are systems on the market that simply *don't work*.

3. Provide local exhaust systems, such as slot hoods or fume hoods, if toners, intensifiers, color process, or solvent-containing products are used. Purchase photo processors that are equipped with factory-built local ventilation systems.

4. Replace dry chemicals with premixed chemicals when possible. When powders must be used, handle and mix them in local exhaust ventilation, such as a fume hood, or with respiratory protection. Avoid skin contact, and clean up dust and spills scrupulously.

5. Do not use or store glacial acetic acid. Purchase acetic acid diluted to concentrations of 50 percent or less. (See page 214.)

6. Obtain Material Safety Data Sheets on all photochemicals, and select the safest materials. Do not use extremely toxic chemicals, such as those containing chromic acid, lead, mercury, uranium, or cyanide.

7. Provide and use protective equipment, including an eyewash fountain, gloves, chemical splash goggles, tongs, and aprons. Provide an emergency shower if concentrated corrosive chemicals are used.

8. Dilute or mix chemicals in local exhaust ventilation, such as a fume hood. Always add acid to water, never the reverse.

9. Gloves and tongs always should be used to transfer prints from baths. Barrier creams can replace gloves if only occasional splashes on the hands are expected. (Note: Barrier creams may smudge prints if they are handled.)

10. Store photochemicals in the original containers when possible. Never store photochemicals in glass bottles, which can explode under pressure.

11. Prepare to handle spills and breakage with chemical absorbents. Chemical containment barriers should be built into the floors of most darkrooms.

12. Floors should be made of material that is easily washed. Floor drains are usually not allowed in areas where regulated substances may be released, such as solutions containing silver, selenium, or ferri-cyanides. Neutralization tanks are not useful for photographic waste, which is likely to be alkaline already or to contain metal ions that will not be removed by neutralization.

13. Set up silver recovery units for all silver-containing solutions, or else hold these solutions for commercial hazardous waste pickup.

14. Dispose of complex photochemicals, solvents, metal-containing toners, and other wastes in accordance with the manufacturer's recommendations and governmental regulations. Check with the local water treatment facility to determine which chemicals may be put down drains. Chemicals that may be released to drains should be diluted and flushed down with large amounts of water. Never flush chemicals into septic systems.

15. Contact a commercial toxic waste disposal service to set up regular removal of those chemicals that cannot be released to drains.

16. Practice good housekeeping. Clean up all spills immediately. Never work when floors or counters are wet with water or chemicals. Eliminate trip hazards and clutter.

17. Clean up and wash off immediately all spills and splashes on the skin. Do not allow splashes on clothing or skin to remain until dry. Instead, remove contaminated clothing, and flush skin with copious amounts of water. After washing off caustic materials, use an acid-type cleanser (a cleanser or a soap with a pH below 7).

18. Keep first aid kits stocked, and post emergency procedures.

19. Prevent electrical shocks by separating electrical equipment from sources of water and wet processes as much as possible. Install ground fault interrupters on all darkroom outlets.

20. Do not allow heat or ultraviolet (UV) light (from carbon arcs or the sun) to affect stored photochemicals. For example, ferri- and ferro-cyanides can release hydrogen cyanide gas if exposed to heat or UV. Dispose of these chemicals as toxic waste, never down the drain.

21. Replace carbon arc light sources, which emit dangerous UV, highly toxic gases, and metal fumes. Use halide bulbs, quartz lamps, sun-

light, or other high-intensity lights. Avoid direct eye contact with all intense light sources. Sunglasses can be used against both sunlight and high-intensity UV lights.

22. Follow all rules for flammable and toxic solvents (see chapter 9) if solvent-containing products such as film cleaners and color photo-chemicals are used.

23. Always be prepared to provide your doctor with information about the chemicals you use and your work environment.

PRECAUTIONS FOR SPECIFIC PHOTO PROCESSES

BLACK-AND-WHITE PHOTOCHEMICALS. Most common black-and-white photochemicals can be used safely if they are purchased premixed and diluted with care and if the precautions above are followed. Provide good ventilation (see general precautions 1 and 2 above).

TONING. Almost all toners require local exhaust ventilation systems. Most of these chemicals are highly toxic and emit toxic gases during use. For example, sulfide toners produce highly toxic hydrogen sulfide gas, and selenium toners produce large amounts of sulfur dioxide.

COLOR PROCESSING. Color processing employs many of the same chemicals that are used in black-and-white processing. In addition, they contain dye couplers that are associated with serious skin problems. Formaldehyde is also present in many color processing products, and some products contain toxic solvents, such as the glycol ethers (see page 39).

Mixing of color processing chemicals and open-bath color processing requires local exhaust ventilation, gloves, and goggles. Small, hand-tank developing can be done with dilution exhaust, gloves, and goggles.

Automatic color processing requires local exhaust ventilation. Today, most automatic color processors are made with local exhaust hoods built into them, or the manufacturers offer exhaust equipment accessories that can be connected to exhaust fan extraction systems. However, many salespeople do not mention these systems unless buyers ask about them.

PHOTOPRINT-MAKING. Many photographic processes have been adapted to printmaking uses. Included are photolithography, photosilkscreen, and

photoetching. These processes use similar chemicals and require similar precautions.

Needed for these processes are high-intensity light sources, which may be the sun, ultraviolet light sources, and carbon arc lamps. Carbon arcs should be avoided (see general precaution 21 above).

There are two types of photosilkscreen processes: direct and indirect emulsion processes. Direct emulsions usually use ammonium dichromate as the sensitizer. Indirect emulsions use presensitized films, which are developed by concentrated hydrogen peroxide and cleaned of emulsion with bleach.

The chemical ingredients used in each of these processes fall into four groups listed in table 31 below.

Photoetching relies on solvents to etch plastics (polymers). Some of these photoetching solvents are highly toxic and may include the glycol ethers (see table 9, page 101).

Photolithography uses solvents and dichromate solutions.

POLYMER PLATE ETCHING. In the 1960s, light-sensitive polymer plates started to replace traditional metal plates, effectively freeing industrial printers from lead fumes generated by traditional Linotype machines. Methods of using these plates for art printmaking have been championed early by printmaker Don Welden (see appendix A, part 5). His technique, called "solarplate printmaking" or "solar etching," is now used by many artists. It is an inherently safer method of printing, because the type of plate used can be cleaned with plain tap water.

In this process, a piece of artwork is first created on a transparent or translucent film. The film is overlaid on the polymer plate, and the film and plate are exposed to the sun or an ultraviolet light source. Wherever the sun strikes the plate, the polymer hardens. The parts of the plate blocked from the sun by the opaque portions of the drawing remain soluble and can be gently scrubbed away from the plate in tap water. This leaves lines and groves etched in the polymer. Then, the plate can be printed either in relief or in intaglio.

The hazards in making the plate are twofold: the ultraviolet light from the sun or a light source (see general precaution 21, above) and the chemicals washed off the polymer plate. The chemicals from the plate are usually trade secrets and are, therefore, kept undisclosed. It is very likely that there is no chronic effects data on these substances. While it is assumed the nitrile gloves will protect against them, it is not known with certainty if this is the case. But

even with these uncertainties, the polymer plate process is safer than those methods that expose users to solvents.

The hazards of printing the plate will depend on the types of inks, cleanup solvents, and printing methods used. Refer to chapter 15 for the hazards of these printing processes.

TABLE 31	PRECAUTIONS FOR PHOTOPRINT CHEMICALS

SOLVENTS used in photoprint-making have varying hazards (see chapter 9), and the ventilation requirements for each will depend on the toxicity of the solvent and the amount that becomes airborne. Glycol ethers are often used, and these usually have reproductive hazards and are absorbed by skin. Provide good ventilation and avoid skin contact, or use special gloves (usually nitrile gloves will provide protection).

CONCENTRATED HYDROGEN PEROXIDE AND BLEACH can cause severe eye and skin damage, and thus require gloves and goggles. When used to remove emulsions, bleach emits chlorine gas, which requires local exhaust ventilation.

DICHROMATES are very toxic and sensitizing. Gloves and local exhaust ventilation, such as a fume hood, should be used when one is working with powdered dichromates.

FERRI- AND FERROCYANIDE compounds release cyanide when exposed to strong ultraviolet light, acid, or heat. They are now known to release cyanide under neutral and alkaline conditions, like those found in the environment, and are regulated as cyanide compounds. The National Toxicology Program proposed studying potassium ferricyanide for cancer effects due to its potential for redox cycling (alternating between being an oxidizer and a reducer), which is a property of some other carcinogens.

PHOTO EMULSIONS, in color and black-and-white films, are usually sensitizers, and skin contact with them should be prevented. Color photo emulsions, in particular, contain trade secret chemicals whose long-term hazards are unknown.

PHOTOPLATE POLYMERS, both water- and solvent-washable types, are usually trade secrets, and their hazards are unknown.

NONSILVER PROCESSES

Brown printing (Van Dyke or Kallitype process) employs ferric ammonium nitrate, tartaric acid (or oxalic acid), and silver nitrate. These chemicals are mixed with distilled water and applied to paper. The paper is exposed to light and developed with a water/borax mixture and fixed with sodium thiosulfate solution. Oxalic acid and silver nitrate are especially hazardous and require extra care to avoid eye and skin contact and inhalation of the dry materials. Developing can be done with dilution ventilation.

Gum printing (gum bichromate) involves coating paper with an emulsion of gum arabic, water, pigments, and ammonium dichromate. After exposure to light, it is developed in water and hung up to dry. Multiple printings can be done by changing the pigments.

Hardening and clearing are done in a solution of potassium alum and water or in a dilute solution of formaldehyde. Mercuric chloride, thymol, and other hazardous biocides may be used to preserve the solution.

Avoid solutions containing mercuric chloride or any other highly hazardous biocide. Dichromates are very toxic and are potent sensitizers. Local exhaust, such as a fume hood, should be used when working with powdered dichromates, dry pigments, and formaldehyde solutions.

Cyanotype (blueprinting) is similar to brown printing, except that ferric ammonium citrate and potassium ferricyanide are used. Ordinary dilution ventilation should suffice for cyanotype. But the ferricyanide waste water must be collected and disposed of as toxic waste.

Salted paper prints use silver nitrate as the major component. Silver nitrate is especially hazardous and requires extra care to avoid eye and skin contact with the solution. Ordinary dilution ventilation should suffice.

Platinum and palladium printing involves exposure to these metals and others that may be present in the solutions. I have even seen lithium chloride and cesium chloride in these chemicals. Look up the hazards of the metals used in these processes (see table 14), and follow the strictest precautions.

Other Processes. There are too many other historic and nonsilver processes to cover here. Included are daguerreotype, wet-plate collodium, ambrotype and tintype, casein printing, albumen printing, carbon printing, carbro printing, oil and bromoil printing. Detailed information on these processes and more information on the processes above can be found in another book: *OvereXposure: Health Hazards in Photography* (see appendix A).

PART IV
THE NEXT
GENERATION

Many individual artists choose to do hazardous processes, reasoning that they have the right to risk their own health. However, the risks individual artists take can extend past their own personal safety into the next generation if they:

Teach hazardous art processes to children or to students who, in turn, will teach others

Expose themselves to substances that can affect their reproductive health or the children they bear

CHAPTER 30
TEACHING ART

The safety of each generation of artists depends primarily on how well they are trained as students. Safety training has altered greatly over the years.

THE 1960S

When I was a student, most universities taught technical courses on art materials. In these courses, students learned about the chemical and physical nature of their materials, how to control their materials' properties to produce desired effects, and how to experiment with materials knowledgeably rather than accidentally. Back then, they knew that effects achieved by accident must be understood if they were to be repeated and exploited.

Not only should these technical courses be revived and updated to include many new art products, but they should be expanded to include information on the hazards of art materials, the laws that apply to their use, and the precautions needed to use them safely.

THE 1980S

I developed and taught two courses covering these subjects at the University of Wisconsin in the summer of 1980. The Environmental Science department at the University continued to teach one of them, but after a few years, it was dropped. And today, there are only a handful of universities that have similar courses in the curriculum.

In my opinion, the major reason these safety courses are not successful is that if the instructors are honest and knowledgeable, it is inevitable that they will be teaching students principles that enable them to recognize that their school's facilities are deficient and that they are being taught projects that violate various laws and regulations.

Obviously, the answer to this problem is to fix the building and comply with the laws, but the chances of this happening are slim. The reasons are purely political.

THE POLITICS

Twenty-five years of providing industrial hygiene services, primarily to schools, has made it clear to me that the failure to comply with training and safety laws in the United States and Canada is blatant and pervasive.

The major roadblocks to compliance are school administrators who, year after year, do not budget time or money for compliance and safety equipment. In my experience, they are more likely to fire teachers who complain about safety than to address the problems. To be fair, administrators are not deliberately putting people at risk. Instead, they often do not fully appreciate the risks and see the regulations merely as budget items. Perhaps the OSHA regulations should be amended to require mandatory training for employers as well as employees.

However, the administrators could not ignore the safety laws without the tacit complicity of a majority of art teachers, their art educational associations, and their unions. In my opinion, a major reason the teachers and their representatives do not fight for compliance is that they fear that the cost of proper safety training and equipment will result in administrators dropping art programs altogether. Other reasons teachers hesitate to comply include reluctance to alter their busy schedules to accommodate training, to change their lesson plans to substitute safer projects, and even to take the competency tests on the technical subjects covered by hazard communication.

As a result, many teachers have consciously chosen to continue to teach their same old hazardous lessons in their favorite toxic media, despite the risks. It is common to find teachers justifying this behavior as an expression of their "love" of art, invoking the kind of rebellious and risk-taking philosophy that was pervasive in the 1960s when I was in school. It was dumb then—it is dumb now.

These teachers need to consider that as long as they are working in a school, their "product" is not art—it is *education*. And there is no art lesson or experience that is worth shortening a student's life by even an hour.

Today, many teachers are inculcating bad safety habits and attitudes in students right in the classroom. This is egregious at all levels of education, but it is most damaging at the college level. I routinely see university students paying tuition to work with dangerous chemicals, without proper training, and in classrooms and studios that are improperly ventilated and equipped.

These college students earn degrees that imply they are prepared for a professional career in art or education. Instead, they are not ready for a career, because they are completely unfamiliar with the laws that govern their work, they have never even seen their art practiced safely and legally, and they are prepared only to set up dangerous and illegal studios and classrooms of their own. In my opinion, schools granting degrees to such students are perpetrating a fraud.

This must be corrected. And the method for correction is already mandated by the OSHA laws that require training. How ironic it is that so many *educational* institutions refuse to comply with a governmental mandate to *educate*.

Not only the teachers, but the students, need OSHA training. Training students in-house also provides an opportunity for schools to develop training materials for which there is a demand. There is money to be made by supplying curriculum guides, videos, and skilled trainers for other schools. These materials can also be modified for worker training in art-related businesses and industries.

In other words, the administrators, teachers, and their representatives are not only ignoring the laws and putting themselves and their students at risk—they are missing a profitable opportunity.

PROACTIVE AND REACTIVE PROGRAMS

Not all schools neglect safety. For example, I am currently working with architects and engineers at six universities on the plans for new art buildings. These schools want their new facilities to be compliant with the Occupational Safety and Health Administration (OSHA) regulations and safety standards. There are also an increasing number of schools that have yearly hazard communication sessions built into the student orientation schedule.

However, these proactive schools are the exception. I more often find myself in schools that are reacting to problems after they occur. Three common scenarios that bring me to schools are:

1. They have been cited by OSHA and given deadlines by which training must be done and programs must be in place.
2. There are one or more lawsuits involving the art or theater departments.
3. They have problems with their workers' compensation insurance as a result of too many claims.

These reasons also demonstrate that the failure to have adequate safety programs at universities is not lack of money. Some schools end up paying far

more for training in haste or settling lawsuits and compensation claims than safety programs and equipment would cost.

And those schools that truly can't afford ventilation systems to support use of hazardous materials can institute a host of safer projects that do not require special systems. These safer projects are embraced by growing numbers of students who wish to make environmental and health factors a part of their artistic statement.

OSHA, COMPENSATION, AND LIABILITY

Most employees and teachers come under either state or federal OSHA laws in the United States or provincial OHSA laws in Canada. These agencies can cite or fine schools that are not in compliance.

Students (except university students in certain states and provinces) are not covered by the occupational laws. If teachers are injured on the job, their needs are covered by workers' compensation. If students are injured or made ill by classroom activities, their usual remedy is to hold the school and/or teacher liable.

LAWSUITS. The liability of schools and teachers can best be protected by extending to students the same rights accorded to adult workers. In fact, even greater care and protection is in order, since students are less trained and less educated than adult workers or teachers. This means that if students are doing the same jobs as workers, all occupational health or safety laws designed to protect workers should be complied with and even exceeded. In the United States, following the OSHA regulations this way can be interpreted as providing "due care."

Most of my experience with school legal actions is in the United States. I think this is true in part because there seems to be a reluctance among Canadians to file lawsuits. However, this is changing. For example, three lawsuits were filed against a Canadian university in 2000 by ex-students claiming damages from chemical exposures. And two more students have consulted with me about their potential lawsuits against the same institution.

It is my opinion that if the schools would talk freely among themselves about these suits, they would have more incentive to address the problems. Instead, these lawsuits are usually settled with gag orders, so that further discussion is ended.

WORKERS' COMPENSATION. In a single year, I evaluated five workers' compensation claims and provided information to lawyers handling three lawsuits. All five actions involved the same art building at one major university.

And while workers' compensation awards only raise the cost of the schools' insurance coverage, lawsuits can result in huge legal defense costs and/or settlements or awards.

Administrators and employers who comfort themselves with the belief that workers' compensation will protect them from lawsuits need to think again. Time and time again, I have been consulted about lawsuits that were taken from the workers' compensation arena into personal injury. This is a tricky maneuver, but it often can be done.

And I would be remiss not to assign a share of blame to the insurance companies who write the workers' compensation and liability policies for schools. I have inspected many schools in the presence of insurance company representatives. The insurance companies also do not want to demand compliance of their clients for fear that they will lose their accounts to less-demanding companies. The most they offer is reduced rates to schools that institute good safety programs.

CITATIONS AND FINES. The failure of regulators to regulate is another indirect cause for many of the injuries and lawsuits. Administrators and teachers often defend their unsafe buildings and practices by asserting that no agency has complained. And they probably will be able to use that defense for yet another decade—provided they don't have a significant accident or occupational illness.

The tight budgets for governmental agencies in both the United States and Canada have reduced random inspections to a pitiful few. With no fear of inspections, there is no incentive to address the problems. In fact, inspections usually occur only *after* an accident, at which time inspectors find a host of compliance issues all at once. The schools are usually cited, fined, and given time limits to correct each violation. I have even seen one university department closed until its administrators complied.

Complaints from employees can also result in inspections. This can put the complaining teacher's job at risk. In the United States, the OSHA regulations include protection for whistle-blowers, but I have seen them fired anyway. I advise teachers who plan to whistle-blow either to be prepared for long, bitter fights or to require OSHA to withhold their identity.

ACCIDENT INVESTIGATIONS

Accidents may be investigated by regulatory agencies, by lawyers representing the injured parties, or by workers' compensation navigators (paraprofessionals

trained to assist workers through the system) and lawyers. These investigators are trying to determine cause. They are looking for evidence that the teacher and/or the school either met or failed to meet any of five major duties: to inform, to train, to enforce, to exemplify, and to provide a safe work environment.

To Inform. Administrators are responsible for providing teachers (employees) with information about job-site hazards. Teachers must pass this information on to students. The information must be complete and specific. For example, if a student is injured or made ill because a teacher neglected to inform the class of potential hazards, the courts may interpret this as *willful* or *knowing* negligence on the part of the teacher and/or school.

To Train. Teachers must ensure that each student knows how to work safely with hazardous materials or equipment. Teachers must develop mechanisms to verify that students are trained to avoid making incorrect assumptions about their comprehension. This is most often done by observing them and their work and by giving safety quizzes. Teachers should keep copies of these quizzes to document that their students have understood the safety presentation.

To Exemplify. Teachers and administrators must model safe behavior. If teachers or administrators are observed violating safety rules, they may be liable for damages caused when students also break the rules. In addition, teachers and administrators must demonstrate a proper attitude toward safety. They must make it clear that safety is more important than finishing the work, cleaning up in time, or any other objective. Administrators who show contempt for the regulations, who glorify risk-taking, or who belittle teachers who try to follow the rules are demonstrating by their actions their failure to exemplify.

To Enforce. Administrators cannot allow teachers to violate the rules. OSHA is very clear on this point. Without an enforcement policy, there is no safety program. Likewise, teachers must be in control of their students and must enforce the safety rules—and administrators must support the teachers' attempts to enforce the rules. In fact, teachers and administrators may be liable even when students willfully break the safety rules if it can be shown that the rules were not enforced. And courts have held that enforcement policies must include meaningful penalties for those that break the rules.

To Provide a Safe Studio or Classroom. No amount of enforcement, training, or information will make up for teaching in an unsafe environment. *If a lesson cannot be done with all proper precautions, safety equipment, and ventilation, the project must be eliminated from the curriculum.* There is never a good enough reason for students or teachers to violate safety laws in the school.

ADMINISTRATORS' SPECIAL ROLE

Administrators are ultimately responsible for the efficacy of school health and safety programs. Some administrators do not fulfill these duties under the guise of allowing teachers and students artistic freedoms. A common example is allowing university students the freedom to work alone at night in buildings without supervision, without security, and even without ventilation if it is turned off after hours. Under these conditions, administrators have no good legal defense for accidents involving chemicals or machinery, for illnesses for which emergency services were not speedily procured, or for assaults in unsecured premises.

So-called freedoms involving risks like these must be rescinded immediately and replaced with sound health and safety discipline. For example, students should have a sequence of deadlines to meet during the semester, so that they do not have work night and day to the point of exhaustion to produce an entire show in the last three weeks of class.

In other words, administrators must administer, teachers must supervise, and students must take direction. Everyone must do his or her own job, or the safety of all and the institution itself are put at risk.

SCHOOL SAFETY PROGRAMS

There are many OSHA regulations that require training (see table 1). These training requirements cannot be met in a single yearly meeting. Instead, schools need an active health-and-safety committee, and training sessions on various subjects should be at least a monthly affair. And the training sessions for the major OSHA rules are mandatory for affected employees.

The cornerstones for school safety-and-health programs are, once again, the OSHA Hazard Communication Standard in the United States and the Workplace Hazardous Materials Information System (WHMIS) training in Canada. These rules are causing an educational revolution in the workplace. Schools should be leading the revolution, not following reluctantly.

Teachers must be so well trained in hazard communication that they can put relevant aspects of the training into their students' lessons. Such training should range from the earliest warnings for children about crayons to explaining the hazards of welding to college students.

COLLEGE STUDENTS

College students are adults. These students may be pregnant or planning families, have allergies or illness, or have other special needs. As adults, they

should be privy to all the health and safety issues in their schools, so that they can make informed decisions about the courses they will take and the materials they will use.

The OSHA regulations already require administrators to provide their teachers access to all reports or tests on the safety of their workplace. If administrators provide this information, then the teacher is aware of problems and has a legal obligation to provide such information to students at risk.

Instead, I often encounter administrators who withhold such information from teachers in violation of the laws. I even find some teachers who think it is better not to discuss the inadequacies of the classrooms in order not to discourage students from taking the courses. These administrators and teachers take a dim view of providing access to building surveys and tests to students. I would remind them that all of these reports are readily available by subpoena if a personal injury lawsuit is filed.

College students should also be included in all the same OSHA and OHSA safety training provided to their teachers. Schools should also include their students in their workers' compensation program. And colleges should develop required courses on the health, safety, and regulatory issues applicable to the arts for those students planning careers.

HIGH SCHOOL STUDENTS

OSHA does not require training of high school students in hazard communication, but failure to train them can put the school's liability in jeopardy. Many high school students already have work experience that involves hazard communication training. Teachers are often surprised to know that even McDonald's employees receive this training. Training is required for high school workers doing any job involving chemicals—including restaurant work, hairdressing and nails, auto body and repair, child care, and cleaning.

My suggestion that high school students be included in OSHA training received backing in a recent NIOSH report on a high school art department. The report recommended that the high school implement an effective Hazard Communication Program "to ensure that *teachers and students* are aware of the hazards of materials they are using and appropriate methods for reducing these hazards."[1]

[1] NIOSH Health Hazard Evaluation Report (HETA 99-0084-2807), Haverhill High School, Massachusetts, David C. Sylvain, CIH, released April 2001.

The first part of the OSHA hazard communication training is an explanation of the rights of workers. This will alert those students with outside jobs whose employers are failing to train them that their rights have been violated. Students usually are very interested in these issues, and teachers can be helpful in protecting them.

Students will also be more valuable to potential employers if they are already familiar with the basic concepts that they must learn during OSHA training. The OSHA training concepts will provide an understanding of art and craft hazards and precautions.

ADULT EDUCATION PROGRAMS

Safety training for adult and continuing education students is imperative, because teachers are bound to encounter students who know more than they do about the hazards of their materials. Sooner or later, a doctor or nurse, union official, plant manager, or some other professional will enroll and will see immediately that the instruction is deficient. Even people who read newspapers and magazines will wonder why the names of well-known hazardous chemicals are listed on classroom product labels.

Adding health-and-safety training will also make adult courses more relevant to their life experience. It also is necessary to avoid liability for illnesses and accidents related to use or misuse of materials, even outside of class. For example, schools can find themselves responsible for harming an adult student's children if the student was never told that working at home can contaminate the home environment. I have seen such an action related to a teacher that encouraged students to use lead solders for stained-glass work at home.

TABLE 32	OUTLINE FOR A COMPLETE ART TEACHER HAZARD COMMUNICATIONS TRAINING

PARTICULARS OF THE LAW THAT APPLY TO YOU
- OSHA: employers, employees, sometimes students
 - Hazard Communication: 29 CFR 1910.1200, your rights under the law
 - Other laws: respiratory protection, protective equipment
- EPA: disposal, storage, containment
- Legal liability: strategies for protecting ourselves from lawsuits

PHYSICAL CHARACTERISTICS OF AIRBORNE SUBSTANCES
- Gases, vapors, fumes, dusts, mists, and smoke

HOW MATERIALS ENTER THE BODY—ROUTES OF ENTRY

- Skin contact
 - Direct damage—corrosives, irritants
 - Absorption through broken skin, through normal skin
- Inhalation
 - Direct damage
 - Absorption by lungs: gases, vapors, and soluble particulates
 - Inert particulates—fibrogenic/benign pneumoconiosis
 - Asphyxiants—physical and chemical
- Ingestion
 - From lung-clearing mechanisms
 - Eating, smoking, drinking in the workplace, accidental ingestion
- Injection

HOW SUBSTANCES DAMAGE THE BODY

- Local toxic effects: define corrosives, irritants, defatting, and drying of skin
- Systemic toxic effects: definition of poison/toxic substance

TOXICOLOGICAL CONCEPTS

- Dose: total body burden
- Acute and chronic effects
- Multiple exposures: additive, synergistic, antagonistic
- Cumulative versus non-cumulative toxins
- Toxins affecting cell replication (DNA): carcinogens, mutagens, teratogens
- Sensitizers: skin/respiratory allergies

FACTORS AFFECTING DEGREE OF HAZARD FROM TOXIC MATERIALS

- Amount of material
- Conditions of exposure
- Length and frequency of exposure
- Toxicity of materials
- Total body burden
- Multiple exposures
- High risk groups: disabled, ill, medicated, etc.

IDENTIFYING CHEMICAL HAZARDS IN CONSUMER PRODUCTS

- What are brand and trade names?
- What do the following terms on consumer products mean?
 - Use with adequate ventilation – Water-based – Natural

 – Danger, Warning, Caution – Biodegradable – Hypoallergenic

 – Generally recognized as safe – Low VOC – Nontoxic
 (GRAS)

- Special law for art/craft materials: Labeling of Hazardous Art Material Act (LHAMA), ASTM D-4236, AP/CP/HL labels, other certifiers

DETECTING AIR CONTAMINANTS

- Sight/color/cloudiness/beams of light/etc.
- Odor/olfactory fatigue/thresholds
- Air monitoring: types of monitors, area sampling, personal sampling

WORKPLACE AIR QUALITY

- ACGIH TLVs, OSHA PELs, and other standards

OUTDOOR AIR QUALITY

- EPA

INDOOR AIR QUALITY

- For offices, auditoriums, classrooms, etc.—ASHRAE standards

VENTILATION

- Natural ventilation systems
- Recirculation systems—ASHRAE standards
 - Air-conditioning: central and local systems
 - Air-purifying systems: filters, ESPs, cyclones, etc.
- Industrial ventilation—ACGIH standards
 - Dilution (a.k.a. general, mechanical) systems
 - Local exhaust: hoods, ducts, fans, air cleaners

SUBSTITUTION

- Selecting dust-free, water-based, or low-volatility materials
- Avoiding highly toxic chemicals: carcinogens, etc.
- Comparing toxicities to find safest (LD50s, TLVs, etc.)

PERSONAL PROTECTIVE EQUIPMENT

- Respiratory protection: written programs, NIOSH approval, fit testing, etc.
- Gloves, aprons, and other protective clothing
- Face and eye protection
- Hearing protection

PERSONAL HYGIENE

STORAGE AND HANDLING OF MATERIALS

HOUSEKEEPING
Cleanup: special vacuums, wet-mopping, etc.
Handling spills, chemical disposal

FIRE, MEDICAL, AND OTHER EMERGENCY SITUATIONS
• Extinguishers, sprinkler and deluge systems
• Emergency plans: abort procedures, drills and training, handicapped access/egress, eyewash fountains, and emergency showers

MEDICAL SURVEILLANCE PROGRAMS
Choosing doctors, medical exams, and tests

APPLYING THE INFORMATION TO SELECTION AND SAFE USE OF:
• Drawing materials: marking pens, colored pencils, chalks, pastels, charcoal
• Paints: watercolor, casein, tempera, acrylic, oil, oil sticks, water-washable oils, etc.
• Inks and printmaking materials: etches, inks, plate oil, photoprint materials, etc.
• Glues and adhesives: white glue, sticks, methyl cellulose, wheat paste, etc.
• Modeling: traditional mineral clays, plasticines, polymer clays, paper clays, etc.
• Ceramic glazes: lead, lead-free, lead-safe, other metals, cups and bowls, etc.
• Metal/jewelry projects: enamels, metals hazards, torches, etc.
• Stained glass: glass itself, lead came/solder, plastic came and "glass," zinc came, etc.
• Found materials
• Other: papermaking, blueprinting, photography, weaving, dyeing textiles, etc.

SPECIAL STUDENTS

Special training must be given to older students who are illiterate, do not speak English, have learning disabilities, or for any other reason cannot readily comprehend directions. Until these students can demonstrate comprehension orally, in another language or some other way, they must not be given access to toxic materials or dangerous machinery.

Educators also need to rethink special-student placement. Students who cannot be expected to demonstrate comprehension or who will never be able to carry out precautions effectively and consistently should not be mainstreamed into art classes in which the students use products that have any potential haz-

ards—even hazards related to abuse of the material. Unless there is one-on-one supervision of such students, they would relegate everyone in the class to working with only those materials safe enough for young children.

ELEMENTARY SCHOOL STUDENTS

A 1992 Bulletin from the Consumer Product Safety Commission stated that art materials with any warning labels whatsoever are not suitable for use by students in grade six and under. These students cannot be expected to understand the hazards of toxic substances or to carry out precautions effectively or consistently. A teacher must childproof the art room to prevent either intentional or unintentional access to toxic materials or dangerous machinery. The same procedures are necessary for students of any age who have physical or psychological problems that preclude comprehension of the hazards or maintenance of sufficient attention or discipline.

Youngsters are so vulnerable to toxic substances and machine hazards that university and high school students must not be allowed bring their children into art classrooms, labs, and shops.

Elementary school classrooms must not be used for adult art programs, unless all adult materials and equipment are removed or secured when the class is over, all waste materials are completely cleaned up, and the ventilation has removed any residual toxic air contaminants. These precautions are not sufficient for adult programs that involve highly toxic metals or solvents such as stained glass, oil painting, etching, and ceramic glazing. These programs simply do not belong in elementary schools.

PRESCHOOLERS

In 1984, I participated in a study conducted by the Center for Occupational Hazards in conjunction with the New York City Department of Health.[2] We surveyed the types of art materials that were being used in city day care and preschool programs.

Ten schools were chosen from the Health Department's list of private and public day care and preschool programs. The ten were chosen to provide a balance between public and private, as well as day care and preschool programs.

[2] *Art Hazards News* 7, no. 2 (March 1984), pp. 1, 4.

Each school received an on-site visit, consisting of an interview and a thorough inspection of all art materials. The name and address of each art material manufacturer was recorded, so that Material Safety Data Sheets (MSDSs) and other toxicological data could be requested.

It was found that when younger children share the facilities with older children, they end up sharing the older children's more-toxic materials as well. The hazards were also greater for young children if they were expected to eat lunch or snacks in the same areas that art classes were being held. Facilities without secure storage areas for art materials also tended to be more hazardous. In several schools, art materials were stored in bathrooms where children had access them.

A total of eighty-one different art products were found in the studied facilities, including paints, chalks, felt-tip markers, varnishes, turpentine, shellacs, pastels, glues, rubber cements, pastes, plasters, inks, crayons, clays, plasticenes, and colored pencils. MSDSs were requested for each of these products. A total of forty-seven MSDSs (58 percent) were received after a two-week follow-up letter and telephone calls. Of the ten day-care programs, over 75 percent were using solvent-containing rubber cements, permanent markers, varnishes, or shellacs. One-half were using adult paints, pastels, and wallpaper pastes that contained pesticides.

We found that in almost all the schools, the materials had been ordered by the administrator. All the administrators assumed without question that art materials sold for use by children were safe. Twenty of the eighty-one products (25 percent) carried the AP or CP seal (see page 41), which was the only voluntary labeling program at that time. However, none of the teachers were aware of the AP/CP program's existence or what the seals meant.

Fourteen years later, I see only small improvements. There is still an attitude among administrators and art teachers that art materials *must* be safe. Many children still eat lunch or snacks in classrooms where art activities are done. Materials for adults and older children still end up in the hands of preschoolers. While there has been a reduction in the number of children's products containing highly toxic chemicals such as solvents, there are still hazardous substances present in many art materials used today. Although teachers are more aware that there is some kind of labeling program, most really don't know how to interpret the label terminology.

Teachers of preschoolers need special training to understand in-depth some of the legal definitions of "nontoxic" in consumer products and art materials.

RULES FOR CHOOSING ART PRODUCTS FOR YOUNG CHILDREN

1. Make sure the ASTM D 4236 conformance statement is on the label. This statement does not mean the product is safe, but that the labeling is conforming to U.S. laws. (See chapter 5 for the inadequacies of these laws.)

2. Make certain the product is clearly marketed for children. Packaging, advertising, and directions for use should be checked to be sure this is the case.

3. Use products that have *no hazard statements* and *no precautionary statements* for children in grades six and under. Older children must be supervised when using products labeled with warnings.

4. Products for children should be labeled "nontoxic," but be mindful of how misleading and limited this term is. (See chapter 5.)

5. No matter what the label says, follow the same hygiene practices you would if the product were toxic. Choose materials that are designed not to create dusts, sprays, vapors, or fumes that can be inhaled or that will result in excessive skin contact. Do not allow food use in art classrooms. Clean up without raising dust, and make sure students wash up carefully before leaving class.

6. Insist that art material manufacturers provide MSDSs on their products. Do not use products for which MSDSs are not available. Be certain that these MSDSs report toxic ingredients rather than referring users to the ASTM labeling standard. Look up any reported toxic ingredients and/or check them with your own experts.

SELECTING ART MATERIALS FOR CHILDREN

Children in grade six and under age twelve still need protection from toxic art materials. However, teachers also need to give them art experiences that will educate and develop their talents. Table 33 lists substitute materials that are safe for children.

TABLE 33	ART MATERIALS AND PROJECTS FOR CHILDREN AND OTHER HIGH-RISK INDIVIDUALS

Children under age twelve or who are intellectually or physically disabled, the chronically ill, elderly people, and others at elevated risk from exposure to toxic chemicals can replace toxic materials with safer ones as follows:

DO NOT USE	SUBSTITUTES
Solvents and Solvent-Containing Products	**Water-Based and Solvent-Free Products**
1. Alkyd, oil enamels, or other solvent-containing paints.	Acrylics, oil sticks, water-based paints, watercolors, or other water-based paints containing safe pigments.
2. Turpentine, paint thinners, citrus solvents, or other solvents for cleaning up or thinning oil paints.	Mix oil-based, solvent-free paints with linseed oil only. Clean brushes with baby oil followed by soap and water.
3. Solvent-based silkscreen inks and other printing inks containing solvents or requiring solvents for cleanup.	Use water-based silkscreen, block printing, or stencil inks with safe pigments.
4. Solvent-containing varnishes, mediums, and alcohol-containing shellacs.	Use acrylic emulsion coatings, or the teacher can apply it for students under proper conditions.
5. Rubber cement and thinners for paste-up and mechanicals.	Use low-temperature wax methods, double-sided tape, glue sticks, or other solvent-free materials.
6. Airplane glue and other solvent-containing glues.	Use methyl cellulose glues, school paste, glue sticks, preservative-free wheat paste, and solvent-free glues.
7. Permanent felt-tip markers, white-board markers, and other solvent-containing markers.	Use water-based markers or chalk.
Powdered Dusty Materials	**Dustless Products or Processes**
1. Clay from mixing dry clay, sanding greenware, other dusty processes.	Purchase talc-free, low silica, premixed clay. Trim clay when leather-hard, clean up often during work. Practice good hygiene and dust control.

DO NOT USE	SUBSTITUTES
2. Ceramic glaze dust from mixing ingredients, applying, and other processes.	Do not use even lead-free glazes in grade 6 or under. Substitute with paints. The teacher can seal the paints with water-based acrylic varnish.
3. Metal enamel dust. Even lead-free enamels contain other toxic metals, and avoiding enamels altogether will eliminate the dangerous heat and acids involved in the enameling process.	Substitute with paints.
4. Powdered tempera and other powdered paints.	Purchase premixed paints, or have the teacher mix them.
5. Powdered dyes for batik, tie-dyeing, other textile processes.	Use vegetable and plant materials (e.g., onion skins, tea, etc.), FDA-approved food dyes, or unsweetened Kool-Aid.
6. Plaster dust. Do not sand plaster or do other dusty work. To avoid burns, do not cast hands or other body parts into plaster.	Have teachers premix plaster outdoors or in local exhaust ventilation. Cut rather than tear plaster-impregnated casting cloth.
7. Instant papier-mâché dust from finely ground magazines, newspapers, etc.	Use pieces of plain paper or black-and-white newspaper with methyl cellulose glues, paste, or other safe glues.
8. Pastels, chalks, or dry markers that create dust.	Use oil pastels or sticks, crayons, and dustless chalks.
Aerosols and Spray Products	**Liquid Materials**
1. Spray paints, fixatives, etc.	Use water-based liquids that are brushed, dripped, or splattered on, or have the teacher use sprays in local exhaust ventilation or outdoors.
2. Airbrushes.	Replace with other paint methods. Mist should not be inhaled, and airbrushes can be misused.
Miscellaneous Products	**Substitutes**
1. All types of professional artist's materials.	Use products approved and recommended for children when teaching children or high-risk adults.

DO NOT USE	SUBSTITUTES
2. Toxic metals such as arsenic, lead, cadmium, lithium, barium, chrome, nickel, vanadium, manganese, antimony, etc. These are common ingredients in ceramic glazes, enamels, paints, and many art materials.	Only use materials found free of highly toxic substances.
3. Epoxy resins, instant glues, or plastic resin adhesives.	Use methyl cellulose, library paste, or glue sticks.
4. Plastic resin casting systems or preformed plastics.	Use only preformed plastics, and use them in ways that do not involve heat, solvents, or any other method that will release vapors, gases, and odors.
5. Acid etches and pickling baths.	Do not use.
6. Bleach for reverse dyeing of fabric or colored paper.	Do not use. Thinned white paint can be used to simulate bleach on colored paper.
7. Photographic chemicals.	Use blueprint paper to make sun-grams, or use Polaroid cameras. Be sure students do not abuse Polaroid film or pictures, which contain toxic chemicals.
8. Stained-glass projects using lead, solder, or glass cutting.	Use colored cellophane and black paper or tape to simulate stained glass. Or use plastic came to set plastic pieces. Teachers can glue it in a ventilated area.
9. Industrial talcs contaminated with asbestos or nonfibrous asbestos minerals used in many white clays, slip-casting clays, glazes, French chalk, and parting powders.	Use other, talc-free products.
10. Sculpture stones contaminated with asbestos such as some soapstones, steatites, serpentines, etc.	Always use stones found free of asbestos on analysis.
11. Face and skin painting/tattooing with art paints or markers that are not labeled and approved for this use.	Always use products approved for use on the skin (e.g., cosmetics or colored sunscreen creams).

DO NOT USE	SUBSTITUTES
12. Scented markers.	Do not use. These teach children to sniff art markers.
13. Random assortments of plants and seeds.	Identify all plants to be sure no toxic or sensitizing plants are used (e.g., poison oak, castor, etc.).
14. Donated, found, or old materials whose ingredients are unknown.	Use clean, unused materials. Products used with food or other animal or organic materials may harbor bacteria or other hazardous microbes (e.g., washed plastic meat trays may harbor salmonella).

CHAPTER 31
REPRODUCTIVE RISKS

It is ironic that one of the most creative things artists can do is called "reproduction." And no undertaking creates more anxiety. Artists planning families who have carelessly used toxic substances for years suddenly reevaluate their work habits and start reading food labels.

Just how much effect our exposures at work have on reproduction is unknown. A search of the literature produced not one study of artists' reproductive problems. This is probably because artists are difficult to study. Our lifestyles and work habits vary greatly. We also use a host of different materials. Some of these materials, however, have been studied, and the data can provide some insight.

ART AS AN INDUSTRY

Painters, potters, printmakers, sculptors, and other artists use toxic substances in the form of pigments, paints, clays, glazes, solvents, dyes, and metals. Filmmakers and photographers may come into contact with toxic developing chemicals. Performing artists may encounter solvents in dry-cleaned costumes and other toxic substances in makeup and theatrical fog effects. Many of the chemicals in these artists' materials are the same as those used in industrial workplaces.

We can expect, then, that artists and industrial workers using the same materials will experience the same reproductive health problems. In fact, artists may be at greater risk than industrial workers if they toil longer than eight hours a day, work without ventilation and protective equipment, or worst of all, work at home, where intimate and prolonged exposure can occur.

CHEMICALS ARTISTS USE

A vast array of chemicals are used in artmaking. There are over two thousand dyes and about three hundred pigments. Photochemicals number in the thousands. Over forty-five different metals are found in art and craft materials, and each one may be present in dozens of different compounds and minerals. Hundreds of chemical solvents can be used to thin hundreds of different natural and synthetic resins, oils and waxes in various paints, inks, varnishes, glues, adhesives, and fixatives. If we count the chemical additives in use to modify all these products, then the chemicals artists use number in the tens of thousands.

Only a tiny fraction of these substances has been studied for reproductive effects. Without animal testing, workers can become the experimental species. For example, a recent study showed that one-third of pregnant IBM computer-chip workers miscarried after exposure to very small amounts of chemicals called glycol ethers. These same chemicals were used in the 1970s and 1980s in many water-based printmaking inks, latex paints, liquid dyes, felt-tip pens, and spray paints.

Today, those same art products may contain glycol ethers that are closely related to those used at IBM, but whose effects are not as well studied. Until more is known, it is wise to avoid unnecessary exposure to these and many other art materials. Two types of chemicals in particular should be avoided: solvents and metals.

SOLVENTS

The term "solvent" is applied to organic chemical liquids that dry faster than water and that are used in products such as paints, inks, cleaners, paint strippers, aerosol sprays, marking pens, and the like. The solvent for which we have the most data is ethyl alcohol, since we drink it in alcoholic beverages. Alcohol consumption causes almost all the adverse reproductive effects medically known, including:

1. Reduced male sex drive and performance
2. Birth defects
3. Reduced male and female fertility
4. Growth retardation and functional deficits in the fetus
5. Spontaneous abortion
6. Breast milk contamination

Alcohol can also be absorbed into the body by inhalation when it evaporates from alcohol-containing products, such as shellacs, lacquer thinners, and inks.

Because we know that alcohol is the least toxic of the solvents, we can assume it takes much less of other more-toxic solvents to cause adverse health effects. Alcohol and all other solvents have many characteristics in common. Most notably, they are all narcotics at some level of exposure. Glue sniffers have proven that they can get high—and even die—from inhaling vapors from any solvent-containing product: glue, gasoline, or spray paints. Even abuse of the correction fluid Wite-Out® killed three people in 1985!

Both by inhalation and ingestion, the narcotic effects of solvents and alcohol can damage the fetus's nervous system. Drinking alcohol during pregnancy can cause problems ranging from minor learning difficulties to severe facial deformities and mental retardation, depending on the amount to which the fetus was exposed. Now, it seems that most solvents are capable of causing similar effects. There are studies associating solvent exposure on the job to higher rates of miscarriages and pregnancy complications. The children also showed higher rates of central nervous system, cardiovascular, and respiratory problems.

The first study showing a connection between solvents and birth defects in humans was published in the *Journal of the American Medical Society* in March 1999. The researchers studied Canadian women exposed to organic solvents who were employed as factory workers, laboratory technicians, artists or graphic designers, printing industry workers, chemists, painters, office workers, car cleaners, veterinary technicians, funeral home employees, carpenters, and social workers. The authors claim their study indicates that "women exposed occupationally to organic solvents had a thirteenfold risk of major malformations, as well as increased risk for miscarriages in previous pregnancies."

METALS

Metals and their compounds abound in art materials: metal-containing pigments (cadmium red, manganese blue, etc.), ceramic glazes, enamels, stained glass, solders, welding rods, and more. Metals can be considered either as "minerals" needed for health (e.g., zinc, calcium, or iron) or as "heavy" or "toxic" metals, which should be avoided (e.g., lead, cadmium, or arsenic).

Actually, many metals are somewhere between these two extremes. For example, chrome and cobalt are needed by the body in tiny amounts, but are toxic and possibly cancer-causing in larger amounts.

Good reproductive health requires that we ingest a proper balance of only those metals needed by the body. This is impossible if we are supplementing our mineral intake with dusts and fumes from our studios and classrooms.

TABLE 34	REFERENCED DAILY INTAKES FOR MINERALS

MINERAL	RDIs* IN MILLIGRAMS
Calcium	1,000
Phosphorus	1,000
Magnesium	400
Zinc	15
Manganese	2
Copper	2
Chromium	0.12[†]
Molybdenum	0.075[†]
Selenium	0.07[†]

* FDA Referenced Daily Intakes.
† Labels on bottles of mineral supplements list these in micrograms (mcg) instead of milligrams (mg). I've listed them all in milligrams to demonstrate how little of the last three substances we should take.

LEAD: A SPECIAL METAL

Lead is especially hazardous. It can interfere with almost every phase of male and female reproduction. Adverse effects from lead can occur even after the child is born.

We are all exposed to lead from before birth (from our mother's blood through the placenta) and every day of our lives after birth from pollution in the air, water, soil, and home environment. If we are exposed to additional lead on the job, it is wise for us to know what our blood-lead levels are and what they mean in terms of our health.

POLLUTION LEAD LEVELS. The average blood-lead level for adults aged twenty to forty-nine years in the United States is 2.1 micrograms/deciliter (μg/dL).[1] However, doctors consider blood-lead levels up to 10 μg/dL to be "normal." If your blood lead is nearer 10 μg/dL, it is a good idea to find the cause

[1] Centers for Disease Control and Prevention. "Update: Blood Lead Levels—United States, 1991–1994," *Mortality and Morbidity Weekly Report* 46 (1997): 141–46. The 2.1 μg/dL level is the geometric mean average for adults who are not work or hobby lead-exposed.

and eliminate it. Check your work habits, tap water, old paint in your house, soil near the house, hobby activities, etc.

In addition, a mother's past lead exposures may also affect her baby. A significant amount of the lead we ingest or inhale is stored in our bones. Some of this lead is released back into the bloodstream during pregnancy. Women who have been exposed to lead in the past should talk to their obstetricians. The doctor may suggest additional tests and dietary calcium to reduce uptake of lead by the fetus.

LEAD LEVELS IN CHILDREN. Lead causes devastating effects on children, including retardation, hearing loss, and kidney damage, depending on the amounts the child takes in. The effects that occur first and at the lowest doses are subtle effects on mental acuity. Studies have shown a small, but measurable reduction in IQ in children whose blood lead levels are at 10 µg/dL. Experts think this effect occurs at even lower lead levels, but it is not as easily measured.

THE NEW CONCERN. It is now known that the mother's and the fetus's blood are roughly comparable. The blood-lead level of the fetus of a pregnant woman with a high "normal" blood lead would also be at about 10 µg/dL. But children whose blood lead is 10 µg/dL show a slight lowering in mental acuity—the younger the child, the more destructive lead is to mental function. While it is likely that the fetus would be most vulnerable of all, it is impossible to prove. Clearly, IQ can't be tested in the womb.

For this reason, it remains only an informed speculation that a supposedly normal blood-lead level of 10 µg/dL in a pregnant woman may still pose a small risk to the fetus.

On the other hand, many apparently normal children have been born to women who have slightly elevated lead levels. Moreover, the small reduction in IQ at 10 µg/dL seen in the studies is a statistical average and does not apply to any individual child. But it seems clear that avoiding lead completely is a small price to pay to eliminate the risk entirely.

OTHER CHEMICALS

There are many other chemicals used in art materials that may have reproductive effects, such as formaldehyde or chemicals that are emitted by art processes, such as kilns' inevitable release of carbon monoxide. Organic chemical pigments and dyes should also be avoided. Many are chemically related to

known carcinogens, and a few are contaminated with highly toxic chemicals, such as dioxins and PCBs. These chemicals are not only toxic—they may also affect reproduction by mimicking estrogen.

ESTROGENIC CHEMICALS

Some chemicals mimic the effects of the female hormone estrogen. They have been shown to cause adverse reproductive effects in males and birth defects in birds, fish, and mammals. Now, some experts think these chemicals are showing similar effects in humans, including:

1. The worldwide reduced sperm count
2. A three- to fourfold increase in cancer of the testicles
3. Increases in male reproductive organ birth defects
4. Decline in the ratio of male-to-female births in the United States, Canada, and other countries
5. Premature breast development in girls age six months to twenty-four months

According to some experts, children are now conceived and born into a virtual sea of estrogens. The chemicals may also be affecting women by increasing rates of breast and other cancers. Substances artists may encounter that either mimic estrogen or alter hormone function include:

1. Bisphenol A, found in some epoxy resins, other plastics, and in flame retardants
2. Dioxins and PCBs, which may contaminate some dyes and pigments such as phthalo blues and greens, diarylide or benzidine yellows and oranges, and dioxazine violet
3. Dioxins in ball clays and other ceramic minerals
4. Nonyl phenol, octyl phenol, and their derivatives, found in epoxy resins, some latex paints, and as special detergents used by art conservators
5. Tung oil, found in many varnishes, coatings, and inks
6. Phthalate plasticizers in polymer clays and other vinyl products

PREGNANCY

During pregnancy, the fetus can sustain two types of damage from exposure to hazardous substances: birth defects and toxic effects.

Birth defects can be caused by chemicals or drugs that alter the development of organs. This means that birth defects only occur in the first three months of pregnancy, as the organs are forming. For example, the drug thalidomide affects the limbs only during formation. Once they are fully formed, the drug has no effect.

Toxic effects are a kind of poisoning that can occur at any stage of pregnancy and even after birth. For example, lead stored in the body can damage brain function at any time from early in conception even through adulthood. But it is the fetus that is most susceptible.

COMMONSENSE PRECAUTIONS

Artists can reduce their reproductive risk from toxic art materials by following some simple rules:

1. Know your materials. Read labels and obtain Material Safety Data Sheets from the manufacturer on all products to which you are exposed to identify the hazardous ingredients in your products.
2. Get advice. Your personal physician may be a good source of information about chemicals, but doctors who are the most qualified to provide this information are Board Certified in Occupational Medicine or Toxicology. Other good sources are the Pregnancy Environmental Hotline at (617) 466-8474 and Arts, Crafts, and Theater Safety at (212) 777-0062.
3. Avoid exposure. If there is no FDA reference daily intake (RDI) for a chemical with which you work, don't let it get into your body. Only take those dietary supplements approved by your doctor.
4. Listen to your body and your mind. If a chemical makes you feel sick or "woozy" (e.g., a narcotic solvent), assume it is not good for your baby. But always keep in mind: Some chemicals in amounts whose effects your body can't detect can, nevertheless, damage the fetus.
5. Protect yourself. Wear gloves, or use methods of painting that keep paint off the skin. Never eat, smoke, drink, apply cosmetics, or do any hygiene tasks in the studio. Never spray, airbrush, sand, work with dry powders, or use any material in a form that can be inhaled, unless you have proper ventilation or protective equipment.
6. Ask your doctor about respiratory protection. Occupational physicians do not recommended respirators for people with certain health prob-

lems (e.g., heart and lung deficiencies) or for certain pregnant women for whom the increased breathing stress caused by respirators could put the fetus at risk.

7. Avoid lead in any form. If you must use it, have regular blood-lead tests. If you have had heavy lead exposure in years past, tell your doctor, because lead stored in bones and tissues from previous exposure reenters the bloodstream during pregnancy. Some physicians increase calcium supplements in such patients to reduce the amount of lead taken up by the fetus.

8. Don't eat or drink from ceramic ware or lead crystal, unless lab tests show that items such as cups, casseroles, and pitchers do not leach lead *or any other metal* into food. Low-fired ware may leach metals, such as lead or boron, into your food. Middle-range and high-fired pottery may leach other metals, such as barium and lithium, into your food. Colored wares may leach colorant metals, such as cadmium, cobalt, and manganese, into food. Plates and containers for dry products are usually not a problem.

9. Keep children out of the studio and away from toxic art materials. Exposure to some toxic substances in childhood can affect the next generation.

10. Don't dwell on past chemical exposures. What's done is done. Stress is not good for you, or the baby either!

If all this causes you to worry: Welcome to parenthood! Worry is about to become permanent.

APPENDIX A
SOURCES AND ANNOTATED REFERENCE LIST

Artists have access to many sources of help and information about their occupational hazards:

Arts, Crafts, and Theater Safety
Governmental Agencies
Standards Organizations
Commercial Sources
Annotated References

PART 1
ARTS, CRAFTS, AND THEATER SAFETY

Arts, Crafts, and Theater Safety (ACTS) is a nonprofit corporation dedicated to providing health and safety services to people in the arts. ACTS maintains a worldwide, free information service by phone, mail, and e-mail. We provide professional safety and industrial hygiene advice, single copies of educational materials, and referrals to doctors and other professional sources of help.

As president of ACTS, I am prejudiced—I think ACTS is the best source of safety information for artists. In fact, ACTS is currently the only nonprofit doing this kind of work.

ACTS has other unique features. For example, we accept donations—but we do not actively solicit them. We recognize that artists are among the least affluent groups in society. We wouldn't want any artist needing information to hesitate to call because he or she can't afford to make a donation.

ACTS also does not accept donations or advertising from businesses or manufacturers. We want artists to know that the recommendations we make are not influenced by financial gain.

Despite these restrictive policies, we generate sufficient income from unsolicited contributions from individuals and foundations and from below-market-value fees for services, including:

1. Providing speakers for lectures, workshops, and courses
2. Conducting U.S. and Canadian regulatory compliance training sessions and inspections
3. Providing technical assistance for building planning, renovation, and ventilation projects

4. Researching, writing, and editing safety materials
5. Sale of publications (see list below)

We maximize the use of this income by keeping our overhead low. We operate from our own home offices, communicate by e-mail and conference calls, and laser-print/copy our own publications. Questions, comments, and requests for our services are welcome.

ACTS FACTS NEWSLETTER
ACTS publishes a monthly newsletter updating health and safety regulations and research affecting the arts. It is available from ACTS for $18 per year.

ACTS DATA SHEETS
The following data sheets are available from ACTS for $0.25 per page. Requests for only a single copy of a data sheet comprising up to six pages will be honored without cost.

- "After Disaster: A Museum Worker's Guide to Re-Entry" (4 pages)
- "A Hazard Communication Program" (a fill-in-the-blanks OSHA program for employers, 6 pages)*
- "All About Wax" (4 pages)
- "Americans with Disabilities in the Scenic Arts" (5 pages)*
- "Anthraquinone Dyes & Pigments" (3 pages)
- "Artist's Oil Painting" (3 pages)
- "Art Painting Data Sheet" (5 pages)
- "Azo Dyes & Benzidine Dyes, Banned German Dyes" (4 pages)
- "Barium Glaze Hazards" (5 pages)
- "Biological Hazards" (11 pages)
- "Carbon Arcs: Still Around" (2 pages)
- "Carbon Monoxide (CO) Detectors" (4 pages)*
- "Carpets: The Case Against Them" (3 pages)
- "Ceramic Ware Hazards" (7 pages)
- "CPSC 1992 Safety Alert" (2 pages)
- "D-Limonene: the Citrus Solvent" (4 pages)
- "Dyes and Pigments" (8 pages)
- "Gloves—Training Materials" (discusses types of gloves, OSHA rules, and rubber hazards, 4 pages)*
- "Heat Exposure" (1 page)*
- "Identifying Dyes and Pigments" (2 pages)
- "Infrared Radiation Protection" (4 pages)
- "Labels: Reading Between the Lies" (6 pages)

- "Lead-containing Art & Theater Materials" (2 pages)
- "Lead: Effects on Adults & Children" (3 pages)*
- "Lead Frit Myth" (2 pages)
- "Linseed Oil: A Fire Hazard" (4 pages)
- "Mold: Nothing to Sneeze At" (3 pages)
- "MSDSs: Reading Between the Lines" (8 pages)
- "Oven-Cured Polymer Clays" (4 pages)
- "Papermaking Safety" (6 pages)
- "Quilting Safely" (6 pages)
- "Rationale: Banning Lead Glazes in Public Schools" (2 pages)
- "Rationale: Banning Lead from Public Schools" (2 pages)
- "Reproductive Hazards for Artists" (4 pages)
- "Respiratory Protection: New Rules" (5 pages)*
- "Respiratory Protection Program" (a fill-in-the-blanks OSHA program for employers, 18 pages)*
- "Selecting Children's Art Materials" (5 pages)
- "Solvents" (9 pages)*
- "Stained Glass Hazards & Precautions" (3 pages)*
- "Teaching Art Safely" (6 pages)
- "Teaching Art & Theater Safely" (7 pages)
- "Teaching College Art Safely and Legally" (5 pages)
- "Teaching Art: Laws and Liability" (3 pages)
- "Teaching Preschool Art Safely" (5 pages)
- "Terracotta & Brick: from Clay to Construction" (18 pages)
- "Threshold Limit Values" (a simplified definition, 2 pages)*
- "Urethane Resin Systems" (hazards and precautions for use of these systems, 6 pages)*
- "Uranium, Lead, and Other Ceramic and Glass Dinnerware Hazards," Abstracts of articles by Professor Ralph Sheets (3 pages)
- "Understanding the MSDS" (4 pages)
- "Ventilation for Art Buildings" (6 pages)
- "Water-based Latex and Paints" (2 pages)

Arts, Crafts, and Theater Safety
181 Thompson Street #23
New York, NY 10012
Telephone: (212) 777-0062
E-mail: *ACTSNYC@cs.com*

* Available through courtesy of United Scenic Artists, Local 829, IATSE.

PART 2

GOVERNMENTAL AGENCIES

OCCUPATIONAL SAFETY AND HEALTH ADMINISTRATION (OSHA)

General Industry Compliance Assistance
Directorate of Compliance Programs
200 Constitution Avenue N.W., Room N-3107
Washington, D.C. 20210
(202) 693-1850
www.osha.gov

ENVIRONMENTAL PROTECTION AGENCY (EPA)

There are a number of addresses in the Washington and Maryland area. It is best to go to *www.epa.gov* and seek information on specific subjects.

U.S. CONSUMER PRODUCT SAFETY COMMISSION (CPSC)

Washington, D.C. 20207
(800) 638-2772
www.cpsc.gov

CPSC enforces the art materials labeling laws and recalls hazardous products of all types, such as candles, cribs, and car seats. A list of recalled products can be accessed in their "Thrift Store Checklist."

NATIONAL INSTITUTE FOR OCCUPATIONAL SAFETY AND HEALTH (NIOSH)

4676 Columbia Parkway
Cincinnati, Ohio 45226
(800) 35-NIOSH
E-mail: *pubstaft@cdc.gov*
www.cdc.gov/niosh

NIOSH conducts health-hazard evaluations of workplaces, schools, and other venues. Individual reports on these studies are free from the NIOSH Publications Office at the address above. Provide a self-addressed, gummed mailing label.

NEW JERSEY DEPARTMENT OF HEALTH AND SENIOR SERVICES

Right-to-Know Program—CN 368
Trenton, New Jersey 08625-0368
(609) 984-2202
www.state.nj.us/health/eoh/rtkweb/rtkhsfs.htm

New Jersey Department of Health's Right-to-Know Hazardous Substances Fact Sheets provide better information than you will find on MSDSs, including more detailed chronic data, information on whether the chemical has ever been formally studied for cancer effects, and odor thresholds when known. They are available for $1 each in hard copy, or single copies can be downloaded from the Web site listed above. The whole database is also available on CD-ROM and online services.

PART 3
STANDARDS ORGANIZATIONS

AMERICAN CONFERENCE OF GOVERNMENTAL INDUSTRIAL HYGIENISTS (ACGIH)

1330 Kemper Meadow Drive
Cincinnati, Ohio 45240
Publications catalog: (513) 661-7881
www.acgih.org

ACGIH sets standards for industrial air quality and ventilation. Especially useful is their handbook, *Industrial Ventilation: A Manual of Recommended Practice*, and their annually updated booklet of Threshold Limit Values.

AMERICAN INDUSTRIAL HYGIENE ASSOCIATION (AIHA)

2700 Prosperity Avenue, Suite 250
Fairfax, Virginia 22031
(703) 849-8888
www.aiha.org

AIHA sets workplace air-quality standards for substances not covered by other organizations and provides lists of industrial hygienists and certified testing laboratories.

AMERICAN NATIONAL STANDARDS INSTITUTE

25 West 43rd Street, 4th Floor
New York, New York 10036
(212) 642-4980
E-mail: *psa@ansi.org*
www.ansi.org

ANSI sets thousands of standards. Of particular relevance to artists are the standards for protective eyewear and eyewash stations.

AMERICAN SOCIETY FOR TESTING AND MATERIALS (ASTM)

100 Barr Harbor Drive
West Conshohocken, Pennsylvania 19428
Publications: (610) 832-9585
www.astm.org

ASTM sets many product safety standards, including the standards for labeling of toxic art materials (ASTM D–4236), many standards for pigments, ceramic materials, and general consumer products, such as candles.

AMERICAN SOCIETY OF HEATING, REFRIGERATING, AND AIR-CONDITIONING ENGINEERS (ASHRAE)

1791 Tullie Circle N.E.
Atlanta, Georgia 30329
(404) 636-8400
www.ashrae.org

ASHRAE sets comfort ventilation and some indoor air-quality standards.

AMERICAN WELDING SOCIETY (AWS)

550 N.W. LeJeune Road
Miami, Florida 33126
(800) 443-9353
www.aws.org

AWS sets welding quality and safety standards and provides certified training courses.

NATIONAL FIRE PROTECTION ASSOCIATION (NFPA)

1 Batterymarch Park
Post Office Box 9101
Quincy, Massachusetts 02269
(617) 770-3000
www.nfpa.org

Some useful NFPA standards include:
• NFPA #10: Standard for Portable Fire Extinguishers
• NFPA #30: Flammable and Combustible Liquids Code
• NFPA #70: National Electrical Code

PART 4

COMMERCIAL
SOURCES

The companies listed here are not the only ones providing services, and inclusion does not constitute an endorsement of these companies or their products.

Lab Safety Supply
Technical Support: (800) 356-2501
To order: (800) 356-0783
www.labsafety.com

A safety catalog supplier that provides a wide array of products and technical support services to help you select the proper equipment.

Direct Safety
(800) 528-7405
E-mail: *directsaf@aol.com*

Another safety catalog supplier that provides a wide array of products and technical support services to help you select the proper equipment.

IVL Technical Sales, Inc.
1977 Franklin Road
Valley Stream, New York 11580
(516) 285-1855
www.ivltech.com

IVL sells air-flow meters, including the Alnor Velometer Jr., which is recommended for artists and teachers.

Long Island Productions
106 Capitola Drive
Durham, North Carolina 27713
(800) 397-5215
Fax: (919) 544-5800
E-mail: *longislandproductions.com*

LIP provides reasonably priced training videos.

Coastal Safety and Environmental
3083 Brickhouse Court
Virginia Beach, Virginia 23452
(800) 767-7703
www.coastal.com

Coastal provides training videos and services.

PART 5

ANNOTATED
REFERENCE LIST

Accrocco, J. O., ed. *The MSDS Pocket Dictionary* rev. ed. Schenectady, N.Y.: Genium Publishing, 2000. A dictionary of terms used on Material Safety Data Sheets. Contact Genium Publishing at 1145 Catalyn Street, Schenectady, New York 12303; (518) 377-8854.

Bingham, Eula, Barbara Cohrssen, and Charles H. Powell, eds. *Patty's Toxicology*, 5th ed. New York: Wiley-Interscience, 2001. Available at www.acgih.org, the nine-volume set costs over $2,000.

Clark, Nancy, Thomas Cutter, and Jean-Ann McGrane. *Ventilation: A Practical Guide.* New York: Center for Safety in the Arts, 1980. A guide to basic ventilation principles and step-by-step guidance for those who wish to evaluate, design, and build an adequate ventilation system. Available at Amazon.com.

Dryden, Deborah M. *Fabric Painting and Dyeing for the Theatre.* Portsmouth, N.H.: Heinemann, 1993. Well-written, 256-page practical guide with accurate safety and chemical information for dyers.

Hawley, Gessner. *Hawley's Condensed Chemical Dictionary,* 13th ed., revised by N. Irving Sax and Richard Lewis, Sr. New York: Van Nostrand Reinhold Company, 1997.

Howard, Keith. *Non-Toxic Intaglio Printmaking, Printmaking Resources.* Grand Prairie, Alberta, Canada, 1998. Obviously, intaglio printmaking cannot be truly "nontoxic." A lack of technical sophistication and an incorrect assumption that consumer products are safer than industrial products are at the root of many of the problems with this book. Still, the book is worth reading and has some useful suggestions.

Rossol, Monona, and Ben Bartlett. *Danger! Artists at Work,* 2nd ed. Port Melbourne, Australia: Thorpe Publishing, 1996.

Rossol, Monona. *The Health and Safety Guide for Film, TV, and Theater.* New York: Allworth Press, 2000. Available from ACTS or, for credit card orders, at (800) 491-2808 or *www.allworth.com.*

Rossol, Monona. *Keeping Clay Work Safe and Legal,* 2nd ed. Flushing, N.Y.: National Council on Education in the Ceramic Arts (NCECA), 1996. Contact (800) 99-NCECA or ACTS for ordering information.

Sax, N. Irving. *Dangerous Properties of Industrial Materials,* 10th ed. New York: Van Nostrand-Reinhold, 2000. Costs in the range of $1,000. A fast general reference.

Shaw, Susan, and Monona Rossol. *Overexposure: Health Hazards in Photography,* 2nd ed. New York: Allworth Press, 1991. Available from ACTS.

Sheets, Ralph W., Professor of Chemistry at Southwest Missouri State University, has written and coauthored many papers on the potential hazards from uranium, lead, and other substances in ceramic and glass dinnerware. Artists can request a data sheet from ACTS, which reprints abstracts of the following papers: "Thorium in Collectible Glassware," "Accidental Contamination from Uranium Compounds through Contact with Ceramic Dinnerware," "Extraction of Lead, Cadmium, and Zinc from Overglaze Decorations on Ceramic Dinnerware by Acidic and Basic Food Substances," "Release of Heavy Metals from European and Asian Porcelain Dinnerware," "Release of Uranium and Emission of Radiation from Uranium-Glazed Dinnerware," "Use of Home Test Kits for Detection of Lead and Cadmium in Ceramic Dinnerware," "Acid Extraction of Lead and Cadmium from Newly Purchased Ceramic and Melamine Dinnerware," and "Radioactive Art Glass and Glass Dinnerware."

Society of Dyers and Colourists, and the American Association of Textile Chemists and Colorists. *Colour Index International,* 4th ed. Bradford, England, and Research Triangle Park, N.C.: Society of Dyers and Colourists and the American Association of Textile Chemists and Colorists, 2001. This resource lists by C.I. name and number all commercially available dyes and pigments and their intermediates.

The latest edition, dedicated to pigments and solvent dyes, is available only online, for an annual subscription price of £275 (roughly U.S.$440).

If you wish to order hard-copy volumes of the index, contact the Society of Dyers and Colourists, Post Office Box 244, Perkin House, 82 Grattan Road, Bradford BD1 2JB England phone: +44 (0) 1274-725138, *www.sdc.org.uk,* e-mail: *sales@sdc.org.uk,* or the American Association of Textile Chemists and Colorists, One Davis Drive, Post Office Box 12215, Research Triangle Park, North Carolina 27709, U.S.A., phone: (919) 549-8141, *www.aatcc.org,* e-mail: *info@aatcc.org.* A nine-volume, hard-copy set costs $1,000.

Spandorfer, Merle, Deborah Curtiss, and Jack Snyder, MD. *Making Art Safely.* New York: John Wiley & Sons, 1995. Most of the suggestions in this book are good ones for working safely.

Welden, Don, and Pauline Muir. *Printmaking in the Sun: An Artist's Guide to Making Professional-Quality Prints Using the Solarplate Method.* New York: Watson Guptill, 2001.

APPENDIX B
GLOSSARY

ACIDIC SOLUTION. An aqueous solution having a pH lower than 7 (neutral). (See definition of pH.) Acidic is the opposite of alkaline. The lower the pH, the more corrosive it is.

ACUTE TOXICITY. Adverse health effect resulting from brief exposure to a chemical. Data commonly includes LC50s and LD50s. The LC50 is the concentration in the air that will kill 50 percent of the test animals when administered in a single exposure in a specific time period, usually one hour. The LD50 is the single dose that will kill 50 percent of the test animals by any route other than inhalation, such as by ingestion or skin contact. These tests establish the degree to which a chemical is acutely hazardous and determine if it will be designated "nontoxic," "toxic," or "highly toxic."

LABEL DEFINITIONS OF TOXICITY IN THE UNITED STATES AND CANADA

Label Term	LD50	LC50
Nontoxic	>5.0 g/kg*	>20,000 ppm**
Toxic	0.05–5.0 g/kg	200–20,000 ppm
Highly toxic	<0.05 g/kg	<200 ppm

* Grams per kilogram of body weight of test animal.

** Parts per million: parts of substance in 1 million parts of air.

As defined by the Federal Hazardous Substances Act (FHSA) in the United States and the Federal Hazardous Products Act in Canada, "nontoxic" means anything that passes the LD50 and LC50 animal tests. Workers need to know that long-term damage, such as cancer and birth defects, are not detected by these tests. This is one reason that the FHSA has been amended to provide chronic-hazard labeling for consumer art materials. (This definition has now been extended to all United States consumer products, but as yet, there is poor compliance.)

ALKALI. An inorganic or organic chemical that is corrosive when dissolved in water is alkaline (see next definition). Alkaline chemicals neutralize acids to form salts and turn litmus paper blue. Also called a base or a caustic.

ALKALINE SOLUTION. An aqueous solution with a pH of greater than 7. (See definition of pH.) The opposite of acidic. The greater the pH, the more alkaline and corrosive the solution is.

ATROPHY. Reduction in size or function of tissue or organs.

AUTO-IGNITION TEMPERATURE. The minimum temperature at which a substance ignites without application of a flame or spark.

BOILING POINT (BP). Sometimes called the "vaporization point," the BP is the temperature at which the substance changes rapidly, usually with bubbling, from a liquid to a vapor. Liquids with low BPs usually expose workers to large amounts of the vapor. If the vapor is also flammable, liquids with low BPs are also fire hazards. A common error is the assumption that no vapor is formed (e.g., from metals) until the BP is reached. However, vapor is formed at far lower temperatures, just as water, which boils at 212°F, evaporates at room temperature.

CANCER. There are three agencies whose reviews of carcinogenicity must be reported on MSDSs: the National Toxicology Program (NTP), the International Agency for Research on Cancer (IARC); and OSHA. They categorize carcinogens as follows:

AGENCY CATEGORY AND EXPLANATION

IARC: 1—Carcinogenic to Humans: sufficient evidence of carcinogenicity
2A—Probably Carcinogenic to Humans: limited human evidence, sufficient evidence in experimental animals
2B—Possibly Carcinogenic to Humans: limited human evidence in the absence of sufficient evidence in experimental animals
3—Not Classifiable as to Carcinogenicity to Humans
4—Probably Not Carcinogenic to Humans

NTP: K—Known To Be a Human Carcinogen: sufficient evidence from human studies
R—Reasonably Anticipated To Be a Human Carcinogen (RAHC)

OSHA: Ca—Carcinogen defined, with no further categorization

Statements such as "this chemical is not considered to be a carcinogen by NTP, IARC, or OSHA" make it appear that the chemical has been evaluated by these agencies and found safe. Instead, it is more likely that the agencies have never evaluated the chemical.

CAS NUMBER, OR CHEMICAL ABSTRACTS SERVICE REGISTRY NUMBER. A number assigned to a chemical by the Chemical Abstract Service, an organization that indexes information published by the American Chemical Society. It is a unique identification number.

CAUSTIC. *See* Alkali *and* Alkaline.

CHRONIC. Adverse health effects resulting from repeated or long-term exposure. Included are cancer, reproductive or developmental damage, and neurological or other organ damage to animals or humans.

COMBUSTIBLE LIQUIDS. Defined by the U.S. Federal Hazardous Substances Act and the Canadian Federal Hazardous Products Act, combustible liquids have flash points between 100°F and 150°F.

DENSITY. The ratio of weight (mass) to volume of a material, usually in grams per cubic centimeters. For example, one cubic centimeter of water weighs one gram. *See also* Specific Gravity.

EVAPORATION RATE. The rate at which a material will vaporize (volatilize, evaporate) from the liquid or solid state when compared to another material. The two common liquids used for comparison are butyl acetate and ethyl ether.

When Butyl Acetate = 1.0	When Ethyl Ether = 1.0
> 3.0 = Fast	< 3.0 = Fast
0.8–3.0 = Medium	3.0–9.0 = Medium
< 0.8 = Slow	> 9.0 = Slow

FLAMMABLE LIMITS. Only applicable to flammable liquids and gases, these are the minimum and maximum concentrations in air between which ignition can occur. Concentrations below the lower flammable limit (LFL) are too lean to burn, while concentrations above the upper flammable limit (UFL) are too rich. All concentrations in between can burn or explode. (Sometimes called lower and upper explosion limits—LEL and UEL.)

FLAMMABLE LIQUIDS. Defined by the U.S. Federal Hazardous Substances Act and the Canadian Federal Hazardous Products Act, flammable liquids have flash points between 20°F and 100°F. Flash points of extremely flammable liquids are less than 20°F.

FLASH POINT. The lowest temperature at which a flammable liquid gives off sufficient vapor to form an ignitable mixture with air near its surface or within a vessel. Combustion does not continue.

GRAS. "Generally Recognized as Safe." A phrase applied to FDA-approved food additives. Many GRAS additives were accepted without testing, because they have been used in food for many years. Unless GRAS status has been recently "reaffirmed," and unless you plan to eat the chemical, GRAS status is irrelevant to art material safety.

HAZARDOUS DECOMPOSITION PRODUCTS. The hazardous chemicals given off when the product burns or when it degrades or decomposes without burning. They should be listed on Material Safety Data Sheets. However, manufacturers often only report the results of high-temperature incineration with all the oxygen necessary for complete combustion. Under these conditions, most organic chemicals will give off carbon dioxide, water, and a few other low-molecular-weight chemicals. Actual burning in open air, heating with torches, hot-wire cutting, or other methods of rapid decomposition will usually produce very different results. Workers should be aware that hazardous decomposition products reported by manufacturers may not be relevant to the way in which the product is actually burned or decomposed.

HAZARDOUS POLYMERIZATION. Polymerization is the process by which the molecules of a chemical can combine to form larger molecules. Examples include the setting up of epoxy or polyester resins. Polymerization is hazardous if during the reaction excessive heat, gases, or some other byproduct is given off in amounts sufficient to cause fires, burst containers, or cause some other kind of harm.

HEPA. "High-Efficiency Particulate Air" filter, which is certified to capture 99.97 percent of particles 0.3 microns in diameter.

HMIS. The "Hazardous Materials Identification System" developed by the National Paint and Coatings Association to provide product information on

acute health, reactivity, and flammability hazards. A zero-to-four rating system is used, with four as the most severe. These ratings alone are not sufficient labeling for workplace safety.

INCOMPATIBILITY. Incompatible substances are those that will react dangerously with the product described. Workers should also use this to determine which substances should not be stored in proximity to the product.

IRRITANT. A substance that can cause an inflammatory effect on living tissue. Irritant effects are usually reversible.

MELTING POINT. The temperature at which a solid changes to a liquid. It applies only to solid materials.

METHEMOGLOBINEMIA. Cyanosis due to the oxidization of the iron molecule in the blood's hemoglobin into a brown pigment that is incapable of carrying oxygen. Can be caused by ingestion of nitrites, nitrobenzene solvents and pigments, and certain other oxidizers.

NECROSIS. Localized death of tissue.

ODOR THRESHOLD (OT). The concentration in air at which most people can smell the chemical. If the OT is smaller than the TLV, then the chemical provides warning before health effects are expected. If the OT is larger than the TLV, one is already at risk by the time the odor can be detected.

OXIDIZER. A substance that yields oxygen readily or brings about an oxidation reaction that causes or enhances combustion of materials. Examples are chlorates, permanganates, organic peroxides, and nitrates.

PH. A value taken to represent the acidity or alkalinity of an aqueous solution. It is the logarithm of the reciprocal of the hydrogen-ion concentration of a solution. For example, pure water has a concentration of H+ ions of $1/10,000,000$ or 10^7, moles per liter. This is commonly expressed by saying that pure water has a pH of 7, which means that its concentration of hydrogen ions is expressed by the exponent 7 (without the minus sign). Solutions with a pH of less than 7 are acidic, those with a pH greater than 7 are alkaline.

SENSITIZER. A material that causes little or no reaction on first exposure, but on repeated exposure will cause allergies or sensitivities in significant numbers of people or test animals.

SOLUBILITY IN WATER. The amount of a substance by weight that will dissolve in water at ambient temperature. Solubility is important in determining suitable cleanup and extinguishing methods. Solubility is usually reported in grams per liter (g/l), or in general categories, such as:

Negligible or insoluble	<0.1 percent
Slight	0.1–1.0 percent
Moderate	1–10 percent
Appreciable	10 percent
Complete	Soluble in all proportions

SPECIFIC GRAVITY (SG). The heaviness of a material compared to a reference substance. When the reference substance is water ($H_2O = 1$), it indicates whether it will float or sink in water. The SG for solids and liquids compared to water numerically equals their density (see above). The SG for gases does not equal density, because the density of air is not 1.0, but 1.29.

STABILITY. The ability of a material to remain unchanged under reasonable conditions of storage and use. A material that has this ability is deemed "stable"; one that does not is "unstable."

TRADE SECRET EXEMPTIONS. Information on the identity of hazardous ingredients can be withheld by the manufacturer if it comprises trade secrets or if the ingredients are proprietary. The MSDS should state by whose authority (usually the state health department) the product's identity can be withheld. Trade secret products should be avoided whenever possible, since it is very difficult and time-consuming for medical personnel to get this data if there is an accident or illness. Even then, the medical person must withhold from the victim the name of the chemical that has caused his or her problem.

UNUSUAL FIRE AND EXPLOSION HAZARD. Unusual hazards, such as those of some organic peroxides that ignite spontaneously under certain conditions or that become explosive when old.

VAPOR DENSITY. The weight of a vapor or gas compared to an equal volume of air. The VD of air is 1.0. Materials with a VD less than 1.0 are lighter than air. Materials with a VD greater than 1.0 are heavier than air. While all vapors and gases will mix with air and disperse, large quantities of unmixed vapor or gas in locations without much air movement—such as storage rooms—will tend to rise or sink depending on their VD. Flammable vapors that are heavier than air can spread to sources of ignition and flash back to the source.

VAPOR PRESSURE. The pressure exerted by a saturated vapor above its own liquid in a closed container. VPs combined with evaporation rates are useful in determining how quickly a material becomes airborne, and thus how quickly a worker is exposed to it. They are usually reported in millimeters of mercury (mm Hg) at 68°F (20°C) unless otherwise stated. Substances with VPs above 20 mm Hg may present a hazard because of their extreme volatility.

WATER-BASED. An unregulated product-label term that may mean that water is an ingredient or that water can be used to dilute or clean up the product. However, keep in mind that water-based products often contain organic chemical solvents.

INDEX

BOOKS FROM ALLWORTH PRESS

An Artist's Guide: Making It in New York City by Daniel Grant (paperback, 6 x 9, 256 pages, $18.95)

The Business of Being an Artist, Third Edition by Daniel Grant (paperback, 6 x 9, 352 pages, $19.95)

Caring for Your Art: A Guide for Artists, Collectors, Galleries, and Art Institutions, Third Edition by Jill Snyder (paperback, 6 x 9, 256 pages, $19.95)

Artists Communities: A Directory of Residencies in the United States That Offer Time and Space for Creativity, Second Edition by the Alliance of Artists' Communities (paperback, 6¾ x 9⅞, 256 pages, $18.95)

Legal Guide for the Visual Artist, Fourth Edition by Tad Crawford (paperback, 8½ x 11, 272 pages, $19.95)

Business and Legal Forms for Fine Artists, Revised Edition with CD-ROM by Tad Crawford (paperback, 8½ x 11, 144 pages, $19.95)

The Artist-Gallery Partnership: A Practical Guide to Consigning Art, Revised Edition by Tad Crawford and Susan Mellon (paperback, 6 x 9, 216 pages, $16.95)

The Artist's Guide to New Markets: Opportunities to Show and Sell Art Beyond Galleries by Peggy Hadden (paperback, 5½ x 8½, 252 pages, $18.95)

The Fine Artist's Guide to Marketing and Self-Promotion by Julius Vitali (paperback, 6 x 9, 224 pages, $18.95)

Corporate Art Consulting by Susan Abbott (paperback, 11 x 8½, 256 pages, $34.95)

The Fine Artist's Career Guide by Daniel Grant (paperback, 6 x 9, 224 pages, $18.95)

The Artist's Quest for Inspiration by Peggy Hadden (paperback, 6 x 9, 272 pages, $15.95)

How to Start and Succeed as an Artist by Daniel Grant (paperback, 6 x 9, 240 pages, $18.95)

Please write to request our free catalog. To order by credit card, call 1-800-491-2808 or send a check or money order to Allworth Press, 10 East 23rd Street, Suite 510, New York, NY 10010. Include $5 for shipping and handling for the first book ordered and $1 for each additional book. Ten dollars plus $1 for each additional book if ordering from Canada. New York State residents must add sales tax.

To see our complete catalog on the World Wide Web, or to order online, you can find us at *www.allworth.com*.